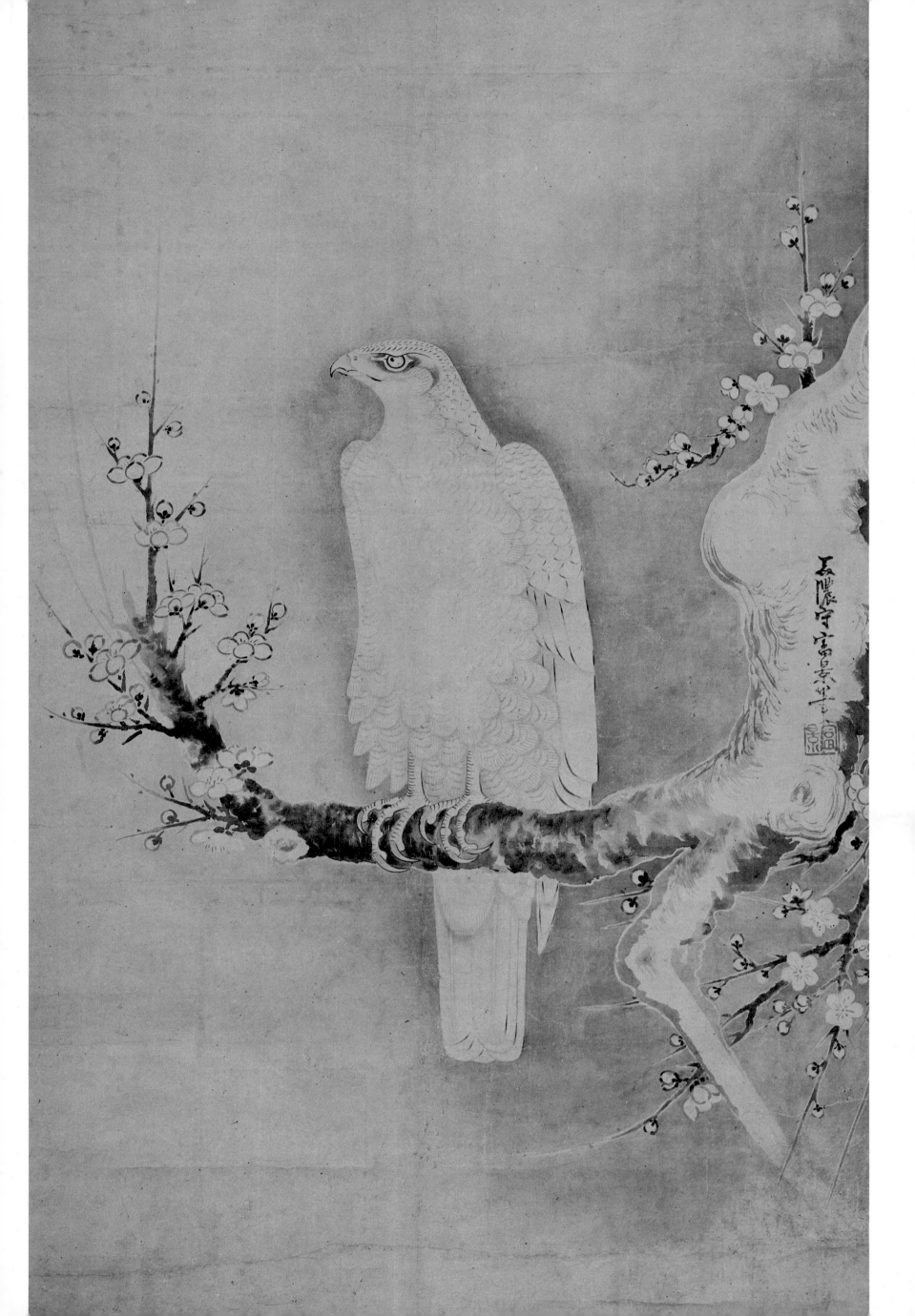

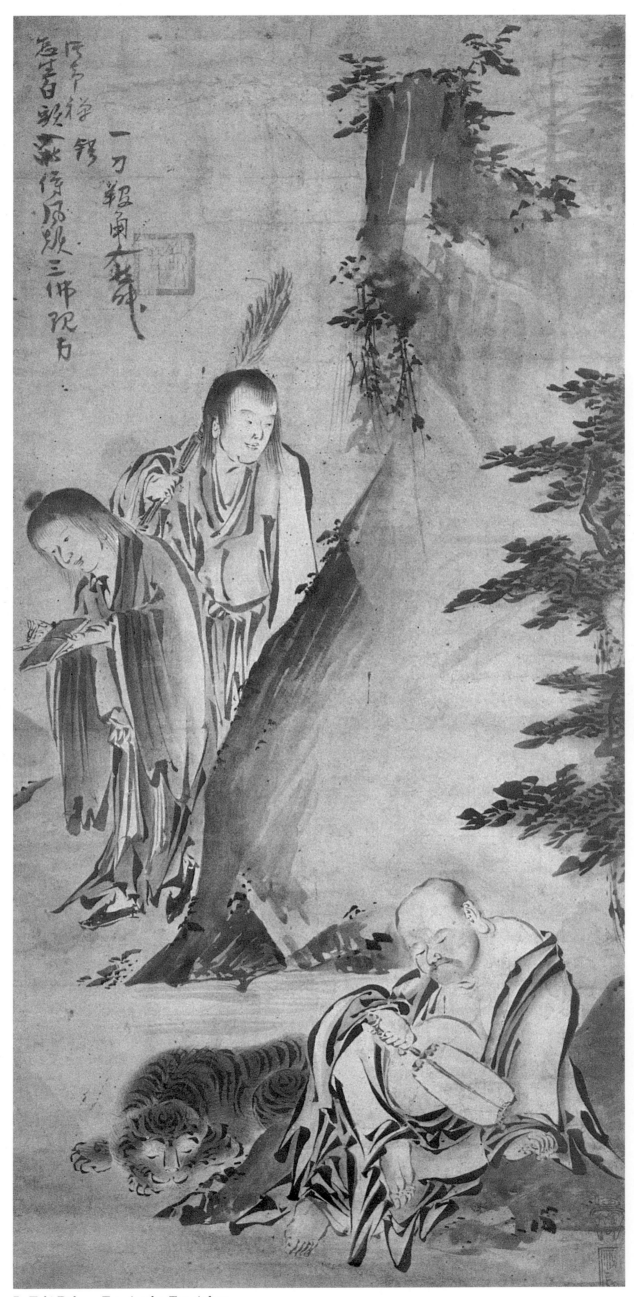

7. Toki Dōbun. *Two Awake, Two Asleep.*

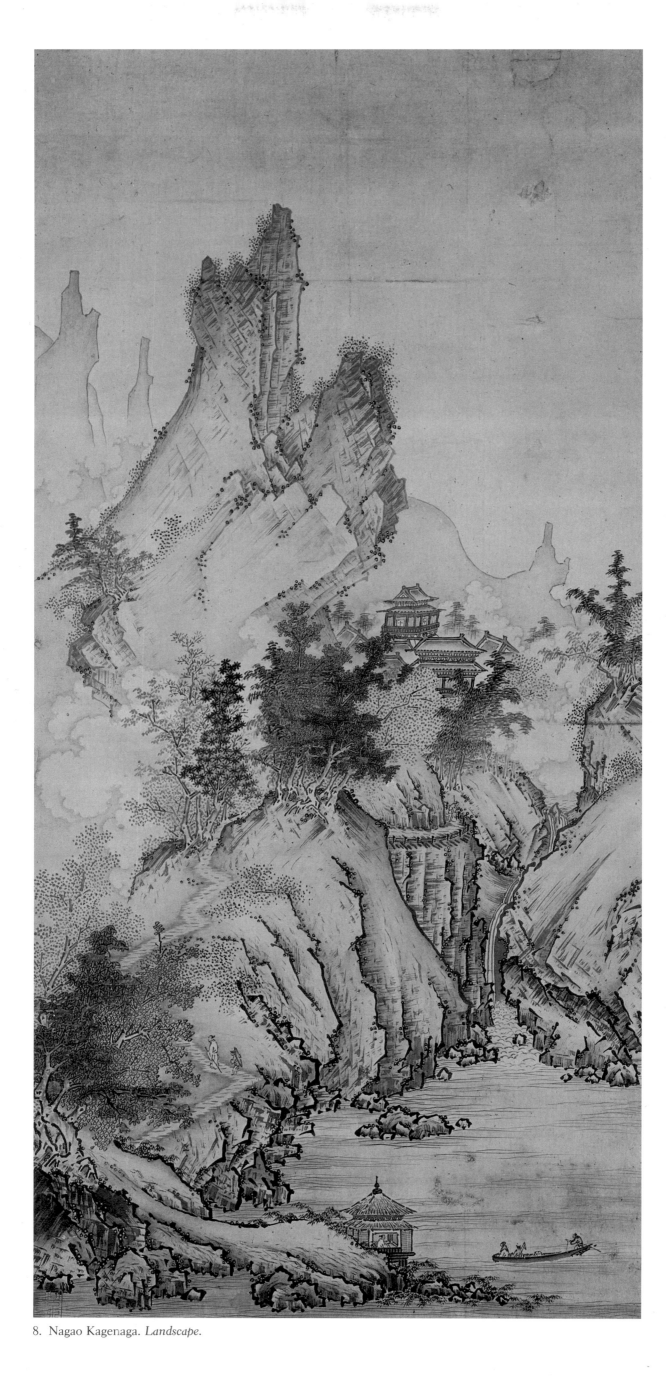

8. Nagao Kagenaga. *Landscape.*

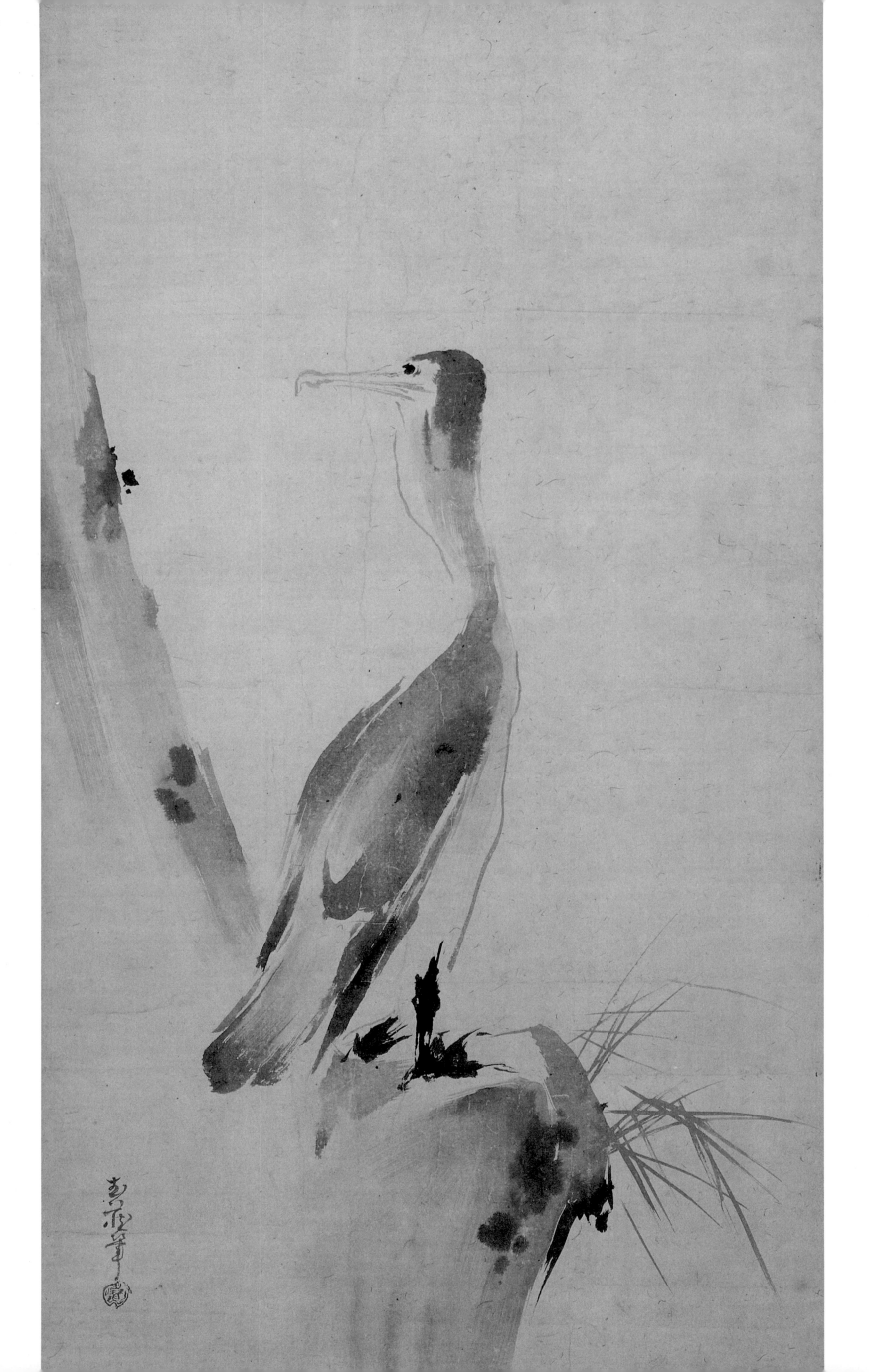

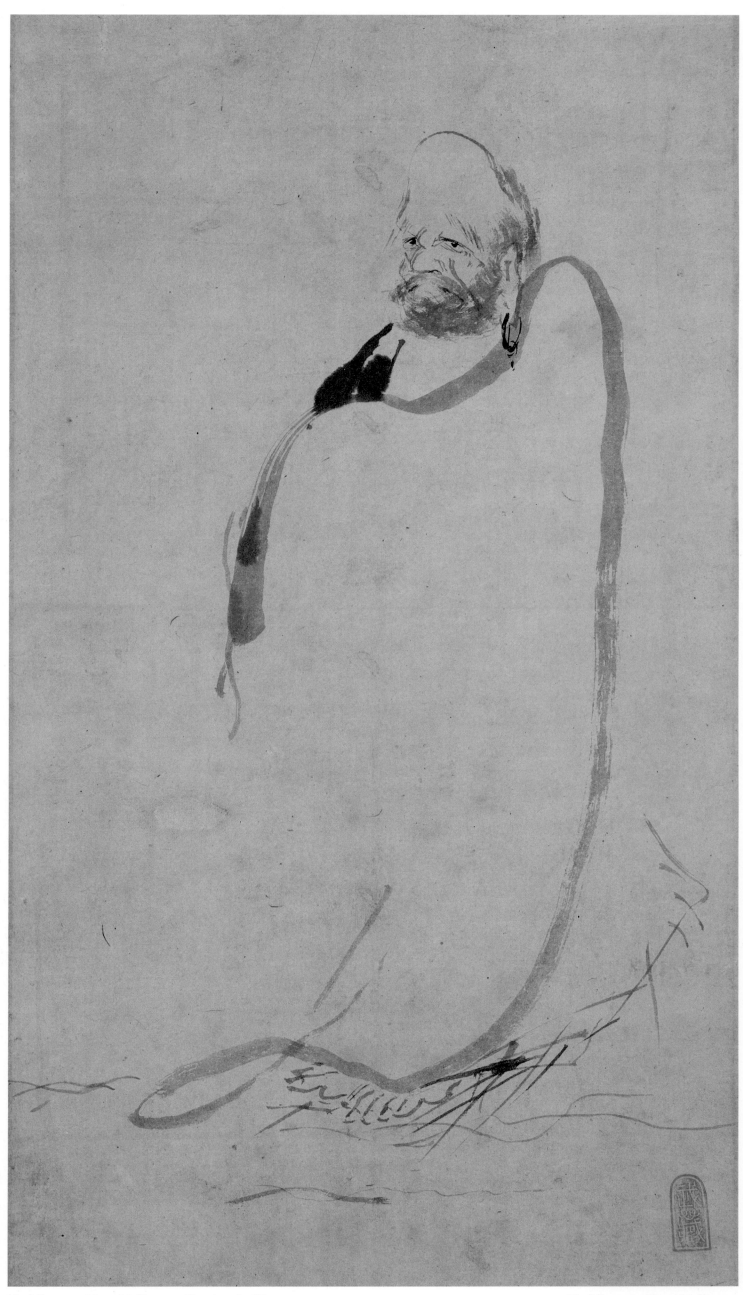

19. Miyamoto Musashi. *Daruma Crossing the River.*

20. Miyamoto Musashi. *Daruma Meditating.* ▷

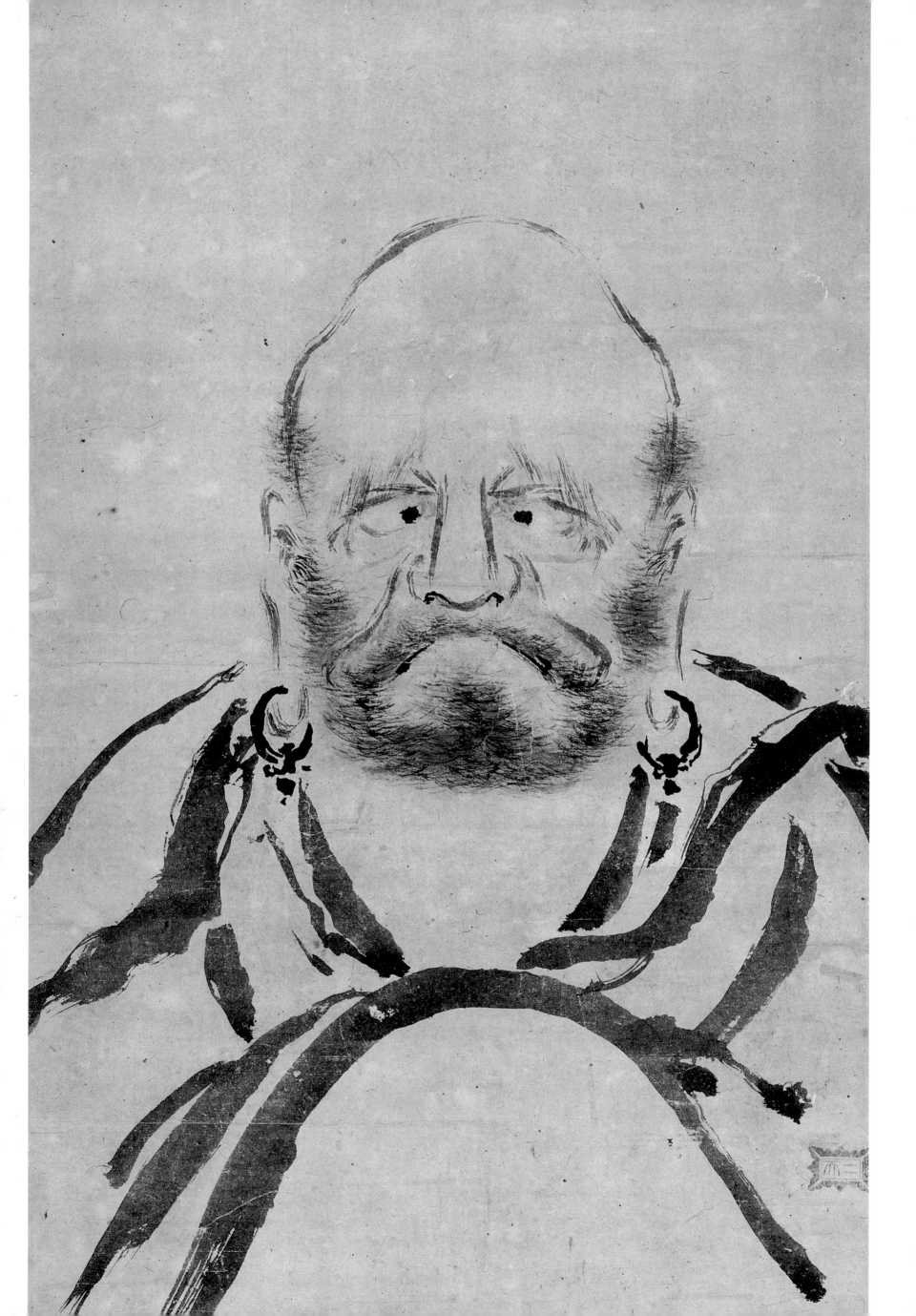

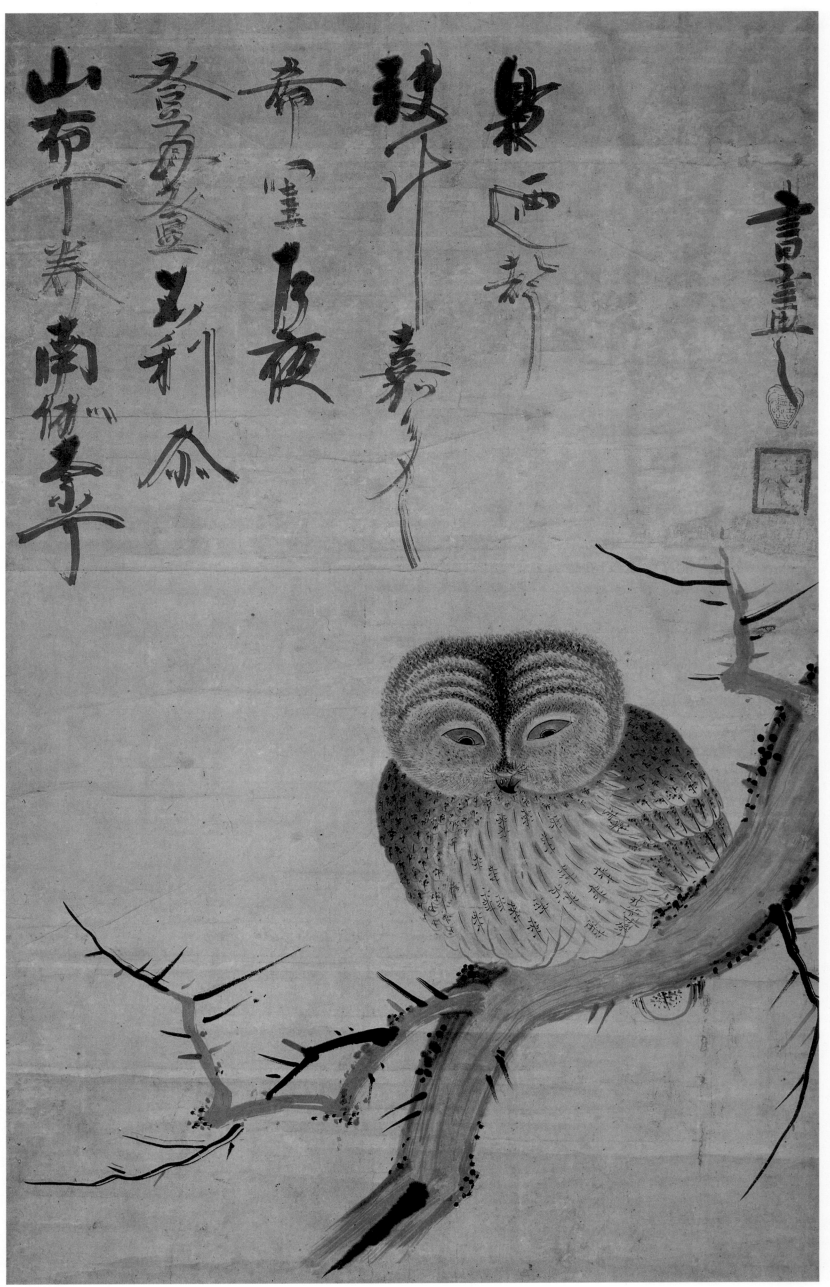

21. Tsuda Bensaku. *Owl.*

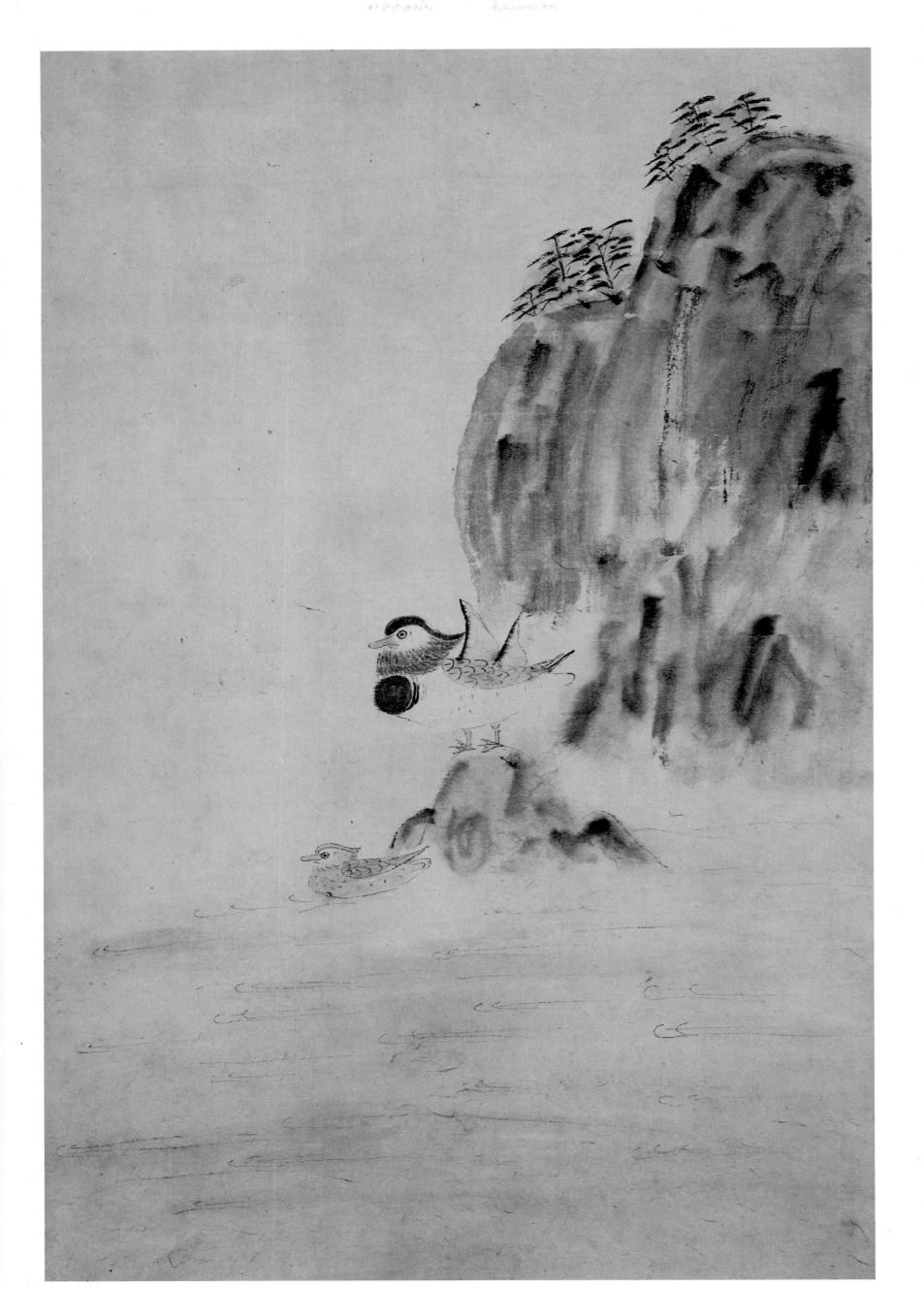

22. Tokugawa Iemitsu. *Mandarin Ducks.*

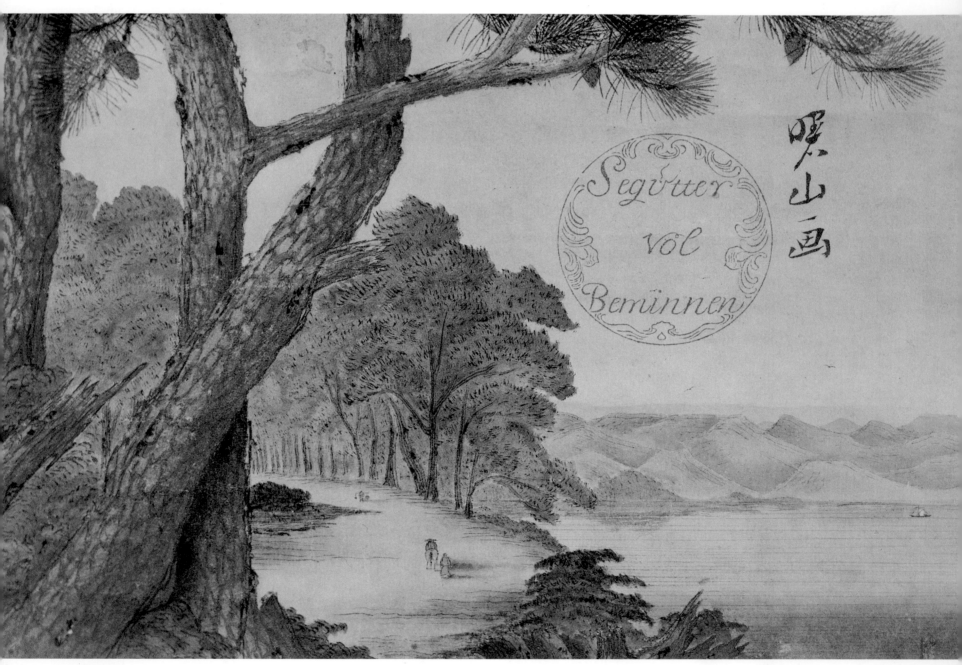

23. Satake Shozan. *Lake Landscape.*

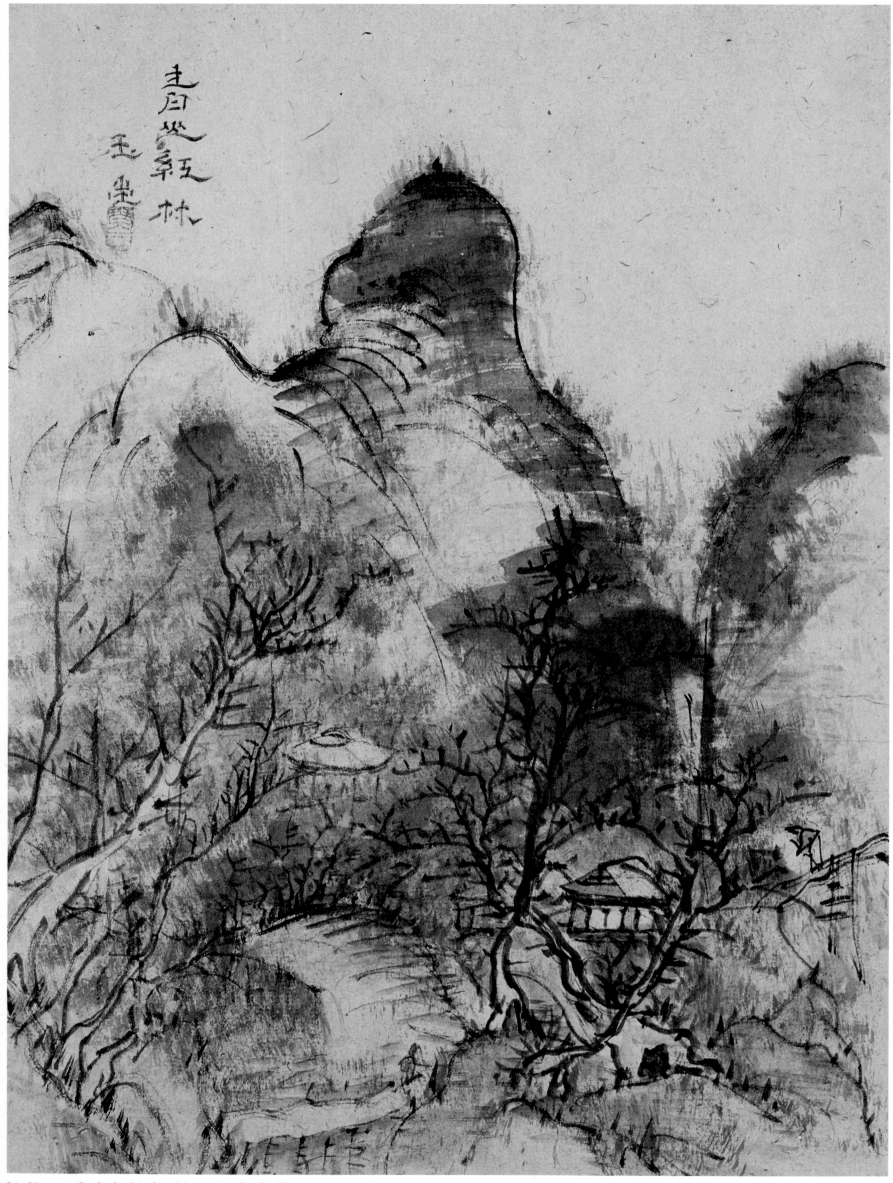

24. Uragami Gyokudō. *Verdant Mountains, Scarlet Forests.*

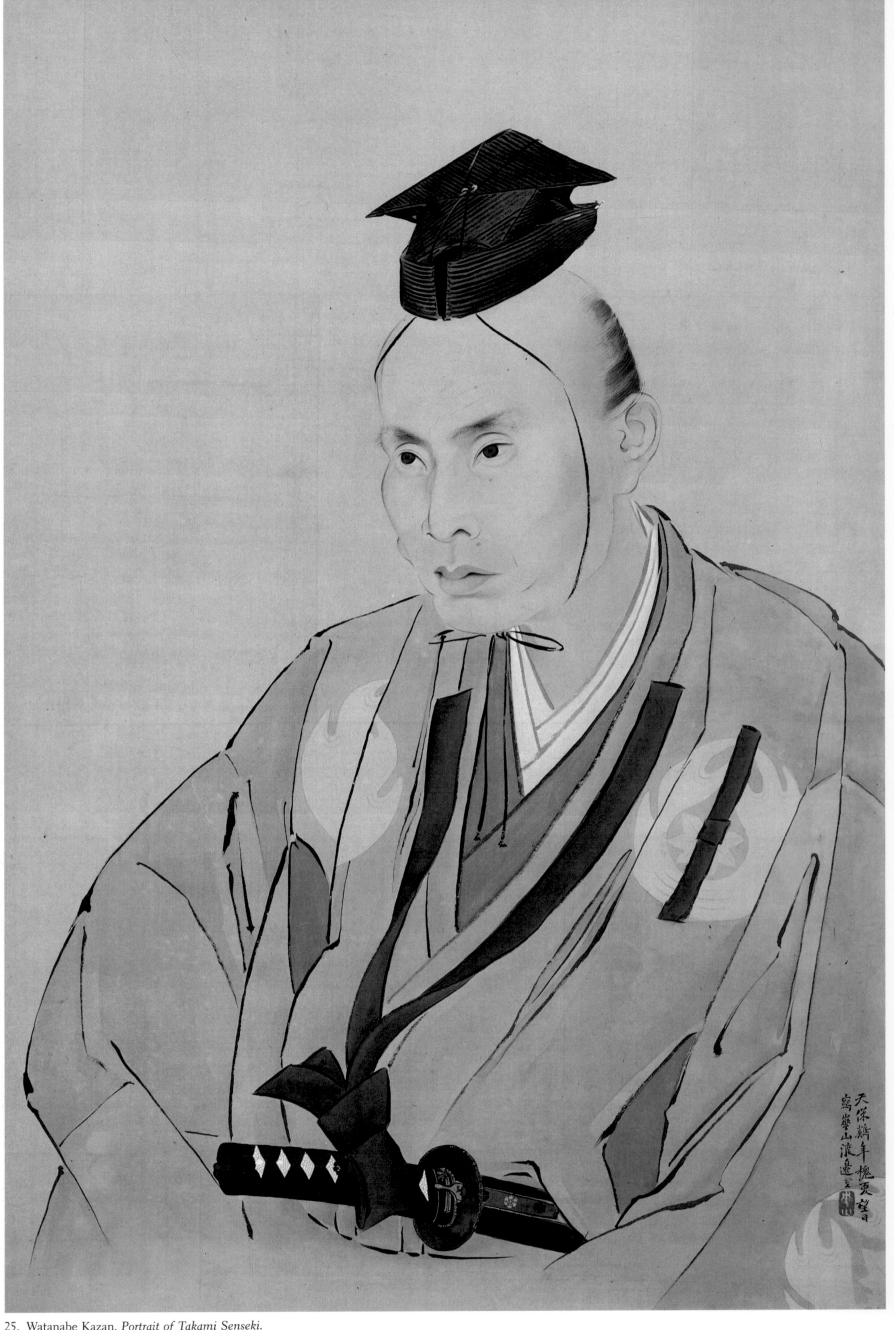

25. Watanabe Kazan. *Portrait of Takami Senseki.*

Samurai Painters

There have been few societies in world history in which the warriors have also been artists. The more highly developed the society, the more there has been a division of labor, culminating in today's technological world. In East Asian cultures, specialization was not unknown, but it was traditionally regarded as important to temper worldliness with cultural attainments; hence a government official might also be a poet, and a samurai, a painter.

It may at first surprise us that the famous Japanese warrior Miyamoto Musashi was a master of the brush, but in Japan these accomplishments are regarded as complementary. While Musashi's prowess with the sword is now legendary, his ink paintings remain as a testament to his artistic skills and as a reminder of the day in which samurai and artist were one.

As we examine samurai paintings, a fundamental truth of art history emerges: artists from a particular profession, social class, or other distinguishing group do not necessarily create a unique painting style. Each artist, whether professional painter, warrior, monk, or scholar, draws from various currents of the pictorial tradition available to him, and only gradually forms an individual style. Thus when the samurai of medieval Japan turned to the arts as a form of personal expression, they followed an ink-painting style that had originated in China with scholars and poets and had been brought to Japan by Zen monks.

How then can we distinguish samurai paintings from other works of the time? This is not always an easy task, but the two outstanding characteristics of samurai paintings are intensity and disciplined energy. These qualities had long permeated samurai life, owing to the inherent nature of their often deadly profession. For the swordsman-painter, exact and painstaking brushwork was banal, realistic depiction of the outer world was unnecessary, and an emphasis upon elaborate technique was considered unworthy of the samurai ideal. It was inner intensity that the samurai strove for in all facets of his existence, and it can be seen in the finest warrior paintings, whether they are of Zen figure subjects, landscapes, or simple nature studies of bamboo or waterfowl. Seldom using color, relying on strong and simple compositions, and employing vigorous brushwork and subtle ink-tones, samurai painters added an important chapter to the history of Japanese art.

A full appreciation of the art of the warrior requires an understanding of the development of the samurai as well as the cultural forces at work in different periods of Japanese history. As we shall see, it was the fortuitous combination of two factors that led to the great days of samurai painting. Warriors came into full control of Japanese government during the medieval period, just when an appropriate ink-painting style was introduced from China into Japan. By taking up the brush, the warrior leaders were able to express their martial spirit in calligraphy and painting, and also to demonstrate that they were men of culture as well as the sword. In earlier eras, the samurai had not been known for their art, but brushwork became important to them in their new role as leaders of government. This period was the artistic culmination of the vital role that the samurai had played in the early development of Japanese society.

ORIGINS OF THE SAMURAI

The history of the samurai has no definite beginning point, but after the founding of the first warrior government or *bakufu* in 1185, members of the samurai class ruled Japan in one form or another until the fall of the Tokugawa regime in 1868. Over the course of their long history, the warriors underwent a number of significant changes, and thus the samurai with which we are so familiar from television dramas and movies, normally those of the late sixteenth century or later, cannot be considered typical of samurai of earlier eras. It may be helpful to examine the historical evolution and culture of this class of professional warriors and point out some of the differences between samurai of various periods of Japanese history.

Japan was originally settled by peoples coming from different parts of Asia. Not surprisingly, considerable conflict surrounded the formation of the Japanese state. Both Chinese and native accounts describe political tension between various communities, and force of arms was frequently resorted to in order to settle the matter of succession. Japanese myths are replete with tales of warfare leading to the emergence of the royal family as supreme rulers, although historical accounts are not reliable until the fifth century.

Perhaps the first Japanese warriors were not "Japanese" at all. When the people in central Japan began to construct massive tombs for their leaders around the year 300 (fig. 1), they placed upon the tombs clay figurines, called *haniwa*, which have fascinated archaeologists and historians ever since. While many of the *haniwa* are of birds, small animals, boats, houses, and other items known in earlier Japan, a large number are of horses and warriors (figs. 2–3). The saddle and bridle fittings, the armor, the swords, in short everything about these warrior-aristocrats suggests a Northeast Asian equestrian culture unknown in Japan prior to the tumulus era (figs. 4–6). There is considerable academic dispute over the introduction of all this horserider paraphernalia. Many argue that these artifacts can be explained by cultural diffusion; others feel they represent an elaborate system of exchange among peoples on both sides of the Korean straits who were ethnically and culturally closely related.

Some historians, however, impressed by the apparent sudden and massive introduction of the horserider technology into the Japanese archipelago, argue that it was brought by mounted invaders from the peninsula. These were most likely Puyo tribesmen from northeastern Asia, a seminomadic people with a military aristocracy who had already founded the state of Paekche in southwestern Korea around the middle of the fourth century. Then, the theory holds, these Puyo

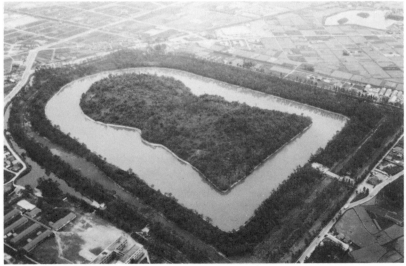

1. Tomb of Emperor Nintoku. Fifth century.

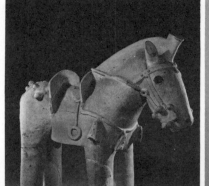

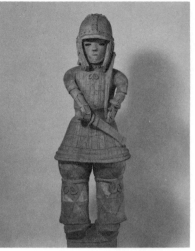

4–6. Sword pommels, sword-guard; fourth to sixth centuries. Gilt-bronze dagger; sixth century. Museum Yamato Bunkakan.

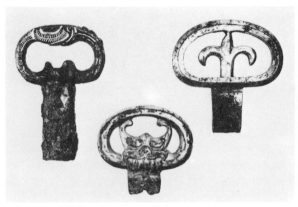

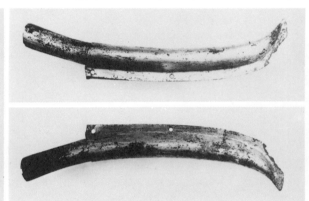

warriors traveled in boats across the straits and conquered the land of "Wa" that would soon become Japan. Whatever theory one subscribes to, it is obvious that the material culture from the great tombs of the fifth century, including swords, daggers, and pommels, was very similar to that later employed by the samurai.

At any rate, from the fifth century onward there was a warrior aristocracy in Japan whose mastery of mounted archery, sword, and spear allowed them to rule the rest of the populace. The subsequent story of the development of the Japanese state is the gradual transformation of this original military aristocracy into a civil nobility which ruled not by arms, but through the sophisticated forms of Chinese civilization. This transformation took place during the seventh and eighth centuries, and was largely completed by the time of the move of the capital to the city of Heian (modern Kyoto) in 794. Indeed, the world depicted in the mid-Heian period *Tale of Genji* bears hardly a trace of similarity to that of the mounted warriors of early Japanese history.

Only a few of these early Japanese warriors were able to make the transition to court nobles, enjoying the fruits of ruling over Japan's sixty-six provinces. The conditions in the countryside remained unsettled, especially in Eastern Japan where territories were still being won from the unpacified aboriginal tribes. Many local clans retained their earlier martial orientation, as the unsettled conditions did not permit them to do otherwise. Thus, the later samurai can be seen as direct descendents of local chieftains of the sixth and seventh centuries.

The rise of the samurai was aided by an imperial decision of 792 to abandon the conscription of peasants for national defense purposes. Once the T'ang dynasty had taken control in China and the Korean peninsula was unified by Silla in the seventh century, the Japanese began to feel secure from any threat of foreign invasion. Furthermore, of the levies imposed upon them, the peasantry most resented the military service requirement, which might condemn them to several years of lonely guard duty on faraway shores. Abandoning conscription, the imperial government chose instead to rely upon the temporary drafting of local strongmen to suppress piracy, banditry, or rebellion in the provinces. This represented a loss of the state's control over coercive violence, and facilitated the development of a locally powerful warrior class which ultimately came to control all military power in the country.

THE HEIAN SAMURAI

The samurai class developed during the Heian period (794–1185) when its members served both as officials at the provincial and district levels and as managers in a growing network of private estates. Their monopolization of military power made them indispensable to the preservation of aristocratic authority. It is in this context that the term samurai first developed, as a noun derived from the word

saburau or *samurau*, meaning "to serve, to be in attendance upon." The word clearly indicated the service function of the warriors in a world politically and culturally dominated by the Heian nobility. It came into usage only slowly, however, and in medieval Japan the term *bushi* (warrior) was commonly employed.

From contemporary records and tales, we can get a picture of the life of the early samurai. First, the major warriors were mounted archers. Stories speak of the "way of the bow and horse" and the "practices of those who hold the bow and arrow." Great warriors like Tametomo of the Genji were known for their prodigious feats as archers. Individual combat, which figures prominently in these early sources, often took the form of the two opponents charging each other on horseback, firing arrows, and dodging those of the enemy.

Second, there was already coming into existence an idealized code of behavior among warriors, elements of which would become part of the *bushidō* ethic of a later day. Among the ideals of the early samurai was courage in battle: to show one's back to the enemy was despised as conduct unbecoming a warrior. Service to one's lord, even to the point of giving up one's life, was the supreme virtue. It was idealized as an uncalculated, pure form of commitment to the lord; the sacrifice of one's family in the performance of one's service was normal and expected. Already in the Heian period the Japanese warrior, at least in these tales, chose death before capture (and possibly torture): the painful practice of *seppuku*, or *harakiri*, was established as the preferred method of suicide.

Of course, these were forms of idealized behavior, as recorded primarily in semihistorical accounts written by courtiers or clerics who were not members of the warrior society. Most of the actual warfare between samurai bands arose over land disputes, and there must indeed have been considerable calculation involved in the emerging vassalage structure: a lord needed to award or guarantee land titles in order to secure the vassalage of a warrior. As members of agro-military groups, the warriors were certainly drawn together for mutual advantage. Nevertheless, the ideal supposedly transcended personal calculation and was found in the "human-heartedness of the warrior" (*bushi no nasake*), based upon courage and loyalty.

Thus, in the Heian period the roots of a vassalage system had begun to form. Certain court figures, either Fujiwara clansmen who could not obtain central government posts or semiroyal figures with the surnames Minamoto or Taira, settled down in the provinces and attracted powerful followers, especially in eastern Japan. These local magnates sought to raise their status by commending themselves into the service of Fujiwara lords and retired emperors in the capital, providing protection and aiding in the collection of taxes in public lands and of rents from estates belonging to these lords. Among the first two such warrior bands to become well known were the Ise branch of the Taira clan (Heike) and the Seiwa branch of Minamoto (Genji).

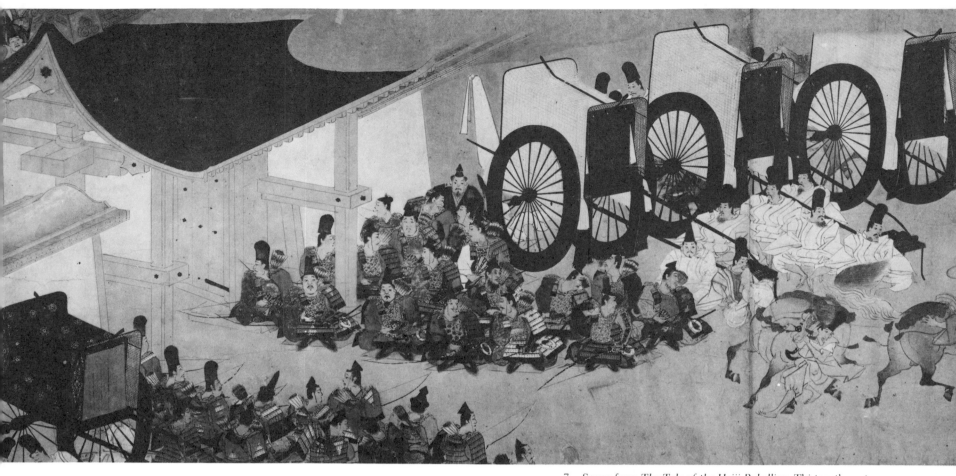

7. Scene from *The Tale of the Heiji Rebellion*. Thirteenth century. Tokyo National Museum.

By the very end of the Heian period the Taira clan under Kiyomori came to dominate the court, but not by the sword. Kiyomori and his kinsmen transformed themselves into court nobles, relying upon all the traditional techniques for acquiring power: membership in the noble council, marriage to noble families and the imperial house, and manipulation of imperial authority. Nonetheless, they paved the way for the first warrior culture of Japan.

THE EMERGENCE OF WARRIOR GOVERNMENT

A major war covering the years 1180–85 brought forth a new form of government. This warfare can be viewed from two different perspectives. At a very high level of abstraction it was a battle between Heike and Genji forces, with the Genji emerging victorious. At the provincial level, however, warriors chose sides in accord with local power realities; the possibilities for solving inter- and intra-familial quarrels or securing firm titles to hereditary holdings proved more important than lineage. A series of provincial wars resulted in the emergence of a unified Genji East, over which Minamoto Yoritomo had extended his control through a newly created vassalage structure.

The romance of these battles is told in the most famous of Japanese war stories, *The Tale of the Heike*, which has become well known to generations of Japanese through the work itself, through Noh and Kabuki plays, and through modern adaptations in novels, television dramas, and films. Genji and Heike battles also became the subject of some of the most dramatic of all Japanese handscrolls (figs. 7–8). Scenes of the carnage continued to be popular in screen paintings well into the eighteenth century. These paintings are among the most famous depictions of Japanese warriors, but they are not yet art done by the samurai themselves.

More important for the history of the samurai and for Japan as a whole, the war brought into existence Yoritomo's military government, or *bakufu*, which gradually developed to handle the growing administrative needs of his expanding area of de facto control. At the end of the war Yoritomo became a major participant in the authority structure by virtue of the fact that he controlled all of eastern Japan. The government was, in effect, expanded to include the warrior hegemon (soon to be known as shogun) of Japan and his regime as the police arm of the state.

Although Yoritomo founded the Kamakura regime, his family was not destined to control it for long. He was succeeded by his two sons as shoguns, but both were assassinated and his own line came to an end. Real power in the *bakufu* gradually shifted towards the Hōjō family, whose rise began with Tokimasa, Yoritomo's guardian during his years of exile. Tokimasa's daughter Masako married Yoritomo and was the mother of his two sons, the Minamoto shoguns Yoriie and Sanetomo. Prodded by one court-inspired revolt and three decades of defense of the country against Mongol invasions (see figure 9), the *bakufu* under Hōjō rule emerged over a period of 150 years

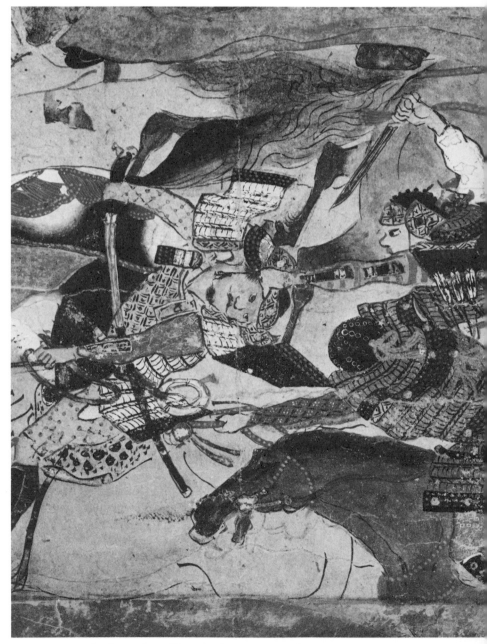

8. Scene from *The Tale of the Heiji Rebellion*. Thirteenth century. Mary and Jackson Burke Collection.

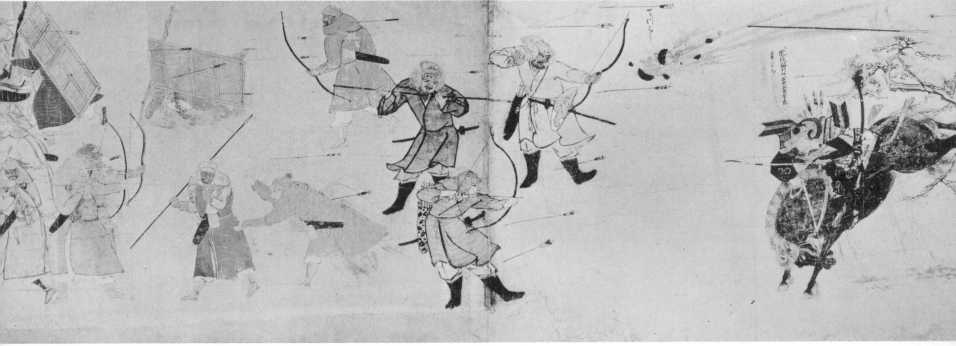

9. Scene from *The Mongol Invasion*. Thirteenth century. Imperial Household Collection.

as the real government of Japan. Although Yoritomo had enjoyed a good deal of support from defecting court nobles and Sanetomo was himself primarily a courtier, the Hōjō attempted to preserve independence and strength of spirit by maintaining their seat of power in Kamakura, away from the overrefinement of Kyoto.

SAMURAI ARTS AND ZEN

The warrior culture found beauty in its own appurtenances. During the Heian period the sword had developed into two types, one for actual use and one for ceremonial purposes. This distinction became particularly clear in the Kamakura epoch, when simply shaped and highly worked blades as well as their occasionally ornate scabbards and sword-guards (*tsuba*) were prized (figs. 10–11). Similarly, armor was often worn for visual effect as much as for protection in battle (fig. 12). Although early Japanese armor had followed the style of that on the Asiatic mainland, during the Heian period a more typically Japanese type developed, able to protect warriors in mounted archery warfare. As the role of the mounted warrior decreased later in the Kamakura period, somewhat simpler armor for samurai fighting on foot developed. This armor remains a magnificent and impressive tribute to the skill of the workers in metal, fabrics, and lacquer. Swords, sword-guards, and armor continued to be artistic as well as practical implements for the samurai in succeeding ages (figs. 16–18).

As the new warrior government settled in Kamakura, other art forms congenial to the samurai were soon developed. In fact, under Hōjō patronage a new warrior culture quite distinct from that of the central nobility gradually emerged. The vital factor in the creation of this culture was the arrival from renewed contacts with Sung China of a new form of Buddhism called Zen. There were many reasons why this creed appealed to the warriors, one being its very newness, which meant it had virtually no connection with the court culture which the warriors saw as decadent. The power of the traditional temples in Nara and Kyoto also had strong political overtones, and by patronizing the new form of Buddhism from China, the Hōjō partially avoided pressures and problems from the older established sects.

The influence of Zen, however, did not come about merely from reasons of political convenience. The spirit of this highly disciplined sect well suited the austere new rulers of Japan. An old saying in Japan claims that Esoteric Buddhism is for the nobility, Zen for the samurai, and Pure Land for the masses. While oversimplified, this proverb has a strong element of truth. The elaborate rituals of Esoteric Buddhism have certainly appealed to the imperial family and high-ranking court figures, while the promise of salvation through faith and the simple repetition of the mantra "Namu Amida Butsu" has made Pure Land Buddhism the most popular mass form of religion in Japan for the past millennium. Through the middle of the thirteenth century the Buddhism of the warriors was still predominantly a mixture of Esoteric and Pure Land sects; the Hōjō leaders

Tokiyori and Shigetoki both died with Pure Land rites. But many leading warriors were already displaying dissatisfaction with the older syncretic tradition. It was ultimately Zen which won greatest favor among the samurai in the late Kamakura and Muromachi periods, and it remained a strong spiritual and cultural force among samurai of later ages as well.

Zen differs from Esoteric and Pure Land Buddhism by teaching that enlightenment is within the powers of each sentient being; through meditation and concentration of spirit any person can attain inner awakening. The pantheon of deities of Esoteric Buddhism was no longer needed, nor did the Zen master rely upon the compassion of Amida Buddha to save him. Through stringent self-discipline and with the aid of an enlightened teacher he could find personal enlightenment, just as the historical Buddha had done in India during the sixth century B.C. Furthermore, Zen's stress on self-reliance and calmness of mind appealed greatly to the warrior leaders of Japan.

If the Hōjō rulers of the Kamakura *bakufu* found Zen appealing, the monks arriving from China and their Japanese counterparts equally found the warriors an apt group of patrons. Although great monks such as Eisai eventually established good relationships with court leaders in Kyoto, they found less sectarian jealousy among the warriors in Kamakura. Zen did not promote militarism or sanction violence, but it did help a samurai prepare himself inwardly for the dangers he must face. In particular, it gave him a means for dealing with the prospect of sudden and untimely death.

Zen encouraged the samurai to face whatever fate lay in store for him without resorting to complex philosophizing or elaborate rituals. The great swordsman of late Muromachi times, Tsukahara Bokuden (1490–1572), wrote a short verse on the ultimate challenge of the warrior.

> *There's only one thing*
> *For a samurai to learn—*
> *To face death unflinchingly.**

The Zen approach was to concentrate entirely upon one's duty, accepting that death might be the result. By emptying the mind through meditation, it was possible to overcome the concern for one's self.

Other poems by samurai on swordsmanship show the profound Zen influence upon the warrior ethos.

> *Victory is for the one,*
> *Even before the combat,*
> *Who has no thought of himself,*
> *Abiding in the no-mindedness of Great Origin.*

*Based upon the translation of Daisetz T. Suzuki, *Zen and Japanese Culture* (Princeton University Press, 1959), p. 73.

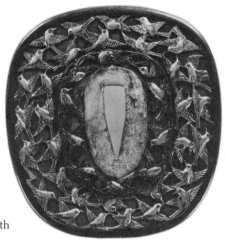

12. Armor. Fourteenth century. Kushibiki Hachiman Shrine.

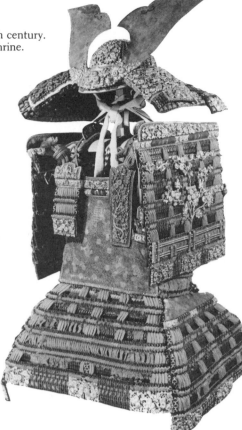

10–11. Sword-guard, sword mounting. Thirteenth century. Tokyo National Museum.

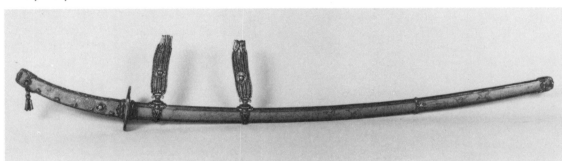

Some think that striking is to strike:
But striking is not to strike, nor is killing to kill.
He who strikes and he who is struck—
*They are both no more than a dream that has no reality.**

The no-mindedness of Zen, which monks attained by overcoming their own egos, was sought by warriors to overcome the fear of death. The discipline of Zen also brought the warrior class a sense of culture that was quite distinct from the elaborate and court-dominated culture of the preceding Heian era. Monks arriving from China brought with them a knowledge of Sung Neo-Confucian philosophy, statecraft, classical literature, calligraphy, and a style of ink painting previously unknown in Japan. As the *bakufu* became firmly established, a desire for cultural credentials that could compete with the attainments of courtiers in Kyoto led to an increasing interest in Zen-allied arts. Thus Zen masters soon were teaching the samurai not only the possibility of individual enlightenment and the impermanence of life and death, but also poetry, calligraphy, and, eventually, painting. Chinese scrolls were eagerly collected, and, by the end of the thirteenth century, poetry by warrior leaders was already being gathered in imperial anthologies.

Thus a new form of culture, the first to be patronized by the warriors rather than by the court or the traditional temples, became dominant in Japan. Although this culture was thoroughly imbued with Zen ideals which penetrated deeply into medieval society, the warriors themselves were not always deeply committed to Zen meditation except insofar as it was incorporated into martial training. The actual religious practices of the samurai were reflective of the whole of Japanese society, in which the older forms of Buddhism, Shinto, Confucianism and Taoism from China, and native folk beliefs all commingled. For example, among the oldest and most famous of the schools of swordsmanship which flourished in late medieval times were those associated with famous Shinto shrines from Kashima and Katori.

Moreover, many wandering swordsmen, particularly in the late sixteenth and early seventeenth centuries, followed the venerable tradition of *shugendō*, a mountain-climbing sect combining Zen, Esoteric Buddhism, and Shinto. These warriors would roam the country fighting duels and polishing their minds; their beliefs can be traced back at least to En no Gyōja in the eighth century. Furthermore, in the late sixteenth century, many warriors also converted to Christianity, although it was banned in the following epoch. Thus, it would be a mistake to associate all samurai with Zen in terms of their religious beliefs and practices. Nevertheless, in terms of samurai culture, Zen was the dominant element. Zen poetry and calligraphy were practiced by many warriors of the medieval period, and it was the Zen-influenced ink brushwork tradition that samurai were to utilize when they turned to painting as an expression of their spirit and culture.

Suibokuga (ink and water painting) had begun in China centuries earlier, but it became especially important in the Sung dynasty (960–1279) when it was widely practiced both by scholar-officials and Zen monks. Ink painting became not only a form of self-expression but also a spiritual exercise, as one could sense the character of the artist in every stroke of the brush, and also harmonize one's mind with the flow of nature or the intensity of Zen masters of the past. The simplicity of brush, ink, and paper (or silk) led to a great strength and subtlety of brushwork. Lines, once drawn, could not be changed, so they had to be applied with great vigor and concentration of spirit to be effective. The flexible Chinese brush was the perfect instrument for this kind of painting, as every movement of the fingers, hand, arm, and body instantly translated itself into variations of thickness or direction of the stroke. Instead of color, painters needed only shades of ink tones from lustrous black to misty grey. The compositions depended as much upon the areas left blank as those painted, for what was left unsaid invited the viewer to contribute his own creative spirit to the total experience of the artwork. This tradition eventually became more revered in Japan than it had been in China, in part because Zen became a more dominant cultural force when transplanted than it ever had been on the mainland.

The *suibokuga* that was first adopted into the Zen-influenced culture of the Kamakura period featured figure paintings. The subjects were most often Zen masters of the past, as well as simply brushed portrayals of Buddhist deities such as the Bodhisattva Kannon, now depicted simply, without gold leaf or bright colors. According to documents, several of the Hōjō leaders painted religious works, and a portrayal of Kannon attributed to Minamoto Sanetomo displays the refined brushwork of the age, in which no superfluous lines are allowed (pl. 1). Although Kannon had been a subject often seen in earlier Buddhist paintings, Sanetomo's work stands in great contrast to these highly colored, delicately brushed devotional images. His lively sense of brush-movement is admirably fused with a restraint and simplicity of composition, giving his painting both internal vitality and depth of expression. In many ways, Sanetomo can be seen as a precursor to the later Ashikaga shoguns, since he is known even more for his cultural achievements—poetry and painting—than any martial prowess. It was not until the succeeding Muromachi (Ashikaga) period, however, that samurai painting became widespread. The countrywide warfare which accompanied the fall of Japan's first samurai government inhibited the art's rapid development.

THE WORLD OF THE MUROMACHI SHOGUN

Despite efforts to retain its strength and self-reliance, the Kamakura *bakufu* gradually lost control over vassals who had become more involved with local political and economic issues. The enormous

*Ibid., p. 123.

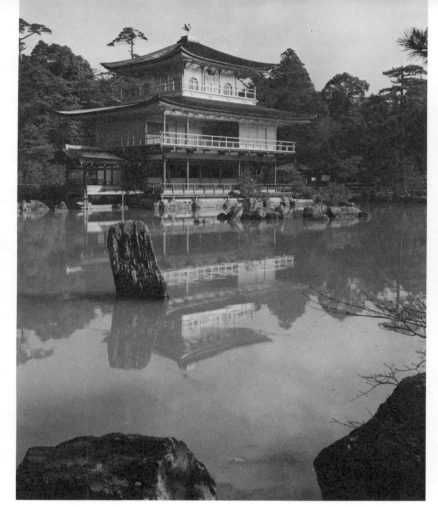

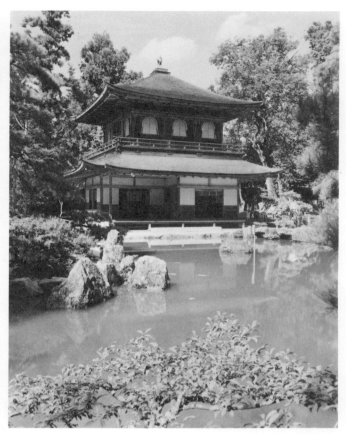

14. Kinkakuji, Kyoto.

15. Ginkakuji, Kyoto.

13. Portrait of Ashikaga Yoshimochi.

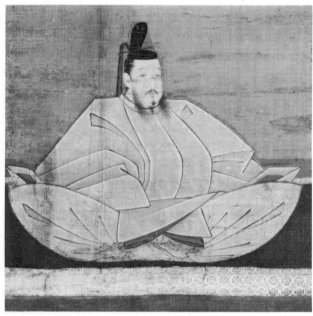

defense problems involved with the Mongol invasions of the late thirteenth century proved beyond the capabilities of the Hōjō leaders, further eroding the loyalty of their vassals. At length Emperor Go-Daigo and a coalition of warriors, including the *bakufu*'s leading followers, destroyed Hōjō rule in 1333. Ashikaga Takauji (1305–58) now turned on Go-Daigo and founded his own *bakufu* in the Muromachi section of Kyoto in 1338. With the entry of Takauji and other eastern warrior leaders into the heart of the old capital, whatever power had remained in the hands of the courtiers in Kamakura times was lost, and the country was ruled solely by samurai warriors during the Muromachi, or Ashikaga, period (1338–1573).

The character of the Muromachi period was entirely different from that of Kamakura times: it was an era of great social, political, and economic unrest and a greater than normal degree of social mobility. The juxtaposition of the new warrior elite with members of the old nobility and the rising Zen monastic order revitalized Kyoto and sparked a cultural, social, and political "renaissance" in medieval Japan. However, in the world of Muromachi Japan, "the freedom of movement and opportunities for personal advancement by the sword resulted in anarchy which ultimately benefited neither the most gifted nor the most creative, but only the most ruthless."*

Within such a milieu the Ashikaga shoguns soon lost their military power. Nevertheless, by a skillful reliance upon the great barons of

*Kenneth Grossberg, *Japan's Renaissance: The Politics of the Muromachi Bakufu* (Harvard University Press, 1981), p. 5.

the day and their own direct vassals, they managed to transform themselves from mere feudal chieftains—like the Hōjō—into something more nearly like monarchs in the European tradition. As their own military power waned, the shoguns emerged instead as protectors and patrons of the arts; and it is safe to say that without them, the culture of medieval Japan would have been very different indeed.

Though vilified by later loyalist historians for his betrayal of Emperor Go-Daigo, Ashikaga Takauji was not only the founder of the Muromachi *bakufu* but also a painter in the ink tradition, a fine poet, and a patron of Zen. Professing remorse for deposing the emperor, Takauji ordered the building of the great Zen monastery Tenryūji. He practiced Zen himself, even after drinking bouts, although he considered himself ignorant and wished for enough years to live in retirement and strive for enlightenment. As a painter, Takauji was particularly noted for his depictions of the Buddhist deity Jizō (pl. 2). Several examples of this subject survive, demonstrating Takauji's restraint and refined strength.

Takauji's great grandson, the shogun Yoshimochi (fig. 13), is said to have practiced brushwork daily, and though his political activities are enigmatic in the extreme, he produced paintings which can be considered the first samurai masterworks. Yoshimochi's portrait of Daruma (Bodhidharma), the first Zen patriarch who became the most important subject of Zen paintings, is particularly fine (pl. 4). The few powerful lines that define the face, contained within the wider soft grey lines of the hood and robe, express the intensity of Daruma with powerful impact. Other subjects brushed by Yoshimochi include at least one depiction of Jizō and several versions of Chinese poets, but Zen subjects were paramount in his work and the simplified ink painting tradition was clearly suited to his artistic spirit. His paintings display the energy and intensity that mark the finest samurai brushwork.

As the cultural hold of Zen deepened, the ink tradition became more fully developed, and leading painting centers were established at many of the major Zen monasteries. Shoguns amassed large collections of Chinese paintings, including many great Zen works which were no longer highly appreciated in China. Many Japanese monks became painting specialists, with ever-increasing technical skills. By the middle of the Muromachi era, a certain professionalization of the ink painting tradition took place in which skillful and evocative landscapes became the most popular theme. The use of "ax-cut" strokes, derived from Chinese ink painting, to model the inner textures of rocks and mountains added strength to these poetic depictions of nature. Although some samurai became expert at landscapes (see plate 8), most warrior-artists preferred to paint the simpler and more intense figure subjects from Zen tradition. To some extent, samurai were free from the tides of artistic fashion, but their art also gradually became more complex in brushwork and elaborate in composition.

This was an era in which a unification of government, religion, and

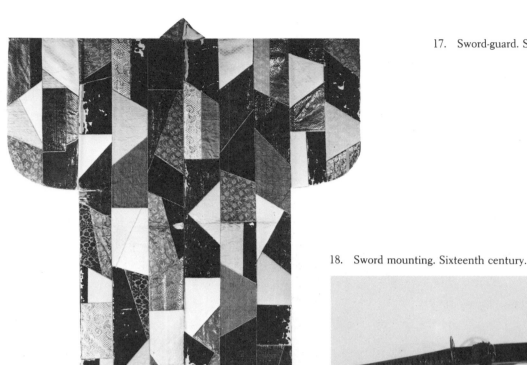

16. Cloak (*dōbuku*) of Uesugi Kenshin. Uesugi Shrine.

17. Sword-guard. Sixteenth century.

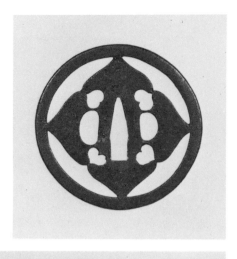

18. Sword mounting. Sixteenth century.

the arts became prevalent. The Ashikaga leaders established large Zen monasteries as national institutions with quasi-political, and even economic, implications. These temples not only served as teaching institutions but also centers of culture and commerce. Zen monks led trading missions to China, advised governments on political matters, economics, and diplomacy, and dominated cultural attainments including painting, poetry, and calligraphy. But if Zen monks were at the center of the artistic world, the samurai played an increasingly active role; the Ashikaga shoguns themselves were the ultimate patrons of the whole cultural milieu.

No one epitomized the role of the Ashikaga shogun as monarch and cultural patron more than the third shogun, Yoshimitsu (1358–1408). In the area of politics, he reunited the warring Southern and Northern courts and reestablished close diplomatic relations with China, acquiring in the process considerable prestige as well as economic and cultural benefits. He assumed various offices and titles and conducted the equivalent of royal progresses which left no doubt in anyone's mind as to who was Japan's supreme leader. Patronizing a large coterie of artisans from various social categories, Yoshimitsu presided over the formation of the Kitayama (Northern Mountain) culture, so named from the construction of his magnificent residence in the northeastern section of Kyoto and represented most popularly by the Temple of the Golden Pavilion (Kinkakuji; fig. 14). In the latter part of the fifteenth century, Yoshimitsu's grandson Yoshimasa (1436–90) served as the driving force behind the development of the so-called Higashiyama (or Eastern Mountain) culture, which centered around his Temple of the Silver Pavilion (Ginkakuji; fig. 15). Though quite different in character, these two cultural periods, one resplendent and one more somber, demonstrate the dominant role Ashikaga shoguns played in the patronage of the various arts.

Through this patronage, however, the shoguns became refined aesthetes more than military leaders. Their strength, while never formidable, depended largely upon maintaining a delicate balance among the great territorial lords known as *shugo daimyō*. These *daimyō* themselves, largely confined to residence in the city of Kyoto from Yoshimitsu's time on, were increasingly unable to maintain regional control due to the emergence of powerful samurai at the local level. From the time of the assassination of the shogun Yoshinori in 1441, the Ashikaga monarchy suffered an irreversible decline. When a number of succession disputes within major *daimyō* families and within the shogunal house itself came to a head in the Ōnin War of 1467–77, Ashikaga control over the country virtually evaporated. Japan fell into a century of turmoil from 1477 to 1573 known as the Warring States period.

Throughout this one-hundred-year period both courtier government and centralized warrior government were absent. It was the heyday of the samurai, as nationwide mobilization for war made him master of village and town, manor and monastery. Japan was frag-

mented into several hundred warrior domains, virtually kingdoms, within which the authority of the *daimyō* was justified by reliance upon little more than raw power. Painters fleeing the periodic ravishings of Kyoto found new patrons in these provincial lords; perhaps under their stimulus, a number of samurai took up the brush in earnest themselves. Leaders of the Toki family, castle lords in Mino province, became known for their outstanding paintings, full of bold energy. They were especially known for their dynamic paintings of hawks (pl. 6), with a full expression of the fierce spirit of these birds of prey. The more finished style and technical refinement of these paintings show the development of the *suibokuga* tradition. The ruler of Yamada castle near Nara, Yamada Dōan, and his descendents were also notable painters of many subjects such as Zen figures and Shōki the demon queller (pls. 9–10).

Thus, despite the warfare and bloodshed of the era, the arts did not all fall into neglect or decadence. The various regional lords vied among themselves to attract scholars and artisans to their castle towns, some of which became important local centers of learning and the arts. Indeed, perhaps never before had elements of higher culture been spread so widely throughout the land. The famous Jesuit Francis Xavier was greatly impressed with the sophistication of the court of Ōuchi Yoshitaka in Yamaguchi, for example, which he records as having ten thousand households when he visited there in 1550. Although politically unstable, Japan was clearly in a period of transition to a bold new age.

THE MOMOYAMA AND EARLY EDO PERIODS

After the century of civil wars during which Japanese society and government were in a state of disarray, three successive generals emerged in the final decades of the sixteenth century to knit Japan back together again into a politically centralized entity. These three men—Oda Nobunaga, Toyotomi Hideyoshi, and Tokugawa Ieyasu—are among the greatest heroes in Japanese history. Their strength of character made them giants of their age, exercising a kind of personal charisma often lacking in other periods of Japanese history. They also inspired a dramatic new era in Japanese arts, exemplified by the dynamic screen paintings, often on glittering gold backgrounds, which were needed to fill their magnificent palaces and castles (fig. 19). Ceramics, lacquer, and fabrics also reflected the grandeur of the new age, certainly one of the most resplendent in Japanese history. The dominance of refined and self-restrained Zen culture was broken, although it was never to die out completely.

Oda Nobunaga (1534–82) was a minor *daimyō* who started the unification process (fig. 20). Self-reliant, open-minded, and above all treacherous, Nobunaga brutally forced the most powerful traditional religious communities into subservience and also brought the Ashikaga *bakufu* to an end in 1573. Under the slogan *tenka fubu*, "the whole realm under one sword," Nobunaga managed by shrewd mili-

19. Himeji Castle, Hyōgo Prefecture.

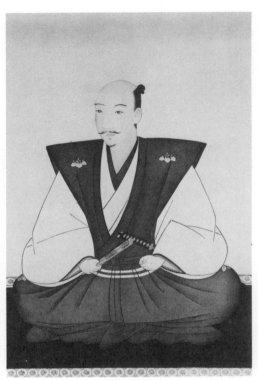

20. Portrait of Oda Nobunaga.

tary tactics (including the use of the newly imported gun) and by deceitful strategems to subdue a number of the important *daimyō* in the countryside. However, he was not to achieve his goal of national unification. He became the victim of the treachery of one of his own generals, Akechi Mitsuhide, a fitting end perhaps for a leader who had himself risen by violence and treachery.

Nobunaga was succeeded by Toyotomi Hideyoshi (1536–98), a peasant who rose to be master of all the land in the greatest rags-to-riches story in Japanese history (fig. 21). Equally as shrewd and ambitious as Nobunaga, Hideyoshi tempered raw power with magnanimity and managed to create a new alignment of all the *daimyō* as his own vassals. Although Hideyoshi did not attempt to restructure an entire new form of rule for Japan, he imagined himself as the man who could carry out the destiny of the Japanese to rule all of East Asia. On the path to conquest of Ming China, however, lay Korea. Hideyoshi, despite dispatching an invasion force of several hundred thousand men from 1592 to 1598, became bogged down on the peninsula with Chinese armies on the one side and Korean patriots on the other. He never attained his grandiose objective, and when he died in 1598, his samurai army was brought home and disbanded.

Hideyoshi had extracted a pledge from his major generals to support his infant heir Hideyori. Within two years one of the generals, Tokugawa Ieyasu (1542–1616; fig. 22), usurped power with a major victory at the battle of Sekigahara. In 1603 he founded Japan's third *bakufu*, which was to hold sway for the next two hundred and sixty-five years.

Ieyasu was originally from the lower ranks of the warrior class; he had served as a successful general under both Nobunaga and Hideyoshi, patiently biding his time. He seems to have possessed considerably more political acumen than either of his predecessors, which enabled him to turn his military victories into a lasting regime. By the adoption of adroit political measures designed to keep the great *daimyō* under Tokugawa control, epitomized by the system of "alternate attendance" between their fiefs and the new capital of Edo (Tokyo), Ieyasu and his successors laid the groundwork for Japan's most successful warrior government.

It was during this period that the samurai reached the peak of their social development. Yet it was also a period full of paradoxes as far as the warriors were concerned. In his day, Hideyoshi had already attempted to freeze Japan's social structure, separating samurai from the other classes. Although Hideyoshi had risen from peasant status, now the warriors became a true hereditary class into which entry was technically barred. At the same time that the samurai were defined as the effective ruling elite of Japan, however, Pax Tokugawa provided Japan with the longest period of protracted peace in her history. The role of the samurai as fighting man, ready to defend his lord or sacrifice himself in the defense of the fief, was no longer essential. Early Tokugawa period samurai were forced to confront the question:

What is the role of the warrior in an age of peace? Perhaps the most famous definition of the role of the samurai was provided by Yamaga Sokō (1622–85).

> The business of the samurai consists in reflecting on his own station in life, in discharging loyal service to his master if he has one, in deepening his fidelity in association with friends, and in devoting himself to duty above all. Should there be someone in the three classes of the common people who transgresses against these moral principles, the samurai summarily punishes him and thus upholds proper moral principles in the land. It would not do for the samurai to know the martial and civil virtues without manifesting them. Since this is the case, outwardly he stands in physical readiness for any call to service and inwardly he strives to fulfill the Way of lord and subject. . . . The common people make him their teacher and respect him.*

In this era of continual peace, the samurai became less a man of the sword or bow, and more a man of the brush. A high percentage filled bureaucratic posts in the *bakufu* administration or the governments of the some two hundred and thirty feudal domains. Most of the philosophers of the day were also samurai. Although their primary interests were history and government, some also wrote on what ultimately came to be called the "way of the samurai" (*bushidō*). The ideal of the warrior was expressed at the beginning of the period by Ieyasu himself when he urged the samurai to master both the civil and military arts. This was the concept of *bunbu ryōdō*, ultimately derived from classical China but preached among the warrior class from at least the time of Imagawa Ryōshun in the fourteenth century.

Ironically, most of the written information we have on the Japanese samurai comes from this period, after the heyday of the fighting men had passed. Warriors now had the time to reflect upon their behavior and their role in society, and they wrote a number of treatises about the ideals of the class. Likewise, as the necessity of actual combat virtually disappeared, martial training became more formalistic and stylized, and the tradition of schools of swordsmanship became divided and highly competitive. The actual content of the training was also altered, as various safety devices like the bamboo sword (*shinai*) allowed warriors to practice with one another without the fear of death or dismemberment. It was clearly a transitional stage from real combat to sport, and the major function of the training was a form of spiritual education. Nonetheless, samurai were encouraged to practice the martial arts assiduously.

The teacher of swordsmanship to the third shogun, Tokugawa Iemitsu (1604–51; fig. 23), was Yagyū Munenori (1571–1646), a stu-

*De Bary et al., *Sources of Japanese Tradition* (Columbia University Press, 1959), pp. 399–400.

40

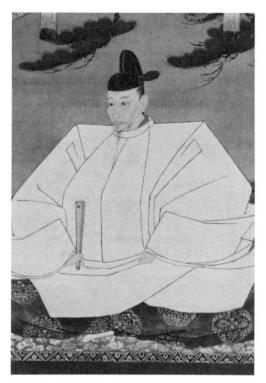

21. Portrait of Toyotomi Hideyoshi.

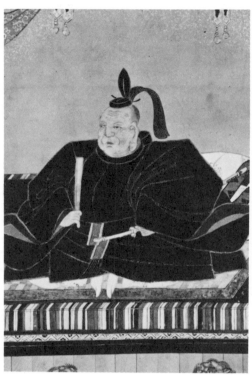

22. Portrait of Tokugawa Ieyasu.

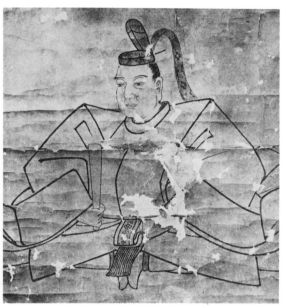

23. Portrait of Tokugawa Iemitsu.

dent of the Zen monk and painter Takuan (1573–1645). Munenori wrote a treatise on swordsmanship in which the Zen influence is paramount. He reiterated the importance of eliminating fear which comes from concern with one's own life, writing that the ultimate secret of swordsmanship lies in being released from the thought of death. He also stressed "no-mind," eliminating all desires, including the desire for success.

> You are said to have mastered the art when the technique works through your body and limbs as if independent of your conscious mind.... However well a man may be trained in swordsmanship, he can never be the master of his technical knowledge unless all his psychic hindrances are removed and he can keep his mind in the state of emptiness, purged even of whatever techniques he has mastered.*

The achievements of "no-mind," when technique can function without conscious effort, was also important to samurai painters. Relying more upon inner vision than upon sketching from nature, artists such as Tsuda Bensaku were able to add new vigor to the samurai art tradition. Bensaku's painting of an owl strongly suggests the controlled power of this nocturnal bird of prey (pl. 21). The total composition shows the boldness of its era, but the technique of the earlier ink painting tradition is still the basis for Bensaku's style. We may contrast his work with a similar painting by Tokugawa Iemitsu, the first of his line to have practiced the art of painting (fig. 24). Bensaku has produced the stronger work, but both reveal the sense of personal character that is vital to this artistic tradition. Skill with the brush is secondary to the individual expression and immediacy of each painting.

Samurai art of the early seventeenth century became an interesting amalgam of early Zen influences in terms of technique and contemporary dynamism in terms of spirit. Perhaps the warrior-artists, inspired by the heroism and vision of the new leaders of Japan, were now finding a time of peace and serenity in which to express their inner feelings in painting and calligraphy. Although the role of the samurai was to change significantly in the ensuing centuries with some of the idealism vanishing in the face of day-to-day realities, much of the finest samurai art was produced during the first decades of the Tokugawa era.

MIYAMOTO MUSASHI: SWORDSMAN AND ARTIST
Perhaps the most famous swordsman of the early Tokugawa period was Miyamoto Musashi, also known by his art name of Niten. One of the reasons for his popularity may well be that he personified the transformation of the samurai at this moment in history. Legends

*Suzuki, op. cit., pp. 165 and 152.

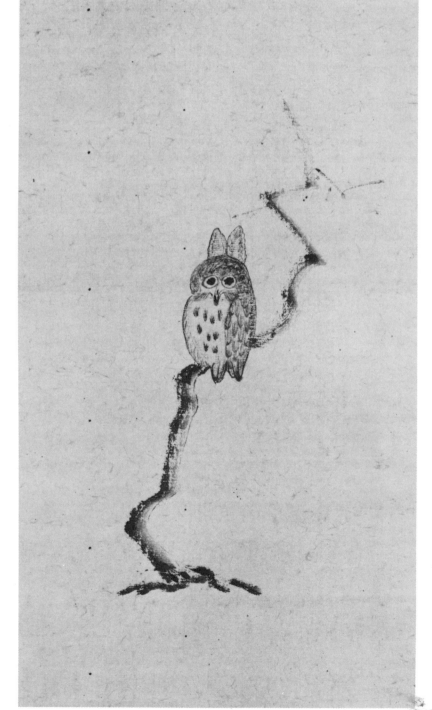

24. Tokugawa Iemitsu. *Owl.*

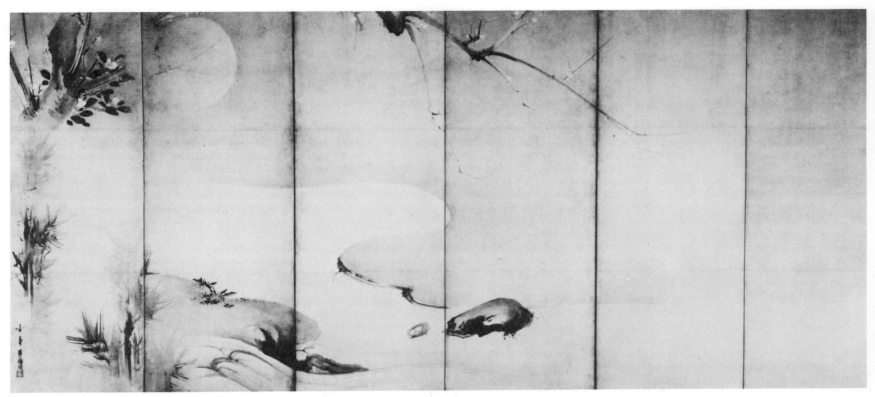

25. Kaihō Yūshō. *Streams in Moonlight*. Nelson–Atkins Museum of Art.

about him, however, have tended to obscure the facts of his life. Who was the real Miyamoto Musashi?

The date of his birth is fixed somewhat uncertainly around 1584; the place was Harima, modern-day Hyogo Prefecture, in west central Japan. Musashi's father was Shinmen Munisai, a skilled practitioner with both sword and the *jitte*, a short metal truncheon with a blunt end. Munisai was once called for a special contest before Ashikaga Yoshiaki and so distinguished himself that the shogun termed him "Japan's premier martial artist." Musashi, too, learned the techniques of the *jitte*, but perhaps because it was a weapon with a limited use, he turned instead to the sword with which he was to achieve his fame. Other than learning from his father, we do not know with whom Musashi studied swordsmanship in his youth, but at the tender age of thirteen he claims to have defeated the noted Shintō-school swordsman Arima Kihei. At sixteen Musashi killed a certain Akiyama of Tajima province in a duel. Subsequently Musashi fought in six major battles from Sekigahara to Shimabara and engaged in more than sixty duels—without once meeting defeat—before he was thirty years old.

Musashi apparently spent many years as a wandering swordsman, attempting to form his own style, perfect his skills, and ultimately unify his spirit. While the tradition of wandering warriors mastering the martial arts was not an unknown phenomenon in earlier Japanese history, the late sixteenth and early seventeenth centuries seem to have been the peak period for this sort of activity. Many of the legendary figures of Japanese swordsmanship are products of this era: Kamiizumi Ise-no-kami, Itō Ittōsai, Yagyū Jūbei and others. Musashi is best known for a style in which he seems to have been the first to employ both the long and the short sword at once. Accordingly, the style was known as *nitō-ryū* ("two sword style") or, after his art name, *Niten-ryū*. While there is indeed such a school, it makes for better legend than history; apparently Musashi did not attempt to use two swords against very skillful opponents.

At one point during his wanderings throughout Japan, Musashi visited the *daimyō* of Kokura in Buzen province of northern Kyushu, Hosokawa Tadaoki (the model for the despicable Buntaro in James Clavell's novel *Shogun*, but historically a model samurai). There Musashi met Sasaki Kojirō, known as Ganryū, who was serving as a swordsmanship instructor to the Hosokawa house. The two noted swordsmen fought a duel at Funajima, later known as Ganryū-jima, a small island at the southern tip of Japan's main island of Honshu. Arriving late, cleverly keeping the sun at his back and taunting his opponent, Musashi confounded Kojirō, ultimately striking and killing him with a wooden sword fashioned from an oar.

Later in his life, long after he had quit his active involvement in duels, Musashi once again visited a Hosokawa fief, this time that of Lord Tadatoshi in Kumamoto Castle, where he accepted a post in the *daimyō*'s service. It was there in 1643 that Musashi wrote his *Go-*

rin no sho (A *Book of Five Rings*), a volume of military tactics based upon his long years of experience as a swordsman in individual duels and in the major military encounters of the day. No one is certain as to what audience Musashi may have had in mind while writing this book, but surely he would have been shocked to learn that in the late twentieth century many businessmen in the United States would be buying the English translation of his *Gorin no sho* in hopes of discovering the secret of Japan's business success.

Sometime during his career Musashi learned how to paint in the Zen-influenced ink brushwork style that had its roots in the Kamakura and Muromachi periods. His paintings also express the new boldness of Momoyama and early Tokugawa period art. Musashi may have been influenced by Kaihō Yūshō (1533–1615), a samurai who, after his family was killed, moved to Kyoto and became one of the great artists of the Momoyama period (fig. 25; title page). Yūshō's work, particularly his ink painting, shows a great strength of line, composition, and spirit. Whether or not due to Yūshō's influence, Musashi became the epitome of the samurai painter, brushing works with an extraordinary power and intensity. His subjects included Zen figures, waterfowl, birds of prey, bamboo, and, more rarely, landscape (pls. 13–20). For his own enjoyment, he also carved wooden Buddhist images with surprising skill.

This, then, is a brief thumbnail sketch of the career of Miyamoto Musashi. Although surprisingly little is known of his life, it is not so much in history as in legend that he is important. Already in Tokugawa times he was the subject of a number of Kabuki plays, and to Japanese today he is best known from the serialized novel by Yoshikawa Eiji (available in English translation as *Musashi*) and from numerous movie versions of this story. For older Japanese the most vivid remembrance, however, may well be the radio broadcast which achieved tremendous popularity during World War II, in which all the parts were read by the late Tokugawa Musei. Perhaps Musashi occupies a special place in the hearts of Japanese because he was the last of his kind, a transitional figure between the skilled warrior of the Warring States period and the bureaucrat-scholar of the Tokugawa era. Those who followed after Musashi's time were a different breed indeed.

THE ERA OF THE CONFUCIAN SAMURAI

By the time of Musashi's death, the samurai were no longer needed in their primary role of warriors. The peace and plenty of the Tokugawa era brought new demands that de-emphasized bravery and swordsmanship and substituted bureaucratic skills. However, not all warriors were content to be gradually transformed into officials, serving the central government or feudal lords in an increasingly commercial society. Some samurai who could not adapt themselves to the new lifestyle or who lost their masters became *rōnin*, wandering and often homeless warriors. Considering themselves above the world

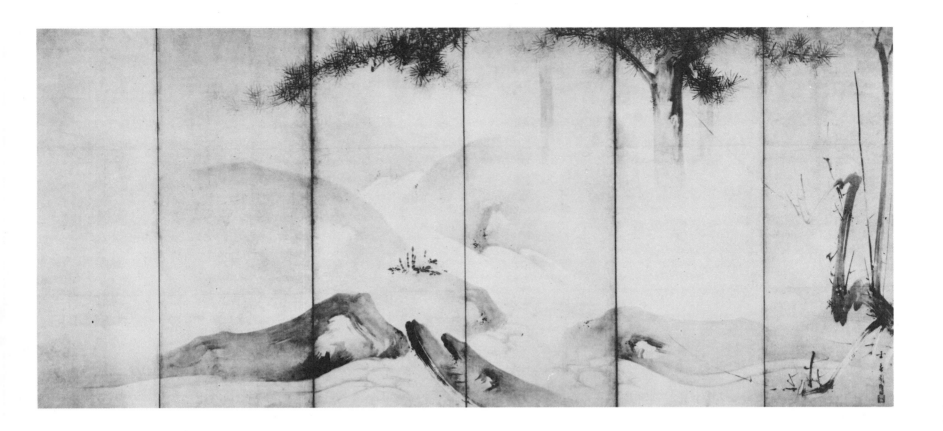

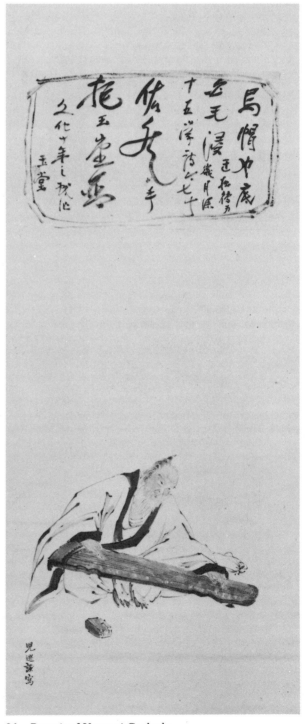

of commerce, these *rōnin* were usually poverty-stricken, and sometimes turned to a life of banditry in order to survive.

For the larger number of samurai who were able to make the transition to bureaucrats, a system of Confucian education fostered by the Tokugawa shogunate inspired a new interest in the Chinese culture of the literati, rather than the Zen culture of previous ages. Samurai painting was soon transformed. For example, the scholarly ink-play subject of bamboo, the "gentleman" who bends but does not break in the wind, was taken up by the short-lived Yoshida Zōtaku (1772–1802), a samurai from Matsuyama. Although this was a traditional brushwork theme especially favored by literati from the Sung dynasty onwards, Zōtaku infused it with new life. He wielded the brush with extraordinary vigor, often showing only a part of the bamboo within a large scroll format. His warrior spirit shines through his paintings, giving them a unique and dynamic boldness (fig. 27).

Some Japanese leaders turned to the West, despite the prohibition of Christianity and the isolationist posture of the government. Satake Shozan (1748–85), the *daimyō* of Akita in northern Japan, not only painted in the European style himself (pl. 23) but also instructed some of his subjects to learn the techniques of volumetric realism and vanishing-point perspective. As he was far from the governmental center of Edo (Tokyo), Shozan's experiments did not draw the castigation of the authorities, and the "Akita school" remains one of the artistic curiosities of eighteenth-century Japan.

The stresses that were placed upon the samurai of the later Edo period are notable in the lives of two men who became great painters as part of their wider cultural interests. The first is Uragami Gyokudō (1745–1820; fig. 26), who was born to a samurai family serving the feudal lord of Bizen (Okayama). As a measure of control over the local *daimyō*, the central government, as noted earlier, required them to spend half of each year in the capital of Edo. During Gyokudō's travels there with his lord, he was able to learn Chinese-style poetry, calligraphy, painting, and music. He became famous for his skill on the Chinese seven-string zither, or *ch'in*, for which he also composed new Japanese music. Although born to the warrior class, he had little interest in the practice of swordsmanship that was now almost useless, preferring cultural attainments while preserving his internal self-reliance.

Gyokudō took the rare step of resigning his samurai position. This meant that his children and all future descendents would also lose their samurai status, and thus it was an extremely serious decision. What caused it? Disgust with the bureaucratic life, which had lost the sense of nobility, may have been a factor. The death of his wife, the restrictions placed by the government upon his favorite (Zen-influenced) form of Confucianism, and the early death of the *daimyō* he had been trained to serve were also contributing reasons. Ultimately Gyokudō must have felt he needed to be completely free to pursue his own goals. He spent seventeen years traveling around Ja-

26. Portrait of Uragami Gyokudō.

CONTENTS

INTRODUCTION

Prince Rogers Nelson first became fascinated with music at the age of six, when he saw his father's three-piece jazz band perform. Everything about it seemed amazing: the sounds that came out of his father's piano; the chorus girls that came out dancing at Nelson Sr's command; the emotive power the whole thing had over the people in the audience.

Prince became obsessed with music as an outlet for his innermost feelings. In the 80s those feelings seemed to fall perfectly in tune with the zeitgeist. Twenty years after that epochal event in a tiny jazz club in his hometown of Minneapolis, Minnesota, Prince had become a global superstar. The most famous musician on the planet, the author and star of *Purple Rain*, had only just turned 26.

Commercial success is one thing. Being one of the most important and talented artists to ever have graced the earth is quite another. With the April 1978 release of his debut, *For You*, Prince began a ten-year run of albums on which he continued to push himself and his art further and further. In a decade widely remembered for its selfishness and soullessness, Prince redefined the concept of 'soulful' music.

Taking his lead from the flag-bearers of funk – Sly Stone, James Brown, and George Clinton – and artistic pioneers such as Miles Davis and Joni Mitchell, Prince imbued his music with his idiosyncratic view of life, turning out music from the mind of a sex-obsessed deviant (*Dirty Mind*); music from a bomb-fearing party-animal ('1999'); music from a God-fearing man searching for a way to reconcile the spiritual with the sexual (*Lovesexy*); and so much more.

When Prince had finished redefining the music, he took his battle for individuality to the record business. During the 90s he waged war against his record label, Warner Bros, changed his name to an unpronounceable symbol, and pronounced himself a slave to the system. He might have faced derision from all corners then but now, almost a decade into the 21st century, it's become obvious that Prince's actions weren't just crucial for him but for whole generations of musicians to come.

Many in the music business continue to suffer as a result of their initial failure to embrace the internet, but not Prince. He was the first artist to release a whole album online via his own self-financed record label, and has continued to seek out new ways to release and promote his music, even going so far as to give it away for free. His fight for artists' rights has shown future generations that they don't have to adhere to anyone else's rules, and shown how one man can stay relevant for more than 30 years on the strength of a passion to challenge the status quo and change the way things are done.

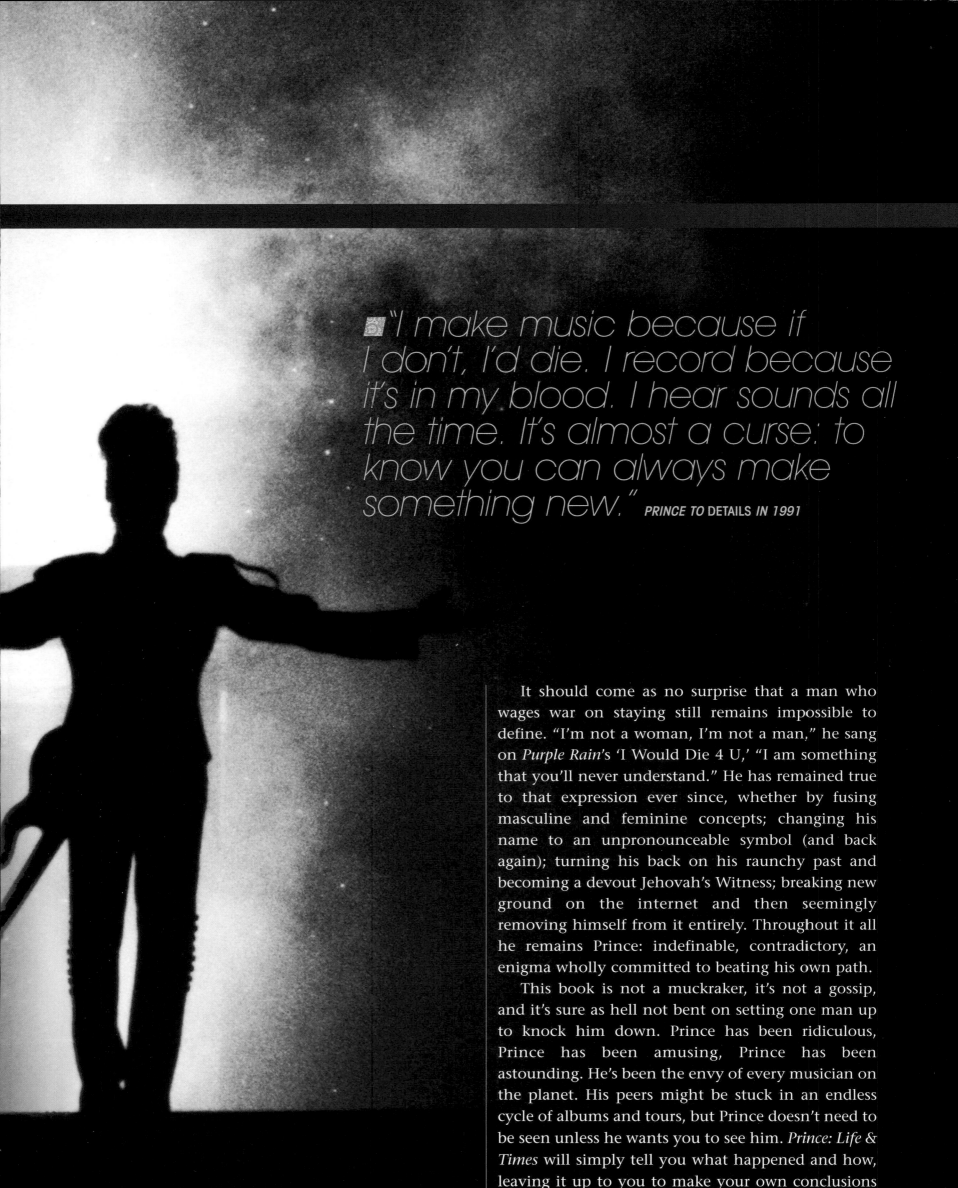

"I make music because if I don't, I'd die. I record because it's in my blood. I hear sounds all the time. It's almost a curse: to know you can always make something new." **PRINCE TO** DETAILS *IN 1991*

It should come as no surprise that a man who wages war on staying still remains impossible to define. "I'm not a woman, I'm not a man," he sang on *Purple Rain*'s 'I Would Die 4 U,' "I am something that you'll never understand." He has remained true to that expression ever since, whether by fusing masculine and feminine concepts; changing his name to an unpronounceable symbol (and back again); turning his back on his raunchy past and becoming a devout Jehovah's Witness; breaking new ground on the internet and then seemingly removing himself from it entirely. Throughout it all he remains Prince: indefinable, contradictory, an enigma wholly committed to beating his own path.

This book is not a muckraker, it's not a gossip, and it's sure as hell not bent on setting one man up to knock him down. Prince has been ridiculous, Prince has been amusing, Prince has been astounding. He's been the envy of every musician on the planet. His peers might be stuck in an endless cycle of albums and tours, but Prince doesn't need to be seen unless he wants you to see him. *Prince: Life & Times* will simply tell you what happened and how, leaving it up to you to make your own conclusions

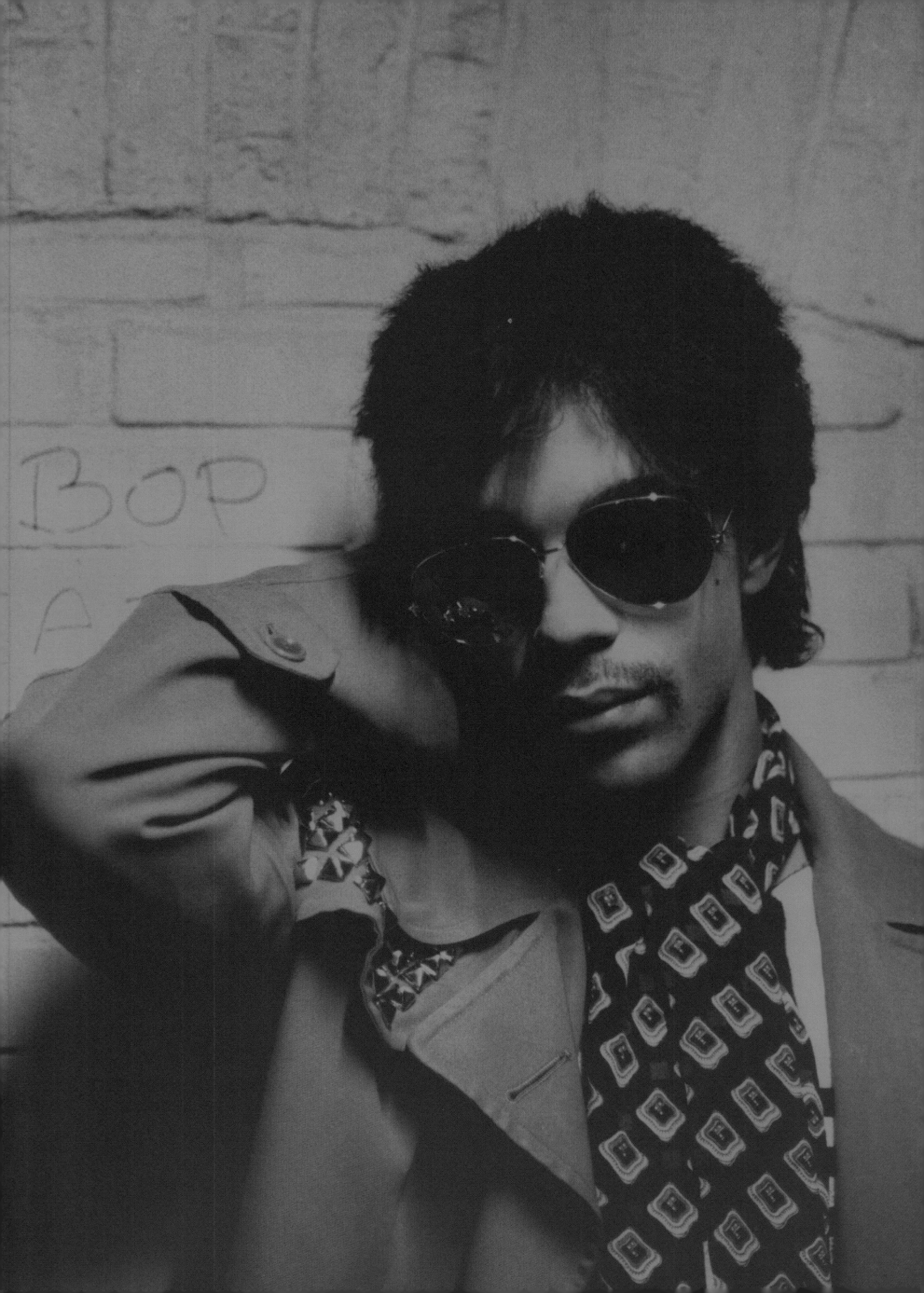

THE SON OF A JAZZ PIANIST AND A SINGER, PRINCE STARTED LEARNING TO PLAY THE PIANO AT THE AGE OF SIX; BY 19 HE WOULD BE SIGNED TO ONE OF THE WORLD'S BIGGEST RECORD LABELS AND PLAYING EVERY INSTRUMENT ON HIS DEBUT ALBUM, *FOR YOU*. REFUSING TO LIMIT HIMSELF SOLELY TO THE R&B MARKET, HE WOULD GO ON TO EXPAND HIS SOUND WITH EACH SUCCESSIVE RELEASE, CREATING A UNIQUE HYBRID OF SOUL, FUNK, ROCK, AND POP.

THE EARLY YEARS
1958–1983

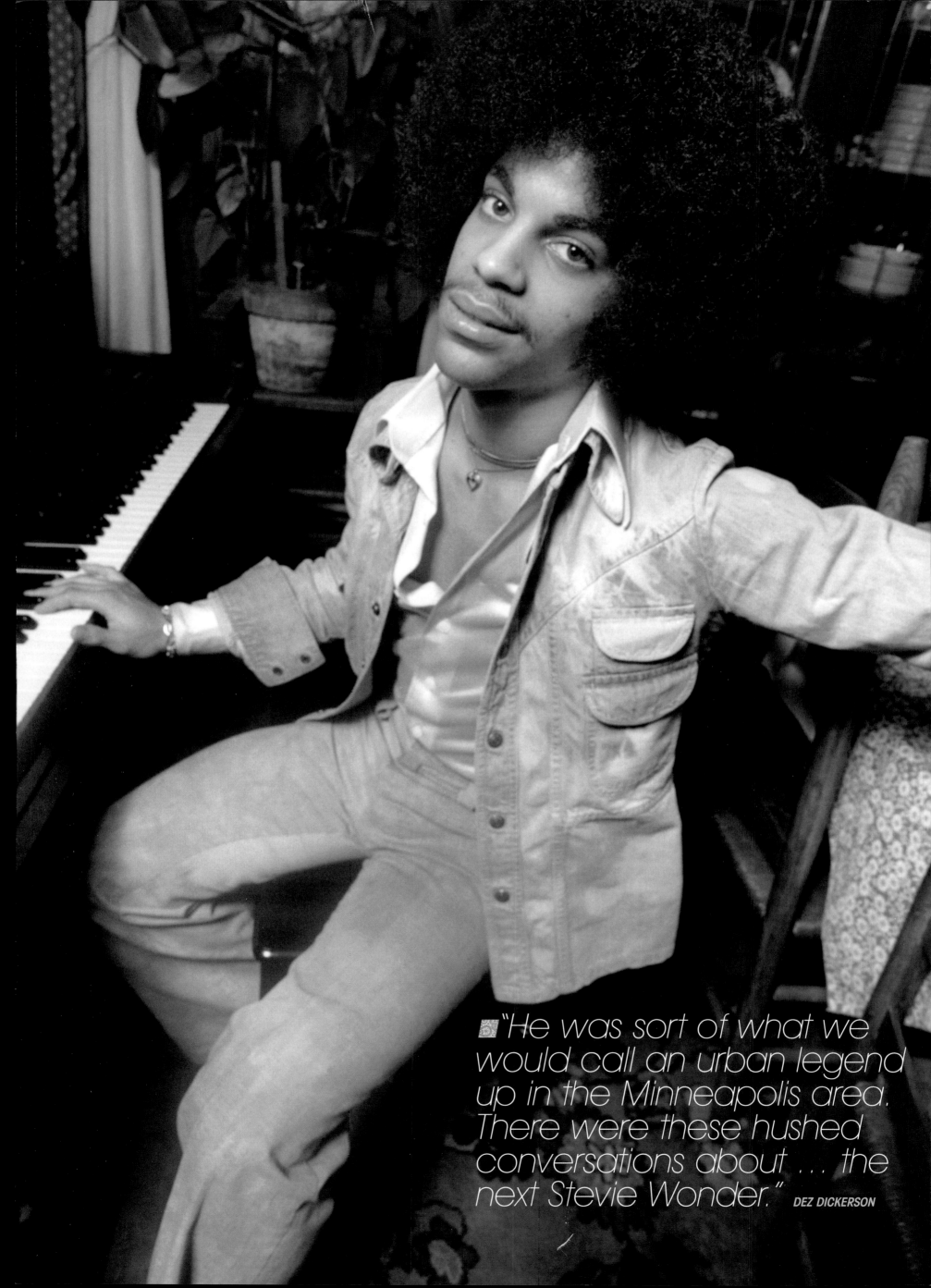

"He was sort of what we would call an urban legend up in the Minneapolis area. There were these hushed conversations about ... the next Stevie Wonder." *DEZ DICKERSON*

experienced would be brought in as the album's executive producer, just in case Prince ran into any difficulties.

The *For You* sessions began in September 1977 at Sound 80 studios in Minneapolis, where Prince had recorded his first proper demo. It was suggested at one point that the engineer of those previous sessions, David Rivkin, might serve as *For You*'s executive producer, but in the end Warner Bros settled on Tommy Vicari, who had previously worked with one of Prince's heroes, Carlos Santana.

Vicari wasn't impressed with the facilities at Studio 80

"Because I do all the instruments, I'm injecting the joy I feel into all those 'players.' The same exuberant soul speaks through all the instruments." *PRINCE*

and suggested decamping to Los Angeles. This worried Husney, who thought his young workaholic might find himself distracted by the city's abundance of sex, drugs, and rock'n'roll. Husney suggested a compromise – the Record Plant in nearby Sausalito – but needn't have worried. As soon as he settled into recording, all Prince wanted to do was work.

After moving out to California in October Prince lodged in a spacious apartment in Mill Valley, overlooking the San Francisco Bay, with Vicari, Husney, and Husney's wife Britt. Their home life was pleasant enough: Husney cooked Prince scrambled eggs, while his wife made the singer's lunch and washed his clothes. Recording was a different matter. Prince made it very clear that this was *his*

show, and would roll his eyes whenever Vicari approached the mixing desk. If ever he did deign to ask the producer something, he would push him away as soon as he'd received enough information. By the time the sessions were finished, Husney said, Prince had "absorbed everything he needed out of Tommy Vicari's brain. ... Tommy was heartbroken, because he had just been treated like shit."

Having completed work on the basic tracks by the end of December, the *For You* team moved to Los Angeles's Sound Labs studio in January 1978 to begin overdubbing. It was here that the pressure seemed to get to Prince. Pushing Vicari away, he spent over a month-and-a-half piling up overdub upon overdub, gradually eroding the spontaneity of the original recordings in a self-conscious bid to prove that he was capable of making the kind of polished, commercial record that Warner Bros wanted. He finally finished the record on February 28, eight months after starting work on it. It had cost $170,500 to make – just $500 short of the planned budget for the first three Prince albums – and had turned its creator into a wreck.

Released on April 7 1978, *For You* received largely positive reviews, although most of them were concerned more with the fact that it was the work of a 19-year-old and had little to say about the actual musical content. Prince's local paper, the *St Paul Dispatch*, called the album "a technical marvel and a curiosity" most interesting "because one man did it."

For You is a competent record, and the making of it proved to be a useful learning experience. Prince had got to grips with a wide range of synthesizers, notably the Oberheim, which would characterize much of his early

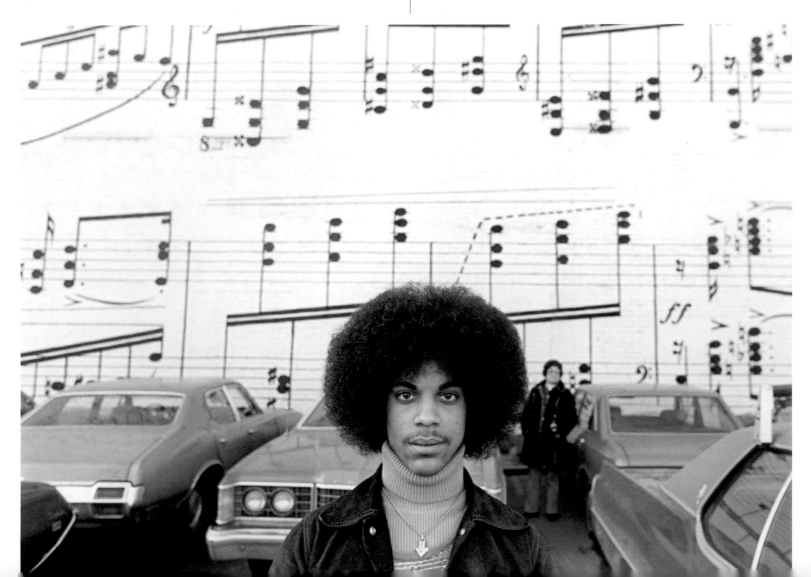

work. He would not feel comfortable enough with the idea of using real brass instruments on record – in the way that James Brown and George Clinton had before him – until the mid 80s. Anxious to avoid replicating the sound of contemporary disco, Prince went for something totally different, creating his own 'horn section' by multi-tracking synthesizer and guitar lines.

Another important characteristic of *For You* is Prince's reliance on high-pitched vocals on both the suggestive, up-tempo material ('Soft & Wet,' the album's only minor hit) and the lovelorn, acoustic ballads ('Crazy You'). The whole thing seemed to be aimed squarely at the young, female R&B market, right down to the softly airbrushed sleeve art of the Afro-haired singer. Only the final track seemed to suggest something else. With its frenzied, finger-tapping solos and similarly showy bass-playing, 'I'm Yours' seems closer to the MOR rock of Journey than Santana, and a firm reminder of the fact that Prince wanted to reach beyond the black audience.

Genuine mainstream success was still some way off, however. As impressive as *For You* might have been, it still bore the hallmarks of overproduction – the opening title track has over 40 layers of Prince's vocals – while too many of the songs simply repeat themselves without going anywhere, and aren't quite snappy or sharp enough for mass appeal.

For You did nonetheless reach Number 21 on *Billboard*'s R&B chart, while 'Soft & Wet' made it to Number 12 on the R&B chart and Number 92 on the Pop chart. Prince set off on a minor promotional jaunt, appearing at signings in cities where the records were selling well. After being confronted by 3,000 screaming fans on one such occasion in Charlotte, North Carolina, however, Prince was more than a little spooked, and soon began to shy away from personal appearances.

In the summer of 1978 Prince used his Warner Bros advance to move into a new home at 5215 France Avenue in the Edina area of Minneapolis. He then set about holding auditions for a band that he could take out on the road with him and chose Del's Tire Mart as a rehearsal space. Bobby Rivkin – the brother of local engineer David Rivkin and an employee of Owen Husney's – came in on drums, while Prince's old school-friend André Anderson (now calling himself André Cymone) played the bass, just as he had done in his mother's basement years earlier. The three of them had played together before, so it made sense to carry on with a well-rehearsed rhythm section.

With a mix of ethnicities already in place (Bobby Rivkin, or Bobby Z as he became known, was white; André Cymone was black), Prince was keen to mix up the band's sexuality as well – just as Sly & The Family Stone had done in the 60s. Prince had his eye on a similar boundary-crossing line-up when he brought Gayle Chapman into the fold, telling her: "You're white, you're blonde, you have blue eyes, and you can play funky keyboards."

Dez Dickerson was next to join. A veteran of the Minneapolis scene with a punkier look than most black guitarists of the time, he was impressed by Prince's professionalism – despite the fact that the singer turned up two-and-a-half hours late for their scheduled rehearsal. "He was very clear that he wanted the band to be an amalgam of rock and R&B," Dickerson later recalled. The only guitarist who opted not to showboat in rehearsals, Dickerson quickly settled into a comfortable, complimentary role in the band. The last member to join was keyboardist Matt Fink, who had been intrigued by Prince ever since Bobby Z played him a demo tape in 1977. He had asked Z to keep him in mind if Prince was ever on the lookout for a keyboard player, and now was the time.

Having assembled the band, Prince spent the rest of the year whipping them into shape while Owen Husney tried to focus his energies on putting together a tour. Since the release of *For You*, however, Prince had begun to see Husney as more of a runner than a manager, perhaps as a result of his frustration that the album hadn't been an instant smash hit.

Prince's demands eventually became too much. After having their equipment stolen from Del's Tire Mart, the band moved into Pepé Willie's basement. "Sometimes the basement was less than balmy," Dez Dickerson recalled. "Prince called Owen and told him to get a space heater and bring it to Pepé's." Husney, however, was waiting on an important call, and didn't think it wise to leave the office. Prince demanded that the job be done there and then. An argument ensued that resulted in Husney quitting on the spot. Prince tried to convince him to return, but the three-page letter he had written detailing what he considered to be a manager's responsibilities didn't jive with what Husney thought the job should entail. Pepé Willie was willing to do the smaller jobs, but that served only to mask a bigger problem: having just released his debut album, and while still trying to get his band tight enough for a tour, Prince lacked a guiding force.

PRINCE HAD HIGH HOPES THAT 1979 WOULD BEGIN WITH A TOUR IN SUPPORT OF *FOR YOU*, BUT HE WOULD FIRST HAVE TO CONVINCE WARNER BROS TO BACK IT FINANCIALLY. IN THE INTERIM PEPÉ WILLIE – STILL DEPUTIZING IN THE ABSENCE OF A REAL MANAGER – ORGANIZED A PAIR OF SHOWS AT MINNEAPOLIS'S CAPRI THEATER.

Prince (JANUARY 1979–APRIL 1980)

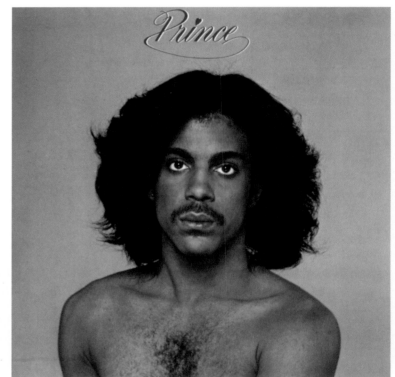

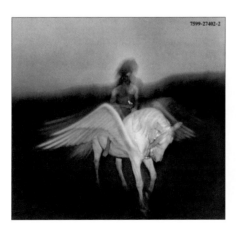

Prince made his live debut as a solo artist on January 5 1979. Given the circumstances, the show was neither here nor there. It wasn't a sell-out, but still drew a crowd of several hundred fans, friends, and family members, all intrigued to see the local-boy-made-good in action. But Prince was still a tentative live performer and often played with his back to the audience. All in all the show – for which each of the bandmembers wore tight spandex, leg-warmers, and high heels – seemed more like a dress rehearsal than a proper concert.

Two nights later a delegation of Warner Bros officials came to watch Prince's second show and decide whether or not he was ready for a full tour. This was unfortunately the night that Dez Dickerson decided to try out a wireless pickup for the first time. It refused to work properly, and as Dickerson later put it: "There were some definite uncomfortable moments … [which] caused a couple of delays." None of this helped Prince, who was already nervous at the prospect of his second ever solo show being his most important to date. The constant breaks to fix Dickerson's equipment disrupted the flow, and when a

"painfully shy" Prince plucked up the courage to address the audience, the guitarist recalled, he "barely spoke above a whisper."

The concert was an unqualified failure. Having put so much effort into proving he could make a record entirely on his own terms, Prince was devastated that he couldn't do the same in a live setting. "I kept trying to speak to him and he wouldn't even talk," recalled his cousin, Charles Smith. "He thought the show was shit." So did the Warner Bros officials, who vetoed any plans for Prince to tour. But this in itself posed another problem: what to do with an artist who had used up virtually all of his three-album budget on one record, wasn't ready to tour, and had just sacked his management?

Warner Bros' main focus was on finding a new management team. The label opted for the Hollywood-based Cavallo & Ruffalo firm, a highly experienced agency run by a pair of Italians, Bob Cavallo and Joe Ruffalo, who had previously worked with Little Feat, Earth, Wind & Fire, and Weather Report. Cavallo & Ruffalo sent runners down to handle Prince's day-to-day requests, and installed

Dez Dickerson's rock sensibilities added another dimension to Prince's early music.

a senior employee, Steve Fargnoli, as his manager. (Fargnoli proved so important to the Prince setup that he was soon invited to become a partner in the company, which was renamed Cavallo, Ruffalo & Fargnoli.)

Prince meanwhile busied himself working on songs for his next album. From late April to late May he recorded at Alpha Studio in Los Angeles with engineer Gray Brandt – Warner Bros having decided, after the Tommy Vicari debacle (which made it clear that Prince wouldn't listen to anybody), that there was little point in insisting on another executive producer. Left to his own devices, Prince recorded the album in 30 days, and needed only a couple more weeks to add overdubs and complete the final mix at Hollywood Sound Recorders – a far cry from the four months spent on *For You*. He even managed to fit in a few sessions with his band – then known as The Rebels – during the same time period.

Prince's self-confidence grew as the sessions progressed, giving him the conviction to trust himself more. One such example came with the recording of first single 'I Wanna Be Your Lover,' which, according to Gary Brandt, "didn't come together until we put the [live] drums on." Prince recorded the drums himself, playing along to what had already been taped. "[Drum machines] are kind of hard to play to," Brandt recalled, "because

they're usually right on the meter." Prince however was "very synchronized," and had no trouble "fit[ting] himself into that track, knowing exactly what would come up."

Prince was released on October 19 1979. It was preceded by the single release of its opening track, 'I

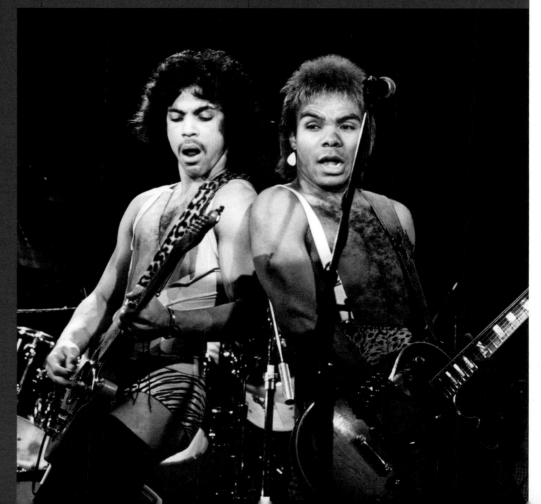

> ## "I knew how to write hits by my second album." PRINCE

Wanna Be Your Lover,' which showed much more commercial promise than anything on *For You*, hitting Number One on *Billboard*'s R&B Chart and Number 11 on the Pop chart. Like much of *For You*, 'Lover' is a simple love song sung in what *Rolling Stone* called "the most thrilling R&B falsetto since Smokey Robinson." It was also a lot tamer than the highly charged 'Soft & Wet,' and as such appealed to a much wider audience.

Taken as a whole, *Prince* sounds like the work of an artist who had learned from the mistakes of his previous album. Where *For You* meandered at times, the follow-up contains a wealth of more varied, interesting grooves. The songwriting is snappier and more hook-laden, as evidenced by 'Why You Wanna Treat Me So Bad?' and 'I Feel For You' (later a hit for Chaka Khan). There are still

Sue Ann Carwell And The Rebels

Ever the workaholic – even at the age of 20 – Prince found it difficult to enjoy his down time. After moving into his new house in Minneapolis during the summer of 1978, Prince met a local singer, Sue Ann Carwell, and was soon working on songs with her both at home and at Sound 80 Studios. But while Prince would later become known for his ability to adapt to a different sound for each project, much of what he recorded with Carwell just sounded like his own material. As such, once Carwell signed to Warner Bros (with the help of Owen Husney), she was assigned to a different producer in order to differentiate her sound from that of the label's other young star.

Prince's interest in masterminding other acts didn't end there, of course. In June 1979, not long after completing work on *Prince*, he told Dez Dickerson of his plan to "record an entire record, with the band, under the nom de plume The Rebels." The band, according to Dickerson's memoir, *My Time With Prince*, "were being asked to come along for the ride and make him look good."

This time around, instead of making something that sounded transparently like his R&B-orientated solo work, Prince decided to build on the rockier elements of

songs such as 'I'm Yours' and 'Bambi.' He also intended for The Rebels to be more of a collaborative effort, even allowing Dickerson and André Cymone to write some of the material. But after working on nine songs at Ears Sound Studio, Colorado, in July 1979, Prince scrapped the project, deciding that the whole thing sounded too generic.

The idea was for The Rebels to be a kind of 'secret' side project, but what Prince learnt from the experience was that, if he

was to successfully mastermind a new act such as this, he should be in control but not necessarily involved on a full-time basis. Similarly, after working with Sue Ann Carwell he realized that there should be some link to his own sound, but not to the point where there was no differentiation between the two. Both experiences proved useful in the long run, however, in that they would inform Prince's plans for the launch of The Time.

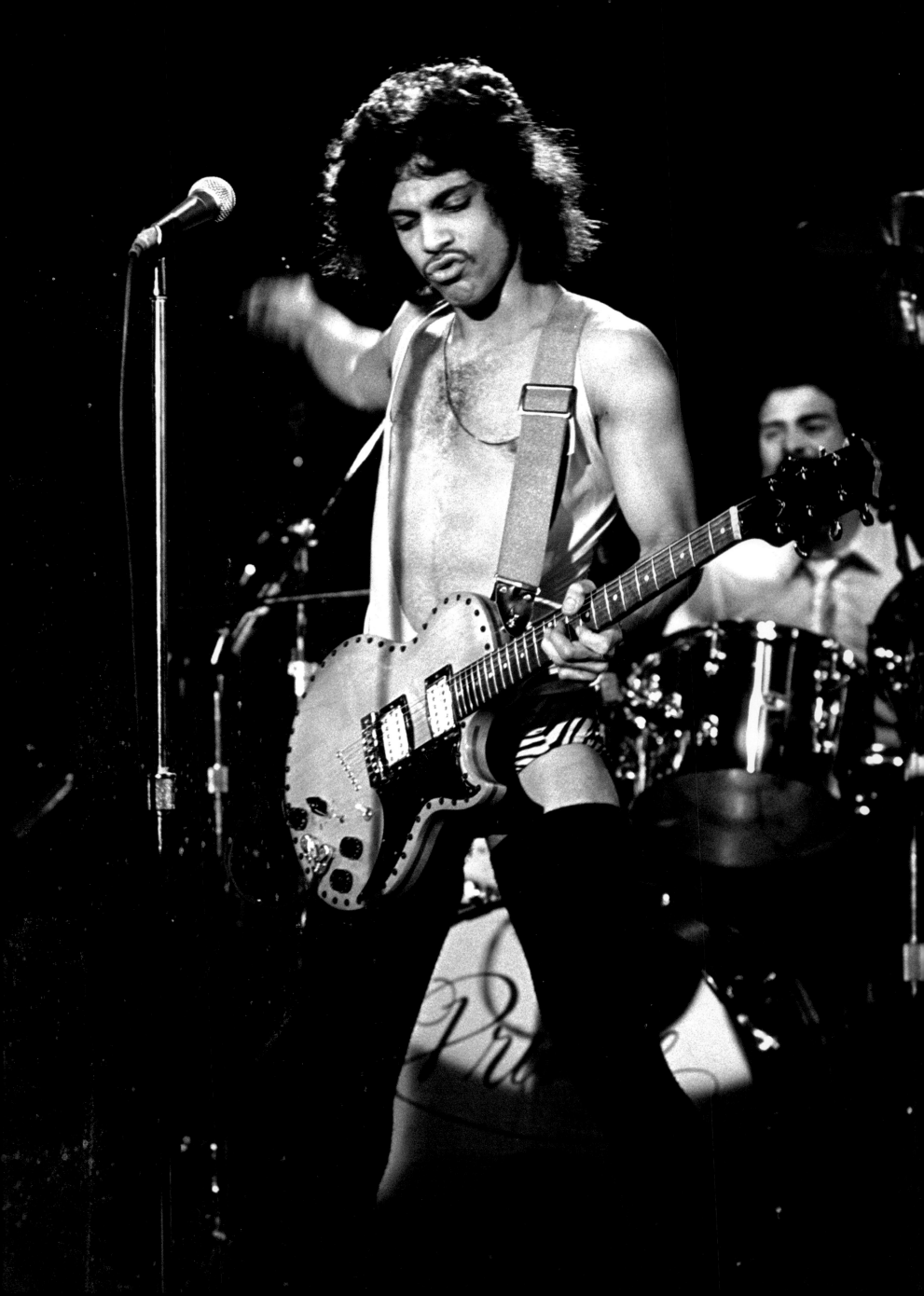

hints of Prince's love for MOR rock, notably on 'Bambi.' But while the music is fairly generic, the lyrics – in which Prince tries to convince a lesbian that "it's better with a man" – point toward the sort of taboo subjects that Prince would later mine to great success. The album's ballads, meanwhile, are tighter and more convincing, helped by a more minimal production style, which made them much more club-friendly. Prince himself was very much aware of the difference this made. "I never saw Prince again," Gary Brandt later said, "but I got countless calls from his managers asking me how I recorded various parts of his album."

Prince was still very much an R&B record aimed squarely at female listeners. On the front jacket Prince is pictured topless, with messy hair and thick moustache, against a baby-blue backdrop; on the back he is naked, riding a Pegasus (no explanation necessary). His name is inscribed in purple, with a heart dotting the 'i.' The album

that he could not scandalize the audience by wearing that spandex and no underwear." Prince took Cavallo's instructions literally. "That's all he wore: a pair of bikini briefs!"

In February Prince was invited to join Rick James's Fire It Up tour as the supporting act in what was billed as the Battle Of Funk. Prince's young bucks did to James what The Time would threaten to do to their master a few years later: winning over the crowd with a short, snappy set that had a lot more going for it than the headliner's two hours of overindulgence. As Bobby Z later put it, "We were young and hungry and we started kicking his ass." James found himself struggling to follow Prince's energetic, flamboyant performance, with large chunks of the audience leaving during his set.

The animosity between the two was further fueled by the fact that Prince and his band tended to avoid socializing with James and his party-hard entourage.

"I was brought up in a black-and-white world … I want to be judged on the quality of my work, not on what I say, nor on what people claim I am, nor on the color of my skin." PRINCE

reached Number 22 on the *Billboard* Pop chart – a mere 141-point improvement on *For You* – and even reached Number Three on the R&B chart. Now it was time, once again, to think about touring.

The Prince tour was certainly eventful. To begin with, two months of shows had to be cancelled after the singer caught pneumonia in early December. Then there was the small matter of an appearance on *American Bandstand*, on which Prince and his band were set to perform the album's first two singles, 'I Wanna Be Your Lover' and 'Why You Wanna Treat Me So Bad?' Backstage they met the host, Dick Clark, one of the most respected figures on American television. Everything was going well until Prince came up with a mischevious idea: he and the band should refuse to answer any of Dick Clark's questions. The band was mortified, but the stunt worked. Prince became infamous almost overnight after answering Clark's questions with nothing more than series of hand gestures, such as holding up four fingers when asked how many years he had been playing. Clark later called it the hardest interview he ever conducted.

Another issue to resolve was the group's image. "We were all groping for images of how we wanted to look on stage," Matt Fink recalled. "Prince pretty much left it up to each individual member of the band to figure it out, of course, with his final approval." For Fink this meant everything from prison chic to a doctor's gown and mask (which earned him the nickname Dr Fink). Prince however had an entirely different look in mind: "loud spandex and bright colors," as Dickerson put it. "I overheard Bob [Cavallo] talking to Prince about the fact

James wasn't sure what to do with a group so far from his own sensibilities. "I felt sorry for him," he later recalled. "Here's this little dude wearing high heels, standing there in a trench coat. Then at the end of the set, he'd take off his trench coat and he'd be wearing little girl's bloomers. The guys in the audience would boo him to death."

As the Prince tour wound down in April, further trouble emerged from within Prince's own traveling party. As a member of a religious sect called The Way, keyboardist Gayle Chapman found herself increasingly conflicted about her role in the group. "Prince was tired of the costumes that I was coming up with," she later recalled. "He sent his girlfriend down to the hotel room that I was in, she knocked on the door … dumped this bag of multicolored underwear on my bed, and said, 'Prince says wear this or you're fired.'"

Chapman felt similarly uncomfortable about having to kiss her bandleader rather suggestively during the song 'Head' (which subsequently appeared on *Dirty Mind*). "There had been some tension between her beliefs and what she was being called upon to do in our live show," Dickerson recalled. "There was a developing role that she was given that involved the simulation of some pretty vulgar things on stage."

Things came to a head when Chapman told Prince she planned to go on a trip with her Way group; Prince wanted her to commit to some short-notice rehearsals instead. An argument broke out that resulted in her leaving the group, leaving Prince with another round of personnel issues to deal with. All of this paled in comparison, however, to the kind of shake-up that Prince already had in mind.

BARELY PAUSING FOR BREATH AFTER FINISHING HIS FIRST FULL TOUR, PRINCE BARRICADED HIMSELF INSIDE THE MAKESHIFT STUDIO IN THE BASEMENT OF HIS NEW HOUSE ON LAKE MINNETONKA TO START WORK ON HIS NEXT RECORD. *FOR YOU* AND *PRINCE* HAD BUILT HIM A STRONG BLACK FOLLOWING, BUT PRINCE HAD HIS SIGHTS SET ON A WIDER MARKET.

Dirty Mind (MAY 1980–JUNE 1981)

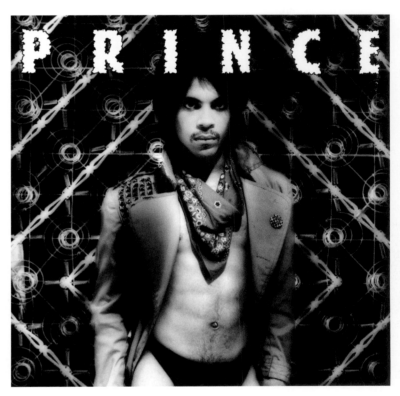

His next move might risk losing an established audience, but would potentially open up a much bigger one. "Nobody knew what was going on," he said, "and I became totally engulfed in it."

For several years a new form of music had been slowly gaining ground in Britain and America. From The Ramones to The Clash, punk had begun to take over the white rock market, which had been dominated for most of the 70s by bands such as Pink Floyd and Led Zeppelin. By the dawn of the 80s bands such as Blondie had begun to add keyboards and a pop sensibility to punk's stripped-down template, creating a sound that was christened 'new wave'.

Prince had noted a similar sea change on the horizon in the disco market, having refused to allow Earth, Wind & Fire's Maurice White to produce his debut on the grounds that it would immediately sound dated. Two years later he hit upon a new sound that shared a number of stylistic similarities with new wave.

Prince had already developed a reputation for being interested in all things carnal thanks to his stage outfits and the brazen sexuality of songs such as 'Soft & Wet.' The new

music he presented to Warner Bros, however, took things a step further. Not only were these stripped-down recordings rough and punky, with an urgent physicality lacking in his earlier work, they were also obscene – and Prince wanted them to stay that way. "It really felt like me for once," he told *Rolling Stone*. "When I brought it to the record company it shocked a lot of people. But they didn't ask me to go back and change anything, and I'm really grateful."

It wasn't quite as easy a sell as Prince might have made it out to be. "The record company, understandably, was very nervous about this sudden change," Dez Dickerson recalled. It wasn't only the lyrical content that bothered Warner Bros, but the blatant shift in musical style. According to Dickerson, the label's attitude was: "We've signed Stevie Wonder and now we've got Ric Ocasek. What happened?" It took quite a lot of smoothing over on the part of Bob Cavallo and Steve Fargnoli before Warner Bros gave the project the green light.

"Mo Ostin did what any 'artist friendly' 80s label head would have done with an artist as gifted as Prince: nurture and support him," Alan Leeds recalled. Prince did agree to

give some of the songs a bit more polish in the final mix, but everything else remained as it was when *Dirty Mind* went on sale, four months after Prince had begun working on it, on October 8 1980. Not everybody at Warner Bros was happy, however. "He turned [the company] into disarray," noted the company's vice president, Marylou Badeaux. "The promotions people would call me and say, 'I can't take this to radio! Is he crazy?'"

Just in case the jacket – a stark black-and-white image of Prince, in studded trench coat, neckerchief, stockings, bikini briefs, and a 'Rude Boy' button, standing in front of the bare springs of an upturned bed (in homage to James Brown's *Revolution Of The Mind*) – wasn't enough, the album was sent to DJs with a sticker that implored them to "please audition before airing." The doe-eyed seducer of Prince's previous albums had been replaced with a predatory look – in Prince's own words – of "pure sexuality."

The shockwaves went off far and wide. Songs such as 'Do It All Night' and 'Dirty Mind' say it all in their titles. Here was a man dispensing with the pleasantries and getting straight to business, ditching the sexual revolution of the 60s in favor of the sexual aggression of the 80s. And it got worse. 'Head' tells the story of a sordid meeting with a bride-to-be on the way to her wedding, while 'Sister' – allegedly inspired by Prince's half-sister Sharon – explores the (fictional) concept of losing your virginity in an incestuous tryst. Prince might have expected his father to have something to say about that, but he seemed more concerned with the language than the subject matter. "When I first played *Dirty Mind* for him," the singer told *Rolling Stone* in 1983, "he said, 'You're swearing on the

"Dirty Mind was a risky record. Some thought we were losing our minds." BOB CAVALLO

record. Why do you have to do that?' And I said, 'Because I swear.'"

Dirty Mind is more than just *The Joy Of Sex* set to music. Tracks such as 'Partyup' and 'Uptown' (about a place where "we do whatever we please") show his socially conscious side – something that would continue to surface again and again as his career progressed.

When it came to touring *Dirty Mind*, Prince was able to go back out as the headliner, rather than as somebody else's support act. The addition of Lisa Coleman, the 19-year-old daughter of Hollywood session player Gary Coleman, on keyboards had a significant impact on the group. After a three-hour audition, during which she and

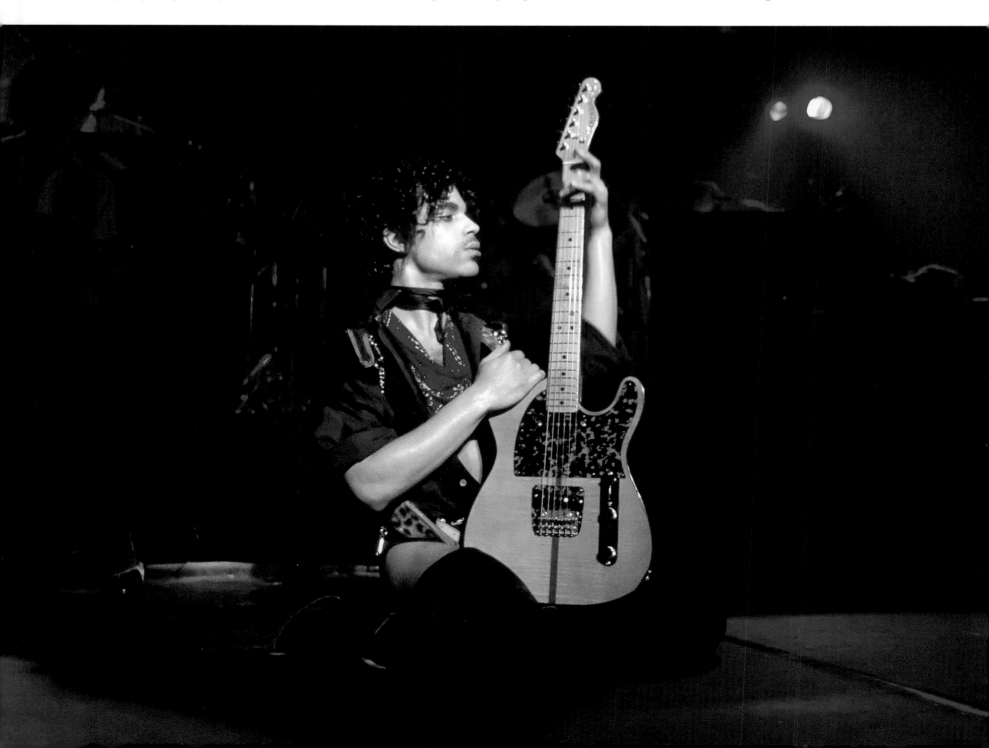

Prince barely spoke, it became clear that Coleman would bring much more to the group than had her predecessor. "Lisa's like my sister," Prince told *Rolling Stone* a few years later. "She'll play what the average person won't. She'll press two notes with one finger, so the chord is a lot larger, things like that. She's more abstract. She's into Joni Mitchell, too."

Prince himself seemed to settle more comfortably into his own skin on the Dirty Mind tour, while the band quickly gelled into a tight musical unit. All manner of hijinks ensued on the tour, from stealing emergency megaphones on airplanes to taking it in turns – rather more dubiously – to be left slumped in wheelchairs, drooling, in airports, pretending to have been left behind.

For all the fun, the tour began on a rather inauspicious note on December 4 in Buffalo, New York, one of several smaller towns and cities that struggled to appreciate this freaky character singing freaky songs in bikini bottoms and stockings. While venues such as the 12,000-seat Cobo Arena in Detroit came close to selling out, Prince found himself playing to half-empty halls in Winston-Salem, Chattanooga, and Nashville. Sales of *Dirty Mind* itself were sluggish as 1980 drew to a close, leading Prince's management to cut the tour short after a show at Chicago's Uptown Theater on December 26 for fear that it would soon start losing money.

While Prince took stock in yet another new house on the outskirts of Minneapolis (which he would soon paint purple) his salvation came in the form of a *Rolling Stone* article headed by the question, 'Will The Little Girls Understand?' Prince's management team had hired publicist Harold Bloom to up their star-in-waiting's media profile. This first piece of serious rock journalism about Prince opened the floodgates for the rest of the music press, including Britain's weekly *New Musical Express* to follow suit. *Dirty Mind* hadn't been selling well – it was performing even more slowly than *Prince* had – but the tipping point, as Dez Dickerson put it, came with "this tidal wave of critical acclaim," notably Ken Tucker's four-and-a-half star *Rolling Stone* review, which called it "the most generous album about sex ever made by a man." The *Minneapolis Tribune* followed suit, heaping praise upon Prince's own unique instrumental sound, a disco-funk mode that is quite recognizable as his."

The Dirty Mind tour resumed in the wake of this upsurge in critical interest, with Prince booked into smaller clubs this time around to ensure that each date

was a sell-out. The press coverage did its job, and a whole new audience began to check out what all the fuss was about. Minnesota's other boy-done-good, Bob Dylan, came to the hometown opening night at Sam's Club on March 9, while Mick Jagger was part of a sell-out crowd at the New York Ritz on March 22 – the same venue that Prince had struggled even to half-fill three months earlier.

By the time the tour wound up in New Orleans on April 6 Prince had begun to make significant inroads into a new, white market. Buoyed by this success, he started working on another side project, building a completely new band out of Minneapolis group Flyte Time and former Champagne drummer Morris Day. Prince's plan was to make direct, funky music with this new group, which he called The Time, while continuing his assault on the mainstream with his solo work.

The buzz around him had grown by now to the extent that he made his first trip to Europe, playing three club dates in Amsterdam, London, and Paris. While some musicians might have spent their first foreign trip seeing the sights, Prince used it to investigate what was going on in the cities' clubs, seeking out new ideas to bring back home with him.

Despite the success he was now having, Prince still found it difficult to keep his band together. "During the *Dirty Mind* period I would go into fits of depression and get physically ill," he told *Rolling Stone* in 1985. "I couldn't make people in the band understand how great we could be together if we all played our part." More than a decade later, he identified the root of the problem: his bassist. "André's ego always got in the way of his playing. He always played on top of the beat, and I'm convinced that was just because he wanted to be heard. André and I would fight every night, because I was always trying to get him to sound like Larry Graham."

André Cymone, Prince's first ever bandmate, quit the group in April 1981. It didn't come as much of a surprise. As early as 1977 Cymone had turned up at the *For You* sessions with the attitude that it would not be long before he would be doing "my thing." Now he had clearly decided that he had watched from the sidelines for long enough. Even so, he continued to bear a grudge against his old friend, claiming later that Prince stole many of his ideas for The Time, along with the bassline for *Controversy*'s 'Do Me, Baby.'

Once again, as Prince looked toward the next step in the expansion of his empire, he found himself having to replace another disgruntled bandmember.

"Prince refuses to play it safe. If he did, he wouldn't have made this album." NEW MUSICAL EXPRESS REVIEW

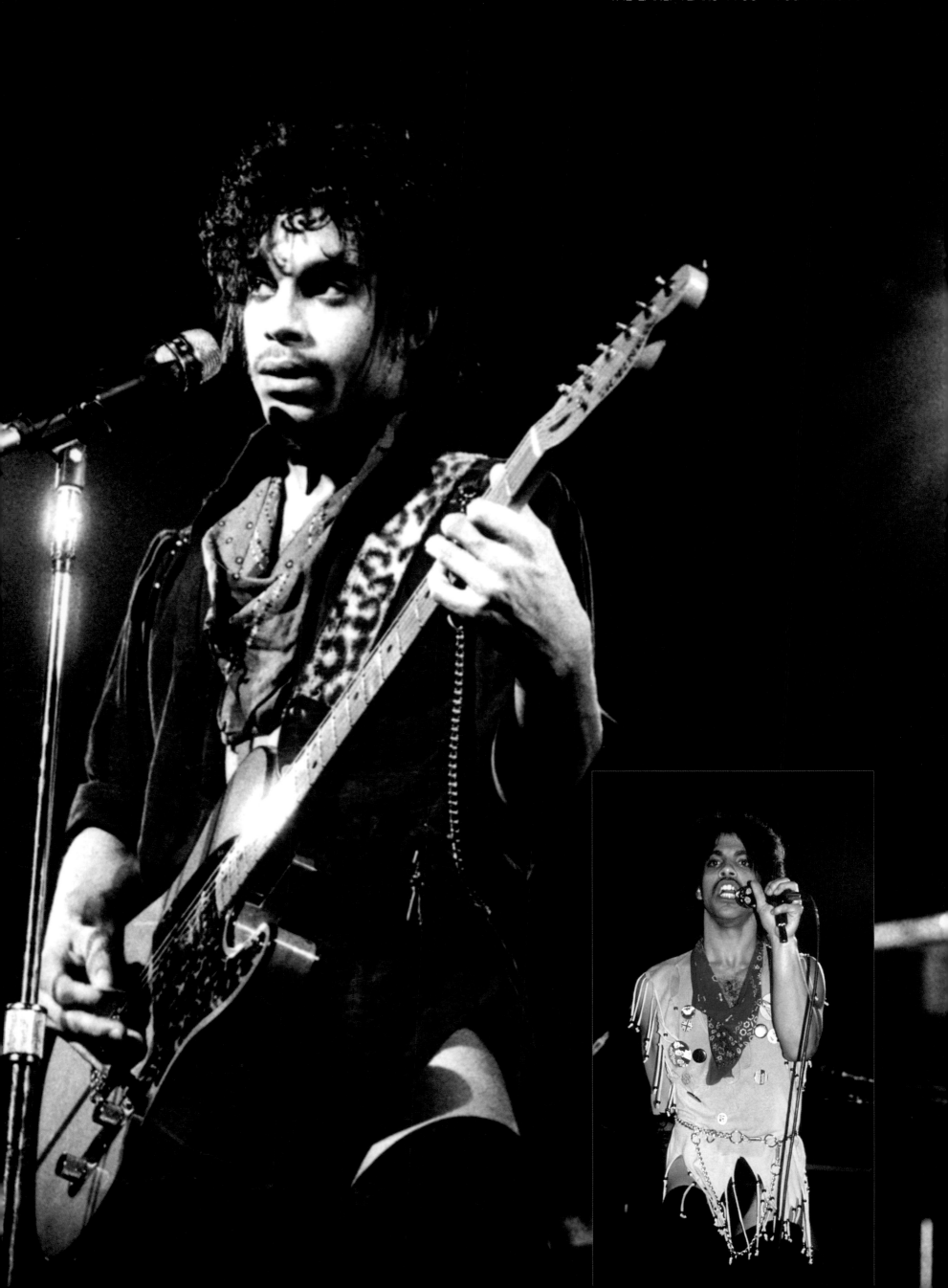

PRINCE STARTED WORK ON THE NEXT PHASE OF HIS CAREER AS SOON AS THE DIRTY MIND CLUB TOUR ENDED ON APRIL 6 1981. OFFICIALLY, THE NEXT ITEM ON HIS AGENDA WAS A THREE-DATE EUROPEAN TOUR IN JUNE, BUT EVEN BEFORE APRIL WAS OUT HE HAD RECORDED AND MIXED AN ENTIRE ALBUM FOR HIS NEW SIDE PROJECT, THE TIME. HE ALLOWED ONLY THE BAND'S LEADER, MORRIS DAY, TO APPEAR – AND EVEN THEN DAY WAS INSTRUCTED TO FOLLOW PRINCE'S GUIDE VOCALS NOTE-FOR-NOTE.

Controversy (JUNE 1981–MARCH 1982)

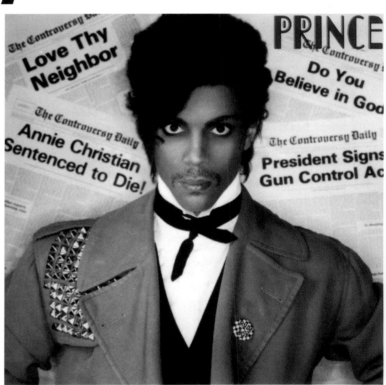

Prince was overflowing with ideas. "He'd come to our rehearsals for five or six hours, then go to rehearsals for his own band, then [work] all night in the studio," recalled Time keyboardist Jimmy Jam. One happy side-effect of having a new band was that Prince could let the semi-autonomous Time take care of the R&B market and focus his own efforts on his impending crossover into the mainstream. He was also aware that the presence of another successful Minneapolis band would help create a buzz around the city and what Prince himself was doing.

Prince co-credited Morris Day and somebody called Jamie Starr (the supposed engineer of *Dirty Mind*) with production on *The Time*, but rumors quickly spread that Starr was a pseudonym. Prince denied it, which of course served only to increase media interest in the record, which ended up outselling *Dirty Mind*.

After returning from Europe in June, Prince started work on his fourth album, *Controversy*, at home and in Los Angeles. While The Time's songs were funky and played to

the kind of black music stereotypes Prince had seen in his youth, his own material carried on in the *Dirty Mind* vein. It wasn't a mainstream success by any stretch of the imagination, but *Dirty Mind* had attracted a new crowd, and Prince intended to build on that. *Controversy* would end up mixing funk with new wave and seductive ballads, sex with religion and politics, creating a whole that feels as confused as it is confusing. A bewildered review in Britain's *New Musical Express* wondered quite how Prince could be so "temporarily valorous" yet "ultimately conservative." Is that what funk was meant to be?

When he started work on *Controversy*, having already fulfilled his initial three-album deal with Warner Bros, Prince would have been well aware of the fact that he needed to deliver the goods this time. Having been brought in to replace André Cymone on bass, 18-year-old former International House Of Pancakes employee Mark Brown (subsequently renamed Brown Mark) asked his new boss what the plan was. "This album has to make it," Prince told him. "He definitely knew what he was doing,"

Brown noted, "but I don't think he had a clue if it was going to work. I think he was feeling that, if it didn't sell, he'd be dropped."

In Europe, Prince discovered that new wave acts such as Gary Numan were already incorporating the cold, synthesized textures of Kraftwerk and the underground electronica scene of the 70s. On his return, he began to seek out ways of intertwining his synths into his sound more deeply than he had on *Dirty Mind*. He also came across the Linn LM-1 drum machine, the first one capable of sampling real drum sounds, and soon realized that it would help him record entire drum parts cheaply and quickly, without having to play them in real time.

Prince's experiments with overlapping LM-1 rhythms and synthesizer parts reach their peak on 'Private Joy,' a song he wrote for his girlfriend Susan Moonsie. Overall, however, for all of its innovative ideas, *Controversy* feels more like a halfway house between *Dirty Mind* and its fully realized follow-up, *1999*; a taster, of sorts, of a sound that Prince had not yet quite mastered.

Having made a tentative entry into the world of political debate on *Dirty Mind*'s 'Uptown,' Prince stepped wholeheartedly into that arena with *Controversy*. The jacket is almost like a color version of *Dirty Mind*'s, with Prince – wearing slightly more clothes than last time around – standing before a backdrop of newspaper headlines based on the album's sensationalist lyrics (plus one that simply reads "Joni," in honor of Joni Mitchell). On the record, 'Ronnie, Talk To Russia' and 'Annie Christian' demonstrate a desire to say something about the world at large. But the former is decidedly naïve ("Ronnie, talk to Russia before it's too late / Before they blow up the world") and the latter, ostensibly about gun control, is more of an inner-worldview than a political worldview, voiced by a man who "live[s] my life in taxicabs." (Even on 'Ronnie,' "the world" becomes "my world" by the end.)

Perhaps the most interesting aspect of *Controversy* is the level of unrestrained self-obsession on it. 'Private Joy' might have started out as an ode to a girlfriend, but is told from the point of view of Prince himself; what she does for him, and how he likes to keep her entirely for himself, without ever mentioning what *he* brings to the relationship. Likewise, 'Do Me, Baby' plays out a seduction fantasy, almost in real time, during which Prince never once lifts a finger. Only on the final track, 'Jack U Off,' does he offer anything in the way of recompense, offering his services "in the back of a car, restaurant, or cinema." But even then he ends deciding, "as a matter of fact, you can jack me off."

The pinnacle of Prince's self-obsession arrives on the title track, on which he attends to various concerns others might have had about him. Is he black, white, straight, gay? Does he believe in God, or himself? (Both, of course.) He claims not to be able to understand human curiosity, but seems to have grasped the fact that it might lead to an interest in him. The inclusion of 'The Lord's Prayer' midway through the song only adds to the sense of confusion and contradiction. Here is a man trying to make sense of himself and his place in the world while also trying to make himself appealing to everybody else (and perhaps toning down the explicit image he had thus far embodied).

The confused state of the record was best summed up by *Sweet Potato* magazine, which suggested that there ought to have been "a serious side and a sex side. Which would have made everything nice and cozy if the penis weren't a political tool in Prince's worldview." As far as Warner Bros was concerned, "[*Controversy*] is a musical outrage and a sincere statement of opposing views." That might be stretching the point somewhat. What is important, however, is that each of these songs, from the rockabilly-style 'Jack U Off' to the spoken word 'Annie Christian,' served to unlock the ideas that Prince would develop and in some cases perfect on *1999*.

Controversy sold more strongly than *Dirty Mind* but its chart performance showed that Prince still had some way to go to achieve genuine mainstream appeal. Released as a

"I was horrible … A lot had to do with me not being quite sure exactly which direction I wanted to go in. Later on, toward the Controversy period, I got a better grip on that." PRINCE

single, the title track stalled at Number 70 on *Billboard*'s Pop chart, despite peaking at Number Three on the R&B listings. It might have helped had Prince deigned to give interviews to explain the ideas behind the album. Instead, hoping that the music would speak for itself, he opted not to walk the promotional treadmill at all.

Prior to setting out on tour in support of the album, Prince played a one-off showcase in Minneapolis and a support slot with The Rolling Stones in Los Angeles. For a boy with his eye on mass appeal, the Stones shows served as a sharp reminder of just how far he was from that goal. The average Rolling Stones fan still rode the coattails of 70s rock'n'roll, about which everything was neatly defined. Men played guitars and slept with women, who were submissive and did what they were told. Prince's songs might often have had a similar message, but his androgynous look – stockings, high heels, bikini bottoms – sent out very different signals, as did the fact of him singing about jacking someone off. That was what women did to men, not the other way around. If Prince was singing about such a thing … well then he must be gay.

Prince's first night supporting the Stones, on October 9, at the open-air Memorial Coliseum, didn't go well. The first out of four acts on the bill, he was booed off stage

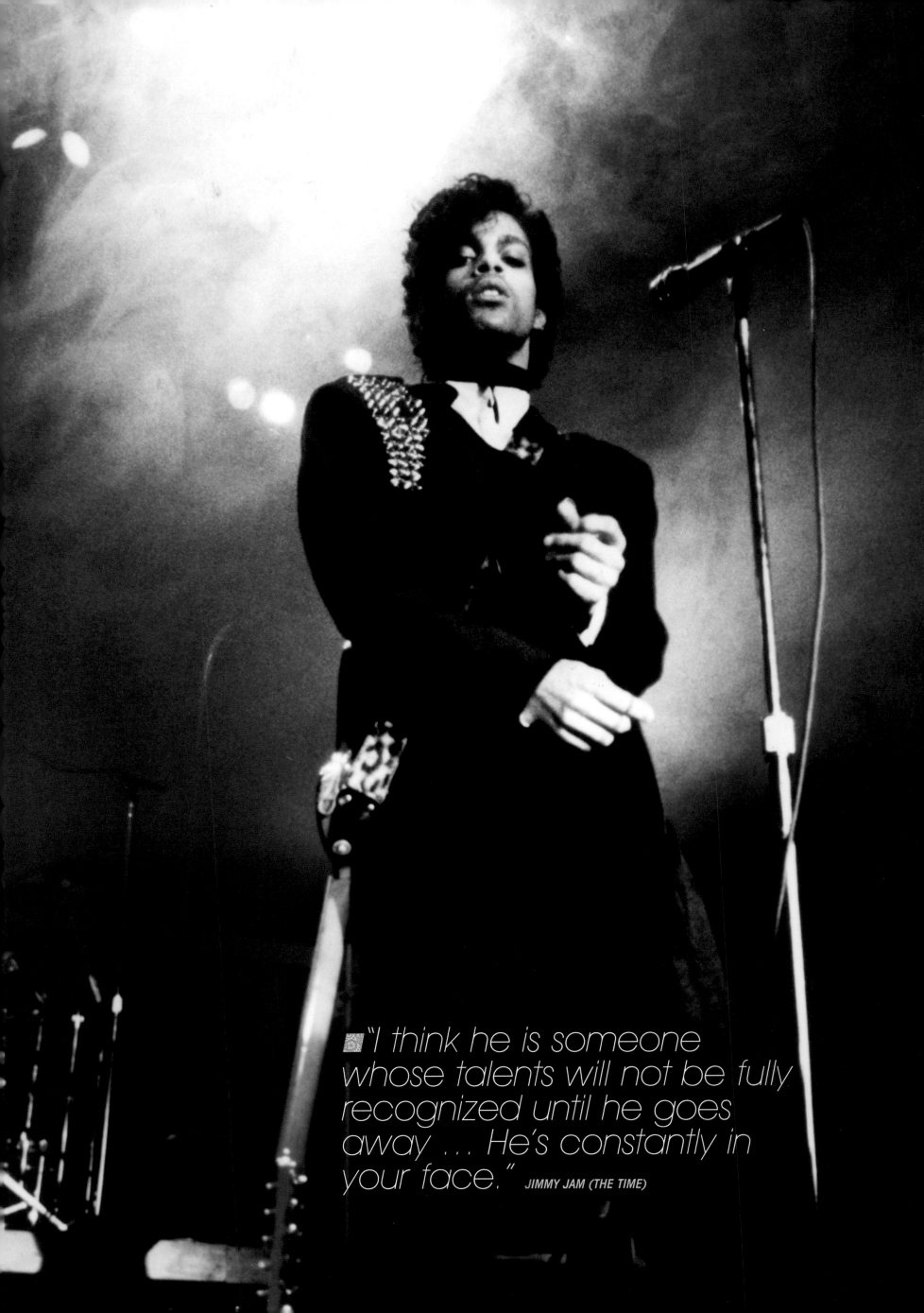

"I think he is someone whose talents will not be fully recognized until he goes away ... He's constantly in your face." JIMMY JAM (THE TIME)

Number One Chick

Of all the friends and family members that Prince has employed over the years – among them cousin/drummer Charles Smith, stepbrother/bodyguard Duane Nelson, and school friend/bassist André Cymone – none has appeared to mean as much to him as Charles 'Big Chick' Huntsberry.

Huntsberry was a giant of a man, a former professional wrestler who stood six feet eight inches tall and had a gray Santa Claus beard. He joined Prince's entourage in January 1982 midway through the Controversy tour and immediately began to confound expectations – not least those of Dez Dickerson, whose first thought upon catching sight of Huntsberry in a Virginia hotel restaurant was: "Oh Lord, I'm gonna die in Richmond." As it happened, Dickerson later noted, "the guy turned out to be one of the most interesting people I ever met." (Later, having warmed to Huntsberry, Dickerson found himself desperately convincing Prince not to fire his new bodyguard for being too imposing a presence.)

After a brief period during which he was avoided by almost everyone on the tour, Huntsberry – who had once had the job of carrying AC/DC's Angus Young around on his shoulders – found himself getting involved in Prince's stage show. He would pull Dez Dickerson off stage during planned altercations between the guitarist and Prince during 'Let's Work,' and on one occasion was called upon to drag The Time off one by one and replace them with Prince's own band. He also quickly became Prince's closest confidante, and would be seen everywhere with him, even to the extent of leading him to the stage at the 1985 Brit Awards ceremony, where Prince won the award for Best International Artist for *Purple Rain*. (The album's liner notes credit him as 'The Protector.')

The closer Prince and Huntsberry became, however, the more the singer began to use his bodyguard as a barrier against the rest of the world – including his bandmates. Even Alan Leeds, hired as tour manager during the *1999* era, found himself having to speak to Prince via Huntsberry to begin with. Within a few years it was not uncommon for Prince to travel on a separate tour bus to the rest of his band, with only Huntsberry, Leeds, and various girlfriends allowed onboard. *New Musical Express* journalist Barney Hoskyns recalled similar scenes during a post-concert dinner on the 1999 tour: "Only when everybody is settled and ready to order does Prince, engulfed in the shadow of his giant, bearded bodyguard … enter the restaurant, gliding silently past the row of booths and making his way to the other side of the room."

Having already developed a reputation as a reclusive egomaniac, Prince soon found himself having to account for his obsession with protection and privacy. A backlash was inevitable. "Nobody has to walk around their home town with a nine-foot bodyguard," Jesse Johnson, the disgruntled former guitarist of The Time, later recalled, "but Prince has dogged so many people, ripped off so many ideas, that he knows he's gonna get his ass kicked."

The cracks began to show on September 5 1984 when photographers started taking pictures of Prince outside a Sheila E. concert at the Agora in Cleveland. After telling the snappers not to take pictures of Prince, the fearless Huntsberry got physical, and one of the photographers ended up injured. Huntsberry had long since quit the Prince organization by the time the case went to court, on October 4 1988. (With the photographer involved seeking $2.75 million in damages, the judge ruled a mistrial, but not before Prince had been ordered to take the stand to defend his dislike of having his picture taken.)

Huntsberry's decision to quit came in the wake of another similar incident, although this time he wasn't present. During the early hours of January 29 1985, as Prince was leaving a Mexican restaurant on Sunset Boulevard, his bodyguards found themselves having to physically remove several photographers from the singer's limo. Prince was incensed. "I don't have any problem with somebody I *know* trying to get in the car with me and my woman," he told *Rolling Stone* shortly after the incident. "But someone like that? Just to get a picture?"

Unfortunately for Prince, Huntsberry had developed a $1,000-per-week cocaine habit. Needing to fund his addiction after quitting his job, the bodyguard sold his story to the *National Enquirer*, which promptly published a kiss-and-tell expose. 'The Real Prince: He's Trapped In A Bizarre Secret World Of Terror' was based largely on interviews with Huntsberry, who is quoted as describing the singer as "the weirdest guy I've ever met. He feels he's a second Mozart."

Among the 'revelations' were that Prince lived in an armed fortress with life-size murals of Marilyn Monroe on the walls, which seemed to leave the singer at pains in future interviews to remind people that he lived a normal life. But despite writing a bitter song about the situation entitled 'Old Friends 4 Sale,' which remained unreleased until it was included on *The Vault: Old Friends For Sale* in 1999 – by which time some of the more personal lyrics had been cut – Prince always cared deeply for his former bodyguard. He kept Huntsberry on the payroll and even bought him a house. Just weeks after Huntsberry quit, Prince admitted to *Rolling Stone* that he had "told him that his job was still there and that I was alone … I miss him."

After kicking his drug habit, Huntsberry became a street evangelist. He spent his time preaching in schools and prisons, and set up Big Chick's Ministries. On April 2 1989, after suffering a severe heart trauma, he prayed to God that he be given one more year to live and to preach the gospel. He died exactly one year later, having fallen into a coma after a church service three days earlier, his heart reportedly as big as a basketball.

On April 30 1990 Prince gave his first live performance of the decade at the Minneapolis nightclub Rupert's. It was an intimate show costing $100 a ticket, with the proceeds – $60,000 in total – going to Huntsberry's wife and six children. Prince dedicated 'Purple Rain' to his former bodyguard, who used to play air guitar to the song from the side of the stage.

Chick Huntsberry quickly became one of Prince's closest confidantes, and helped protect the singer from the outside world.

after 15 minutes. "He could only stay on for two or three songs," Bill Wyman later recalled, "because the crowd threw things at him. He made great records, but he couldn't perform on stage." Prince was so shaken by the experience that he flew straight back to Minneapolis and refused to return for the second concert, which was scheduled for October 11. It took an hour-and-a-half on

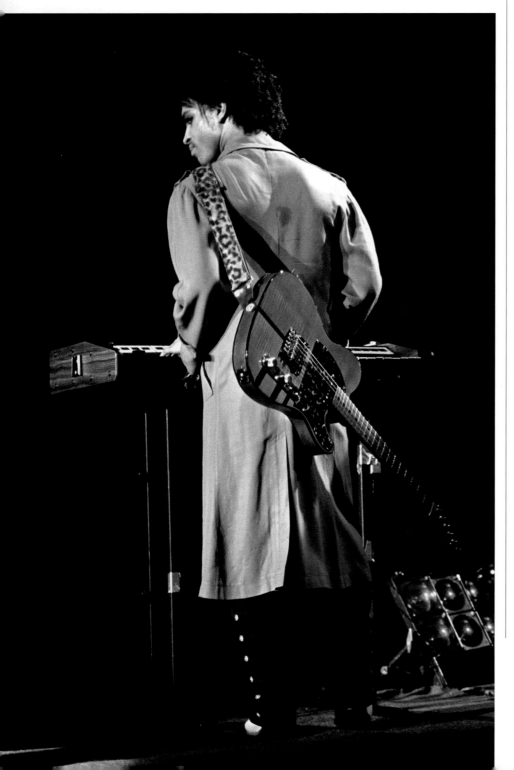

> "Music is like a newspaper to him, and his attitude is: what's the point of reading last week's paper?" ALAN LEEDS

the phone with Dez Dickerson – following pleas from Steve Fargnoli and even Mick Jagger – before Prince would change his mind. Dickerson suggested a few changes to the set that might make the show heavier (and thus more palatable), and appealed to Prince's sense of pride, telling him: "We can't let a few dirtballs run us out of town like this … we got to come back, and show them what we're made of."

Two days later, The Rolling Stones' fans turned up armed and ready for a fight, having heard about what happened on the first night. Fruit, vegetables, Jack Daniels, and even a bag of rotting chicken came flying through the air at the group. But Prince played on, completing a full set despite the hostile response, and gained a lot of ground with the LA press as a result.

Prince began a tour of his own a month later, on November 20, but even that wasn't without its own set of problems. His longest stint so far as a headliner, it was a huge success in terms of his previous tours. Deciding to make his shows more theatrical, he hired set designer Roy Bennett to build a stage with hydraulics, two tiers of stage, ramps at either side, a fireman's pole, and a set of blinding lights that shone through from the Venetian blinds used as a backdrop.

Prince's stage persona had evolved at a similar rate. He now wore a shirt and trousers beneath his purple trench coat and built long segments of audience participation into the set, in which he more or less acted out the words to 'Do Me, Baby' with the women in the audience. *Dirty Mind*'s 'Head' became the centerpiece of his shows, and found him sitting on top of the speakers, virtually masturbating his guitar to the climax of a ten-minute jam.

With a setlist that largely ignored his first two albums (save for the singles 'I Wanna Be Your Lover' and 'Why You Treat Me So Bad?'), the Controversy tour presented Prince as an ambassador for sexual freedom. For some audience members, however, it was all too cerebral, particularly by comparison to the short, snappy set by The Time that preceded Prince's arrival. Little did Prince realize that his protégés would soon be doing to him what he himself had done to Rick James a year or so earlier.

Tensions increased between the acts, with The Time fighting for more money and more respect. Even though they were bringing *his* music to life night after night, Prince refused to up their pay. Similarly, when he started work on The Time's second album in December, during a break between legs of the tour, he refused to give Morris Day and co any artistic control.

During the final show of the tour, on March 14 1982 at Cincinnati's Riverfront Coliseum, Prince and his entourage threw eggs at The Time while they played. Backstage, Prince's newly hired bodyguard, Chick Huntsberry, tied guitarist Jesse Johnson to a coat hanger so that Prince could throw more food at him. Management ordered that there was to be no interruption to the headliner's set, but as soon as Prince walked off stage a full-scale food-fight ensued, and carried on all the way back to the hotel. As ever, Prince seemed incapable of ending an album-tour cycle without there being some level of dissent within his camp. It was around this time too that Prince decided to scrap an entire film project called *The Second Coming* (named for his entrance music) after an argument with the director, Chuck Statler. Hours of footage shot on tour and at Prince's home went to waste, and Prince instead went back into the studio, where he would cut three more albums in five months.

What Time Is It?

THREE ALBUMS INTO HIS CAREER, PRINCE REALIZED TWO THINGS: FIRST THAT HE NEEDED TO CREATE MORE OF A BUZZ THAN HE COULD SIMPLY BY BEING 'PRINCE,' AND SECOND THAT HE HAD SO MANY IDEAS FOR SONGS AND PERSONAS THAT HE COULDN'T POSSIBLY USE THEM ALL HIMSELF.

Prince's own releases had to follow some of pattern: suddenly making an album of lightweight pop-funk would disrupt a carefully planned chain of events. The way to address this, he decided, was to create a 'ghost band' that would not only give Prince another outlet for his ideas but would also make it seem like he wasn't just out there on his own. The Minneapolis Sound, as it came to be known, had its roots in the club circuit that Prince played on with Grand Central and Champagne, but this time he was (theoretically) in control of the whole scene. Each of its bands would be characterized by the same funky rhythms, pop hooks, and new wave elements, and deploy the same instantly recognizable stripped-down production, but none would be better than Prince himself.

After convincing Morris Day to donate his song 'Partyup' to *Dirty Mind*, Prince promised to repay his old friend by making him the frontman of a new band. Unsurprisingly, given that he was still playing in local bands and working as a runner for Prince, Day jumped at the chance. The rest of the band, which was dubbed The Time, also came from Minneapolis. Bassist Terry Lewis, drummer Jellybean Johnson, and keyboardists Jimmy 'Jam' Harris and Monte Moir had all played together in Flyte Tyme, while guitarist Jessse Johnson had played in other local bands. (Before recruiting Day, Prince had courted another local singer, Alexander O'Neal, who later became hugely successful in his own right but wanted more than Prince was willing to pay him to be in The Time.) The crucial final addition to the line-up was dancer/valet Jerome Benton, who became Day's comic foil.

The Time's look was based around the retro-pimp fashions of two generations back: Stacy Adams shoes, bright suits, and long, thin ties. It was perfectly in keeping with the skinny, drainpipe suits of the emerging new wave bands of the era. Morris Day's image – that of a self-obsessed skirt-chaser, as seen in *Purple Rain* – had its origins in a pimp persona Prince used to mess around with, for which he put on an old man's 'hustler' voice. But while Day and his cohorts certainly looked the part, they weren't expecting any great success in their own right.

"We knew we weren't going to make any money," Jimmy Jam recalled. "Prince was very upfront: 'There's not going to be a lot of money in this.'"

Having assembled the band, Prince got to work on both his own *Controversy* and The Time's eponymous debut, while also running his new group through strict rehearsals until he was happy that they could work as a unit. As good as they got, The Time wouldn't be allowed to play a note on their debut album. Prince recorded all the music himself, crediting the production to a pseudonym, Jamie Starr, and to Morris Day (who was at least allowed to sing on the record, but had to follow Prince's guide vocals note-for-note).

The Time's infectious pop-funk was a lot less challenging than *Dirty Mind*, and a lot less weighty than what Prince was cooking up for *Controversy*. Its tightly written, simple songs soon found favor with the record-buying public, many of whom quickly guessed that this

The Time's frontman, Morris Day.

Jamie Starr character – who had also been credited as an engineer on *Dirty Mind* – was actually Prince himself.

Prince took The Time out with him on his Controversy tour in November 1981, but this excursion – as ever – was far from easy. While Prince's own live shows were becoming ever more lofty and conceptual, The Time quickly became a much tighter unit than Prince might have imagined. And like any good students, they made a point of trying to out-do their master on stage. The problem, of course, was that Prince didn't like being shown up.

What made things even more tense was Prince's refusal to acknowledge the fact that, although he was the mastermind behind the music, what brought The Time to life was the band itself, particularly the charisma between Morris Day and Jerome Benton. Well aware of their own

bunch of people, throwing eggs is not too cool." Things got even worse after The Time's set. Jesse Johnson found himself handcuffed to a wall-mounted coat rack in Prince's dressing room and subjected to further humiliation after the show. Prince of course demanded that no interruptions be made to his own performance, but as soon as he left the stage a food fight ensued. When the battle continued at the hotel, Prince made Morris Day pay for the damage caused, claiming that he had started the whole affair.

Such was Prince's work rate that, instead of having a cooling-off period after the Controversy tour, he went straight back to work not just on his own *1999* and a record by his other new side-project, Vanity 6, but also a second album for The Time, *What Time Is It?*. The same tensions quickly rose to the surface, as the band was once again given no creative control. The Time became further exasperated when, for the 1999 / Triple Threat tour, it was requested that they play behind a curtain as Vanity 6's backing band before playing an hour-long set of their own, with only a small pay increase to show for it.

"Back when we first started Prince would stand on the side of the stage. He'd crack up and he'd love it. Then he'd realize, 'Oh man, I've gotta go on stage now and follow these guys.'" JIMMY JAM

Not surprisingly The Time baulked at this offer, so Prince took to bullying them after they finished playing – which

worth, The Time began to ask for more money, but Prince wouldn't give it to them. The group began to boil with resentment – particularly Jesse Johnson, who Matt Fink later described as having "a major ego problem."

The bad blood between the two groups boiled over during the final Controversy show in Cincinnati, when during The Time's set Prince and some of his cronies egged their support act from off stage. "I thought it was kind of low," Morris Day later recalled. "I know it was meant in fun, but when you're trying to do your show in front of a

naturally served to create further tension between the two parties. To make matters worse, he then decided to drop the group from the line-up when the tour reached major cities such as New York and Los Angeles. As relationships continued to sour, former James Brown tour-manager Alan Leeds was brought in to keep the peace. But the problems didn't end there.

Frustrated at the lack of creative freedom afforded them, Jimmy Jam and Terry Lewis had begun to produce other groups without telling their boss. Midway through

The comic performances of Morris Day (left) and Jerome Benton gave The Time's live shows an extra dimension.

the second leg of the Triple Threat tour, the pair missed a show in San Antonio after finding themselves snowed in in Atlanta, where they had been recording The SOS Band. Jerome Benton had to mime playing the bass on stage while Prince played Lewis's parts off stage, and Lisa Coleman stood in for Jimmy Jam.

When the missing members returned, Prince fined them $3,000 each – an extortionate amount for musicians who already felt they were grossly underpaid. When the tour finished in April, he sacked them both, wholly undermining Morris Day's authority as The Time's supposed leader. "That was fucked up," Day recalled. "For me, it was like being the president, but having to answer to the CEO. I had a fair amount of control … but the bottom line was always his."

By the time shooting began on *Purple Rain*, Monte Moir had also quit the group. Replacements for him, Jam, and Lewis were all found in the shape of bassist Jerry Hubbard and keyboardists Mark Cardenez and Paul Peterson. But The Time didn't have much longer to run, as Morris Day made it clear that, as soon as *Purple Rain* was finished, so was he. Not only had Prince undermined his power within the band, he had also begun making it more obvious to the public that the Jamie Starr / Starr Company credits were actually pseudonyms.

"When people came to realize how big a role he played in some of these projects," Alan Leeds recalled, "they started to lose a little respect." By the time a third Time album – *Ice Cream Castle*, named for a Joni Mitchell lyric – was released, the group had ceased to exist, despite the fact that, ironically, they had been allowed to play their own instruments this time around. (Undeterred, Prince had already started to assemble a new group out of the wreckage: The Family.)

Jerome Benton stayed in the Prince camp for short while longer, joining an augmented line-up of The Revolution as a dancer. Having had a relatively small part in *Purple Rain*, he was promoted to the role of Prince's comedy foil, Tricky, in *Under The Cherry Moon*. Meanwhile Jesse Johnson struck out as a solo artist, as did Morris Day, who found success both with his 1985 debut, *Color Of Success*, and as an actor. Jimmy Jam and Terry Lewis went on to form Flyte Tyme Productions and create massive chart-busting hits in the 'Minneapolis sound' mould. They won a Grammy for their work on Janet Jackson's 1986 album *Control*, and subsequently worked with a wide range of R&B stars, including Gladys Knight, Luther Vandross, and Mariah Carey.

The original line-up of The Time reconvened for a fourth album, *Pandemonium*, which was recorded and released to tie in with Prince's third movie, *Graffiti Bridge*. The album project was originally called *Corporate World*, and was set to feature only Morris Day and Jerome Benton, but Warner Bros insisted that the original line-up be brought in if Prince wanted the company's backing for the movie. But even then, six years later, The Time still found themselves forced to stand in his shadow. The original idea, according to Jimmy Jam, was that *Graffiti Bridge* would tell the story of The Time in the same way that *Purple Rain* "had told Prince's story … [but] it turned into a Prince movie with a cameo by The Time."

That was almost it for The Time, although the group has been sporadically active in the years since. A new line-up, billed as Morris Day & The Time, began touring during the mid 90s, and made an appearance in Kevin Smith's 2001 movie *Jay And Silent Bob Strike Back*. The group also performed as part of Prince's 1999 New Years Eve show (actually recorded on December 17) and supported him on a handful of Musicology dates in 2004. The original line-up then reconvened in 2008 for a duet with Rihanna at the Grammy Awards, following it with a Prince-like run of shows in Las Vegas.

AFTER COMPLETING HIS CONTROVERSY TOUR, PRINCE GOT STRAIGHT TO WORK ON TWO SIDE PROJECTS: A SECOND ALBUM FOR THE TIME AND A DEBUT FOR VANITY 6. PRODUCTION ON BOTH WAS CREDITED TO JAMIE STARR, THE PSEUDONYM THAT PRINCE SEEMED DESPERATE TO DISTANCE HIMSELF FROM.

1999 (MARCH 1982–MAY 1983)

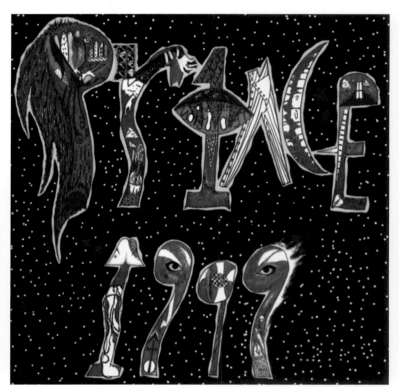

In his only interview of 1983, conducted with the *Los Angeles Times*, he was keen to get certain facts straight: "One, my real name is Prince. Two, I'm not gay. Three, I'm not Jamie Starr." (Only much later would he admit that he was "just getting tired of seeing my name. If you give away an idea, you still own that idea. In fact, giving it away strengthens it.")

Such was the confusion that, in Britain, *Melody Maker* even went so far as to call The Time and Vanity 6 plagiarists. Mining the same dancefloor-friendly funk and new wave sound as *The Time*, both *What Time Is It?* and *Vanity 6* helped Prince maintain his grip on the black market, while also allowing him to stretch out into ever-more experimental territory on his own next record.

Prince shut himself away like a mad scientist to work on his fifth album. Parts of it were recorded in his own 24-track basement studio (which he called Uptown), with the rest completed at Sunset Sound in Los Angeles with Peggy McCreary, an engineer who had also worked on *Controversy*. Prince seemed more obsessed with this new project than he had been with any before. He often pulled

24-hour stints in the studio, with McCreary forced to stay with him around the clock. With just the two of them in the room, there were regular flare-ups – particularly if there was any sort of hold-up. Prince would pace around waiting for tapes to be rewound for playback or for technical problems to be fixed. (As much as he had embraced new studio technology, it seemed that the machines often weren't fast enough to keep up with him.)

"I remember days when Prince would come into the studio at, like, 9am, kick you out of the room for about twenty minutes, then write a song," recalled Peter Doell, who worked sporadically as an engineer on *1999*, and later with Miles Davis. "Then he'd come back ... and you'd better have the drums tuned up and ready, because he's going to play the daylights out of the drums ... Then he'd go on and do the bass, keyboards, and by one o'clock you're mixing it, and by four o'clock you run off and have it mastered ... He was an unbelievable cottage industry."

As these long and often arduous sessions continued Prince began to push his new ideas further and further, building on his *Controversy* experiments and taking studio

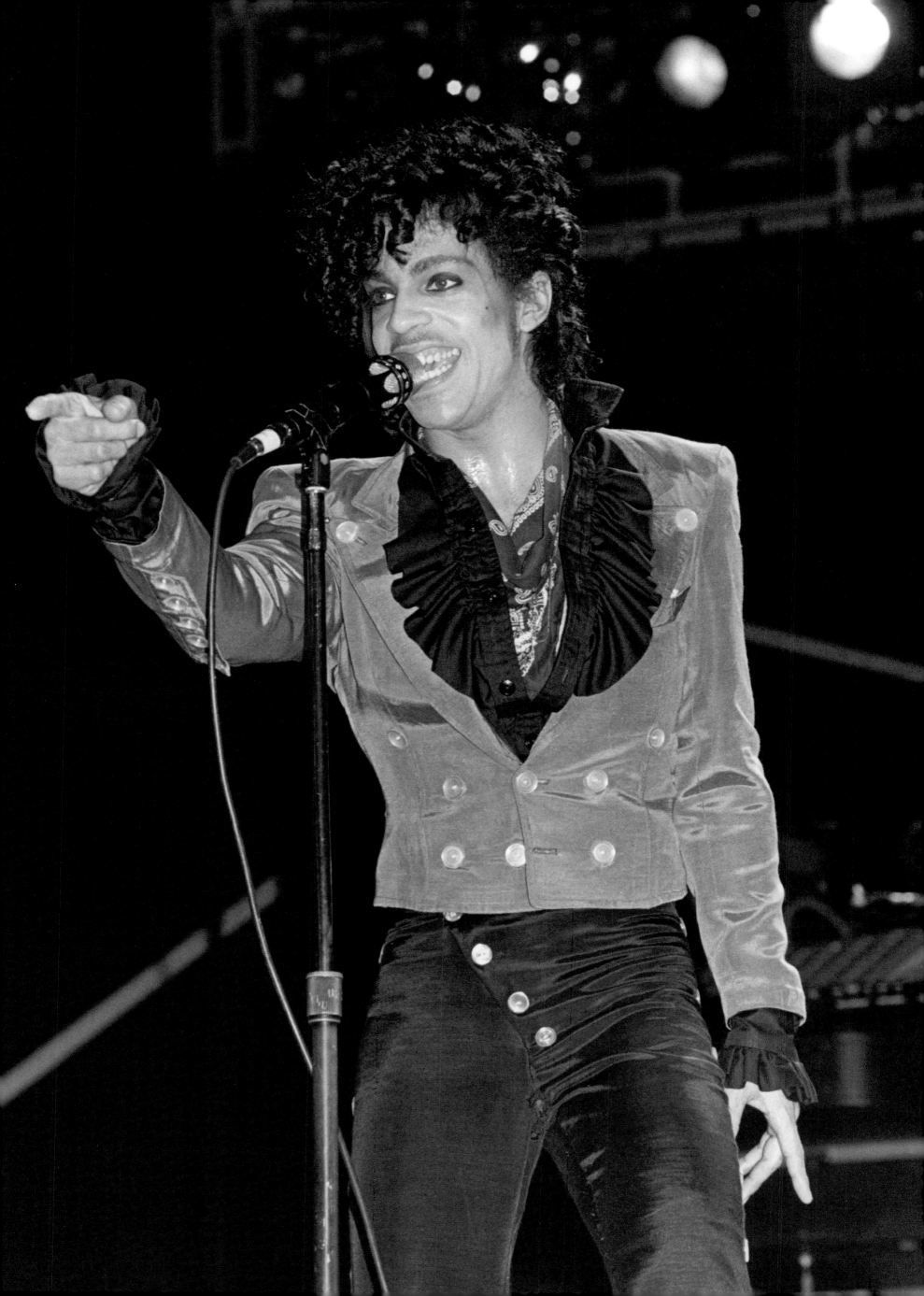

Nasty Girls: Vanity 6

After touring *Controversy* with one 'ghost band' in tow, Prince decided that he needed to create a second group to further increase the hype surrounding the Minneapolis scene – without letting on that it was all the work of one man. It would also give him an outlet for another aspect of his personality that didn't fit with his being Prince.

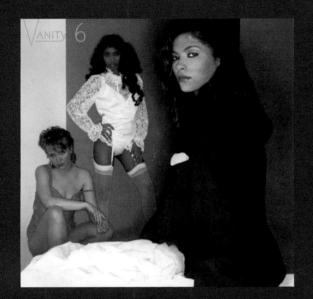

His initial plan was to create an all-girl group called The Hookers, comprising his girlfriend Susan Moonsie, set designer Roy Bennett's wife Brenda, and Cavallo, Ruffalo & Fargnoli employee Jamie Shoop. The group's image – lacy lingerie, stockings, and heels – was supposed to turn the wholesome 60s girl-group look on its head, presenting instead a group of predatory women out stalking bars and clubs looking for sex.

Things changed in the aftermath of the January 1982 American Music Awards, whereupon Prince met Denise Matthews, a lady of Hispanic descent who looked almost like his female counterpart. "Prince sent

"I first met Prince at a party. He sauntered over to me, smiled wickedly and said, 'Will you come to the bathroom with me? I want to try on your coat.' It turned out he had nothing on under his own leopard-skin coat." VANITY

someone over to talk to me," Matthews recalled. "He took my my number and gave it to Prince, who called me the next day. He came to pick me up that night in a white limo and we went out to dinner." Jamie Shoop was dropped in a flash and replaced

by Matthews, who became Vanity (having rejected Prince's original suggestion, which was to call her 'Vagina' – pronounced 'Vageena').

With the line-up of Vanity 6 – named for the number of breasts in the group – complete, Prince started recording a debut album for them, while also working on *What Time Is It?* and *1999*. *Vanity 6* was a moderately successful record full of lightweight pop tunes with titles such as 'Nasty Girl,' 'Wet Dream,' and 'He's So Dull,' and a general mood that veered closer to new wave than funk. The album presented the group as a vampish foil to The Time's gang-of-pimps image, while once again the production was credited to Jamie Starr in an attempt to make it look like another one of this mysterious tycoon's masterpieces.

At the same time as recruiting Matthews for Vanity 6, Prince began a stormy relationship with her. Matthews had left her Niagara Falls home at the age of 15 (following the death of her father and her mother's slip into alcoholism and depression) and set her sights on becoming rich and famous. Meeting Prince seven years later was exactly what she wanted. "He told me he was going to make me a star," Matthews recalled, "so I moved out to Minneapolis to live with him."

The relationship was fraught from the start, however. On a professional level, Matthews wasn't keen on Prince's instructions to "get out there, take off all your clothes, and run around naked," but at the same time she craved attention, and enjoyed putting on an aggressive front that hid the scars of abuse suffered at the hands of her father. Then there was the way Prince treated his girlfriends. During the Triple Threat tour, for which Vanity 6 served as the opening act, Prince continued his relationship with Susan Moonsie and started a third with another potential musical interest, Jill Jones.

"He juggled the affairs on a day-to-day basis," Alan Leeds recalled. "Some nights Vanity would disappear with Prince, then some nights Jill would appear on the Prince bus, leaving Vanity in the hotel." As Barney Hoskyns, who covered the tour for the *New Musical Express*, recalled: "Nobody seems to remark how peculiar it is that Vanity, supposedly enjoying pride of place between the little chap's sheets, actually kips on her own in a separate bus and scarcely exchanges a word with him throughout the days I'm on the tour."

In reality Prince – whose preference tends to be for more demure ladyfriends – quickly became weary of Vanity's attitude, particularly after she slipped into a cycle of drink and drug abuse as a way of dealing with the pressure of touring and Prince's refusal to be with her and her alone. ("I did [drugs] on the sly," she recalled, "but nobody tried to stop me.") Nonetheless Prince had her written into the *Purple Rain* script and began to work on a successor to *Vanity 6*. But then in August 1983, during pre-production of the movie, Matthews either quit or was sacked (possibly over a pay dispute). She was replaced by Patricia 'Apollonia' Kotero in the newly renamed Apollonia 6.

Matthews retained the name Vanity and recorded two solo albums, *Wild Animal* and *Skin On Skin*. She has also starred in a handful of movies. All the while her drink-and-drugs lifestyle continued to spiral out of control, to the extent that, when she started dating the notorious rock lunatic Nikki Sixx a few years later, his equally wild Mötley Crüe bandmate Tommy Lee was moved to remark: "There's something really crazy about Vanity." Describing their first meeting in his autobiography, Sixx himself recalled: "She opened the door naked with her eyes going around in her head. Somehow I had a feeling we might just hit it off."

By the time she reached her thirties, having smoked crack cocaine for years, Vanity found herself temporarily deaf and blind. She suffered kidney failure (having already lost one kidney), internal bleeding, and a stroke, and spent three days on a life support machine. After miraculously surviving this ordeal, Matthews renounced her Vanity days and became a born-again Christian. She now runs a ministry in Freemont, California.

trickery to the extreme, thereby keeping his peers and his listeners guessing for as long as he could. The Linn LM-1 drum machine became increasingly prominent. It had only featured on one song on *Controversy*, but can be heard all over *1999* in between layer upon layer of synthesizer. The combined effect is that of a cold, hard, mechanized take on Phil Spector's organic, eardrum-crashing Wall Of Sound. What Prince had over Spector, however, was that he could turn out hits for himself as well as for others.

By July Prince had completed a ten-track album, which he took to managers Bob Cavallo and Steve Fargnoli. But as much as they liked what he had done, they felt this new work needed a 'Controversy' or a 'Dirty Mind' – an opening track that could show in no uncertain terms what the rest of the record was about. "He yelled at us," Cavallo recalled, "and then he went back to Minneapolis and kept recording."

Prince recorded the song in question – which would give the new album its title, and end up becoming one of his signature works – in less than a day, between late-night rehearsals with The Time. As Jimmy Jam later recalled, Prince walked in one afternoon at around 2pm and played the assembled musicians his latest creation. "We're going, 'Hey! When did you do this?' 'I did this last night after I left.' Oh, man, it's not fair!"

Prince's defining statement of the era, '1999' touches on a theme that would continue to crop up in his work: that of partying to the end, in the face of a looming apocalypse. The previous album's 'Ronnie, Talk To Russia' voiced similar concerns, but its lyrics were too specific (and too naïve) to appeal to a wider, cross-generational audience. While '1999' has a similarly paranoid, fear-of-the-bomb theme, it isn't rooted in one spot. With one of Prince's catchiest and most danceable tunes beneath it, it remains – like Stevie Wonder's best work – as relevant today as it was in 1982 (and at the turn of the millennium).

"Mommy, why does everybody have a bomb?" Prince asks in a sped-up voice at the end of the song. Never has certain death sounded so inviting. Mimicking the call-and-response vocals of Sly & The Family Stone's 'Dance To The Music,' Prince has keyboardist Lisa Coleman sing the opening phrase, followed by Dez Dickerson, allowing the song to build before coming in himself on the third line. The opening is inspired and disorientating in equal measure, not just because of the switch between voices but also because of the melodic changes it goes through, which came as a result of the fact that Prince, Coleman, and Dickerson recorded their vocal parts together, only for Prince to split them up later on, meaning that some 'lead' parts had been planned as harmonies.

While promoting the wildly eclectic *Emancipation* set in 1997, Prince described *1999* as "nothing but me running the computers myself, which is why [it] isn't as varied." This might well be true, but *1999* remains one of his most successful and enduring works, not least because

of the way that he was able to refine and perfect the cluttered, anything-goes approach of *Controversy*. The lyrics, meanwhile, are deeper but more accessible. 'Little Red Corvette' might sound to begin with like a simple pop song about lost love, but lines about "a pocket full of horses, Trojan" carry a safe-sex message, Trojan being a popular brand of American prophylactic. (The fact that "some of them were used" adding a rather creepy undercurrent.)

Elsewhere, 'Free' is a gospel ballad with an unusually patriotic theme, given that it was written by a man with a reputation for being pop's most morally bankrupt sexual deviant; 'Delirious' is a much stronger take on the rockabilly pastiche of 'Jack U Off'; and 'Automatic' and 'Lady Cab Driver' show off a newfound sadistic streak. ('Lady Cab Driver' features a spoken-word passage in which Prince has sex with the driver in the back of her cab, with each thrust being dedicated to the likes of "the creator of man," "politicians who are bored and believe in war," or the question of "why I wasn't born like my brother, handsome

"The 1999 album was the seismic shift where all of the things that were attempted and all of the things that were pointed towards ... came together in this sort of perfect storm." DEZ DICKERSON

and tall.") The lyrics are also much more humorous than one might have expected of Prince. He teaches the perennially unfunky to dance on 'D.M.S.R.' – "All the white people, clap your hands on the four" – and whisks a lover away on "Prince International" during 'International Lover''s extended sex-as-flying metaphor.

Perhaps the most remarkable aspect of *1999* is the fact that it never feels overlong or self-indulgent, despite the fact that 'Lady Cab Driver' runs to nine-and-a-half minutes, and that half of the remaining ten tracks clock in at more than six. Taken as a whole, *1999* marks the point at which Prince had learnt to ride a groove for as long as he wanted, endlessly reworking it so as to prevent it from getting stale.

Once Prince had completed work on his most powerful album yet, Steve Fargnoli was given the job of taking it to Warner Bros and trying to convince the label to release it as double album for the price of a standard LP. Once again the Warner executives were being asked to stick their necks out for a relatively underground artist, having already let him produce his own debut and run off into ever-stranger territory on his subsequent releases. Now the label was being asked to release an album that was in serious danger of making a loss.

Fargnoli, however, had become Prince's greatest ally when it came to dealing with Warner Bros, and was able to

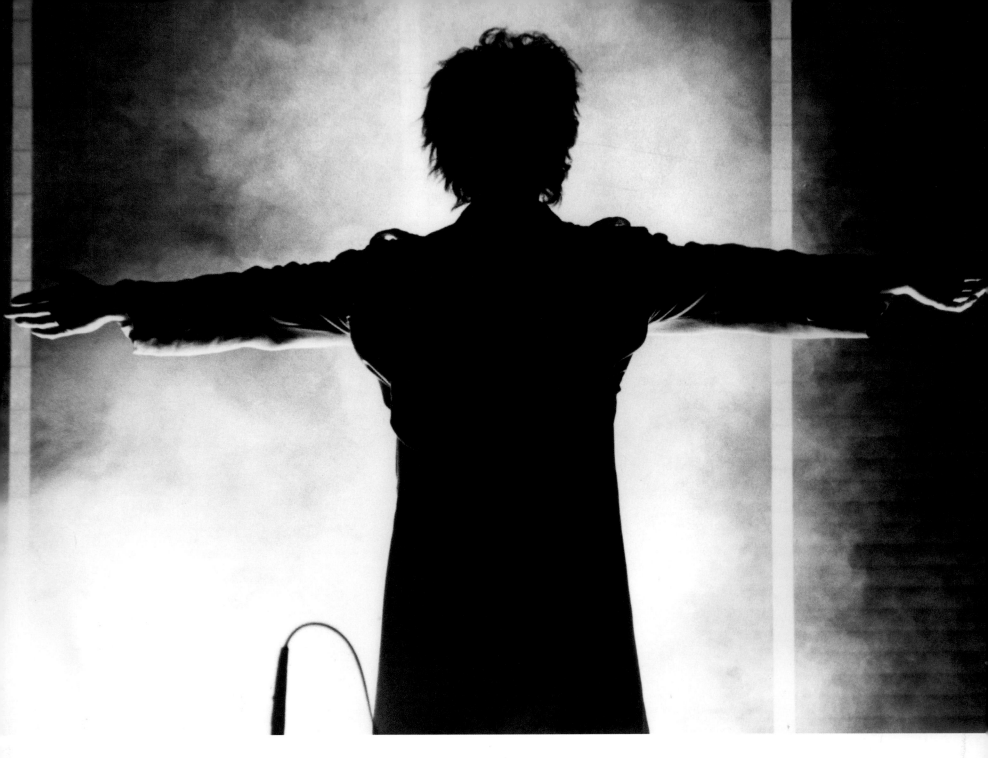

convince chief executive Mo Ostin that a double-album was the only way to go. (The label's European arm wasn't so easily convinced. It released *1999* as a seven-track single album to begin with, omitting some of the longer songs, before issuing the full-length version in 1983.)

As it was, Ostin and his cohorts needn't have worried. A few weeks after the album's release, *Rolling Stone* praised the diversity of *1999* and its creator. "[Prince] works like a colorblind technician who's studied Devo and Afrika Bambaataa & The Soulsonic Force," the magazine declared, "keeping the songs constantly kinetic with an inventive series of shocks and surprises." Even Miles Davis, in his autobiography, was moved to call *1999* "the most exciting music I was hearing in 1982" and Prince himself "someone who was doing something different," who he "decided to keep an eye on."

Even so, when the title track stalled at Number 44 on the *Billboard* Pop chart, it seemed like mainstream success might still prove elusive. Not everybody was impressed by Prince's 'Specially priced two record set,' either. The *New Musical Express* thought it was a prime example of the desperate moves a record company makes when "the only people who like you are the people who get their records free." As with *Dirty Mind*, however, there was something of a snowball effect. Prince's live shows were fast becoming unmissable, with newspapers such as the *Philadelphia*

Enquirer going out of their way to "unequivocally recommend [this] wonderful, provocative show."

The 1999 tour built on the Controversy setup. This time Prince presented his full army of talent to the world in the form of a Triple Threat line-up that saw Vanity 6 open and The Time play second on the bill, while his new Roy Bennett-designed stage set included a bed that came up through the floor so that he could reenact the lyrics to 'International Lover' each night. The musical arrangements were similarly ambitious. Bobby Z had his work cut out trying to figure out how to incorporate his own live drumming alongside electronic rhythms triggered by the Linn LM-1. "I felt like an auto-assembly worker looking at a robot for the first time, wondering if I still had a job," he recalled, adding that he got little in the way of guidance from his boss. "Prince said, 'Here it is, figure out what you're going to do with it.' The machine was on the record and I had to augment that and get it to work live."

As with the Controversy tour, the Triple Threat dates were marred by an air of antagonism between Prince and The Time. Feeling overworked and underpaid, the group took their frustrations out on stage, doing their best to outdo Prince each night. As guitarist Jesse Johnson recalled, "Some nights we'd knock on his dressing room door and say, 'We're gonna slaughter you!'"

A new source of frustration came when The Time were ordered to play behind a curtain while Vanity 6 gyrated in their lingerie for 40 minutes while singing the likes of 'Nasty Girl,' 'Drive Me Wild,' and 'Wet Dream.' Vanity wasn't in the best frame of mind either. Her relationship with Prince had begun in a rush of passion, but was slowly fizzling out. She and Prince were no longer 'exclusive,' as he could often be found shacked up with new backing-singer Jill Jones – yet another girl he promised to write an album for – or any other girl who took his fancy. Overwhelmed by sudden stardom and upset by Prince's casual approach to their relationship, she turned to drink and drugs to get through the tour.

Things got so bad for all concerned that midway through the tour Prince had to bring in Alan Leeds, who had previously served as James Brown's tour manager, to keep everything together. Leeds saved the day, despite initially finding himself having to communicate with Prince – like everyone else on the tour – via Chick Huntsberry. In the end Leeds became as close a confidante to Prince as had the bodyguard, but was still never quite sure when to be 'Alan the big brother,' 'Alan the best friend,' or 'Alan the gofer.' The key was knowing what Prince wanted when. "I'd better not confuse the three roles," Leeds recalled, "because if he sends me on a mission and I come into rehearsal empty-handed, and I start laughing and joking like we did in front of the TV last night, I'm not going to last very long."

Despite the internal turmoil within the Prince camp, everything seemed to be going from strength to strength on the outside. Perhaps the most crucial breakthrough came when '1999' began to appear on heavy rotation on MTV in December, just as the Triple Threat tour was taking off. The exposure was invaluable. Not only was Prince now being foisted onto television screens on a regular basis, he was also one of the first black acts to appear on the channel – a few months ahead of Michael Jackson's 'Beat It' – proving to Prince that his music could break down racial barriers.

Fortunately for Prince, this newfound exposure had coincided almost exactly with his decision to take more care over his music videos, which had up to now been rather mundane. The '1999' promo stuck to that same basic formula of filming a live performance of the song, but had enough fast edits – and enough shots of Lisa Coleman and Jill Jones in lingerie – to appeal to the MTV crowd.

Next came 'Little Red Corvette,' for which Prince even performed a brief but elaborate dance routine during Dickerson's guitar solo. The song itself saw Prince finally get to grips with a rock sound that wasn't generic (as his previous stabs at the genre had been). 'Corvette' even had a proper rock guitar-solo, edited together from three different takes played by Dez Dickerson, one of the few musicians to get such a spotlight on a Prince album during this phase of his career. It proved to be just the hit Prince needed, reaching Number Six on *Billboard*'s Pop chart right in time for the launch of the second leg of the tour. (Interestingly, the single stalled at Number 15 on the R&B chart.)

The MTV exposure led to even greater interest in the Prince live experience, which in turn boosted his crossover appeal as a bona fide hitmaker. The *1999* LP soon broke into the US Top Ten and ended up selling three million copies within in a year. By the time the year for which it was named arrived, the album had gone Platinum four times over.

But while the final stages of the 1999 tour should have been one big party, things weren't quite so simple. Prince had irreparably damaged his relationship with The Time, and pushed Vanity into a world of drink, drugs, and depression, making her unreliable and irritating to be around. He was also going to have to find a replacement for Dez Dickerson, who like former bandmate Gayle Chapman had found God and had begun to feel rather conflicted about his role in Prince's band. "I knew I didn't have it in me to continue – spiritually, emotionally, creatively, mentally," he later recalled. Prince let Dickerson go, but continued to support his former sideman. He had Cavallo, Ruffalo & Fargnoli take over Dickerson's affairs, offered to help write and record his solo project, and gave his band, The Modernaires, a showcase spot in *Purple Rain*.

Dickerson had long since wanted to work on his own material, so his departure from the band didn't come as a surprise. Prince had a ready-made replacement to hand in the form of 19-year-old Wendy Melvoin, a friend of Lisa Coleman who had been traveling with her in the tour bus and who would occasionally jam with the band during soundchecks or rehearsals if Dickerson wasn't around. Melvoin was a simple, handy replacement – just the sort of musician Prince needed to capitalize on his newfound commercial appeal. And she had a twin sister, too.

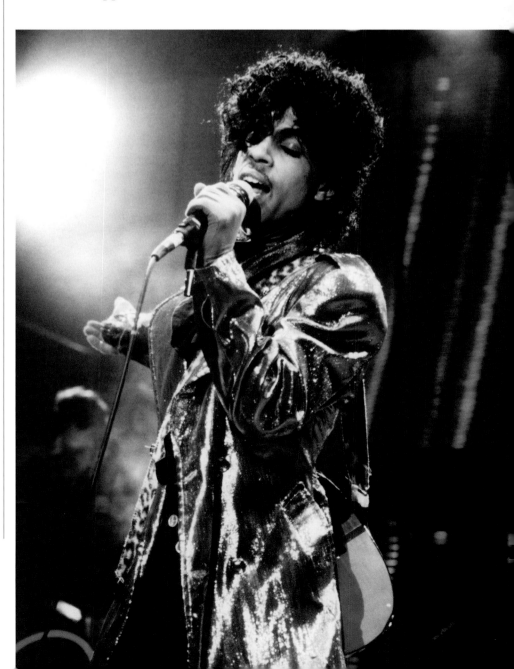

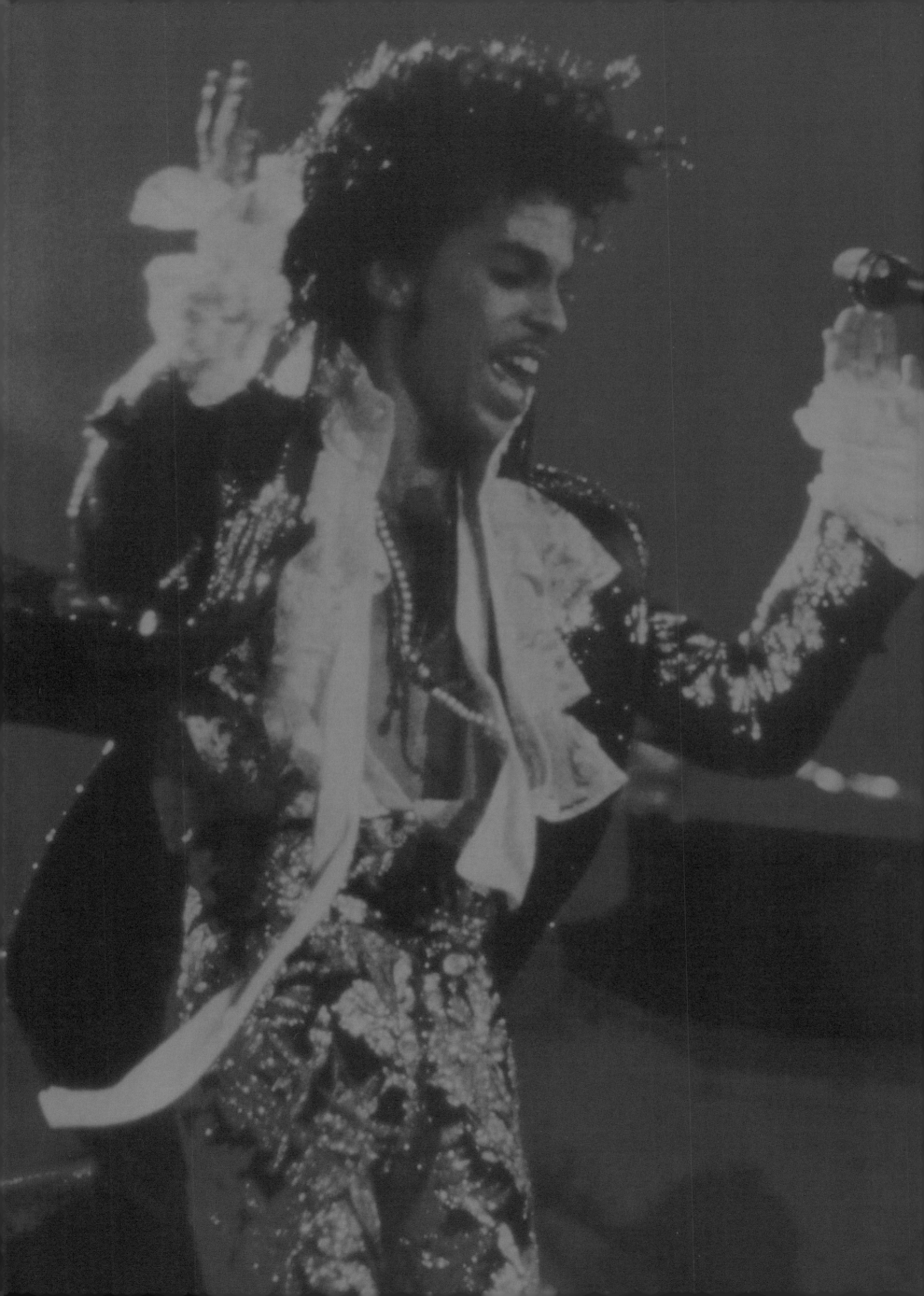

2

WITH THE CROSSOVER SUCCESS OF '1999'
FINALLY LAUNCHING HIM INTO THE
MAINSTREAM, THE STAGE WAS SET FOR
PRINCE TO BECOME AMERICA'S MOST
TALKED-ABOUT ARTIST. THE *PURPLE RAIN*
MOVIE AND SOUNDTRACK MADE HIM A
GLOBAL STAR AND GAVE HIM THE FREEDOM
TO CHASE HIS ARTISTIC MUSE AS FAR AS HE
WANTED, CEMENTING HIS STATUS AS ONE OF
THE DECADE'S MOST INVENTIVE MUSICIANS.

PURPLE REIGN
1983–1989

AT THE START OF 1983, 'LITTLE RED CORVETTE' AND *1999* WERE IN THE PROCESS OF TURNING PRINCE INTO A MINOR CROSSOVER STAR IN AMERICA. THE 'LITTLE RED CORVETTE' VIDEO – ONE OF THE FIRST BY A BLACK ARTIST TO BE SHOWN ON MTV – MADE HIM AN INSTANT SMALL-SCREEN ICON. BUT FEW WOULD HAVE GUESSED THAT, IN JUST OVER A YEAR, PRINCE WOULD BECOME A BIG-SCREEN LEGEND, TOO, NOT TO MENTION A GLOBAL POP PHENOMENON.

Purple Rain (FEBRUARY 1983–APRIL 1985)

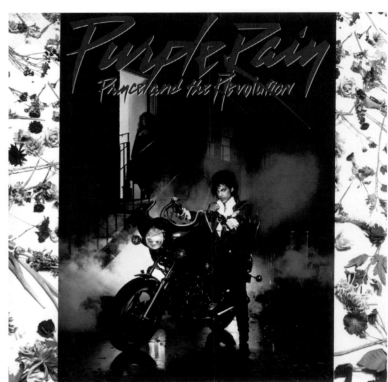

By the end of 1984 Prince had become the first act since The Beatles to simultaneously top the US charts with a single ('When Doves Cry'), album, and movie (both *Purple Rain*). He had also found time to write hit albums for The Time (*Ice Cream Castle*), Apollonia 6 (*Apollonia 6*), and Sheila E. (*The Glamorous Life*), and a hit single for Sheena Easton ('Sugar Walls,' a thinly veiled exploration of her internal anatomy), while Chaka Kahn resurrected his 1979 track 'I Feel For You' and put it back into the charts.

But back in 1983 he was still, as Jimmy Jam put it, "at the point where he wasn't yet a superstar, but was right at the point of doing it." What Jam and everybody else wondered was: "What's your next move gonna be?" As it turned out, Prince's next move was to do what David Bowie did with *Ziggy Stardust*, and write himself into fame.

Prince was (and is) an avid movie fanatic, so it's no surprise that he had long courted the idea of making a motion picture of his own. The man who stamped his dominance over the recording process with the words "Produced, arranged, composed, and performed by Prince"

would naturally have wanted to exert a similar authority over the other main avenue of popular entertainment. He would also have noticed how Sylvester Stallone made himself into a superstar with *Rocky* in 1976. Six years later, when Prince first began to consider making a movie, the *Rocky* franchise was into its third installment.

According to drummer Bobby Z, "Prince was fascinated with the camera," and had already started taping rehearsals and concerts and filming short skits. He had begun to come up with the basic concept for *Purple Rain* as far back as the *Dirty Mind* period. During his Controversy tour of 1982, Prince had started to film his shows for something called *The Second Coming*, which would intersperse concert footage with dramatic elements. In the end the project was scrapped, but much the same concept reappeared for the *Sign "O" The Times* concert movie a few years later.

By the time the second leg of the Triple Threat tour in support of *1999* began in February 1983 Prince had taken to carrying around a purple notebook in which he wrote down ideas for the semi-autobiographical movie that was

beginning to form in his mind: *Purple Rain*. He wasn't yet a superstar, but did have some leverage. He had told his managers at Cavallo, Ruffalo & Fargnoli that if they wanted to hold onto him beyond the imminent expiration of his contract they had better get him a movie deal with Warner Bros. "I want to star in the movie," he told Bob Cavallo. "I want my name above the title and I want it to be at a major studio."

Unfortunately for Cavallo, Warner Bros Pictures wasn't particularly keen on the idea of pumping heaps of money into the pipe-dream project of a mid-level singer with only a handful of hits to his name. If he wasn't able to carry on making hit records, the company reasoned, he wouldn't be able to attract the sort of crowds a major motion picture needs to make its money back.

"There was no precedent for this," tour manager Alan Leeds recalled. "Rock'n'roll stars with a couple of hit albums did not make major movies. Let alone somebody from the black community having the gumption to do it in the mainstream." Before it was to agree to such a deal, Warner Bros needed proof that Prince was the star that the movie was supposed to turn him into.

Thankfully Prince still had the full backing of the head of Warner Bros' music division, Mo Ostin. Although no distribution deal had been secured, Ostin put up four million dollars of the label's money to get the ball rolling. Having been given at least something of a green light, Cavallo and his colleagues went out in search of a screenwriter. They soon found 46-year-old William Blinn, who had won an Emmy award for his work on the *Roots* television show and was an executive producer of *Fame*, which had just completed its second series. By the time Blinn was introduced to Prince, the movie concept had formed into something that centered on the incestuous Minneapolis music scene and recalled Prince's early struggle for success in bands such as Champagne.

Blinn found Prince less than willing to communicate at first, making his attempts at writing a treatment (for what was then known as *Dreams*) rather difficult. "Casual conversation is not what he's good at," Blinn later said. "He's an enigma. He wants to communicate but he doesn't want you to get too close." After gathering together "12 to 14 pages" of ideas Blinn flew out to Minneapolis to watch the March 15 Triple Threat show. Later that night he went to Prince's house, where it became clear to Blinn that the singer was on "an honest quest to figure himself out. He saved all the money on shrinks and put it in the movie."

But he very nearly didn't get the chance. After the Triple Threat tour came to an end in May Blinn moved out to Minneapolis to start work on the project, only for Prince to start canceling meetings or walking out of them. Blinn came close to withdrawing from the project altogether when the singer left a meeting at a cinema after 20 minutes. "You've got a rock'n'roll crazy on your hands," Blinn told Steve Fargnoli. "I know he's very gifted, but frankly, life's too short." And with that Blinn got on a plane back to Los Angeles.

Whether or not Prince realized that he was to blame for Blinn's departure or simply didn't want to see his dreams crumble is unclear, but the singer quickly called his screenwriter to apologize for his behavior (which he blamed on stress). Blinn returned to Minneapolis to give the project another chance, at which point Prince played him some of the songs he had already written for the movie on his car stereo. "Behind the strange combination of shyness and creativity," Blinn realized, "he is very, very bright, quite gifted, and quite professional … not always what you find in the rock world." *Dreams* was finally becoming a reality.

While Blinn worked on the script Prince carried on

"It was about creating a reality that people would respond to." ALBERT MAGNOLI

writing new songs and rehearsing them with a new line-up of The Revolution. Wendy Melvoin came in in place of Dez Dickerson, who had left to pursue his own music career after informing Prince that he was no longer happy with the theatrical direction the music seemed to be heading in.

Another new addition was Alan Leeds. Having joined the Prince entourage as manager of the Triple Threat tour, Leeds was given the job of overseeing the various projects Prince was currently involved in, which now included

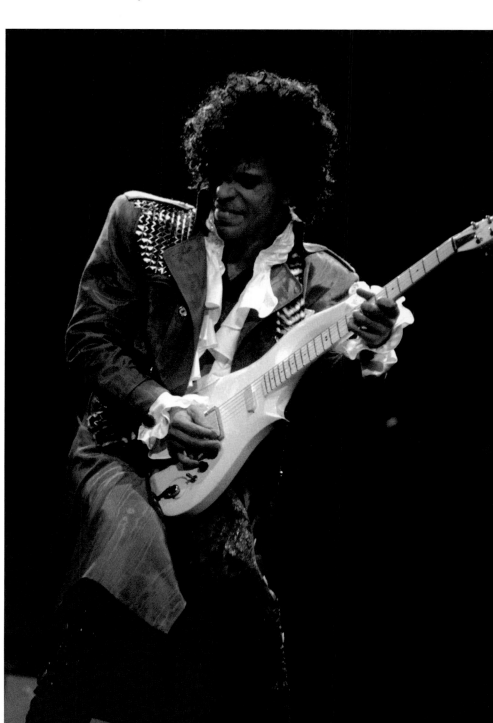

much more than just writing and recording music. Prince & The Revolution, The Time, and Vanity 6 were all busy rehearsing in a warehouse in St Louis Park, Minneapolis. They also took acting classes three days per week for three months under the tuition of drama coach Don Amendolins.

Although each musician's movie role would essentially be an extension of his or her own personality, some seemed more cut out for acting than others. Morris Day, Amendolins noted, had "natural abilities" that the others lacked; Vanity was "lazy"; and Prince was "very, very good. He'd flip right out of his persona and be whatever character he had to be." Perhaps surprisingly, he also seemed to take direction better than the rest. An even tougher job fell to choreographer John Command, who had the job of condensing years of dancing training into a few short months.

Everything seemed to be on the up. Prince debuted the now formally named Revolution at Minneapolis's First Avenue, the club that would become the focal point of *Purple Rain*, on August 3 during a benefit concert for the Minneapolis Dance Theater Company, raising $23,000. The show itself was a resounding success, and recordings of it

"*The most interesting thing about Purple Rain to me was the timeliness of it. It actually captured a musical revolution as it was happening.*" JIMMY JAM

made with a mobile truck provided no-fuss backing tracks for 'I Would Die 4 U,' 'Baby I'm A Star,' and 'Purple Rain.' Elsewhere however things had begun to fall apart.

When William Blinn's *Fame* television show was picked up for a third season he decided to quit work on what was now called *Purple Rain*, leaving Minneapolis for good after handing in his first draft on May 23. It took Cavallo, Ruffalo & Fargnoli until September – just two months before shooting was due to commence – before they found a new writer-director. The man in question was Albert Magnoli, who came on the recommendation of director James Foley, but whose previous experience as a director was limited to a 1979 short entitled *Jazz*.

Although Magnoli wasn't interested in rewriting Blinn's script, he had an auspicious first meeting with Prince's management team. "Cavallo asked me what kind of story it would be if I was to make a film with Prince," he recalled. "I just started telling him a story off the top of my head, and in that ten minutes I had outlined the concept of *Purple Rain*." Even more promising was Prince's initial reaction to Magnoli. "We sat down," Magnoli continued, "I pitched him the concept, and the first words out of his mouth were: 'You've only known me for ten minutes, yet you tell me basically my story. How is that possible?'"

Magnoli's arrival might have helped, but the project still refused to run smoothly. Prince's current side-projects,

The Time and Vanity 6, were supposed to be playing his rivals in *Purple Rain*, but as both groups were essentially Prince puppets they were becoming reluctant to cooperate. In April Prince had fired the two main musical talents in The Time, Jimmy Jam and Terry Lewis, after they missed a Triple Threat show because they were stranded in Los Angeles following a recording session with The SOS Band. (Prince was also upset generally that they had begun to produce other artists.) Keyboardist Monte Moir left The Time of his own accord after the sacking, leaving only singer Morris Day – and even he seemed ready to quit as soon as *Purple Rain* was finished.

At least Day was still around to lead a new line-up of the band, for which Prince recruited bassist Jerry Hubbard and keyboardists Paul Peterson and Mark Cardenez. That was more than could be said for Vanity. Depressed about the relationships Prince continued to have with other women, she became addicted to drink and drugs and embarked on affairs of her own. "She was a competitive pistol," according to Alan Leeds, and "wasn't about to let Prince's desire for control sentence her to the confines of her room." Depending on who you believe she was either fired or quit at the end of August, leaving Prince only a few weeks to find somebody else to learn the script and sing to the music he had written for the second Vanity 6 album.

After auditioning close to 1,000 women in Los Angeles and New York, Prince settled on 22-year-old Patricia Kotero. She was practically the mirror image of Vanity, proving that in Prince's world, no one was indispensable. According to Magnoli, she was also "very sweet and tremendously accessible," which to Prince no doubt meant that she was malleable enough to fit the role. She might not have been as talented as Vanity, but certainly had the right look. Prince had little option at this stage but to forge ahead.

Purple Rain began shooting on November 1 1983, which gave the cast a few weeks to try to complete all of the outdoor scenes before the bitter cold of a Minneapolis winter crept in at the end of the month. Not all of them were finished in time, however, so some of the cast and crew were flown out to Los Angeles as indoor shooting continued in Minneapolis. Mo Ostin's four million dollars were beginning to run out, leaving the whole team in desperate need of major financial backing if the project was going to be seen through to the end.

Bob Cavallo and Steve Fargnoli went back to Warner Bros Pictures and this time were able to convince the company of the movie's worth – just as cast and crew were celebrating at the movie's wrap party in Minneapolis at Bloomington's Holiday Inn on December 22. Although a few scenes had to be re-shot in Los Angeles on December 27, post-production on *Purple Rain* could now begin in preparation for the movie's theatrical release.

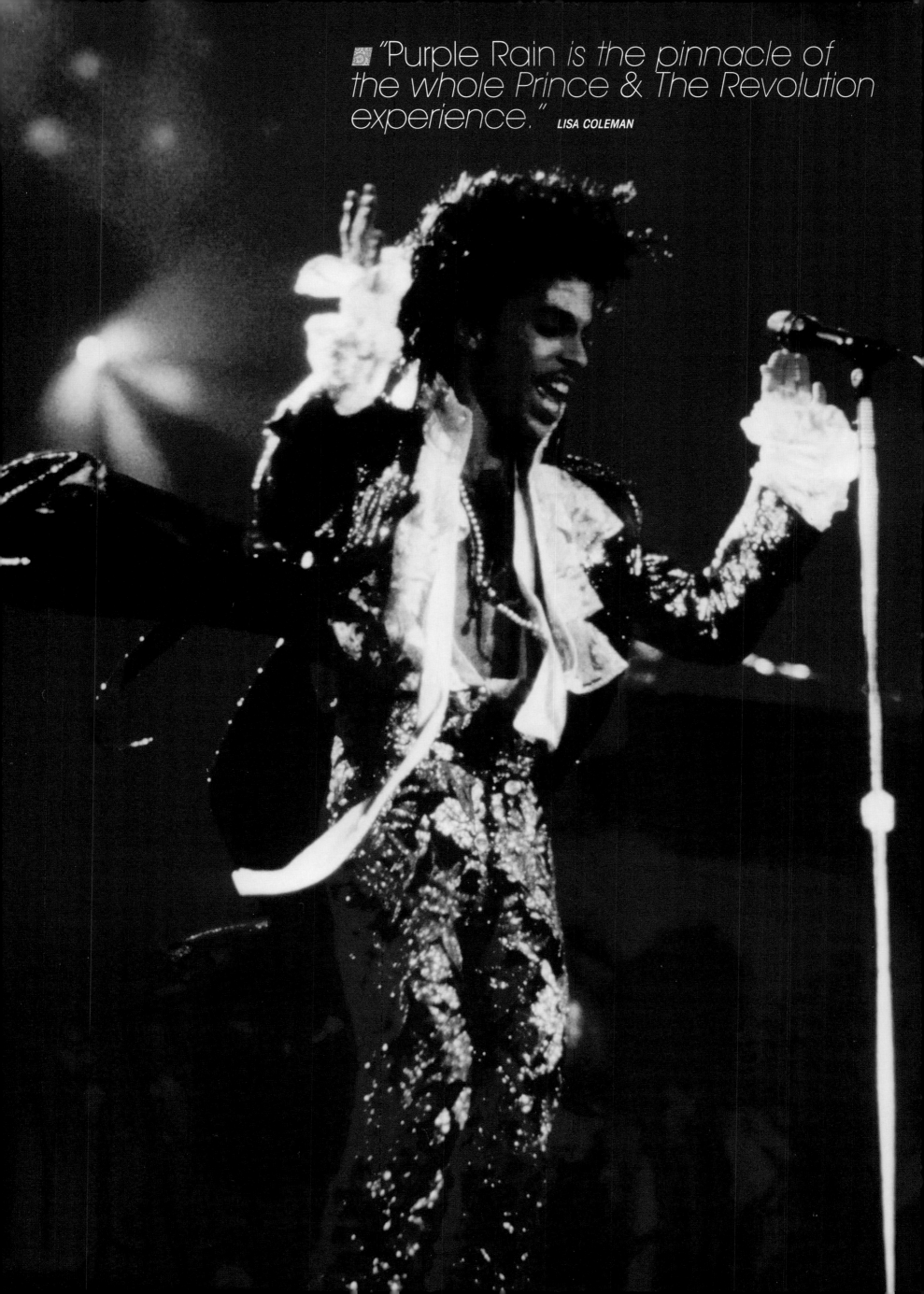

"*Purple Rain is the pinnacle of
the whole Prince & The Revolution
experience.*" LISA COLEMAN

A perfectly orchestrated promotional campaign meant that when *Purple Rain* opened on July 27 1984 it brought in $7.3 million in just three days. It went on to make around $70 million in total, which was reportedly more than ten times the cost of production. According to Albert Magnoli, the movie's excellent opening weekend meant that its distribution needed to be stepped up several gears. Having initially planned to show the film in 200 theaters, Warner Bros now decided to present it on over 900 screens across the USA. Following the word-of-mouth success of the Controversy and Triple Threat tours and the May 1984 single 'When Doves Cry,' the release of the *Purple Rain* soundtrack album raised anticipation for the new movie to fever pitch. The summer of 1984 was set to be Prince's season. Anyone who hadn't yet seen him live clamored to get a look at Prince in action; those who already had were eager to relive the excitement.

In the two decades since its release, the *Purple Rain* movie has become dated on a number of levels. That it helped the define the 80s is without question, but in so perfectly capturing the zeitgeist it also now exemplifies so many of the decade's worst cliches. There's the big hair; the new romantic clothes; the obligatory topless-woman scene, in which the hapless Apollonia is asked if she wants to "purify" herself in Lake Minnetonka; and an awkward scene in which Jerome Benton throws a stereotypically loudmouthed ex-lover of Morris Day's into a dumpster. (When challenged by MTV about the movie's alleged sexism, Prince admitted that "sometimes, for the sake of humor, we may have gone overboard.") Even the editing techniques that once helped tie the visual experience of *Purple Rain* to the fast pace of MTV aren't quite as dazzling as they once were.

As an insight into Prince's psyche, however, *Purple Rain* is indispensable. The Battle Of The Bands trials surrounding rival acts The Revolution, The Time and Apollonia 6 are based on Prince's early days as a struggling musician in Minneapolis, during which time he played in Champagne on the same club circuit as Flyte Time. The scenes work not just as dramatic construct but also as a tribute to Prince's hometown and the people who helped him in his early days.

Most of the characters and musical acts in the film – The Revolution, The Time, Apollonia 6, and even First Avenue club owner Billy Sparks – use their real names, and are essentially extensions of themselves. Prince, however, plays The Kid, a semi-autobiographical construction with an almost magical air. He seems to have the ability to appear and disappear at will, whether on the side streets on his purple motorcycle or in scenes such as the one in which he seems to vanish when Apollonia turns to compliment him on a performance.

In 1996 Prince told Oprah Winfrey that the most autobiographical part of the film was "probably the scene with me looking at my mother, crying." Although Albert Magnoli later suggested that the part where The Kid's father warns him never to get married was based on something Prince once told him, the singer himself seemed adamant, in a 1985 interview with *Rolling Stone*,

that "[the] stuff about my dad was part of Al Magnoli's story. We used parts of my past and present to make the story pop more, but it was a *story*."

Even so, the career of the father in *Purple Rain* – an abusive failed musician named Francis L – seems to echo that of Prince's real father, John L Nelson. Prince has never spoken about exactly what went on behind closed doors in his family. But given that his parents divorced when he was young, and that he then became estranged from his father for lengthy periods (and even made overt references to child abuse on record), it would seem that his was not a particularly happy childhood. That the specter of physical abuse lingers in The Kid's relationship with Apollonia – and that he even envisions his own suicide after his father attempts to take his own life – suggests that Prince was playing out something of an Oedipal nightmare on the big screen.

The *New York Post* review of *Purple Rain* noted that, in The Kid's world, "women are there to be worshipped, beaten, or humiliated." Most other reviews of the movie, however, were content simply to revel in the "affirmation of [Prince's] versatility and substance" (*Miami Herald*), his "taste for androgynous appeal" (*Philadelphia Daily News*); or the fact that the movie "reeks of unadorned " (*Detroit Free Press*). Perhaps the lack of armchair psychology in these reviews is a reflection of the two-dimensional nature of the movie, in which Wendy and Lisa are simply the girls of The Revolution; Morris Day, a "full-fledged young comedian" in the eyes of noted critic Pauline Kael – relaxes into a pimp persona; and Apollonia serves as the eye candy.

Albert Magnoli might have tried hard to invest some feeling and motivation into the characters, but what audiences tend to remember about the movie are the performances. *Purple Rain* might not have aged all too well, but the musical segments remain as incredible as they ever were, particularly Prince's, which wring every drop of emotion out of a character that, elsewhere in the movie, seems moody, inarticulate, and self-obsessed.

One interesting aspect of *Purple Rain* is that, although Prince's parents were both black, The Kid's mother is played by Greek actress Olga Kartalos (one of only two professional actors in the movie, the other being Clarence Williams III, who played Francis L). This was in part another example of Prince's efforts to blur the truth of the story, but it might also say something about the light-skinned singer's attempts to appeal to a mixed mass audience. Having tasted mainstream success already with 'Little Red Corvette,' Prince was keen to follow up with something simple and bombastic and cross right right over – just like Bob Seger, whom Prince kept crossing paths with on his 1999 tour. And so Prince wrote 'Purple Rain,' a guitar-led anthem that builds from a simple chordal opening to a huge crescendo with strings, almost five minutes of guitar soloing, and Prince's most impassioned vocal performance to date. The song became an instant lighters-in-the-air classic and helped the accompanying album sell 13 million copies in the USA alone.

The *Purple Rain* soundtrack album still stands as

1983

Mid-May: Prince & The Revolution, The Time, and Vanity 6 begin rehearsals and acting classes in a warehouse in St Louis Park, Minneapolis.

May 16: Wins in six categories at the annual Minnesota Music Awards.

May 23: William Blinn completes first draft of *Dreams*, but leaves the project to work on the third season of the *Fame* TV show.

June 6: *The Wild Heart* by Stevie Nicks released. Prince plays keyboards on 'Stand Back.'

June 29: Voted Musician Of The Year at the second annual Black Music Awards.

August: Denise Matthews, aka Vanity, quits – or is asked to leave – the *Purple Rain* project.

August 3: Prince & The Revolution make their official debut at the First Avenue club in Minneapolis as part of a benefit for the Minnesota Dance Theater. Recordings of three songs from the show will be used on *Purple Rain*.

August 15: Recording sessions for *Purple Rain* begin at Sunset Sound studios, Los Angeles, continuing until September 21.

August 17: 'Delirious'/'Horny Toad' released; reaches Number Eight on *Billboard*.

September: Patricia Kotero – aka Apollonia – is hired to replace Vanity.

September 15: Albert Magnoli starts work on a new *Purple Rain* script.

October: New versions of 'Let's Go Crazy' and 'Computer Blue' are among the songs recorded in the rehearsal warehouse in St Louis Park, Minneapolis.

November 1: Shooting of *Purple Rain* begins in Minneapolis.

November 23: 'Let's Pretend We're Married'/'Irresistible Bitch' is released, but fails to match the success of Prince's other recent singles, stalling at Number 52.

December 22: Principal shooting of *Purple Rain* completed. While the wrap party takes place, Cavallo, Ruffalo & Fargnoli convince Warner Bros to finance the movie's distribution.

December 27: Extra scenes shot for *Purple Rain* in Los Angeles.

1984

January–April: Spends the first few months of the year at Sunset Sound working on The Time's *Ice Cream Castle* and *Apollonia 6*, as well as songs for *Around The World In A Day* and Sheila E.'s *The Glamorous Life*.

May 16: 'When Doves Cry'/'17 Days' released; goes on to become Prince's first US Number One, and biggest UK hit to date (Number Four).

June: Forms The Family with the surviving members of The Time and girlfriend Susannah Melvoin and begins work on an album with them.

June 4: *The Glamorous Life* by Sheila E. released; Number Seven R&B, Number 28 Pop.

June 25: *Purple Rain* released.

July–August: Work continues on The Family's album in Minneapolis. Prince meets Alan Leeds's saxophonist brother Eric Leeds, who plays on the album and joins the live incarnation of The Revolution. Meanwhile, engineer David Rivkin asks string arranger Clare Fischer to work on some Family songs. He will go on to work with Prince throughout his career, but the two will never meet.

July 4: *Ice Cream Castle* by The Time released; reached Number 24 on the Pop chart and Number Three on the R&B chart.

July 18: 'Let's Go Crazy'/'Erotic City' released, on its way to becoming Prince's second US Number One hit.

July 26: *Purple Rain* receives its premiere at Grauman's Chinese Theater, Hollywood.

July 27: *Purple Rain* opens in theaters across the USA.

August 4: *Purple Rain* takes over from Bruce Springsteen's *Born In The USA* at Number One on the *Billboard* 200. It will remain there for 24 weeks.

September 7: *A Private Heaven* by Sheena Easton released, featuring the Prince composition 'Sugar Walls.'

September 26: 'Purple Rain'/'God' released; peaks at Number Two in the USA and Number Eight in Britain.

October: Rehearsals commence for the Purple Rain tour in Minneapolis. During this time Prince records 'Condition Of The Heart' for *Around The World In A Day*, finishes The Family's album, and records a longer version of 'I Would Die 4 U.'

October 1: Apollonia 6's Prince-penned eponymous debut is released; Number 24 R&B, Number 62 Pop.

November 4: The Purple Rain tour begins at Detroit's Joe Louis Arena, with support from Sheila E.

November 28: 'I Would Die 4 U'/'Another Lonely Christmas' released; peaks at Number Eight on *Billboard*.

December: Work begins on Sheila E.'s second album, *Romance 1600*. While touring, Prince continues to record songs for his own *Around The World In A Day* in studios across America.

1985

January–February: Continues to work on *Romance 1600* and *Around The World In A Day*.

January 28: Wins in three categories at the American Music Awards, but declines to participate in the post-awards studio session for 'We Are The World.'

February 2: Records '4 The Tears In Your Eyes' for the *We Are The World* album in a mobile recording truck in New Orleans.

February 9: *Purple Rain* is finally knocked off the top of the *Billboard* album chart by Madonna's *Like A Virgin*.

February 19: Wins in two categories at the British Phonograph Industry Awards in London.

February 21: *Around The World In A Day* is given its first airing at Warner Bros' Los Angeles headquarters.

March 25: Wins an Academy Award for Best Original Song Score for 'Purple Rain.'

April 2: Cavallo, Ruffalo & Fargnoli announce that Prince will

> "We didn't want him to make that *Under The Cherry Moon*: a black-and-white movie, which wasn't musical, in which he died at the end, in the south of France." BOB CAVALLO

retire from live performance after the end of the Purple Rain tour, which ends on April 7 at the Orange Bowl, Miami.

April: New version of '4 The Tears In Your Eyes' recorded at Los Angeles' SIR Studios. Later included on *The Hits/The B-Sides*. Elsewhere, the previously unknown scriptwriter Becky Johnston begins work on *Under The Cherry Moon*.

April 12: *We Are The World* charity album released, featuring the Prince composition '4 The Tears In Your Eyes.'

April 17: Work begins on *Parade* at Sunset Sound Studios, Los Angeles. Sessions continue until May 17. Prince also films the 'Raspberry Beret' promo video during his stay in LA.

April 22: *Around The World In A Day* released; reaches Number One in the USA and Number Five in the UK.

May: Only a few weeks after the release of one new album, Prince completes work on the first version of another one, *Parade*. Rehearsals begin in a new warehouse building on Washington Avenue, Minneapolis, Prince's old base in St Louis Park having been torn down to make way for a recording complex.

May 7: *The National Enquirer* publishes an exposé, based on revelations by former bodyguard Chick Huntsberry, entitled 'The Real Prince: He's Trapped In A Bizarre Secret World Of Terror.'

May 15: 'Raspberry Beret'/'She's Always In My Hair' released; reaches Number Two on *Billboard*.

May 24: Returns to Sunset Sound to work on material for a Jill Jones solo album. Also records 'Hello,' which will become the B-side to his next US single ('Pop Life') as well as the UK release of 'Raspberry Beret' (which reaches Number 25).

May 24: 'Paisley Park'/'She's Always In My Hair' released in the UK, where it reaches Number 18.

June 1: *Around The World In A Day* knocks *We Are The World* off the top of the *Billboard* 200.

1985

critics and fans alike, Prince decided to
ega-selling funk-rock of *Purple Rain* with a
m that owes a debt to 60s psychedelia.

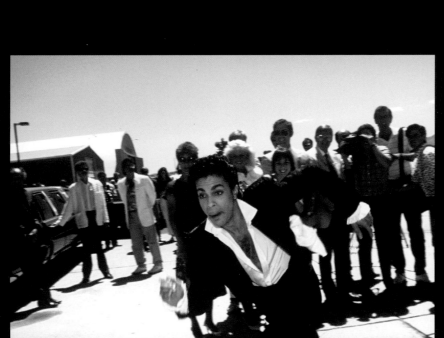

1986

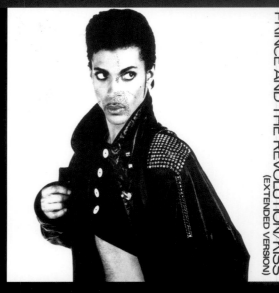

Prince almost missed out on a Number One hit when he gave 'Kiss' to his bassist's band, Mazarati. He saw sense the following day, however, reclaimed it, and turned it into his third US chart-topper.

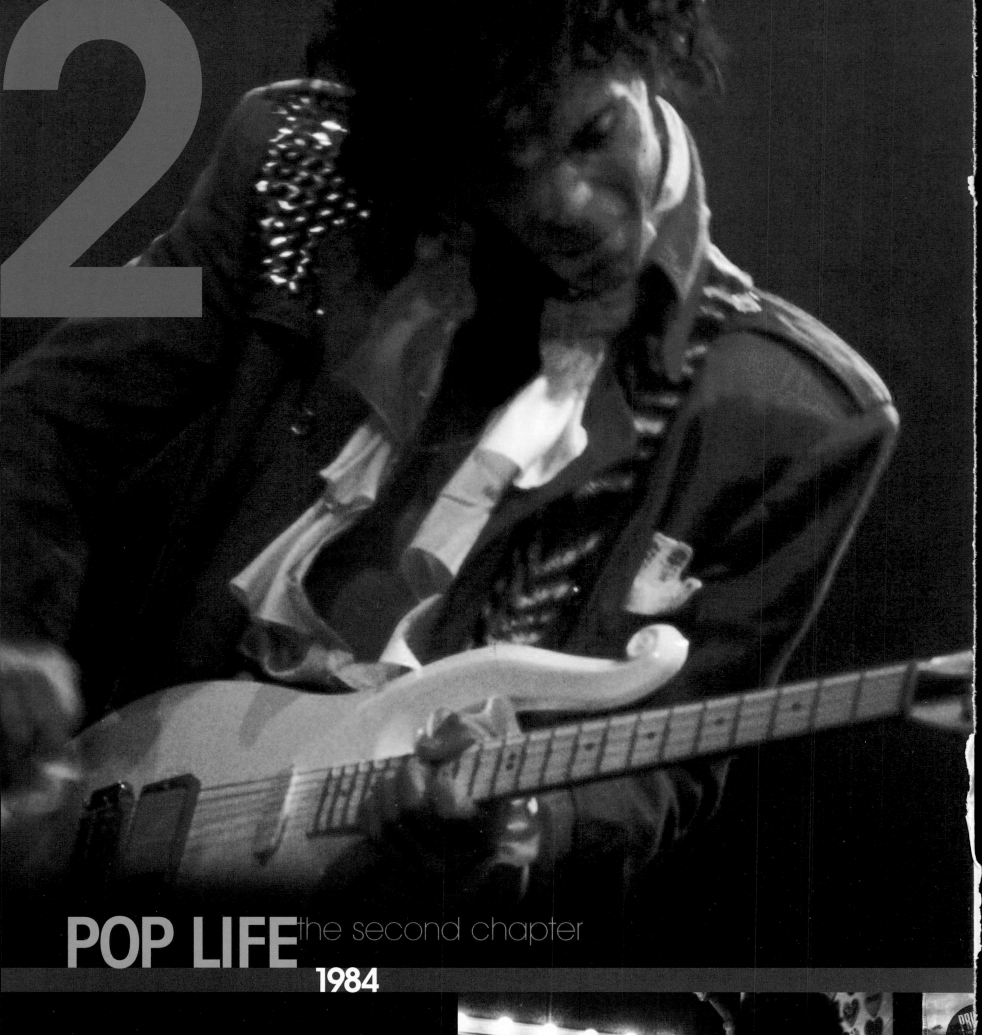

2

POP LIFE the second chapter
1984

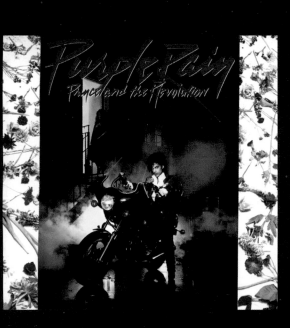

In 1984 Prince became the first artist since The Beatles to simultaneously have a Number One movie, album, and single in the USA when he released *Purple Rain* and 'When Doves Cry.'

Confoundin
follow the m
low-key albu

The Glamorous Life: Sheila E.

Larry Graham aside, drummer and percussionist Sheila E. is perhaps the only musician Prince has worked with who could claim to be better attuned to their instrument than he is. As the daughter of former Santana percussionist Pete Escovedo – and Goddaughter to Tito Puente – it came as little surprise that she followed in her father's footsteps. Having already left school to tour with her dad, she found herself working with bassist Alphonso Johnson in 1976 at the age of 19. Two years later, so the story goes, she met Prince at an Al Jarreau concert. But it wasn't until 1984 that the pair really hit it off.

Prince ran into Escovedo again shortly before the release of *Purple Rain* and immediately began to think of her as a potential replacement for The Time and Apollonia 6 on his upcoming tour. But despite having played over the years with Marvin Gaye, George Duke, and Lionel Richie, Sheila E. wasn't quite ready to front a live band. She did a good enough job, but her performances lacked the pizzazz of The Time. (She did however at least offer rather more depth than Vanity 6.)

Her records were a different story. The first three Sheila E. albums – *The Glamorous Life* (1984), *Romance 1600* (1985), and *Sheila E.* (1987) – seem on the one hand to have been designed to keep Prince prominent in the R&B market, but could often be more rhythmically complex than Prince's other output of the time, and clearly benefited from her exemplary percussion work.

It also soon became clear that Sheila E. would not be just another puppet project. Although her debut album was credited, like all the rest, to the ubiquitous Starr Company, Escovedo claimed that Prince was too busy with *Purple Rain* to have had much to do with it. "He'd call on the phone to see how I was doing," she told Liz Jones,

"and on the last day he came to listen to it, but there was no time for him to put any parts on it." This wasn't actually true. Prince's obvious 'guest' vocal on the title track was the first clue to the fact that, as Escovedo's father later revealed to *Rolling Stone*, Prince had actually written and performed every note.

Escovedo was nonetheless an important part of Prince's personal and professional life. She quickly became a rival to Susannah Melvoin for his affections, and would be invited to play percussion at the end of his shows with The Revolution – returning the favor of his frequent guest appearances during her support slots. She also began to ease Bobby Z away from the drum stool in the studio, appearing on such tracks as *Around The World In A Day's* 'Pop Life' and *Parade's* 'Life Can Be So Nice,' and on some of the *Dream Factory* songs. Prince even let her play on *Lovesexy*, and brought her in for the tours in support of both that album and *Sign "O" The Times*. Even the recently sacked Bobby Z was forced to admit that she was among the world's top-five drummers.

Escovedo left Prince's band in 1990, whereupon she was replaced by Michael Bland in the first official line-up of The New Power Generation, but has carried on making records as Sheila E. In the years since she has toured with her father, performed with Ringo's All Starr Band, and played on Beyoncé's 'Work It Out.' She also continues to play with Prince from time to time, notably during his 2006 Brit Awards appearance, and at the three concerts he played in Minneapolis in July 2007 to publicize the launch of his 3121 fragrance. Prince recently returned the favor by playing with Sheila and her family at Harvelles, Redondo Beach, on March 29 2008.

As well as maintaining her musical career, Escovedo co-founded the Elevate Hope Foundation with former Bride Of Funkenstein Lynn Mabry. On December 13

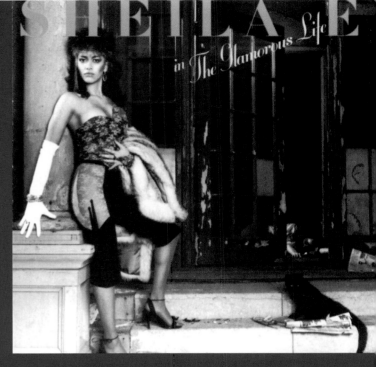

2003 the foundation put on the Family Jamm in aid of victims of child abuse. Escovedo was joined by numerous Prince alumni, including Carmen Electra, Jill Jones, Eric Leeds, Apollonia, and Matt Fink. In 2007 she formed the group C.O.E.D. (Chronicles Of Every Diva) with former Prince bassist Rhonda Smith and released the single, 'Water Of Life.'

As Prince & The Revolution were fast becoming the biggest band in the world, so Minneapolis was growing into a new role as the epicenter of a cool. The local press had already been writing for some time about a 'Minneapolis Sound,' but now the rest of the world was beginning to catch on. Prince reacted to this new level of exposure in his own way. "When the film came out a lot of tourists started coming to First Avenue," he told *Rolling Stone* in 1985. "That was kind of weird, to be in the club and get a lot of, 'Oh! There he is!' I'd be in there thinking,

'Wow, this sure is different than it used to be.'"

The key difference was that, having achieved the fame that he craved, Prince was too big and too famous to enjoy it. In his memoir, *My Time With Prince: Confessions Of A Former Revolutionary*, Dez Dickerson recalls going backstage to see Prince after a show in Washington DC and inviting him on a shopping trip the following day: "At first his eyes got bright, and then, sad, and he answered, 'I can't do stuff like that anymore.' Fame had changed things, and, sometimes, it hurts."

The Revolution

PRINCE FIRST SERVED NOTICE OF THE EXISTENCE OF THIS MOST FAMOUS OF HIS BACKING BANDS ON THE FRONT OF *1999*, ON WHICH THE WORDS "anD thE rEVOLUtioN" ARE PRINTED BACKWARDS WITHIN THE 'I' OF HIS OWN NAME. BUT IT WASN'T UNTIL AUGUST 3 1983 THAT THE GROUP – WHICH WOULD LATER BECOME ALMOST AS FAMOUS AS PRINCE HIMSELF – MADE ITS LIVE DEBUT, AT A BENEFIT FOR THE MINNEAPOLIS DANCE THEATER COMPANY HELD AT THE CITY'S FIRST AVENUE CLUB.

As well as raising $23,000, the show marked the live debut of guitarist Wendy Melvoin alongside longstanding Prince sidemen Bobby Z Rivkin (drums), Matt Fink, and Lisa Coleman (keyboards), and relative newcomer Mark Brown (bass). Such was Prince's faith in this new group, however, that he recorded the entire show, and ended up using three songs from it on *Purple Rain*.

By the time the album came out, The Revolution had become superstars in their own right. They were almost too much of a good thing. Prince had long sought mass appeal, but now that he had achieved it, he found himself criticized for making the white musicians – Melvoin in particular – too much of a focal point, to the detriment of the group's only black player, Mark Brown. He also began to feel threatened by the success of the group, and soon started to cut himself off from them, reminding them that they were *his* band, not part of *the* band. (Conversely, the bandmembers quickly became unhappy with the size of their paychecks, which seemed to bear no relation to the huge sums Prince himself was now earning.)

As much as he might have hated to admit it, Prince needed The Revolution – particularly Melvoin and Coleman. "The more famous he got, the more he relied on us to speak," Melvoin recalled. The group had also coalesced into a potent musical force. Midway through the Purple Rain tour, Prince invited saxophonist Eric Leeds (brother of tour manager Alan) to jam with the band during the encores – the first time that he had allowed brass instruments on stage with him.

Leeds also began to educate Prince about jazz, with which he quickly became enamored. Melvoin and Coleman, meanwhile, had started to introduce him to white pop and rock'n'roll from the 60s and 70s, as well as other more recent music that the singer had missed while locked away in the studio for the past half-decade. Prince's inner circle started to resemble a kind of university clique, trading ideas and inspirations back and forth. He was, Melvoin recalled, "hungry for influences to take him further, so he relied heavily on me and Lisa to guide him in the directions he couldn't think of himself."

The spirit of collaboration continued in the studio. Melvoin and Coleman would hole up with Prince and help him on his way to new musical discoveries on *Around The World In A Day* and *Parade*. "It's true that I record very fast," he told MTV in 1985. "It goes even quicker now that the girls help me."

Live performance, however, was another matter entirely. During the Purple Rain tour, Prince added saxophonist Eric Leeds, drummer Sheila E., and various dancers and backing singers to the Revolution line-up. By the time of the 1986 Ht & Run tour, he had turned the band into what Eric called the "counter-Revolution" bringing in trumpeter Matt 'Atlanta Bliss' Blistan, bodyguards-turned-dancers Wally Safford and Greg Brooks, and ex-Time dancer Jerome Benton, as well as finding a role for his girlfriend, Susannah Melvoin (twin sister of guitarist Wendy).

Few among the original line-up were happy about this turn of events, but for Prince, it all made perfect sense. Having been criticized for courting the white market, he wanted to return to his roots with a larger-scale soul/funk revue in the same vein as George Clinton's P-Funk groups. He was also keen, as always, to make his shows more theatrical. This was simply the live equivalent of his sometime habit of sacrificing subtlety on his later records in favor of building up layer upon layer of overdubs.

Prince made some concessions to The Revolution, such as giving Melvoin a lead vocal on *Parade*'s 'I Wonder U' and even worked with them on a group effort entitled *Dream Factory*, but the tensions continued to rise. "Prince is an entertainer," Wendy Melvoin later recalled. "He wanted more entertainment, and Lisa and I wanted less." In July 1986 Melvoin, Coleman, and Mark Brown all threatened to quit before the Hit & Run tour kicked off, but all three were convinced to ride it out.

By the end of the tour, however, Prince himself had had enough. He had started to argue with Melvoin and Coleman regularly during the *Dream Factory* sessions, partly because of the fact that his relationship with Susannah Melvoin was in disarray. On the final night of the tour – September 6 1986 at Yokohama Stadium, Japan – Prince smashed up all of his guitars after a final encore of 'Sometimes It Snows In April.'

Prince had never done anything like it before. Perhaps unsurprisingly, it marked the end of his association with The Revolution. In early October, he invited Melvoin and

Coleman to dinner at his rented Beverly Hills home and fired them both. He then called Bobby Z to tell him that he was going to be replaced by Sheila E., with whom Prince had been working in the studio for several years already. Matt Fink opted to stay on, but Mark Brown quit, partly out of loyalty to the others but also because he was unhappy at Prince's decision to return to making funk-based music.

As far as Prince was concerned, they all "needed to play a wide range of music with different types of people" so that they could "come back eight times as strong." Others around him were less than convinced. Having hit what looked like a creative peak with The Revolution during the *Dream Factory* sessions, he now seemed to want to go back to where he had been several years ago – that is, recording everything on his own.

Melvoin and Coleman were left further embittered by what they saw as a lack of credit on *Sign "O" The Times*, which features re-recorded versions of tracks from the *Dream Factory* sessions. The pair did nonetheless go on to establish themselves as session players, and as a duo in their own right (as Wendy & Lisa). They have also composed a number of movie soundtracks together, including *Dangerous Minds* and *Toys*.

Prince made intermittent contact with the duo during the 90s, but neither of the collaborative projects that he suggested came to fruition. Having initially invited them both to play on a song entitled 'In This Bed Eye Scream,' he eventually decided it would be better just to dedicate it to them. He then toyed with the idea of making a new Revolution album based at least in part around older recordings, to be called *Roundhouse Garden*, but that never made it beyond the planning stage either. Asked why not, Prince told fans at a Q&A session to "ask Wendy and Lisa," fuelling rumors that, having recently become a Jehovah's Witness, he would not work with them unless they publicly renounced their homosexuality.

It took until the early 21st century for the trio to patch things up. Prince and Wendy Melvoin played together as a duo on the *Tavis Smiley Show* in February 2004 in support of *Musicology*. Then, on February 15 2006, both Melvoin and Coleman joined Prince for his show-stopping appearance at the Brit Awards. The duo also appear on two tracks on his 2007 *Planet Earth* LP, 'The One U Wanna C' and 'Lion Of Judah.'

> *"He was hungry for influences to take him further, so he relied on me and Lisa to guide him in the directions he couldn't think of himself."* WENDY MELVOIN

AS THE PURPLE RAIN TOUR DREW TO A CLOSE, EVERYONE EXCEPT PRINCE SEEMED CONFUSED AS TO WHAT WOULD HAPPEN NEXT. SOME MEMBERS OF THE REVOLUTION WERE SURPRISED THAT HE HADN'T OPTED TO MILK THE ALBUM AND MOVIE FOR ALL THEY WERE WORTH, BUT PRINCE HAD BEEN UNWILLING TO SIGN UP FOR ANYTHING BEYOND A SIX-MONTH TOUR OF THE USA, WHICH MEANT THAT NO ONE ELSE GOT TO EXPERIENCE THE PHENOMENAL LIVE SHOW UNTIL THE VHS RELEASE OF *PRINCE & THE REVOLUTION: LIVE*.

Around the World in a Day

(FEBRUARY 1984–APRIL 1985)

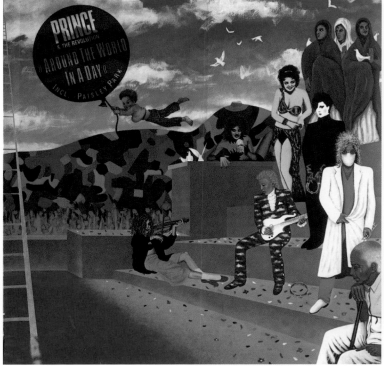

Worse news was to follow on April 2 1985 when Prince's manager, Steve Fargnoli, announced the singer's plan to retire from live performance completely following the completion of the tour. "I'm going to look for the ladder," Prince had reportedly told Fargnoli by way of explanation. "Sometimes it snows in April." A decade later, Prince gave a less cryptic explanation to *Icon* magazine: "I was doing the 75th Purple Rain show, doing the same thing over and over – for the same kids who [now] go to Spice Girls shows. And I just lost it. They put the guitar on me and it hit me in the eye and cut me and blood started going down my shirt, and I said, 'I have to go on stage.'"

There were suggestions from outside the Prince camp that the singer's personality had been adversely affected by the success of *Purple Rain*. The Time's guitarist Jesse Johnson would later claim that Prince was "such an asshole" that he "had to change my phone number to stop him calling me. He'd just say, 'Jesse, your album sucks,' and hang up." (A year later, having heard that Johnson's second solo album, *Shockadelica*, didn't actually contain a

song by that name, Prince recorded one himself in an effort to 'prove' his idea that every great album title needed a great song to back it up. He then had his own 'Shockadelica' pressed up for club play in advance of the release of Johnson's album, which subsequently made it look like Johnson had stolen the idea from him, rather than the other way around.)

To others however it seemed that Prince was finally starting to get on better with people. During the Purple Rain tour he had begun to take influence from the jazz records played to him by new Revolution saxophonist Eric Leeds, and also the 60s and 70s acts Wendy Melvoin and Lisa Coleman grew up with. As Alan Leeds put it, the three of them "made it their own project [to turn] Prince onto different kinds of music. He had a very genuine interest in expanding his musical curiosity."

Their influence fed into a newly collaborative way of working as Prince started to invite members of The Revolution – particularly Melvoin and Coleman – into the studio with him as he recorded the follow-up to *Purple Rain*. The catalyst for this was in fact a song that that

We Are The World

Since releasing his debut album in 1979, Prince seemed barely to have put a foot wrong as far as music critics were concerned. Each record he made was another bold step in an artistic career trajectory, with *Purple Rain* marking his artistic and commercial peak. But having made six albums in seven years under his own name (and plenty more for The Time, Vanity 6, Apollonia 6, and Sheila E.), it was inevitable that there would be some kind of backlash – and that Prince would play a large part in engendering it himself.

On January 28 1985 Prince performed 'Purple Rain' and won in three categories at the American Music Awards – Favorite Album in both the Black and Pop fields, and Favorite Single for 'When Doves Cry.' If the assembled audience of contemporary stars and living legends didn't already think him slightly strange, more than a few eyebrows would have been raised by the fact that he was accompanied by bodyguard Chick Huntsberry each time he went up to get an award.

After the show 45 of America's most prominent musical acts of the time had been asked to go and take part in the recording of 'We Are The World,' a song written by Michael Jackson and Lionel Richie and scored and arranged by Quincy Jones in aid of USA For Africa, a charity set up to raise money for famine relief in Ethiopia. Prince was among the artists invited to the session, along with Bob Dylan, Bruce Springsteen, Huey Lewis, Stevie Wonder, Diana Ross, Tina Turner – the kind of mix of rock and soul that Prince himself had helped bring together a few years earlier.

But while the tape rolled, Prince was having dinner at a Mexican Restaurant on Sunset Boulevard. A piece of paper with his name on it might have been taped to the floor next to Michael Jackson's, but he never turned up to sing. Prince felt he had a perfectly good explanation for this. "We had talked to the people that were doing [it]," he told *Rolling Stone* a few months later, "and they said it was cool that I gave them a song for the album." This, he said, was the best thing for all concerned: "I'm strongest in a situation where I'm surrounded by people I know … [but] I probably would have just clammed up with so many great people in the room."

That might well have been true. Bob Dylan later recalled that he felt so uncomfortable that he had to be guided through the recording by Stevie Wonder. But Dylan still turned up. Prince's 'explanation' served only to fuel rumors that he was selfish egoist. It didn't help that, after leaving the Mexican restaurant at 2am, Prince had a paparazzi photographer forcefully ejected from his limo by a bodyguard. All of a sudden, he had gone from being the hero of the Awards night to the villain of the piece – the man who cared nothing for charity, and would be prepared to let his bodyguards loose on anyone who dared try to get close to him.

In his defense, Prince had indeed agreed to donate a song of his own to the USA For Africa album. He spent February 2 recording it with Wendy Melvoin and Lisa Coleman at New Orleans's Superdome during a break in the Purple Rain tour. But as much as the resulting '4 The Tears In Your Eyes' might have been a beautiful ballad about striving to maintain hope and faith in a dire situation, it was too little too late. Whatever good Prince might have done, it was overshadowed by his no-show, and his apparently mean-spirited behavior.

Prince gave his side of the story in 'Hello,' the B-side – rather aptly – to his 'Pop Life' single, which addresses the (mostly negative) effects of fame. Bemoaning the press's treatment of him, he sought also to remind his critics of his past charitable work: "We're against hungry children / Our records stands tall / There's just as much hunger here at home." Or, as he told *Rolling Stone*, paraphrasing 'Hello''s lyrics: "We'll do everything we can, but y'all got to understand that a flower that has water will grow, and the man misunderstood will go."

Coleman's brother David had recorded in a three-day session at Sunset Sound in June 1984 that Prince paid for as a birthday present – an act of kindness that seems to be rather at odds with Jesse Johnson's opinion of him. (In a similar moment of benevolence, Prince reportedly gave his father a co-writing credit on his forthcoming album's 'The Ladder' just so that he could earn some money from the royalties.) David Coleman used those three days to record a demo tape with Wendy Melvoin's brother, Jonathan, which they promptly gave to their sisters. "There was song on it called 'Around The World In A Day,'" Lisa Coleman recalled. "Wendy and I flipped, and played it to Prince. There were a lot of different types of instruments on it, interesting sounds – Arabic music, the oud, cello, finger cymbals, darbuka."

Inspired by this wide sonic palette, Prince re-recorded the song, with David Coleman's input and blessing, as the title track for his new album. He was so enthusiastic about it, in fact, that he started work on the new project straightaway, despite the fact that he was midway through recording a second solo album for Sheila E. Whenever he had a break from touring he would stop off at any available studio to work on the record – or, failing that, use a mobile recording unit. By the early hours of Christmas Day 1984, Prince had recorded and mixed the entire album, having put down vocals for the closing track, 'Temptation,' with engineer Susan Rogers during the final session.

On February 21 1985, with the end of the Purple Rain tour still two months away, Prince played *Around The World In A Day* to executives in Warner Bros' Los Angeles office. The quick turnaround was a shock to the label, which hadn't expected a follow-up to *Purple Rain* so soon. According to a report in *Rolling Stone* magazine in April,

The Beautiful One: Susannah Melvoin

When Prince hired Wendy Melvoin to replace Dez Dickerson in 1983, he had no idea it would lead to one of the most intense relationships of his life, but that's exactly what happened. Shortly after hiring Melvoin in May 1983 he met her sister, Susannah. The pair were instantly attracted to each other, and it wasn't long before she had split up with her boyfriend of the time and moved from California to Minneapolis to be near Prince. She quickly took pride of place among Prince's girlfriends of the time, driving Vanity away and pushing Jill Jones into the background.

Coming from the same stock as her sister Wendy, it's no surprise that Susannah had an affinity for music. She quickly began to introduce Prince to new influences in literature, art, and music, and would soon be working in the studio with him as one of two singers in The Family – a band some felt Prince had formed just so that he could keep her near. She also added backing vocals to *Parade*, joined the ever-expanding line-up of The Revolution for a time, designed the *Dream Factory* jacket, and – unlike the rest of The Revolution – even received a credit on *Sign "O" The Times*. Such was Prince's devotion to Susannah that he even planned to give her the lead female role in *Under The Cherry Moon*. There were even suggestions that he had proposed to her shortly before they flew out to Paris together in August 1985 to begin pre-production. When it became clear that she couldn't act, however, Prince sent her home, replacing her with Kristin Scott-Thomas (with whom he then allegedly had an affair).

Despite behaving, on the one hand, like a committed monogamist, Prince continued to flaunt his affairs. This made life difficult not just for Susannah but also for her sister and Lisa Coleman. Whenever Prince upset her, she would confide in Wendy, who in turn would talk to Coleman – which made it almost impossible for them all to work together. "It was hard," Coleman told Prince biographer Liz Jones. "We couldn't take sides. Prince was trying to draw the lines all the time." Such is Prince's hold over his girlfriends that Susannah stuck it out until December 1986, and even then moved only to a nearby apartment.

Prince, it seems, just didn't know how lucky he was at the time. Susannah inspired some of his greatest ballads, including 'The Beautiful Ones' and 'Nothing Compares 2 U,' and had a profound impact on *Sign "O" The Times*. His obsession with her is writ large on a song once slated for *Dream Factory*, 'Big Tall Wall,' on which he declares his intention to build said wall around his lover "so U can't get out," and confirmed by the dark themes of much of the material he wrote during and immediately after the break-up of their relationship.

That Prince never fully let go of her became clear in a 1997 web-chat with AOL. Despite usually being so deft at avoiding anything approaching a personal revelation, he gave a simple, honest response to the question of who had inspired 'Forever In My Life' (despite being married to Mayte at the time): "Susannah. She knows." It seems fitting, then, that the song most directly inspired by her has never been heard by anyone other than Prince and his engineer, Susan Rogers.

Shortly after Susannah finally left him for good, Prince recorded a song called 'Wally,' in which he reportedly confided his deepest thoughts about her to his bodyguard and dancer, Wally Safford. Prince erased the song once, before recording it again for posterity but never releasing it.

the label received a phone call late that afternoon to say that its biggest star would be there in 45 minutes. Prince arrived in a limo, dressed in a purple kimono, holding a single rose, flanked by his father, bodyguards, management, and Wendy Melvoin. He led around 150 executives to a fourth-floor conference room, played them the album – barely speaking, except in a low whisper to Mo Ostin – and then left as suddenly as he had arrived. One employee present subsequently told *Rolling Stone*: "Everyone sort of stood up and applauded after the record was over, and then he wasn't there anymore."

The record blindsided Warner Bros just as it would the

to sound more like a late-60s psychedelic album. If that wasn't enough, *Around The World In A Day* came with an insistence that there would be no singles, no promotional videos, and not even any adverts in magazines. Prince seemed adamant that only 'real fans' find out about the album, which should be seen as the work of a creative artist and not just another commercial product.

"I had a sort of F-you attitude," Prince told The Electrifying Mojo, a Detroit-based DJ, on June 6 (the day before he turned 27). "I was making something for myself and my fans, and the people who supported me through the years." For some in the Prince camp, this seemed like a serious misstep, but the singer himself was anxious not to be pidgeonholed. "I saw kids coming to concerts who screamed just because that's where the audience screamed in the movie," he explained to *Entertainment Weekly* in 1999. "I wanted to totally change that."

This might well have been the case, but most critics were left unconvinced by the album's surface-level psychedelic sheen, particularly when it came to the Eastern-sounding title track or the Beatles-esque escapism of 'Paisley Park.' These criticisms weren't entirely accurate – Prince certainly hadn't

> "I think the smartest thing I ever did was record *Around The World In A Day* right after I finished *Purple Rain*. I didn't wait to see what would happen." PRINCE

public when it was released on April 22, a mere two weeks after the completion of the Purple Rain tour. The label wanted *Purple Rain 2*, but what Prince gave them seemed

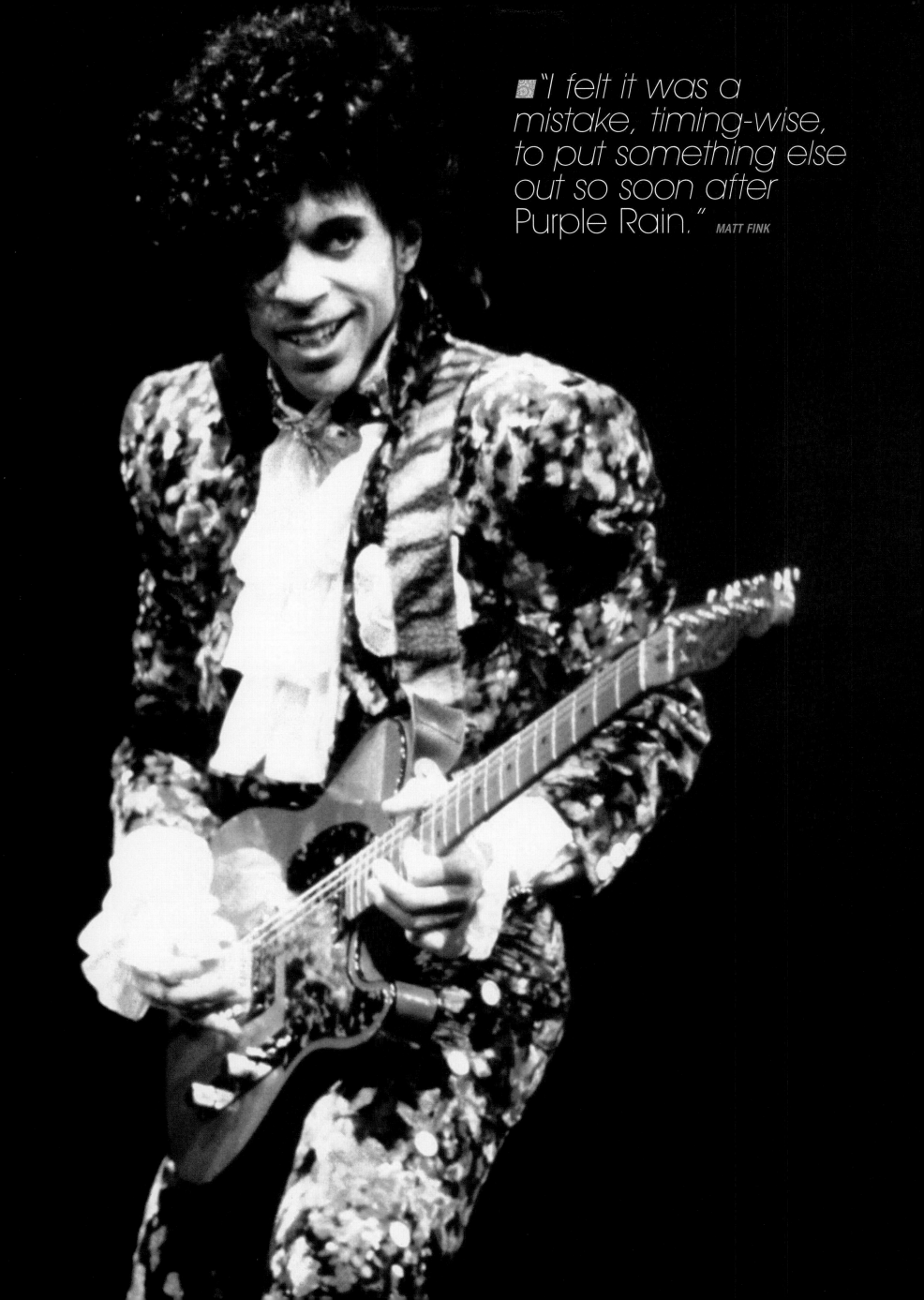

"I felt it was a mistake, timing-wise, to put something else out so soon after Purple Rain." *MATT FINK*

abandoned his old sound quite as dramatically as some reviewers suggested – but then nor was the singer's claim in an interview with MTV around the time of the album's release that *"Around The World In A Day is a funky album."*

There are however hints of almost everything that came before it on *Around The World In A Day*. The utopian themes of 'Uptown' resurface on 'Paisley Park,' which Prince told *Rolling Stone* was his attempt "to say something about looking inside oneself to find perfection." Elsewhere, there are the usual extended sexual metaphors ('Raspberry Beret' and 'Tambourine,' a barely disguised tribute to masturbation); heart-wrenching ballads ('Condition Of The Heart'); strident, rock-based patriotism ('America'); plus the usual battle between religious fulfillment (the gospel ballad 'The Ladder') and sexual obsession ('Temptation,' a close relative of 'Darling Nikki,' complete this time with a conversation with God).

All in all, it was pretty much standard Prince fare – or as close as you might get to such a thing. But coming so soon after *Purple Rain*, it was also something of an eye-

opener. If the previous album's 'Darling Nikki' was, as Prince later suggested, "the coldest song ever written," then 'Paisley Park' is about as warm an invitation as you might reasonably expect to come in, sit down, and relax.

"If there was a theme to *Around The World In A Day*," Alan Leeds recalled, "[it] was that it was the anti-*Purple Rain* record." This, it seems, was the only thing critics

> **"I think he really had fears of being typecast as Mr Purple Rain. By the time that tour was over, he was so sick of that music and that whole concept."** *ALAN LEEDS*

could settle on. Whether it was any good or not was a different matter. The *New York Times* was impressed, having decided that Prince was "asking, perhaps demanding, to be taken seriously." For the *New Musical Express*, however, it was one creative leap too far. "Prince's position is presently unassailable," it claimed, "[but] contrary to his own high self-regard, this does not make him infallible."

The only other thing reviewers could agree on was the album's somewhat superficial debt to psychedelia, notably The Beatles. For *The New York Times*, the album "might more accurately have been titled *Around Great 60s Rock In A Day*", while the *Detroit Press* noted that "The Beatles, and John Lennon in particular, bear heavily on 'Paisley Park' ('Penny Lane') and 'The Ladder' (an 'Instant Karma' for the 80s)." For *Newsweek*, the album seemed like "an eerie attempt to recapture the utopian whimsy that characterized The Beatles' *Sgt Pepper*."

Prince of course disputed this. "The influence wasn't The Beatles," he told *Rolling Stone*. "They were great for what they did, but I don't know how that would hang today." He made a point too of defending his decision not to make *Purple Rain 2*: "You know how easy it would have been to open *Around The World In A Day* with the guitar solo that's on the end of 'Let's Go Crazy,' just put it in a different key? That would have shut everybody up who said that album wasn't half as powerful. I don't *want* to make an album like the earlier ones. Wouldn't it be cool to put your albums back-to-back and not get bored?"

To his credit, much of the album's power came from subtle textures rather than rock-star posturing. But criticism seemed unavoidable this time around, even when it came to the artwork, which many took to be a rather too obvious reference to The Beatles' *Yellow Submarine*. "The cover art came about because I thought people were tired of looking at me," he explained to *Rolling Stone*. What he was going for this time, he said, was something "a little more happening than just another picture … some way I could materialize in people's cribs when they play the record." Rather tellingly, however, the

gatefold jacket includes a drawing of Prince, holding his 'cloud guitar' and dressed in the cloud-covered suit he wore in the 'Raspberry Beret' promo video. The cartoon Prince looks considerably older than his real-life counterpart did at the time, as if to suggest that his recent ascent to superstardom had had quite the aging effect.

Despite the muted critical response and deliberate lack of promotion, *Around The World In A Day* still peaked at Number One on *Billboard*, ironically knocking the *We Are The World* album off the top spot. But while *Purple Rain* had clung onto the top spot for 24 weeks, its successor only hung on for three, by which time its creator's confidence seemed to be faltering. Relaxing his earlier standpoint, he rush-released 'Raspberry Beret' as a single, shot a promo video for it, and gave his first interview for two years to *Rolling Stone*.

For the most part, however, Prince seemed too busy to let the response to *Around The World In A Day* bother him, noting that it had been bought by "the same three million" people who bought *1999*. "It's important to me that those people believe in what we're trying to say," he said, "as opposed to just digging it because it's a hit."

Even before the album was released, Prince was well on the way to making the follow-up, *Parade*. He might not have ended 1985 as the most bankable pop-star of the year, but was still the most creative, and still had enough credit in the bank that his carte blanche would not yet be revoked. If nothing else, *Around The World In A Day* put him on the path toward what he considered to be the ultimate artistic expression. Although some of his critics didn't like what he was doing, he retained a level of respect as he forged on, bucking ever more against the conventional wisdom about what a commercially successful musician should do.

Keeping It In The Family

After The Time disintegrated is 1984, Prince was left for a short time without a full-band side-project to work with. But while Morris Day and Jesse Johnson embarked on their solo careers, Prince pulled the remains of The Time back together to form The Family. Keyboardist Paul Peterson was given the task of fronting the new group, with Prince's girlfriend of the time, Susannah Melvoin, taking the role of co-vocalist. Jerome Benton carried on as dancer/comic foil, with Jellybean Johnson on drums. They were joined by Miko Weaver, who also played guitar with Sheila E., but here seemed to be more of a nominal presence than a fully-fledged group member.

Prince began work on *The Family* during the summer of 1984 in much the same as he had The Time's albums: writing all of the songs, playing all of the instruments (except for saxophone and strings), and laying down guide vocals for Peterson – now known as St Paul – to follow. Unlike Morris Day, however, Peterson was clearly a sideman, not a frontman, and struggled to keep up with the recordings.

Leaving aside the quality of the material, *The Family* just didn't have the drive of The Time – and nor did it have Prince's total commitment. It was released on his Paisley Park label in August 1985 while the singer himself was busy shooting *Under The Cherry Moon* in France. He had little interest in promoting the album, so simply left it to Warner Bros. Peterson ended up leaving the group after just one concert at First Avenue, citing a lack of creative input, while the remaining members of The Family then found their way into the ever-evolving line-up of The Revolution.

Ultimately it seems that forming The Family was just Prince's way of keeping Susannah Melvoin by his side for as long as possible. The album artwork makes plain his infatuation with her. She dominates the main jacket artwork (by *Vogue* photographer Horst P Horst), and features in several interior snaps taken by Prince himself.

Just as importantly, however, The Family gave him an outlet for his first tentative experiments with both live saxophone (played by Eric Leeds) and string arrangements by Clare Fischer. Both of these elements would be more fully developed on *Parade*, but for now just meant that *The Family* was jazzier and less accessible than anything The Time had done.

The Family also released a single, 'The Screams Of Passion,' but the group's most lasting legacy came with their recording of the original version of 'Nothing Compares 2 U,' as famously covered by Irish singer Sinead O'Connor. Prince had nothing to do with O'Connor's rendition, however, and in fact – if she is to be believed – later had a fiery meeting with her. "Prince started to give out to me for swearing in interviews," O'Connor told *The Mirror* newspaper in 2007. "When I told him to go fuck himself he got very upset and became quite threatening … A few blows were exchanged. All I could do was spit. I spat on him quite a bit."

Prince has not responded to these claims, but some commentators have made clear their cynicism, noting that O'Connor's remarks were timed to coincide with Prince's 21 Nights In London residency. Others meanwhile have expressed doubts that the diminutive Prince could ever hold his own in a fight with the taller and rather more imposing O'Connor.

'Kiss,' a song originally given to Mazarati but reclaimed a day later, was most listeners' highlight: a taut, sparse blend of funk and R&B sung in a falsetto Curtis Mayfield would have envied. The promo video features just Prince, Wendy Melvoin, and an unidentified female, showing just how valuable Melvoin was to Prince at the time.

Part of the album's genius is the way that it runs through all sorts of tried-and-tested Prince tricks while still sounding like nothing that came before it; part of its charm is the way that it sounds like Prince is stretching himself beyond his comfort zone to incorporate influences he hasn't fully mastered. It marks one of the few occasions where he has sounded out on a limb. Ironically, it would be kept of the top of the US charts by Janet Jackson's *Control* – an album produced by sacked Time members Jimmy Jam and Terry Lewis.

Given that Warner Bros had put up ten million dollars to make *Under The Cherry Moon* but only recouped three million, it was decided that the best way to turn both projects into full-blown commercial successes would be for Prince to go out on tour. As ever, however, the singer was still of a mind to do things the hard way. His US 'tour' consisted of ten Hit & Run dates, for which the city and venue of each performance would only be announced hours before showtime. This created enough fervor that each night was sold out, but still came as a disappointment to Warner Bros, who had high hopes for a blockbuster tour. Prince did perform a further 15 shows in Europe and four more in Japan, but that was as far as the promotional jaunt for *Parade* went.

The tour itself was bittersweet. Tensions between Prince and The Revolution had grown, largely because the show was now essentially a funk revue, the props of previous tours replaced by horn players, bodyguards-turned-dancers, Sheila E. on percussion, Miko Weaver on rhythm guitar, and various remembers of the now-defunct Family. "I was behind the piano, next to Bobby Z," Mark Brown recalled, "and behind three guys that used to be bodyguards. I started feeling a little underappreciated."

The tour did introduce a new, iconic part of Prince folklore: the aftershow gig, which would see the band take to the stage of a smaller venue in the early hours of the morning and play a much looser, jam-based set. "The aftershows were a natural outgrowth of an artist who was intrigued [by] the idea of performing often and in a variety of venues," Alan Leeds explained. "Prince enjoyed the intimacy and immediacy that small clubs provided."

After several years of playing together, Prince & The Revolution seemed to have reached their musical high-water mark. But it was not to last. The final night of the tour, at Japan's Yokohama Stadium on September 9, marked the end of an era in Prince's career. At the end of the show Prince smashed his guitars and walked off. It would be the last time he played with The Revolution,

closing the curtain on the most collaborative phase of his career and dismantling one of his most celebrated backing bands – with whom he had recently cut another (unreleased) album, *Dream Factory*.

Wendy Melvoin and Lisa Coleman were fired a month later, Bobby Z was replaced by Sheila E., and Mark Brown left of his own accord, leaving only Matt Fink from the

> "I remember the first time that I heard the song 'Kiss,' really feeling that he had managed to re-capture some of that raw R&B emotion from some of his earlier music." *DEZ DICKERSON (GUITARIST, 1978–83)*

original line-up. Prince would subsequently put together a new backing band from the musicians he had left, but things would not continue as they were. With the *Parade* era over, Prince decided that he wanted to reclaim everything for himself again.

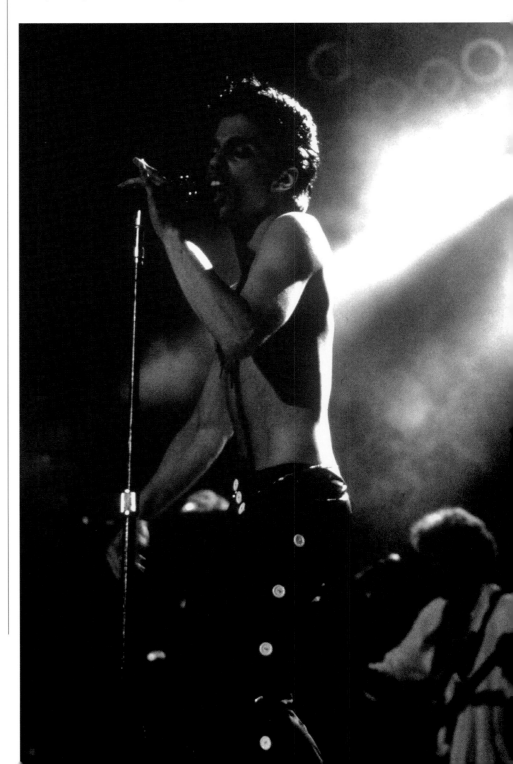

Prince Vs The King Of Pop

PRINCE AND MICHAEL JACKSON WERE BOTH INSTRUMENTAL IN BRIDGING THE GAP BETWEEN BLACK AND WHITE MUSIC IN THE EARLY 80S, AND BOTH MIGHT CLAIM TO HAVE BEEN THE DECADE'S MOST IMPORTANT MUSICAL FIGURE.

But while Jackson certainly sold more records – including *Thriller*, the biggest-selling album of all time – Prince produced a much wider and more powerful array of music. Comparing the two men in his autobiography, Miles Davis wrote, "I like Prince a little better as an all-round musical force. Plus he plays his ass off as well as sings and writes."

There are more similarities between the two men than might be immediately apparent – not least the fact that casual observers tend to think that both lost their minds somewhere along the line. More specifically, both became megastars at a young age and used their newfound wealth to build their own playgrounds: Jackson's Neverland Ranch, and Prince's Paisley Park. Both have made headlines over their alleged sexual preferences and what can be interpreted as somewhat ambivalent attitudes toward race. They're also both fantastic dancers.

The main 'rivalry' between the two men began when 'Little Red Corvette' came out in February 1983, one month before Jackson's 'Beat It.' Both records stormed into the white mainstream market and made unprecedented strides on MTV. They also both featured rock guitar solos by rock'n'rollers, leading Bobby Womack to complain that the two men had "groomed their music for the white audience." Although Jackson surged ahead of Prince in terms of sales of *Thriller*, it took him until 1987 to issue a follow up, *Bad*, which received much less ecstatic reviews. During the same timeframe, Prince had written and recorded ten albums for himself and others, all the while becoming more and more critically fêted.

Prince has always been keen to play down any rivalry between the two. "I could talk to you about Michael Jackson," he told the *New Musical Express* in 1995, "but I would just be doing the job that a journalist does so there's no point." According to Robin Power, star of *Graffiti Bridge*, Prince was offered a lucrative licensing deal with Coke shortly after Jackson signed up with Pepsi, but turned it down. "He didn't want to be compared to Jackson," Power told Prince biographer Liz Jones. "He felt he should be compared with Miles [Davis] or [John] Coltrane," Power added, which perhaps gives another reason why he didn't want to appear on 'We Are The World,' which Jackson co-wrote.

Despite what Prince told the press, there clearly was some sort of battle between the two men. In December 1985, while working on *Under The Cherry Moon* in San Francisco, Prince was visited by Jackson, whom he challenged to a game of table tennis. Prince's competitive streak reportedly got the better of him, leading him to hit the ball across the table at Jackson as hard as he could. While paying a return visit a month later, Prince shared a pizza with Jackson's pet monkey, Bubbles, leading to reports in the *National Enquirer* that Prince had used mind-control tricks to send Bubbles mad. (The two men had also been in a studio together briefly in 1978, when Prince asked to sit in while Jackson worked on *Off The Wall*, though they never spoke.)

The *Bad* sessions threw up another interesting tale. Jackson had his producer, Quincy Jones, speak to Prince about the possibility of a duet on the album's title track. The plan was for Jackson's management to plant false

> *Prince has always been ahead of the curve. The King Of Pop, by contrast, lost his crown long ago.*

news stories in the press about a bitter rivalry between the two men leading up to the release of the single – which would serve as a supposed final battle. Problems arose, however, when Prince began to look in detail at the song's lyrics – and the first line, "Your butt is mine," in particular. "Who's singing that to whom?" Prince asked, "'cause you sure aren't singing that to me." Instead he offered up a reworking of his 1976 song 'Wouldn't You Love To Love Me?,' but Jackson rejected it.

Nowadays, Prince still tends to release at least one album per year, but Jackson hasn't made an album since 2001's poorly received *Invincible*. Personal and financial problems have seemingly driven him into exile, with 2008 seeing him content to rest on his laurels with a 25th anniversary edition of *Thriller* – to sit alongside the 20th anniversary edition – rather than make a new record.

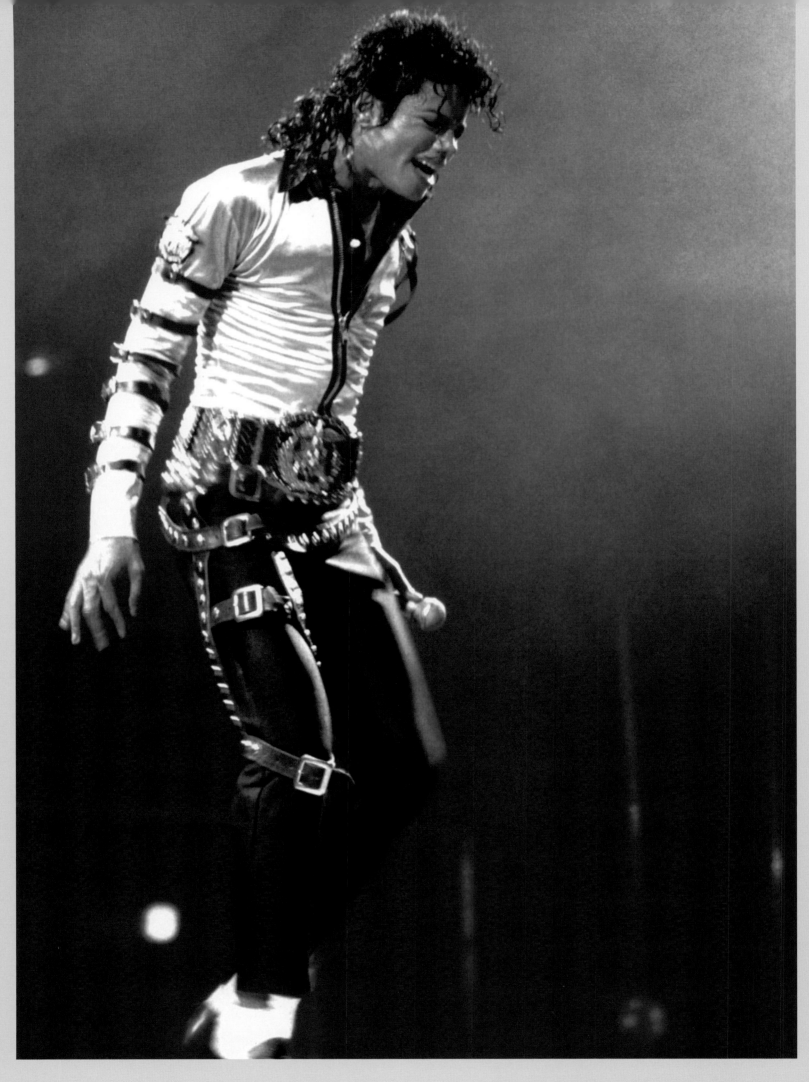

Even so, the media loves a good rivalry. In 2007, Prince's 21 Nights In London at the O$_2$ Arena gave rise to rumors of Jackson's plans to perform a 25 or 30-night run at the same venue. This doesn't seem to fit too well, however, with recent footage of Jackson looking worryingly weak (in stark contrast to Prince, who seems to have a lot more energy than the average 50-year-old). Similarly, after Prince's universally praised halftime show at Superbowl XLI on February 4 2007, it was rumored that Jackson would give an even greater performance at the 2008 event, but in the end the role fell to a distinctly less showy Tom Petty.

All in all, Jackson might have sold more records, but Prince's declaration that "U must become a Prince before U're king" still holds true. When it comes to lasting influence, with everyone from Timbaland to Hot Chip citing him as an inspiration, Prince has always been ahead of the curve. The King Of Pop, by contrast, lost his crown long ago.

IN MARCH 1986, THE CASUAL OBSERVER MIGHT HAVE EXPECTED PRINCE'S FOCUS STILL TO BE ON *UNDER THE CHERRY MOON*, WHICH WAS STILL IN NEED OF A FEW EXTRA SCENES, AND *PARADE*, WHICH WAS DUE TO GO ONSALE IN A COUPLE OF WEEKS' TIME.

Dream Factory (MARCH 1986–JULY 1986)

Continually discarding old ideas in favor of new ones, Prince had already started work on yet another new project under the glow of a stained-glass window in his new home studio in Chanhassen, Minnesota, which would serve as Prince's main base of operations while he waited for Paisley Park to be built. That project was *Dream Factory*, the culmination of his recent embrace of the spirit of collaboration.

Having traded tapes regularly with Wendy Melvoin, Lisa Coleman, and Clare Fischer while making *Parade*, Prince took things a step further at the tail end of 1985, forming The Flesh with Sheila E. on drums, Levi Seacer Jr on bass, and Eric Leeds on saxophone. The group made a series of impromptu, jazz-based recordings at Sunset Sound studios around the turn of the year. Prince had

Although Sign "O" The Times is widely considered to be among Prince's finest works, Dream Factory could have been even better.

them pressed up as *The Flesh* but never released it, although 'Junk Music' found its way into *Under The Cherry Moon* and 'U Got 2 Shake Something' turned up as 'Shake!' by The Time on *Graffiti Bridge*.

The Flesh might never have materialized, but it was clear that Prince had grown more interested in the idea of working with a group in the studio. So it was that he invited The Revolution to work on what is now one of his most famous unreleased albums, *Dream Factory*. Although Prince recorded most of 'The Ballad Of Dorothy Parker' and 'Starfish & Coffee' on his own, the remaining seven songs all prominently feature The Revolution – notably 'Visions,' a solo instrumental piano piece by Lisa Coleman, who also sings the lead vocal on 'A Place In Heaven.'

The sessions seemed to gratify the band, particularly Melvoin and Coleman, with whom Prince worked most

closely. Having expanded the live line-up of The Revolution to a point where some felt the chemistry had been ruined, Prince seemed to be using these sessions to assuage tensions within the group. But as they continued it became clear that he wanted to reclaim the album for himself.

By May 1986 the Hit & Run shows had begun to take off, and the original members of The Revolution once again found themselves sidelined by new members. Arguments between Prince, Melvoin, and Coleman were exacerbated by the fact that Prince's relationship with Melvoin's twin sister, Susannah, was falling apart, leaving Wendy stuck between her boss and her sister.

Keen to avoid any further conflict, Prince worked on in the studio alone. By the end of June he had assembled enough material to expand *Dream Factory* to a 19-track double album featuring lengthy solo tracks such as 'Crystal Ball' and 'Movie Star.' At one point he even reportedly considered turning the project into a Broadway musical about the trappings of fame.

On July 18 Prince had a final master of *Dream Factory* pressed. The artwork, which was designed by Susannah Melvoin and included a space for each member of The Revolution to draw something to represent him or herself, seemed to suggest that this was very much a group record, but many of the truly collaborative songs – including 'Sexual Suicide,' 'Big Tall Wall,' and 'Teacher, Teacher' – had been removed and replaced by solo recordings (some of which would later resurface on *Sign "O" The Times*).

The Revolution felt foxed again. Midway through the Parade tour it became clear that these would be their last shows together. But by then Prince was already thinking about shelving *Dream Factory* and moving on to something new.

Although the album that rose from its ashes, *Sign "O" The Times*, is widely considered to be among Prince's finest works, *Dream Factory* could have been even better. It would

Wendy Melvoin was one of Prince's closest collaborators during the *Dream Factory* sessions.

certainly have been his most eclectic record. The tentative sessions during 1984–85 from which Prince picked up rock, pop, and jazz influences from his bandmates here reached their natural conclusion, with the band hitting new creative peaks all the time. Perhaps their greatest moment together came with the recording of 'Power Fantastic' at Prince's home studio. As Alan Leeds writes in the liner notes to *The Hits/The B-Sides*, "Lisa Coleman found herself playing the grand piano in the upstairs living room while the rest of the band huddled in the basement studio. Connected only by mics and earphones, The Revolution still managed to pull off the exquisite song in a single take – even the jazzy intro that Prince suggested just as tape was ready to roll."

There weren't too many other moments like this on the final version of *Dream Factory*, but Prince was still wise enough to hold onto the group recordings of things he couldn't do alone. Lisa Coleman's solo-piano piece, 'Visions,' is about as low key an opener as one might find on a Prince record, but contrasts well with what follows: the squelchy funk of the title track, on which Prince – in his sped-up 'Camille' voice – renames Hollywood "Holly Rock" and describes fame as a dream factory, designed to keep you unaware of reality. Elsewhere, 'Strange Relationship' has an Eastern psychedelic feel that's missing on the *Sign "O" The Times* version, and 'All My Dreams' takes the carnivalesque sound of *Parade*'s opening tracks to its logical conclusion.

Despite being a sprawling double-album, *Dream Factory* is brighter and more cohesive than *Sign "O" The Times*. The material set for inclusion on it spanned the length and breadth of Prince's abilities, from 'Movie Star,' a hilarious spoken-word piece about a Morris Day-like character trying to woo clubbers with his looks, to 'Crystal Ball,' a nine-minute run through jazz, funk, and reggae that sounds more like a mini-album than a single song. Written in the wake of Prince's sudden return from France following America's air raid on Libya in April 1986, 'Crystal Ball' reprises the '1999' theme of partying in the face of death – or, in this case, staying close with an expert lover who draws "pictures of sex" on the walls.

Much of the solo *Dream Factory* material later appeared in altered form on either *Sign "O" The Times* or the three-disc outtakes collection *Crystal Ball*. But the fact that nobody got to hear it as it was originally intended – alongside the last gasps of The Revolution – is a travesty. *Dream Factory* proved exactly how important the group were to Prince's artistic growth, and could well have had an even greater impact than *Sign "O" The Times*. Not one to look backward, however, Prince let the *Dream* fade away, and turned instead his attention to a new, semi-collaborative project, Madhouse, and the eventual follow-up to *Parade*.

AFTER SACKING THE REVOLUTION IN OCTOBER 1986, PRINCE FOUND HIMSELF ALONE, MUSICALLY SPEAKING, FOR THE FIRST TIME SINCE 1978. WITH *DREAM FACTORY* ON THE SHELF AND HIS NEW PAISLEY PARK STUDIO COMPLEX STILL NOT COMPLETE, HE WENT BACK DOWN TO HIS BASEMENT STUDIO TO START UP A NEW PROJECT WITH ONLY SUSAN ROGERS FOR COMPANY.

Sign "O" The Times

(OCTOBER 1986–SEPTEMBER 1987)

The recordings Prince made after that would prove to be a lot darker than the *Dream Factory* songs, suggesting that he had been deeply affected by the loss of The Revolution and arguments with Susannah Melvoin – and also perhaps the fact that sales of his albums continued to slip, despite the ever-increasing critical fervor with which they were greeted.

Prince's response to all of this, of course, was to retreat into the studio and let his anger manifest itself on tape. Within ten days he had completed work on an album called *Camille*, which had its roots in 'Erotic City,' the B-side to his 1984 single 'Let's Go Crazy.' Prince had figured out a way of recording high-pitched vocal tracks by slowing the tape down, singing in real time, and speeding it back up. The result made it sound like he had recently ingested a large quantity of helium.

Prince used the effect again on 'Dream Factory' to ask the question: "Got any dreams you ain't using?" The voice fascinated him to the extent that he decided to give it the name Camille. Although he has never quite admitted it, it seems likely that Prince took it from the nickname of the

19th-century French hermaphrodite Herculine Barbin. (When an interviewer for Yahoo! put it to him that his brother believed this to be the case in 1997, Prince replied simply: "Your brother is very wise.") Prince's plans for Camille even extended at one point to a movie, for which he planned to play both himself and his high-pitched alter ego.

While messing around with Camille in the studio in late October, Prince recorded a new song that set James Brown-style horn and guitar riffs against murky, hollow-sounding drums. 'Housequake' would become an important signifier of his continuing musical evolution. "It came at a time when there were other changes in his life," Susan Rogers recalled. "'Housequake' represented a new [style of] dance music for him."

With 'Housequake' in the bag, Prince quickly cut a whole album's worth of Camille material. By November 5 a self-titled album (to be credited to Camille, not Prince) was ready for mastering. A 'Housequake'/'Shockadelica' test pressing went out to clubs soon after that – partly so that Prince could get 'Shockadelica' out there before Jesse

Johnson's album of the same name was released – but the album ended up being shelved almost as quickly as it had been made, despite it already having a catalog number and artwork (a stick drawing of a man with crosses for eyes).

◼ "Concepts for albums were coming to him almost as quickly as the songs were." *ALAN LEEDS*

His work on the project wasn't entirely in vain, however. 'Rebirth Of The Flesh' aside, all of the *Camille* songs resurfaced in some form or other, either on *Sign "O" The Times*, as B-sides, or on the soundtrack to *Bright Lights, Big City*.

Prince's reasons for scrapping *Camille* aren't clear, but it's likely that he had concerns about the commercial viability of the project. With sales of his recent albums dropping incrementally, he knew that he needed to come up with a sure-fire hit this time around – particularly with The Revolution gone, and all eyes on him alone. He

needed to show that he had grown as a musician, and that he hadn't needed The Revolution to get where he was. Picking up the pieces of *Dream Factory* and *Camille*, Prince decided that his next release would be his defining statement: a three-LP set called *Crystal Ball*, with the song of the same name as its centerpiece.

Continuing at the same frantic pace that had yielded *Camille*, Prince had completed the 22-track triple album by November 30 and promptly sent Steve Fargnoli to play it to Warner Bros. "He knew that just having the balls to do three records would create a big bang," Alan Leeds noted. It did, of course, but the 'bang' was more destructive than creative. Having made concession after concession for Prince up until now, the label baulked at the idea of putting out a triple album.

Prince's attitude, as Alan Leeds recalled, was: "Don't mess with me, this is it!" But this time Warner Bros flatly refused. Prince might have been the label's most creative artist, but that wasn't enough to justify the expense of putting out a three-record set. It would be too costly to produce, and too expensive for the casual fan to want to buy. Already concerned by the rate at which Prince put out new albums – which confused casual buyers and made it virtually impossible to maximize their commercial potential – Warner Bros refused to agree to release an album that seemed to be aimed only at critics and die-hard fans. Chief executive Mo Ostin insisted that the album be no longer than a double, forcing Prince to cut down his carefully constructed masterpiece.

This was the first real feud between label and star, but is indicative of problems that would emerge down the line. As far as Prince was concerned, Warner Bros had no business telling him what to do with his art. Despite losing interest in what *Crystal Ball* ended up being almost as soon as it was completed, he retained a bitterness about the overall situation for much longer. "I delivered three CDs for *Sign 'O' The Times*," he said in 1996. "Because people at Warner were tired, they came up with reasons why I should be tired too. I don't know if it's their place to talk me in or out of things."

As 1986 came to a close, Prince had lost his biggest Battle to date with Warner Bros, watched Susannah Melvoin walk out of his door for the last time, and been forced to trim his masterpiece by 30 per cent. Stripping away the lengthy 'Crystal Ball' along with several *Camille* songs and others dating back to *Dream Factory*, Prince pushed 'Sign "O" The Times' up to the front and made it this new, slimmer album's title track. (The songs featuring sped-up vocals are, of course, still credited to Camille.)

The only new addition was the second disc's hard-rock opener, 'U Got The Look,' which Prince recorded in December, and which went on to become one of his most successful singles. But had it not been for Sheena Easton, who happened to visit Prince while he was working on it, the song might never have been completed. Prince had been struggling to get the song right until Easton turned

up and added her vocals. (Her presence on the record – and in the accompanying promo video, which was shot during a day off in Paris in June 1987 – led to speculation that she had become yet another one of Prince's girlfriends.)

Sign "O" The Times was finished by the middle of January 1987, and released on March 30 to some of the strongest reviews Prince has ever received. Unaware that it had once extended across an even wider musical terrain, critics fell over themselves to praise the album's diversity, scope, and musicianship. "Prince's virtuoso eclecticism has seldom been so abundantly displayed," exclaimed *Rolling Stone*. For the *New York Times*, "Prince isn't just rearranging ordinary songs; he's started to warp the songs themselves."

The *New Musical Express* was slightly more cautious. Noting that some of the tracks on side one sounded like demos, the paper nonetheless concluded that, while this might signal the end for any other artist, for Prince it could "only enhance" a career that has "so far been brilliantly stage-managed." There were still a few criticisms from elsewhere: some reviewers simply found the whole thing too eclectic for its own good, suggesting perhaps that trimming down *Crystal Ball* hadn't been quite so bad an idea after all.

The *Sign "O" The Times* jacket shows a more mature-looking Prince on the set of a local production of *Guys & Dolls*. He has his musical equipment set up in front of fading city lights screaming about Drugs, Arcades, and Girls Girls Girls, suggesting that he had decided to put music before the rock'n'roll lifestyle. In contrast with the backdrop, Prince himself is out of focus, staring out into space, leaving his sex-obsessed past behind him. One rather pointed addition, however, is the glowing, purple crystal ball sitting on top of the drum riser – a clear sign that he had not yet forgiven or forgotten Warner Bros' decision to veto the original triple-album concept.

Such personal messages would of course have been lost on the casual buyer, who would have had no choice but to marvel at this two-disc magnum opus. As he had with *1999*, Prince chose to open the record with a note of social commentary, but 'Sign "O" The Times" is no call to hedonistic arms. Over a sparse drum pattern, Prince makes reference to AIDS, gang violence, and drug addiction. "Some

say a man ain't happy," he concludes, "unless a man truly dies."

'Sign "O" The Times' was the most mature statement Prince had yet made, but it also served to wrong-foot his audience. It's not until 'The Cross' – two thirds of the way through the second disc – that he returns to the world outside of his usual themes of sex, love, and partying. The way he treats these themes, however, marks *Sign "O" The Times* out as a much more mature work than anything that came before it. Alongside typical tales of lust – 'Hot Thing,' 'It,' 'U Got The Look' – Prince deals with the breakup of his relationship with Susannah Melvoin in a much more honest, conflicted manner than might have been expected. Having closed disc one with 'Forever In My Life''s declaration that "I wanna keep U 4 the rest of my life," he then goes on, in 'If I Was Your Girlfriend,' to express his jealousy at the close bond between the Melvoin sisters, asking, "Would U run 2 me if somebody

"What people were saying about Sign "O" The Times was: 'There are some great songs on it, and some experiments on it.' I hate the word 'experiment.' It sounds like something you didn't finish." PRINCE

hurt U / Even if that somebody was me?" Then, on the aptly named 'Strange Relationship,' he admits he "can't stand 2 see U happy," but also "hate[s] 2 see U sad."

Sign "O" The Times does more than just play out the demise of a relationship: it gave Prince the chance to show the world exactly what he was capable of musically. At its best, the album can be seen as the culmination of everything Prince had done – and been exposed to – previously, without ever betraying his musical roots. As *Q* magazine put it, the album's funk edge "slices straight through the white gut of pop."

'Housequake' and 'It's Gonna Be A Beautiful Night' (the latter recorded live in Paris with The Revolution in 1986) are the album's funkiest moments, while the likes of 'Play In The Sunshine' and 'I Could Never Take The Place Of Your Man' offer up perfect pop-rock for the mainstream. For all its brilliance, *Parade* betrays

All That Jazz

The emergence of Madhouse marked a change in the way Prince approached his side projects, which he had previously used as a means of maintaining his standing in the R&B world while his own work veered off in ever more experimental directions. This time however his intention was to explore new ideas that didn't fit on his solo records.

By the mid 80s Prince was becoming increasingly interested in jazz, as evidenced by his shortlived experiments with The Flesh and his collaboration with Miles Davis. Having scrapped plans for a fully collaborative jazz record, he spent four days at the end of September 1986 recording a jazz-funk album by the name of *8*, with contributions from Eric Leeds (saxophone and flute) and Matt Fink (a few synthesizer solos).

The album was released on January 17 1987 and credited to Madhouse, with no other names anywhere on the jacket. While in the past Prince had left clues to his involvement in records by The Time, Vanity 6, and others, he was keen this time to distance himself from the project completely, either out of a genuine wish to let the music speak for itself, or because he feared a backlash from 'serious' jazz critics.

He was right to be wary: *8* demonstrates only a superficial understanding of how jazz works, and is far too regimented – because Prince played most of the instruments himself – to sound truly improvised. By comparison to Miles Davis's late-60s and early-70s fusion work on albums such as *Bitches Brew* and *On The Corner*, *8* is incredibly tame.

Nonetheless, it didn't take fans long to recognize the Prince sound and buy enough copies to push *8* – a completely instrumental oddity – to Number 25 on

Billboard's R&B chart, and Number 107 on the Pop chart. One of its eight numbered tracks, 'Six,' then reached Number Five on the R&B singles chart.

Prince took his new side project out on the road with him as the featured support act on his European Sign "O" The Times tour. Keen to mask their identities as much as possible, Madhouse performed in sunglasses and hooded black robes. (Prince would even step out to play drums with them from time to time.)

For the second Madhouse album, *16*, Prince brought in drummer John Lewis as well as Eric Leeds, Levi Seacer Jr, and Matt Fink from his live band. Released on November 18 1987, *16* had more of a harder-edged group dynamic than its predecessor, but failed to make as much impact. The single 'Ten' stalled at Number 66 on the R&B chart, while the album itself didn't chart at all.

Since then Madhouse has been stuck in a kind of limbo, with Prince recording several prospective *24*s over the years. A ten-day session with Eric Leeds in December 1988 yielded eight more tracks, each with subtitles such as '17 (Penetration)' and '18 (R U Legal Yet?),' but none were released. ('21' to '24' were grouped under the name 'The Dopamine Rush Suite.')

In July 1993 he made another attempt, bringing in Eric Leeds and various members of the New Power Generation – Michael Bland on drums, Levi Seacer Jr on guitar, and Sonny Thompson on bass. The only numerically titled track, '17,' later appeared on the compilation album *1-800-NEW-FUNK*, but Warner Bros had no interest in putting out the likes of 'Asswoop' and '(Got 2) Give It Up.'

A few years later, Prince reportedly

reworked some of his *Kamasutra* album (as included alongside 1997's *Crystal Ball*) as a third Madhouse record. But although a couple of tracks surfaced in 1998 and 2001, a full third Madhouse album has never appeared.

The two surviving Madhouse albums are not masterpieces in any sense, but are interesting because of their dissimilarity to anything else in Prince's 80s output. But if this is the best jazz-fusion that Prince could offer, it's clear that he had only just begun to scratch the surface of what Eric and Alan Leeds had been introducing him to. Listening to *8* and *16*, it becomes clearer why Prince might not have wanted to collaborate directly with Miles Davis (as oposed to trading tapes): he was simply no match for a real master of the genre.

Prince's struggle to harness new sounds and styles that he wasn't yet familiar with. On *Sign "O" The Times* he seemed to have mastered them effortlessly, shifting with ease from rock to psychedelia to funk to jazz, all the while maintaining his role as the world's leading loverman. (The closing 'Adore' is one of his greatest ballads and a vocal tour de force with overlapping harmonies that are among Prince's most complex.)

Sign "O" The Times is a perfect blend of Prince's own formative influences and the new musical worlds he had been introduced to by The Revolution. In many ways it is his equivalent of Sly & The Family Stone's *There's A Riot Goin' On*: a masterpiece built on a foundation of subdued, murky funk, and the culmination of a creative surge that would never again be repeated.

Part of the album's unusual feel stems from Prince's acceptance of happy accidents. A snowstorm caused a power shortage during the recording of 'The Ballad Of Dorothy Parker' (a song Prince claimed to have written in a dream, but which seems to reflect his arguments with Susannah Melvoin). When the power came back, Prince carried on recording, but the sound desk wasn't yet back to full power. "Half the new console wasn't working," Susan Rogers recalled, "[and] there was no high end at all." But rather than try to rework or remix the song, Prince stuck with the supposed imperfections of the recording, willing perhaps to accept it as a sign of good fortune from a higher power.

The same was true of the recording of 'If I Was Your Girlfriend.' The distortion on Prince's voice wasn't

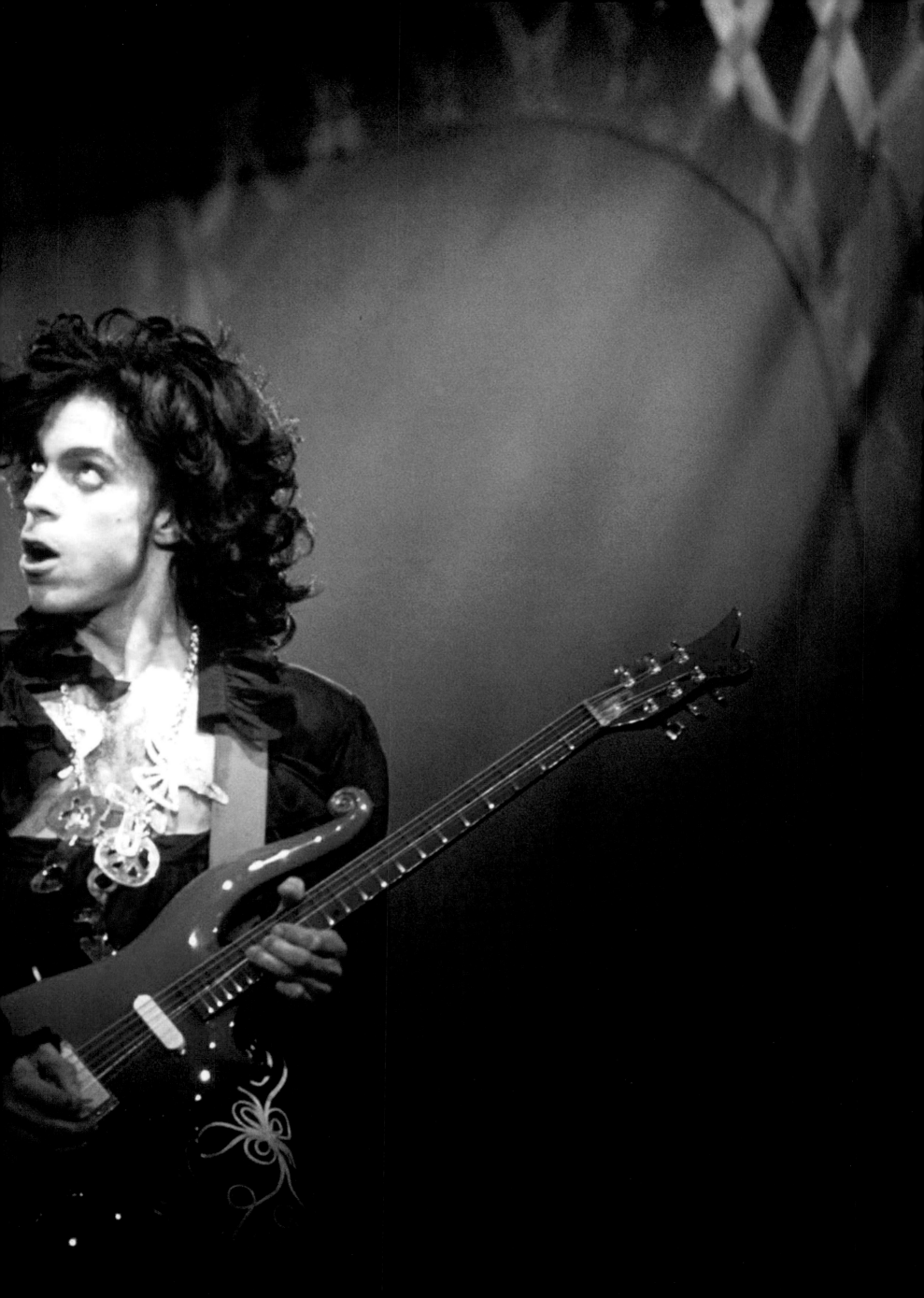

introduction by Ingrid Chavez (billed as Spirit Child), a rap by Cat Glover, and some of the more complex drum tracks (played by Sheila E.). So strong was his belief in this new work that he had begun rehearsing his band for a Lovesexy tour before Warner Bros had heard a note.

When it came to presenting the album to the label in March, Prince once again arrived with a series of awkward demands. This time around, instead of wanting to have a plain black jacket, he enlisted Jean Baptiste Mondino (his original choice of director for *Under The Cherry Moon*) to photograph him sitting naked on a large flower. There he sat, staring out as though in a trance, his genitalia covered only by a raised thigh. Warner Bros was concerned that

"I don't think Prince ever directly explained Lovesexy. But casual conversations with some of us revealed a lot." ALAN LEEDS

some stores would refuse to stock the album, which did prove to be the case, even though the imagery is rather more passive than the covers of *Dirty Mind* and in many ways even *Purple Rain*. For Prince, however, there was nothing to be concerned about. "All that album cover was, was a picture," Prince told *Rolling Stone* in 1990. "If you looked at that picture and some ill came out of your mouth, than that's what you are – it's looking right back at you in the mirror."

Further headaches ensued when Prince announced that the nine-track CD should be presented as a single 45-minute piece, without track breaks. To him, of course, this was just another way of ensuring that the listener appreciated his art as a single entity, not as a collection of songs. To Warner Bros, however, it was another way of alienating the casual fan. (Prince got his way, although later pressings of the album are split into individual tracks.)

Prince had also decided that, as with *Around The World In A Day*, the album should be taken on its own artistic merits, and thus released without the accompaniment of promo videos or anything else that might diminish the air of mystery around it. It was fast becoming clear that, while still a bona fide musical genius, Prince had begun to lose his business savvy. Thankfully, he eventually relented and made a promo video for 'Alphabet St' – but only at the 11th hour, resulting in Alan Leeds having to scrabble around to find a director at short notice on a Sunday morning. The result was a quickly dated, blue-screened affair that sees Prince dancing and driving his "white rad ride" through a dense fog of letters which, at one point, spell out the phrase, "Don't buy *The Black Album*, I'm sorry." (Somewhat ironically, given Prince's recent attitudes toward hip-hop, 'Alphabet St' features a rap by Cat Glover.)

As far as Prince was concerned, *Lovesexy* was his most

intensely personal album yet. Most critics agreed, but were unsure exactly what conclusions to draw from the battle between sex and religion expressed in the songs. Even those closest to Prince weren't entirely sure what to make of it. The *St Paul Pioneer Press* described it as "a hasty note from a troubled soul," while *Rolling Stone* saw fit to exclaim that "the hardest questions may not lend themselves to easy answers, but make for much better music." Others were more cagey, with the *Detroit Free Press* suggesting that it "may take some time for listeners to get a handle on."

Most of the strengths and weaknesses of *Lovesexy* stem from the fact that it came from such an honest splurge of this-is-what-I-am-thinking recording. As Alan Leeds later noted, Prince responded to "an unpleasant reality" in the same way he always did: by "construct[ing] a reality of his own." In this case, having reached a low ebb and apparently unnerved himself with the darkness of *The Black Album*, he had found religion. Luckily for Prince, this particular religion was one that allowed him to reconcile his sexual and spiritual feelings with ease; one that allowed him to sing about "drippin' all over the floor" ('Lovesexy') and bodies jerking "like a horny pony" (Alphabet St) while also exclaiming, "Love is God, God is love" ('Anne Stesia').

Elsewhere on the album, the likes of 'Dance On' and 'Positivity' mark a return to socio-political concerns, notably gang warfare, while 'Anna Stesia' can be read as a direct acknowledgment of Prince's loneliness and need for salvation. The opening 'Eye No,' meanwhile, welcomes listeners to "the New Power Generation," which marks his first use of the term.

Musically, however, there was nothing particularly new about *Lovesexy*. The beats might have been harder and more complex than before – evidence of the fact Prince had become a semi-regular fixture on the Paris and London club scenes – but by now it was hardly surprising to hear a blend of different musical styles on a Prince record. The main talking point here concerned whether or not Prince had forgotten how to write tight, structured, melodic songs, or whether he had deliberately wanted to try to create one long movement. His insistence on a 'one track' CD suggests the latter, as does his later declaration that the album was intended to be "a mind trip, like a psychedelic movie." There are some neat production tricks throughout, too, not least the way Prince and either Glover or Sheila E.'s vocals mutate into Prince's own voice on the title track.

Prince himself was clearly happy with how *Lovesexy* turned out, but it sold only 750,000 copies, making it his least successful album since his debut, *For You*. It remains a firm fan favorite, although there is still some debate as to whether it marks a final creative peak or the start of a slow, steady decline into mediocrity. Its failure to sell irked Prince, who clearly felt that his most honest work to date should have been received with unparalleled enthusiasm.

It's unlikely that releasing *The Black Album* would have

made a difference to Prince's overall career path. But it might have helped reassert his dwindling credentials in the R&B world, and held a slightly broader appeal, but still showed no real progression or departure from what came before. Both albums were simply consolidations of old tricks – it just depended which tricks listeners preferred.

Even after *Lovesexy* struggled in at Number 11, Prince refused to believe that his most personal concept to date could fail, and had begun to plan the most extravagant tour of his career. Until now he had worked with neat, economical stage sets. The Controversy and Triple Threat tours made much of a simple set of ramps, lights, and a fireman's pole, while the Sign "O" The Times stage set was essentially a large-scale reproduction of the album art.

The Lovesexy set, however, took in swings, a miniature basketball court, and a set of hydraulics that would lift its star up toward the roof during the 'spiritual rebirth' part of 'Anna Stesia.' It cost two million dollars even before the costumes were made and a 90-person team brought in to run the show. Then there was the wireless technology required for the band to be able to get around the massive stage, not to mention the three-quarter-scale '67 Thunderbird Prince had built – at a cost of $250,000 – to take him to and from the stage. One final extravagance was nixed in the planning stage. "There was also supposed to be a fountain that poured hundreds and hundreds of gallons of water down into the center of the stage," recalled set designer Roy Bennett. "That would have been a very short show."

As well as generating the vast expense of building, storing, and transporting the stage set, Prince put his band on the payroll for six months of rehearsals before the tour had even started. He then took the crucial decision to switch the tour around right before it was due to kick off, scrapping the American leg in favor of taking the show to Europe, where *Lovesexy* was performing much more strongly. As with the Sign "O" The Times tour, however, it would surely have been more prudent to try to boost the album's performance at home first rather than allow it to sink even further down the charts. Switching territories at the last minute incurred all manner of costs, suggesting once again that Prince had lost his business sense.

From a musical perspective, however, the Lovesexy tour was as astounding as it was ambitious. Played in the round, it was set up to tell the good-versus-evil story of Prince's spiritual awakening. After running through a greatest hits set of earlier, sex-obsessed songs – 'Erotic City,' 'Jack U Off,' 'Dirty Mind,' and so on – Prince (as Bob George) would be shot down by a fleet of policemen. Then, after an extended reading of 'Anna Stesia,' during which Prince would literally be taken higher and higher into the arena, bathed in golden light, the show turned into a celebration of *Lovesexy*, with a smattering of old favorites such as 'When Doves Cry' and 'Purple Rain.' (When the accompanying tour movies, *Livesexy 1* and *Livesexy 2*, were released on VHS, the sets were reversed, giving the *Lovesexy* songs prominence.)

By the time the Lovesexy tour made it to the USA in September, Prince fans seemed to be losing interest in *Lovesexy* and the man himself – somewhat surprisingly, given that he had not been out on a full-scale tour of the country since 1985. It all ended up being reminiscent of the Dirty Mind tour, with sell-out crowds in Prince strongholds such as New York and Detroit, followed by a struggle to half-fill arenas elsewhere.

The US leg of the tour ended in November 1988. More than ever before, Prince was in need of a hit. As he sat at home in the months before an eight-date Japanese tour schedule for February 1989, he found his focus returning to an idea he had drafted more than a year earlier. After years of trying to escape it, he was beginning to come around to the idea of making a *Purple Rain Mk II*. But before that project got off the ground, another sure-fire commercial hit landed in his lap, attached to another movie project which, tellingly, wasn't one of his own.

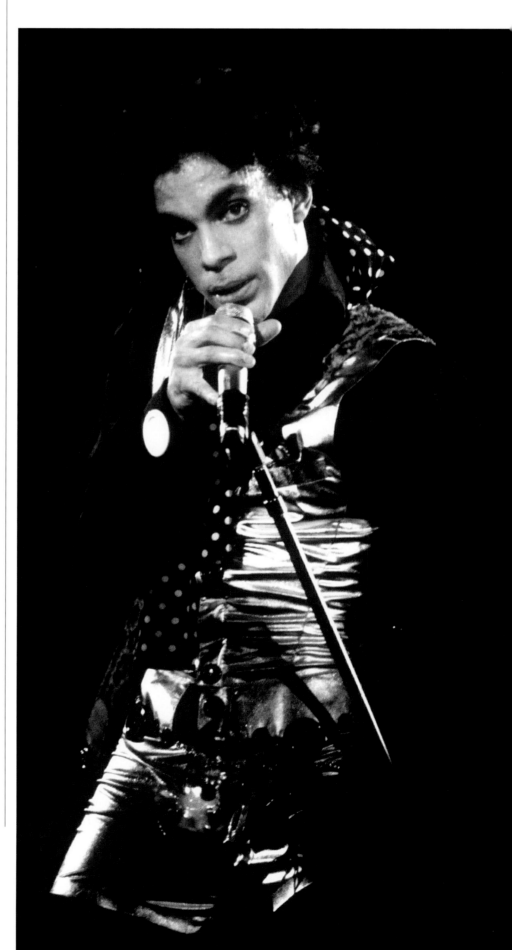

FRUSTRATED BY THE RESPONSE TO *LOVESEXY*, PRINCE TURNED HIS ATTENTION AT THE END OF 1988 TO HIS ATTEMPTS TO RESURRECT A PLAN FOR *GRAFFITI BRIDGE*, A BIG-SCREEN FOLLOW-UP TO *PURPLE RAIN*, BUT ONCE AGAIN PROGRESS WAS FAR FROM SMOOTH. FOLLOWING DISAGREEMENTS ABOUT HOW TO PROCEED WITH THE PROJECT, HE SACKED HIS LONG-STANDING MANAGEMENT TEAM OF CAVALLO, RUFFALO & FARGNOLI AND BROUGHT IN ALBERT MAGNOLI, THE DIRECTOR OF *PURPLE RAIN*, TO HANDLE HIS AFFAIRS INSTEAD.

Batman (JANUARY 1989–JUNE 1989)

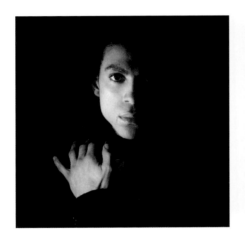

Magnoli knew he had a difficult job on his hands. Prince was desperate to re-establish himself as a creative force within the movie industry and repeat the commercial success that had eluded him since *Purple Rain* – and thus halt an alarming financial freefall, exacerbated recently by the losses made on the Lovesexy tour and the hefty severance packages paid to Cavallo, Ruffalo & Fargnoli. Fortunately for all concerned, Magnoli's first move was a masterstroke (or at least a slice of extremely good luck).

In October 1988 Warner Bros Pictures had started shooting the first serious big-screen adaptation of *Batman* with goth-lite director Tim Burton at the helm. While putting together rough edits of some early footage, Burton had used '1999' and 'Baby, I'm A Star' to backdrop specific scenes. Prince's songs worked so well that Burton got in touch with Magnoli to see if the singer would be interested in contributing to the soundtrack. (His original scheme was for Michael Jackson to soundtrack the 'light' side of the movie, with Prince providing the 'dark' songs, but that didn't last for long.)

Prince wasn't sure about the idea at first, but flew out to London in January 1989 to meet Burton on the Gotham City set at Pinewood Studios. Suitably impressed by a 20-minute showreel – and, some have suggested, a meeting with Kim Basinger – Prince decided to put his own movie plans on hold and work on the *Batman* soundtrack instead. The fact that one of the first songs he learnt to play on his father's piano was the original 60s *Batman* theme would have helped – as indeed would the reported commissioning fee of one million dollars. So enthusiastic was Prince about the project, in fact, that he tried to cancel the Japanese leg of the Lovesexy tour in order to get straight on with it, but was convinced otherwise.

On his return, Prince spent six weeks in February and March working on songs for the soundtrack. Despite having originally been asked only to 'contribute,' he presented Burton and Warner Bros with a full eleven-track album. Deciding that the *Batman* brand had enough commercial clout to warrant both a Prince soundtrack and an instrumental score by Danny Elfman, the company gave him the green light. Burton, however, rejected two of

The *Batman* songs 'Electric Chair' and 'Trust' were intended to represent The Joker, played in the movie by Jack Nicholson.

the songs Prince had recorded, '200 Balloons' and 'Rave Unto The Joy Fantastic.' Prince subsequently released '200 Balloons' as the B-side of 'Batdance,' but ended up hanging on to 'Rave' until 1999's *Rave Un2 The Joy Fantastic* LP.

The final nine-track *Batman* album went on sale on June 20 1989, three days before the movie opened in the USA. Those who bought it after having seen the movie might have been slightly confused by its contents, however: only 'Partyman' and 'Trust' appear prominently in the movie, while 'Scandalous' (co-written by Prince's

"The one-man band from Minneapolis knew from the get-go that Batman ... was going to be the biggest tie-in this side of shoelaces." ROLLING STONE

father, John L Nelson) plays over the second half of the end credits. Nothing more than snippets of the other tracks were used, suggesting that Prince's over-enthusiasm might have gotten the better of him.

Batman is hardly a great piece of work and, while some reviews praised its commercial appeal, others were quick to note a distinct lack of major artistic progression. The stripped-down funk sound is closer to *The Black Album* than *Lovesexy*, but despite Prince's efforts to interject the psychological quirks of Batman/Bruce Wayne and The Joker into most of the songs, there are no great stretches of the imagination (except perhaps for Kim Basinger's moans of pleasure on 'Scandalous').

Rolling Stone was correct to assume that some of the songs had simply been "sitting around Paisley Park" and

not written specifically for the movie, since 'The Future,' 'Electric Chair,' and 'Vicki Waiting' all came from 1988 recording sessions. The song that Prince seemed to put the most effort in on is 'Batdance,' a dance-orientated collision of samples of movie dialogue and other songs from the soundtrack put together so meticulously – in the manner, somewhat ironically, of hip-hop acts such as Public Enemy – as to suggest that Prince had spent more time on it than anything else on the record.

Nonetheless, the success of the movie helped push the genuinely catchy singles 'Partyman' and 'Batdance' up the charts – the latter beat the *Ghostbusters II* soundtrack single 'On Our Own' by Bobby Brown to Number One – and resulted in the album selling more than four million copies, making it Prince's most commercially successful offering since *Purple Rain*. It also added him to a very select group of artists to have released two *Billboard* Number One soundtrack albums. The only downside, it seemed, was that Prince had had to agree to sign the publishing rights to the songs used in the movie over to Warner Bros, which means that only the single B-sides '200 Balloons,' 'Feel U Up,' and 'I Love U In Me' appear on the comprehensive compilation *The Hits/The B-Sides*.

For Prince himself, however, the commercial success of *Batman* was a mixed blessing. On the one hand, it must have irked him to some extent that something so commercially minded, throwaway, and unrepresentative of his true artistic vision had become such a big hit when albums much closer to his heart (particularly *Lovesexy*) were widely ignored. What he couldn't argue with, however, was the fact that *Batman* had re-established him as a commercial force in both the music and movie worlds after years of diminishing financial returns, giving him much greater clout when it came to convincing Warner Bros to back his *Graffiti Bridge* project.

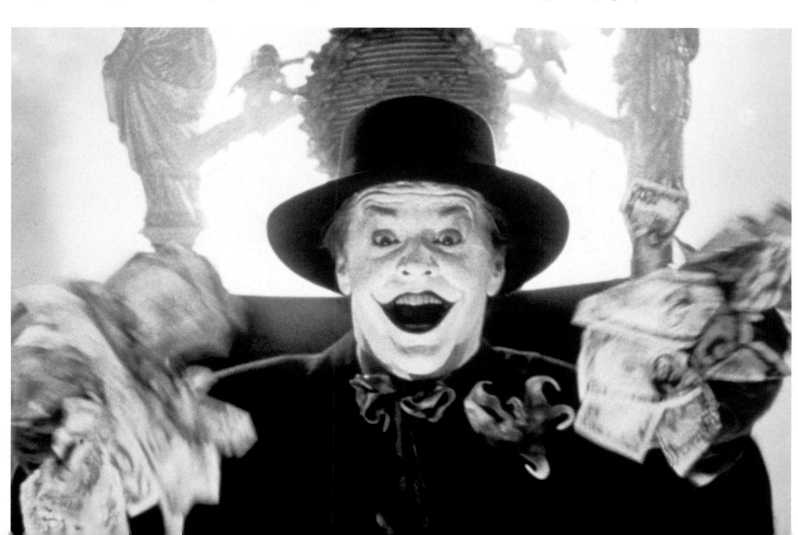

Lemon Crush: Prince And Kim Basinger

Prince has tended, over the years, to avoid having relationships with other public figures – except, of course, those involved in his various side-projects. What this tells us about him is open to interpretation, but it's interesting to note what happened when he tried to pull another star with a profile as high as his own into his orbit.

Prince met Kim Basinger in January 1989 at London's Pinewood Studios on the set of *Batman*, in which she plays the part of Vicki Vale. He fell so hard for her that some have suggested that her involvement in the movie is what really made him want to record the soundtrack. (It's not hard to imagine him relishing her seductive admission to The Joker: "I just *love* purple.")

Basinger had previously played the female lead in *9½ Weeks*, a steamy look at the dark side of relationships that was, perhaps unsurprisingly, one of Prince's

favorite movies of recent times. When it came time for her to join Prince in the studio to add her vocals to what is essentially a tribute to her, 'Scandalous,' the pair reportedly staged their own homage to *9½ Weeks*' sex-and-food shenanigans, leaving the Paisley Park engineers to clean honey off the mixing desk the following morning. (Basinger's contributions to the main edit of 'Scandalous' are limited to a few groans of pleasure, but the 'Sex Suite' mix includes a series of suggestive exchanges between her and Prince.)

The pair's relationship was strange and shadowy from the start. It was once rumored that Prince offered up as much as five million pounds to speed up Basinger's immediate divorce from make-up artist husband Ron Britton, while others have suggested that Prince had an almost hypnotic hold over her. She even sacked her manager and installed Albert Magnoli in his place. She also worked with Prince on a third draft of *Graffiti Bridge* and agreed to play the female lead – with Prince offering to record an album for her in return.

Then, almost as suddenly as the relationship started, it was over. Basinger left Paisley Park in January 1990, throwing another spanner into the *Graffiti Bridge* works. It's not entirely clear what happened between them, since almost every word spoken about the relationship is based on rumor and allegation. Perhaps the weirdest tale told is the one that claims that Basinger's family had become so concerned about her infatuation with Prince that they essentially had to kidnap her from Paisley Park. Whether this is true or not, Basinger did leave in such a hurry that she left her car in Prince's driveway. (He eventually had it towed.)

Neither party has said a lot about the affair since. In 1990, Prince told *Rolling Stone*, "I really don't know her that well." But he seems to have harbored feelings for her since, and even allegedly offered to help with the eight million dollar lawsuit she faced after pulling out of the movie *Boxing Helena* in 1993. (That year he also released 'Peach,' which is based around her distinctive moans and groans.)

"Holy hit singles, Batman!
Prince has done it again!"

DETROIT FREE PRESS (JUNE 19 1989)

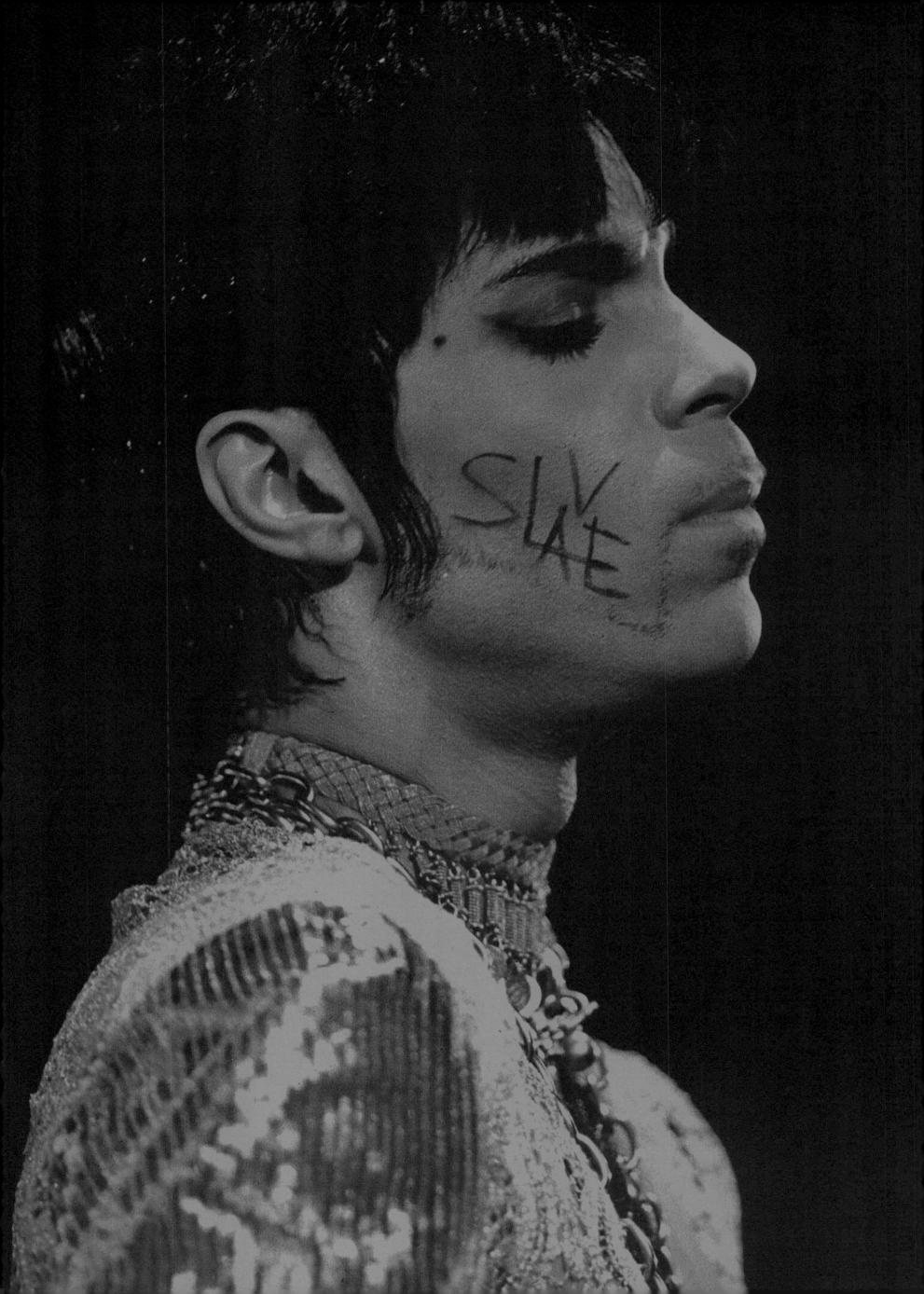

3

DESPITE STARTING THE DECADE WITH HIS SECOND BIG-SCREEN FLOP, *GRAFFITI BRIDGE*, PRINCE QUICKLY HIT ANOTHER PURPLE PATCH WITH *DIAMONDS AND PEARLS* AND THE SIGNING OF WHAT HE CLAIMED WAS A '$100 MILLION' DEAL WITH WARNER BROS. AS THE DECADE CONTINUED, HOWEVER, HIS STAR BEGAN TO FALL. HE BECAME EMBROILED IN A BITTER WAR WITH WARNER BROS AND ENDED UP CHANGING HIS NAME TO AN UNPRONOUNCEABLE SYMBOL IN AN EFFORT TO REDEFINE HIMSELF.

WHAT'S MY NAME?
1989–1995

AFTER THE WIDESPREAD FAILURE OF *UNDER THE CHERRY MOON*, IT TOOK PRINCE A LONG TIME TO GET THE FOLLOW-UP OFF THE GROUND. HE HAD BEEN CARRYING AROUND A TREATMENT FOR *GRAFFITI BRIDGE* – NAMED FOR A REAL MINNEAPOLIS LANDMARK – SINCE SEPTEMBER 1987.

Graffiti Bridge (JULY 1989–NOVEMBER 1990)

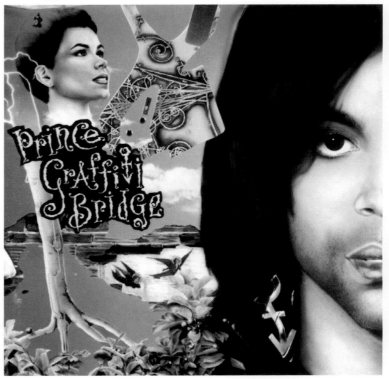

Back then the plan was for Madonna to play Ruthie Washington opposite Prince's Camille Blue. But when Madonna came to Paisley Park to look at the script she told Prince that it was terrible and that she wanted nothing to do with the project. (The pair did nonetheless collaborate on her 'Love Song,' later featured on her 1989 LP *Like A Prayer*.)

Similarly, Bob Cavallo assumed that the 20-page treatment Prince gave him in advance of a meeting with Warner Bros in December was a draft, and suggested hiring a professional writer to turn it into a screenplay. Prince of course felt that the 'draft' was all he needed, but for Cavallo it looked like a disaster waiting to happen. "He didn't really wanna work with us anymore," Cavallo later claimed, "but if I could have gotten that film made, I think he would have." As things stood, however, Cavallo didn't feel particularly inclined toward raising funds for a project that already seemed doomed to failure.

Prince's response to this, on December 31 1988, was to fire his entire management team, along with his lawyer and financial advisor. This would prove to be a big mistake. Cavallo, Ruffalo & Fargnoli – and Steve Fargnoli in particular – had played a crucial role in keeping Prince's career on track over the years. They had done all the fighting with Warner Bros on his behalf, and had managed to get him almost everything he wanted. Without them, Prince would find himself in a much weaker position at the negotiating table. Sacking his lawyers and financial advisors at the same time only exacerbated the problem, and left him in the position of having to install a new team at a time when his financial situation was less than buoyant.

Fortunately, Prince had recently been back in touch with *Purple Rain* director Albert Magnoli, who had shot some of the Lovesexy shows for a planned documentary, and whose movie-industry contacts would certainly be useful when it came to trying to get *Graffiti Bridge* made. (Unlike Cavallo, Magnoli seemed unconditionally supportive of the project – at least to begin with.) But while his loyalty was so far uncontested, Magnoli had yet to prove himself able to turn around Prince's deteriorating financial situation and do battle with Warner Bros.

Magnoli's first move as Prince's manager – getting him

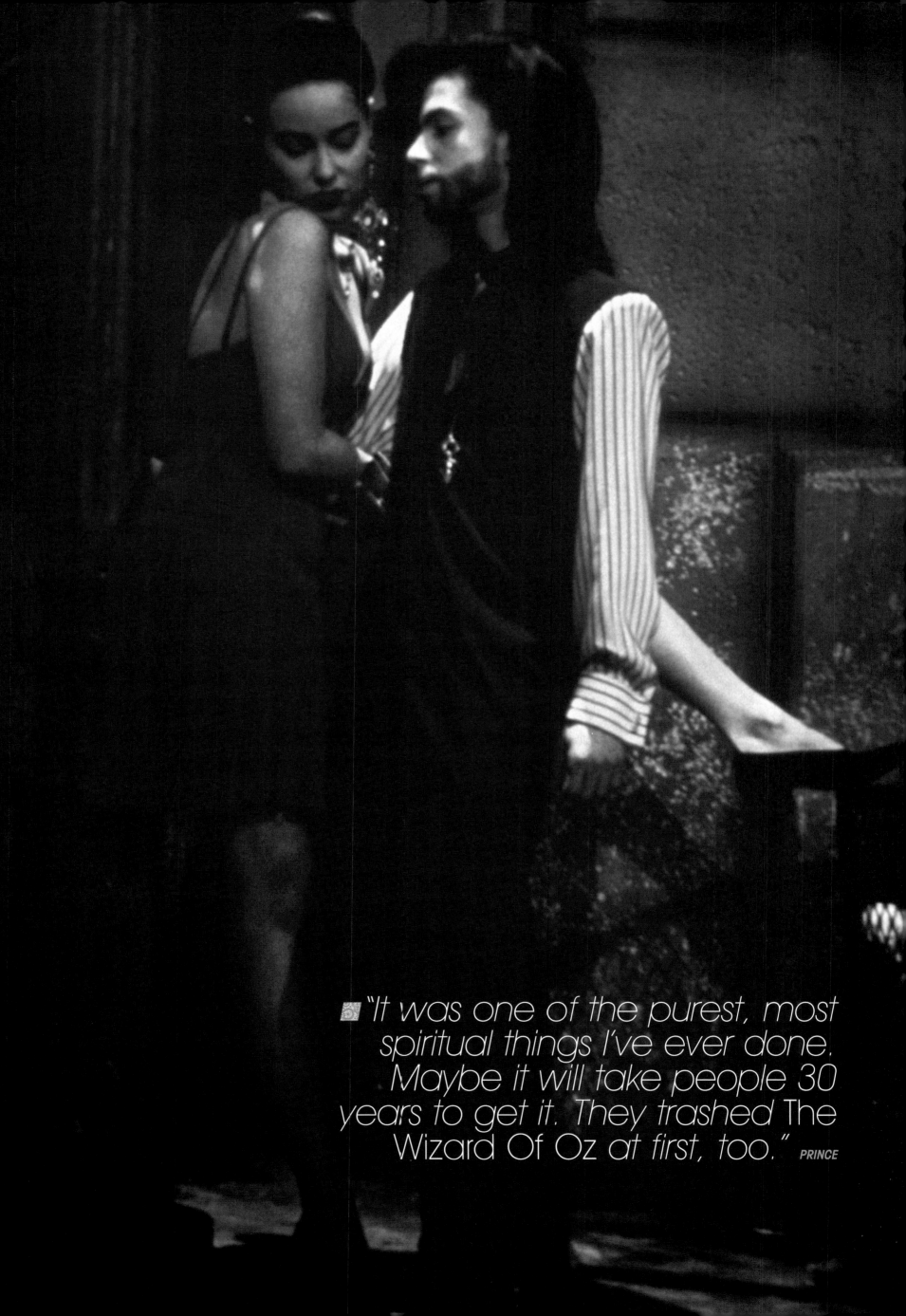

"It was one of the purest, most spiritual things I've ever done. Maybe it will take people 30 years to get it. They trashed The Wizard Of Oz at first, too." *PRINCE*

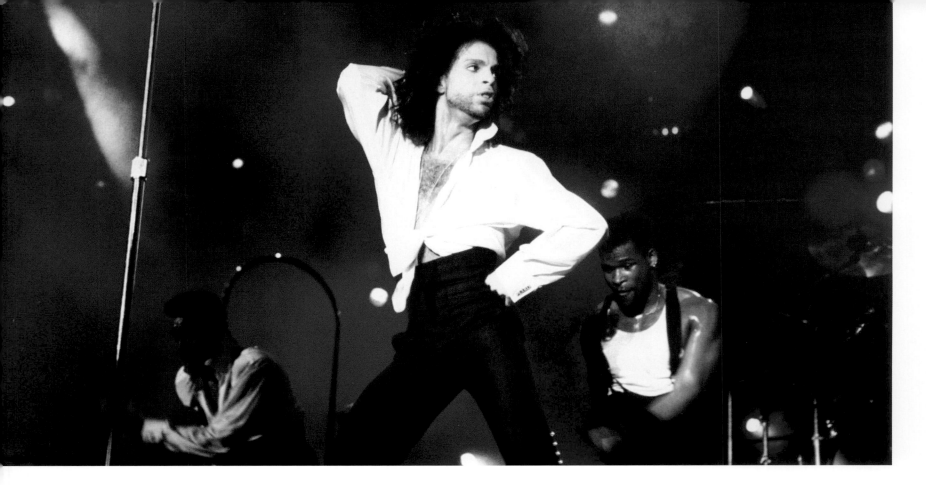

the *Batman* soundtrack – was hugely successful. It turned around a run of seemingly poor decisions – withdrawing *The Black Album*, replacing it with the poor-selling *Lovesexy*, and then going off on a loss-making tour – that had left Warner Bros feeling decidedly unsure about the idea of investing in another risky, big-budget project. But once Prince had proven he was still capable of multi-million sales, the company became more open to the *Graffiti Bridge* project – particularly now that it was being billed as a follow-up of sorts to *Purple Rain*.

Prince came away from *Batman* with a newfound commercial clout and Kim Basinger – whom he now planned to cast as *Graffiti Bridge*'s female lead – on his arm. But while Albert Magnoli was already talking about setting up a movie production company in partnership with Prince to "do projects that are diversified and take the entire gamut of entertainment," the singer was in fact still struggling to raise enough money for the first one. As 1989

"Graffiti Bridge *should be bronzed immediately and delivered to Hollywood's Hall Of Shamelessness, where it might draw bigger crowds than it's likely to at movie theaters."*

WASHINGTON POST

drew to a close, Magnoli started to feel the same way as Bob Cavallo had a year earlier.

"My idea for the film was for a higher-budget, more elaborate concept," he recalled. "But Prince wanted a lower-budget approach and to get the film out within a year. So I just said, 'Why don't you do that, 'cause I'm shooting for the moon here.'" And so it was that Prince found himself looking for his third management team in the space of a year.

This time he hired Arnold Stiefel and Randy Phillips, who had promised to secure the financial backing needed to make *Graffiti Bridge*. In what can be seen as an important shift in priorities, Prince now seemed to be hiring people who would tell him what he wanted to hear, not what he needed to hear. "He was beginning," recalled Warner Bros Vice President Marylou Badeaux, "to not listen to anyone who was not a 'yes' man."

In fairness to Stiefel & Phillips, they did make good their promise to secure seven million dollars of Warner Bros Pictures' money – exactly the same amount that Mo Ostin had put up in order to get *Purple Rain* off the ground. Warner Bros had been sold on the fact that the movie was set to reprise the feud between Morris Day and The Kid, and agreed to finance it on the condition that the original line-up of The Time would appear.

This didn't seem like it would be a problem. Prince had already started working with Morris Day and Jerome Benton on a new album called *Corporate World*, so could easily use those recordings as a springboard to The Time's *Pandemonium*. He was also able to convince Jimmy Jam, Terry Lewis, and Jesse Johnson to return on the basis that *Graffiti Bridge* would tell The Time's side of the story.

Unsurprisingly, however, the plot emphasis began to shift almost as soon as the movie entered production, and as seemed to be the case whenever Prince tried to make a movie, this one step forward was followed by another step back. Having split up with Kim Basinger in January 1990, he was left looking for a new female lead – just as had been the case when Vanity quit on the eve of shooting *Purple Rain*. Since his other on-off girlfriend of the past few years, Anna Garcia, had already packed her bags and flown back to Britain, Prince approached Ingrid Chavez, whom he had met

For the Nude tour Prince brought in a new hip-hop element in the form of The Game Boyz.
RIGHT Jerome Benton (left) and Maurice Day returned to reprise their *Purple Rain* roles in *Graffiti Bridge*.

IN DECEMBER 1990, SHORTLY AFTER COMPLETING WORK ON THE FOLLOW-UP TO *GRAFFITI BRIDGE*, PRINCE DECIDED ONCE AGAIN TO SHAKE UP HIS MANAGERIAL INFRASTRUCTURE. ONE MIGHT HAVE EXPECTED HIM TO RE-HIRE ARNOLD STIEFEL AND RANDY PHILLIPS, WHO HAD DONE A REASONABLE JOB FOR THE DURATION OF THEIR INITIAL 12-MONTH CONTRACT, BUT PRINCE SAW THINGS DIFFERENTLY.

Diamonds And Pearls

(DECEMBER 1990–JULY 1992)

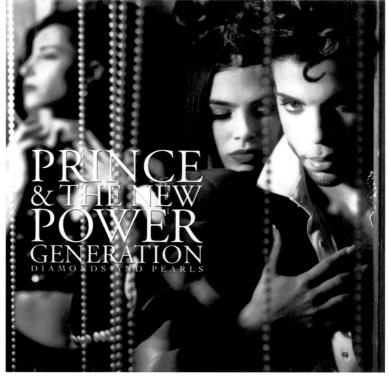

As far as he was concerned they had done what he wanted of them – securing financial backing for *Graffiti Bridge* – and could now be shown the door. When it came to replacing Stiefel and Phillips, Prince opted not to seek out professional businesspeople but to promote from within his already close-knit circle. And so it was that Gilbert Davison stepped up from head of security (a role he had inherited in 1985 from Chick Huntsberry) to manager and President of Paisley Park Enterprises, while press officer Jill Willis, formerly of the New York PR company Rogers & Cowan, was installed as Vice President.

Prince's touring band – now known officially as The New Power Generation – was given a similar overhaul. When Matt Fink told the singer that he wasn't available for two appearances at the Rock In Rio festival in January 1991, he found himself replaced by Tommy Elm, whom Prince rechristened Tommy Barbarella after the cult Jane Fonda movie. (The move was similar to the sacking of Jimmy Jam and Terry Lewis from The Time in 1983 in that Fink had been busy producing another band at the time.) Meanwhile, Levi Seacer Jr switched from bass to guitar, following the departure of Miko Weaver at the end of the Nude tour, and Sonny Thompson was brought in on bass.

Prince had planned to spend the early months of 1991 trying to drum up interest in his forthcoming *Diamonds*

> "Prince's music in the 90s suffered because, for the first time, he allowed outside trends to influence his work." *ALAN LEEDS*

And Pearls, but instead found himself distracted by other matters. On February 1 he was sued by his former managers, Cavallo, Ruffalo & Fargnoli, who claimed $600,000 in severance pay and damages for breach of

contract, fraud, and denial of contract in bad faith. Prince was also charged with ignoring his managers' advice since 1985 and continuing to flood the market with competing product (a claim that would perhaps have hurt the singer more than the others). He retaliated by suing his former lawyers, arguing that they had negotiated an unfavorable settlement with Cavallo, Ruffalo & Fargnoli.

The whole mess was eventually settled out of court, but meant that it wasn't until March that Prince could really concentrate on the business of convincing Warner Bros to release his new album. The company had been keen instead to release a greatest hits set in an effort to break a run of increasingly low-selling albums. What the label executives hadn't anticipated, however, was that, on *Diamonds And Pearls*, Prince had stopped chasing his artistic muse and decided, for the first time ever, to concentrate specifically on writing hits.

In fact, Prince was so determined to make a success of *Diamonds And Pearls* that he went out on the promotional circuit well before the album's release, performing at industry showcases, making one-off television appearances, and playing 'Gett Off' in his 'assless' pants at the MTV Video Music Awards. He even hired a pair of dancers, Lori Elle and Robia La Morte, to play the roles of 'Diamond' and 'Pearl.' These were the very sorts of promotional activities that Prince would have baulked at a few years earlier, but now they were helping to push his media profile up to its highest point since *Purple Rain*.

Another change could be seen in relation to the singer's attitude toward promo videos. In the past he had sometimes refused to make them at all, insisting that his art be judged on its own merits, but this time he went into overdrive, issuing a video EP with promos not just for the album's first single, 'Gett Off,' but also for its B-sides. According to the director, Rob Borm, Prince worked like a man possessed on the main 'Gett Off' promo, even going so far as to make executive decisions on the edit from the back of his limo. "He would call me up," Borm recalled, "and say, 'Rob, you know that third shot in [the] sequence? Trim two frames off the tails.'" The high-concept piece, which Prince wanted to look like the 1979 movie *Caligula*, ended up costing five times more than its original $200,000 budget.

The well-oiled promotional machine had certainly done its job by the time *Diamonds And Pearls* went on sale in October 1991. Prince might almost have driven himself and his band – who had had to get used to nine-hour rehearsals and three hours' sleep – into the ground, but it all paid off in the end. The album ended up selling more than six million copies worldwide and found its way into the upper reaches of both the British and American album charts.

It's not hard to see why. *Diamonds And Pearls* has a neat, polished, early-90s sound and contains little that might challenge the casual listener. "You know when you buy someone's record and there's always an element missing?" Prince asked *Details* magazine. "The voice is wrong or the drums are lame or something? On mine there's nothing missing."

In reality, however, that's part of the problem. Denser

"Black awareness is really taking an upturn today, and he really wants to be a part of that." TONY M (RAPPER, 1991–93)

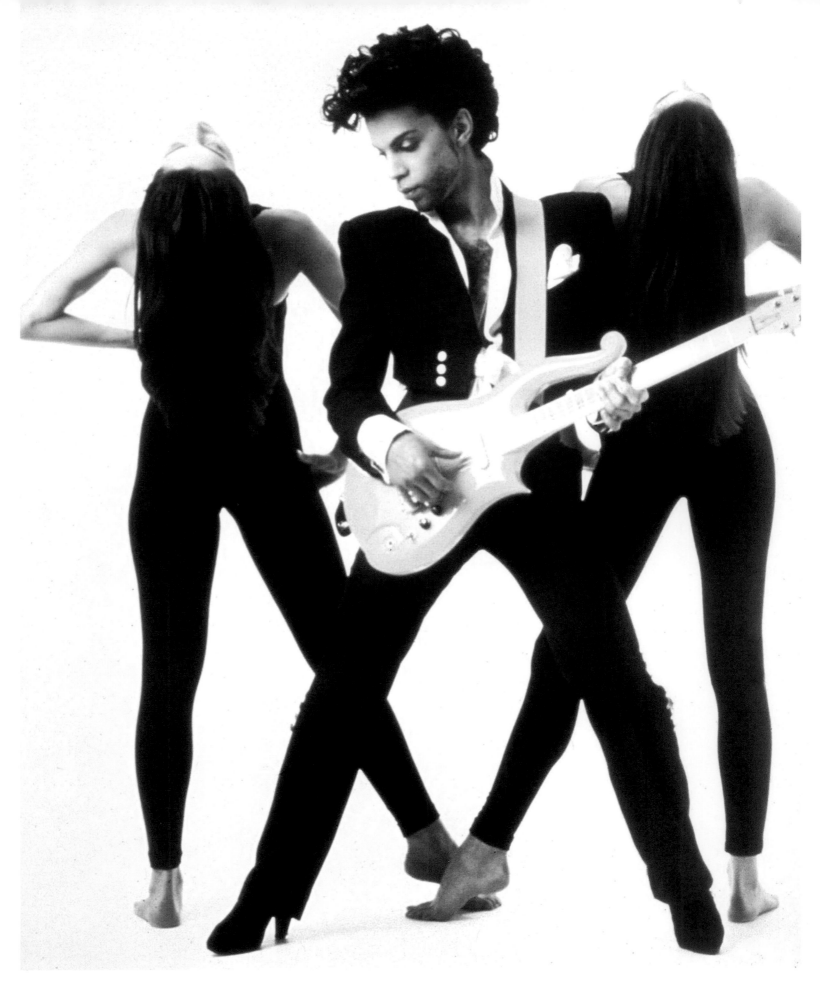

even than *Lovesexy*, the album almost sinks under the weight of its over-production. Tracks such as 'Thunder' and 'Cream' – two of six singles to be drawn from the album – are undeniably catchy, but are so slick that they could easily pass as standard pop-radio fodder. So too could the fan-favorite title track, which shows Prince at his most bombastic. The falsetto-sung 'Insatiable' is more subtle, but is essentially a re-write of 1989's 'Scandalous.' And while Prince's heart is in the right place on 'Money Don't Matter 2 Night' and 'Live 4 Love' (which focuses on the Gulf War), neither song quite manages to drive its message home.

Prince recorded much of *Diamonds And Pearls* live in the studio with The New Power Generation – something of a bone of contention among the bandmembers, who later felt that he had failed to credit them properly for their input. As talented a bunch as these musicians were, however, they lacked The Revolution's capacity for risk and experimentation, resulting in a series of arrangements largely devoid of the quirks and twists that made otherwise simple songs such as 'Mountains' work so well. (While *Sign "O" The Times* had been recorded on a six-track machine, *Diamonds And Pearls* makes use of as many as 48 tracks.)

The album is hampered further by a smooth R&B sheen designed to win back the favor of the black audience many critics felt Prince had left behind. Even those involved with the record weren't entirely convinced by

Prince flanked by dancers Diamond and Pearl in 1991.

this particular change. "I was dismayed that Prince wanted to emulate the sound of current black music," recalled engineer Michael Koppelman. "It was frustrating to see what I consider to be a very talented musician fucking around with a lot of trendy crap."

The most glaring change to the Prince sound is the singer's wholesale embrace of hip-hop – something he had spoken out against several years earlier. During the previous year's Nude tour Prince had brought in three male backing dancers, The Game Boyz, and quickly discovered that one of them, Tony Mosley, could rap. After giving him a few solo spots on the tour, Prince invited Mosley to rap on a number of tracks on *Diamonds And Pearls*, even basing an entire song, 'Jughead,' around his less than engrossing delivery about managers being "parasites" and "money minders."

'Jughead' certainly had an impact, but not in the sense that Prince might have anticipated. After hearing it, Steve Fargnoli served him with a five-million-dollar lawsuit, claiming defamation and breach of contract (Prince and Cavallo, Ruffalo & Fargnoli were forbidden from talking publicly about each other as part of their previous settlement).

Prince's attempts to ingratiate himself with the hip-hop world didn't end there. In case anyone had missed the point, he took to singing into a gun-shaped microphone on stage, but it didn't seem to have the desired effect. As Alan Leeds later recalled: "The 'keep it real' hip-hop community wasn't buying Tony M or a gun-shaped microphone from a guy Prince's age [33] who had grown up in a relatively middle-class Midwestern environment." Even his most supportive critics failed to rally round Prince this time. The general feeling was that Prince needed a rest; or, as *Entertainment Weekly* put it, that "too many years churning out records by himself in his Paisley Park complex have taken their toll." As far as the *New Musical Express* was concerned, it all served as proof that Prince was no longer a "vital force acting on pop music's zeitgeist."

Prince's use of a gun-shaped microphone was all part of a concerted effort to reassert his 'masculine' qualities. He seemed determined to keep that going offstage, too. As keyboardist Rosie Gaines recalled, "when he was with the boys I was just another woman to him. He was kind of a male chauvinist at that point." While Prince tended to travel with Diamond, Pearl, and his latest discovery, Mayte Garcia – a 19-year-old dancer whose mother had sent the singer a video of her dancing to 'Thieves In The Temple' a year earlier – Gaines found herself stuck for long stretches on a tour bus with the rest of the male membership of the group, by whom she was often bullied. Unsurprisingly, she left at the end of the tour. (She was replaced, for the next album, by Morris Hayes.)

Like the album itself, the Diamonds And Pearls tour was Prince's most conventional to date. The stage set, which included various statues and a 'love symbol'-shaped

spaceship, was certainly extravagant, but the musical arrangements left little room for improvisation and felt more like a revue, while the newly hired brass section – which brought total membership of The New Power Generation up to 17 – played much more of a straightforward R&B role than the jazzy duo of Eric Leeds and Matt Blistan had in years past.

The tour was a resounding success, but the cost of the stage show, huge entourage, and regular bonuses for bandmembers who played at aftershows cut right into any potential profits. "The amount of money spent on the road was just ridiculous," recalled Prince's UK publicist of the time, Chris Poole. "His accountants told me later that it didn't make any money. That he spent it all, basically."

This didn't seem to matter to Prince, who still seemed not to have grasped how precarious his financial situation had become. Perhaps he simply felt that, having re-

> *"I was brought up in a black-and-white world … I always said that one day I would play all kinds of music and not be judged for the color of my skin but the quality of my work."* PRINCE

established himself as a commercial success, he didn't need to worry anymore. He had almost completed his next album even before the Diamonds And Pearls tour finished, and was so confident in the material that he took to playing tracks from it over the public address system before taking the stage during his eight-night run at London's Earl's Court Arena. His intention was to release these new songs on an album with an unpronounceable title as quickly as possible. But as is so often the case with Prince, things didn't work out quite as he had planned.

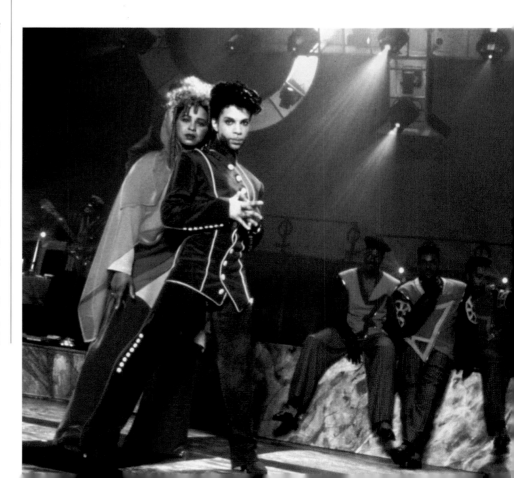

THE SUCCESS OF *DIAMONDS AND PEARLS*, HIS BEST-SELLING RECORD IN YEARS, PUT PRINCE IN A MUCH BETTER POSITION WHEN IT CAME TO RENEGOTIATING HIS CONTRACT WITH WARNER BROS IN AUGUST 1992. FROM THE LABEL'S PERSPECTIVE, THE NEW DEAL WAS GEARED TOWARD ENCOURAGING PRINCE TO CARRY ON MAKING HIT RECORDS.

Love Symbol (AUGUST 1992–SEPTEMBER 1993)

It reportedly gave him a 20 per cent royalty rate and a huge advance of ten million dollars per album – on the condition that the previous album managed to sell more than five million copies.

Prince's view on this was that his new '$100 million' deal put him on an ever higher pay-scale than Madonna and Michael Jackson, who had both recently negotiated $60 million contracts with Warner Bros and Epic respectively. More conservative estimates suggested that he stood to make around $30 million. As far as the public was concerned, the new deal made Prince pop's most bankable act. But for Warner Bros, the litmus test would be his 14th studio album, given the title of an unpronounceable symbol, and later dubbed *Love Symbol*, which the singer had once again recorded with, and co-credited to, The New Power Generation.

Warner Bros had high hopes that, despite its unpronounceable title, the new album would repeat the success of *Diamonds And Pearls* when it was released on October 13 1992, almost exactly one year after its predecessor. In the event, however, it barely managed to

sell a million copies. So much for the ten-million-dollar advance on the next one.

Part of the problem lay in the choice of singles used to promote the album. Prince decided to follow 'Sexy MF,' which was unplayable on radio because of its course lyrics and limped in at Number 66 on *Billboard*, with the unrepresentative 'My Name Is Prince,' a hip-hop track unlikely to attract any new listeners. Warner Bros had wanted to release the majestic, Eastern-tinged '7' instead, and would be vindicated when they eventually did, as '7' fittingly reached Number Seven on the Hot 100 (a marked improvement on 'My Name Is Prince''s Number 36).

By then, however, the *Love Symbol* LP's fate had been sealed. The critics found the album to be as confusing as any Prince release to date. Some reviewers even confused themselves, with *Spin* arguing on the one hand that the record broke no new ground, and on the other that it served as further evidence of Prince's "silly and crafty genius." The *Minneapolis Star-Tribune* was firmer in its findings, declaring the album to be "a royal disappointment."

The confusion was Prince's own fault. In the press

release that accompanied the album, he described it as a "rock soap opera" designed to play out across the record's 75-minute runtime. The plan – at least to begin with – was for it to tell the story of how he met and wooed the Crown Princess Of Cairo, played by his latest love interest, Mayte Garcia, while being hounded in a series of spoken-word segues by a news reporter (played by Kirstie Alley). But then, right at the last minute, he decided to add a new song, 'Eye Wanna Melt With U,' and had to cut some of the segues to make room for it.

This left only his battles with Alley – which seem only to confirm the singer's obsession with avoiding interviews and frustrating journalists – and made it virtually impossible to understand what was going on in narrative tracks such as '3 Chains O' Gold.' The *3 Chains O' Gold* VHS, which strung together several promo videos, helped clarify matters a little – until you get to the '7' clip, which serves only to muddy the waters further as Prince suddenly finds himself having to kill off seven of his past selves.

Love Symbol is much more impressive without the 'rock soap opera' tag. In terms of scope, it's not quite up there with *Sign "O" The Times*, but certainly trumps *Graffiti Bridge*. One major improvement on *Diamonds And Pearls* is the performance of The New Power Generation, who appear on around half of the songs. After tightening up on the road and growing more accustomed to working in the studio, the musicians sound willing and able to go wherever their leader wants to take them. (On *Diamonds And Pearls*, by contrast, Prince seemed at times to be pandering to his cohorts' limitations.)

The album isn't without flaws – the reggae-lite touches on 'Blue Light,' Tony M's raps on both 'My Name Is Prince' and 'Sexy MF' (a catchy riff in search of a song), the throwaway ballad 'Sweet Baby' – but they are more than outweighed by its strengths. The straightforward R&B

Welcome 2 The New Power Generation

Along with his 'love symbol,' the very phase 'New Power Generation' has come to represent much more to Prince than just a name. To the man himself, it has always been more of a concept than a tangible entity. On 'Eye No,' recorded in 1987 and included on 1988's *Lovesexy*, he welcomes listeners to his new power generation, explaining that his "voice is so clear" because "there's no smack in my brain."

Right from the outset the NPG seemed to symbolize self-improvement and the quest for a better, healthier lifestyle. That it first emerged on Prince's most spiritual album to date was no accident. He took the concept even further a year later on *Graffiti Bridge*, naming the album's second track 'The New Power Generation' and declaring: "We want 2 change the world." Even before he started referring to his band by the same name, he seemed to have decided that the NPG should lead the way when it came to advocating a better life.

It's somewhat ironic then that the band that eventually took the name, and which was deemed important enough to be credited alongside him on albums such as *Diamonds And Pearls*, initially seemed like nothing more or less than a tight, proficient group of session musicians. As far as Prince was concerned, this was just what he needed. He could, he told *Rolling Stone*, "keep switching gears on them and something else funky will happen." But while The New Power Generation certainly had the hard R&B chops required to keep up with current trends in the black music market, they

would never be anywhere near as innovative and influential a band as The Revolution.

For a while, Prince seemed to hide behind his new band in effort to push forward a more masculine – and more black – image. After that the group became a useful tool to hide behind when it came to recording and releasing music. Warner Bros didn't want Prince to keep releasing so many albums, and wouldn't let him license his recordings to any other labels. So when *Goldnigga* and *Exodus* were released, in 1993 and 1995 respectively, they were credited to the New Power Generation, despite coming from the same place as all of his other records.

No one was fooled, of course, but Prince continued to use the name as an outlet for ideas that didn't quite fit the 'Prince' formula. Since the mid 90s the concept has expanded. The 'band' released its third album, *Newpower Soul*, in 1998, while the NPG brand expanded to include a record label (replacing Paisley Park Records), the NPG Orchestra, and NPGMusicClub.com, Prince's successful online website, fan club, and download store.

The New Power Generation has mirrored George Clinton's P-Funk crew in its revolving-door membership policy. There have been more than 27 official members over the years (not including dancers and guest players), among them Rosie Gaines, Maceo Parker, and esteemed musicians such as Rhonda Smith, John Blackwell, and Renato Neto. Prince has continued to credit the group on his albums, right up *3121* (2006) and *Planet Earth* (2007). Whatever the line-up, Prince's goal seems to be to

surround himself with the best musicians he can at any given time. "I love this band," he told *Vibe* magazine in 1994, before noting of a later line-up in an interview with AOL that his musicians "stomp much booty."

Letting the group change and evolve over time – almost of its own accord – seems to be particularly important to him. "I have been blessed with having these people come to me," he told Spike Lee in 1997. Seven years later, he seemed keen to explain that using new musicians is "one of the ways we keep it fresh ... I like to find new young kids that have something that they can bring to the sound."

The New Power Generation might have started out as a somewhat uninspiring backing group, but, almost two decades later, the band – and indeed the entire overarching spiritual concept – remains one of the most important mainstays in Prince's life.

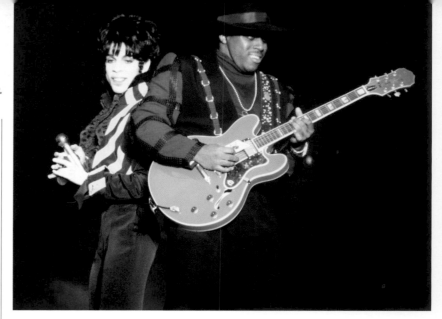

Prince and guitarist Levi Seacer Jr on the Act II tour.

tracks on *Diamonds And Pearls* seemed to get lost under the weight of over-production, but here Prince manages to pull his songs back from the brink of bloated excess. The Eastern-tinged '7' remains one of his finest moments on record, its interlocking vocal parts as accomplished as anything else he has recorded. 'Eye Wanna Melt With U' might not push many boundaries, but its hard club beats sit perfectly between the softer 'Blue Light' and 'Sweet Baby.' All in all, the competing elements of rock, hip-hop, funk, reggae, jazz, and dance music might sometimes be baffling, but they're always intriguing. When he does fail, you can at least tell that Prince is doing his best to reassert himself as pop's greatest risk-taker.

In March 1993 Prince began his first full American tour for five years, Act I. He might have ditched Diamond and Pearl, but the show was very much the 'rock soap opera' than *Love Symbol* had set out to be. The first half of the set saw him act out the album's attempted storyline in a manner that made a lot more sense on stage than on

"*He works long hours but he accomplishes a lot. No one works more quickly … if something's missing in his arrangements, he just does it himself and moves on.*"

HANS-MARTIN BUFF (PAISLEY PARK ENGINEER)

record. Having plucked his Arabian princess, Mayte, out of the audience, he would find himself on the run from assassins desperate to reclaim the Three Chains Of Turin from her. After an interval, the second half of the set comprised a more straightforward run through the hits.

A lot had changed by the time Prince commenced Act II in Europe at the end of July. Not only had he disposed of The Game Boyz, he had also changed his name to the unpronounceable album symbol that gave his most recent album its title. Taking to the stage each night as O{+> with gold chains hanging down over his face, he would begin by explaining his dissatisfaction with Warner Bros – which had started to object more strongly to the rate at which he wanted to release his music – to the audience. Then, having scrapped the high-concept theatrics of Act I, he would play a straightforward, career-spanning greatest hits set. This would be, he claimed, the last opportunity to her these songs live, since they now belonged to Warner Bros and 'Prince' – somebody that O{+> was no longer willing to be.

For a while it seemed that, despite the name change, Prince would carry on working exactly as he had done before. He had already recorded his next project – *I'll Do Anything*, a movie soundtrack that would ultimately be scrapped when the director opted to cut the movie's musical element – and would continue to put out low-selling albums by other artists on Paisley Park Records while gearing up for the release of his next solo album. Warner Bros, however, was beginning to show signs of a serious case of Prince fatigue, and when the label finally opted to release its long-awaited greatest-hits album, it sent the singer off in a completely different direction.

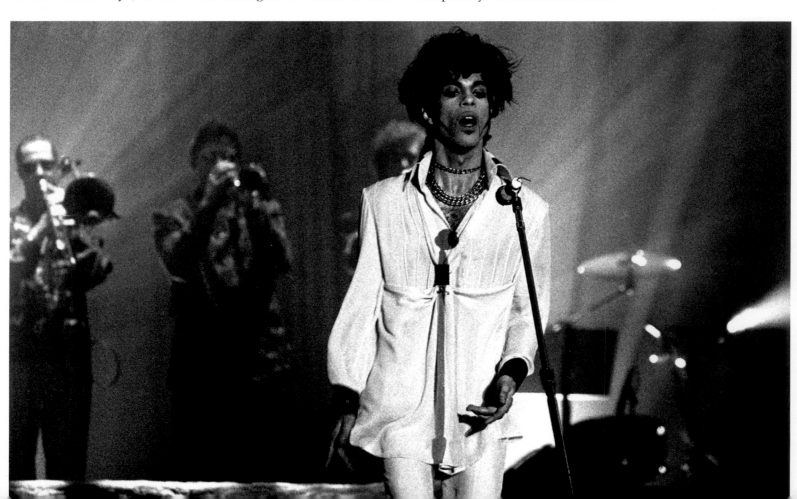

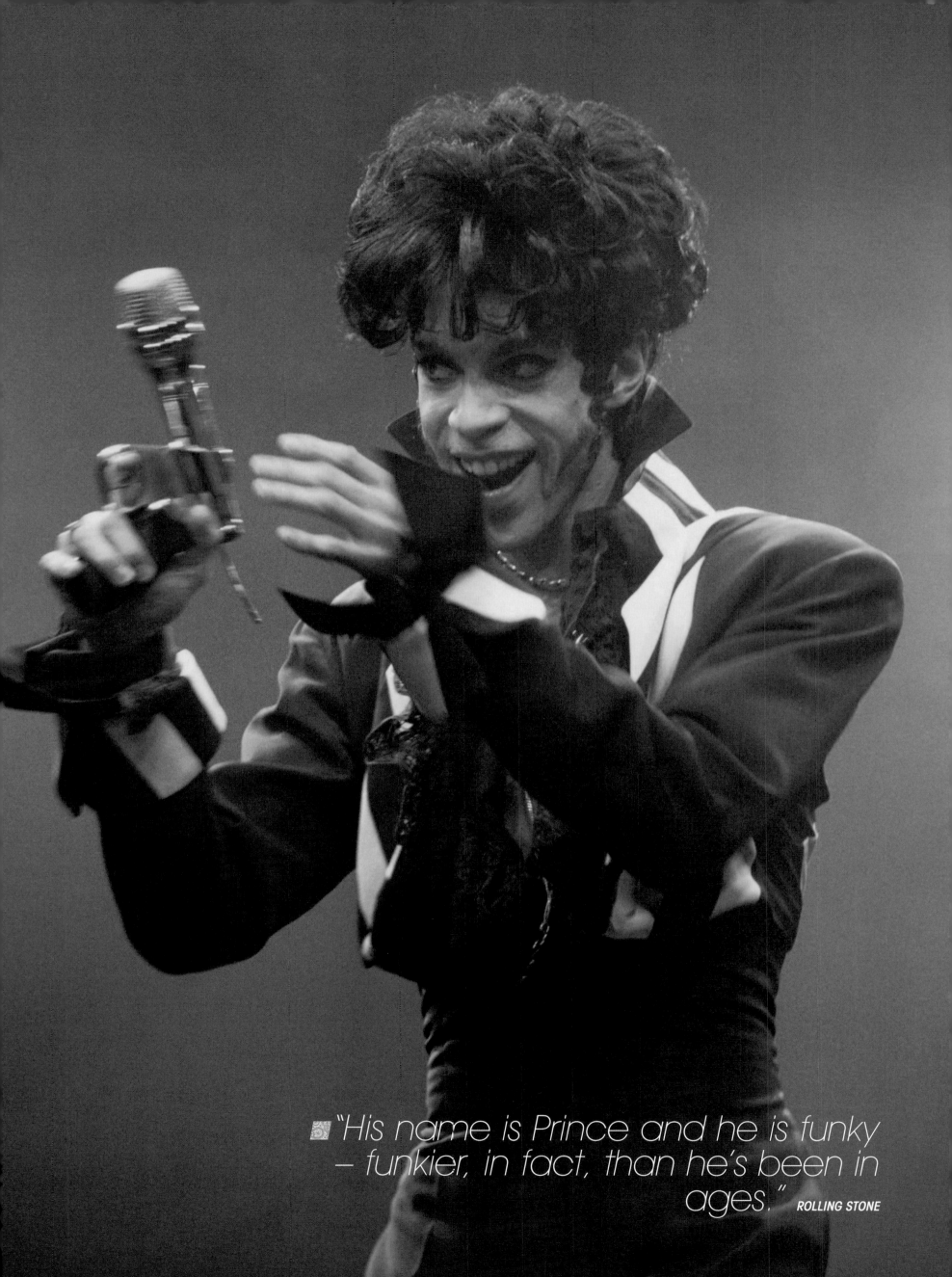

"His name is Prince and he is funky
— funkier, in fact, than he's been in
ages." *ROLLING STONE*

WARNER BROS HAD BEEN KEEN TO TAKE A BREAK FROM SATURATING THE MARKET WITH NEW PRINCE MATERIAL EVER SINCE THE SINGER CAME ALONG WITH *DIAMONDS AND PEARLS* – HIS 13TH ALBUM IN AS MANY YEARS – IN MARCH 1991. A GREATEST HITS SET, THE LABEL REASONED, WOULD GIVE CONSUMERS A BREAK FROM THE ENDLESS STREAM OF NEW PRINCE PRODUCT THAT SEEMED INCREASINGLY TO BE COMPETING WITH ITSELF, WHILE ALSO CONSOLIDATING AND CELEBRATING A REMARKABLE BODY OF WORK ACCRUED AT SUCH A FRANTIC PACE SINCE THE LATE 70S.

The Hits/The B-Sides

(SEPTEMBER 1993)

As far as Prince was concerned, putting out greatest hits albums was something you did once you had passed your prime. Fortunately, *Diamonds And Pearls* proved to be his most commercially minded work in years. There were no convoluted concepts, the overall sound was aimed squarely at the contemporary R&B market, and it ended up selling more strongly than any Prince record since *Purple Rain*. But the idea of a greatest hits set didn't go away completely.

By July 1993, Prince was trying to push yet another new project onto Warner Bros, having already followed *Diamonds And Pearls* with the *Love Symbol* album the previous October. *Goldnigga* was billed as the full-length debut by his backing band, The New Power Generation, but Warner Bros flatly refused to release it, and instead decided to finally unveil the greatest hits collection it had been sitting on for the past two years.

The Hits/The B-Sides gave Warner Bros a chance to recoup some of the money it had lost when *Love Symbol* failed to generate even a fifth of the revenue of *Diamonds And Pearls*. The first two *Hits* discs (also made available to buy as separate albums to begin with) are largely focused, as one would expect, on Prince's single releases, and provide a remarkable non-chronological document of one of the greatest artistic trajectories of any musician in the history of pop. For anybody wondering where Prince might be going in the 90s, it served as a reminder that he had done more than enough in the 80s. The likes of 'When Does Cry' sounded no less innovative in 1993 than they had when originally released nine years ago.

The *B-Sides* disc, available only as part of the three-disc set, would have been revelatory to listeners who had not bought the original singles. It contains some of Prince's greatest material, from the electro-funk 'Erotic City' and the pop-rock 'She's Always In My Hair,' to the live favorite 'How Come U Don't Call Me Anymore' and two genuinely moving ballads, 'Another Lovely Christmas' and 'I Love U In Me' (another track in the gender-shifting mould of 'If I Was Your Girlfriend').

The package also includes a handful of rarities aimed

squarely at the Prince completist: 'Power Fantastic,' from the *Dream Factory* sessions; an alternate version of '4 The Tears In Your Eyes' originally broadcast during Live Aid; two recent recordings, 'Peach' (a rock track built around a Kim Basinger sample) and 'Pope' (another less-than-essential excursion into hip-hop); 'Pink Cashmere,' a ballad written for ex-girlfriend Anna Garcia; and a flawless live duet of 'Nothing Compares 2 U,' sung with Rosie Gaines on the Diamonds And Pearls tour. The only thing missing, because of contractual complications, was anything from *Batman*, but nobody seemed to mind.

By the time *The Hits/The B-Sides* was released, Prince had publicly declared that he would now only offer Warner Bros archival material from The Vault and not new songs, but *Rolling Stone* didn't seem too concerned. "If 'She's Always In My Hair' and 'Another Lonely Christmas' are any indication of the reported 500 songs Prince has in his vaults," the magazine supposed, "his label might just get its money's worth," before concluding that *The Hits* stood among the "essential documents of past decade."

Rolling Stone's opinions were amplified elsewhere. According to *Q* magazine, "Most truly essential compilations contain a few stars from pop's astrological map; these three [discs] contain a whole galaxy." *Entertainment Weekly* described *The Hits* as a "vital affirmation that, at one time, Prince's very strangeness and eccentricities had a point; he was never weird simply for weirdness' sake."

Running to 56 tracks and more than three hours of music, complete with illuminating linernotes by Alan Leeds, *The Hits/The B-Sides* remains the best one-stop for Prince's Warner Bros years, covering as it does pretty much everything except *The Gold Experience*. Subsequent Warner Bros compilations pale in comparison. *The Very Best Of Prince* (2001) and *Ultimate Prince* (2006, complete with a second disc of relatively obscure 12-inch mixes) are just slimmed-down versions of what came before.

It's interesting to note that Warner Bros released all three compilations – at least in part – with the intention of knocking the wind out of the sales of whatever else Prince was doing at the time. *The Hits/The B-Sides* came out right when Prince had begun to publicly criticize the label in the media, somewhat undermining

his attempts at waging war with the company. In July 2001, *The Very Best Of* was released a few months before the singer's return to using the name 'Prince' with the rather more challenging *The Rainbow Children*, while

Running to 56 tracks and more than three hours of music, complete with illuminating linernotes by Alan Leeds, The Hits/The B-Sides remains the best one-stop for Prince's Warner Bros years.

Ultimate Prince was initially intended to coincide with his much trumpeted major-label return, *3121*, before Prince and Universal managed to convince his old sparring partners to delay its release until August 2006. Even a decade after Prince and Warner Bros officially ended their relationship, it appears that at least one party can't help but return to the battlefield from time to time.

seemed to many to be far behind him. Prince's vocal delivery is one of his most convincingly impassioned, while the multiple layers of vocal harmonies and instrumental overdubs prove that he was capable of piling up the production without sapping a song of its energy and emotional power. The song's euphoric peak and climax are almost as grand as 'Purple Rain.'

'The Most Beautiful Girl In The World' was a much-needed artistic and commercial success, suggesting that O{+> could be just as vital as the singer's former incarnation. For Warner Bros, however, the whole affair was particularly galling, the label having only agreed to the release in an attempt to get Prince off its back, not expecting the song to become his most successful single since 1989's 'Batdance.'

For Prince, all of this was proof that Warner Bros didn't know what it was doing, and by extension that he should be allowed to release what he wanted when he wanted. The single's success made him even more determined to break free from the label and encouraged him to drum up further support by publicly declaring that the album from which the song was taken, *The Gold Experience*, would never see the light of day because Warner Bros refused to release it.

He was however able to convince the label to let him put out a second record through NPG a few months later, a full-length compilation album named for the free-phone

telephone number he had set up to take orders for Prince and O{+>-related merchandise. Distributed once again by Bellmark, *1-800-NEWFUNK* was unable to repeat the success of 'The Most Beautiful Girl.' It barely sold at all, in fact, and only reached Number 45 on the *Billboard* R&B chart.

The only song on the album credited to O{+> is 'Love Sign,' a duet with Nona Gaye, the daughter of Motown legend Marvin Gaye. Prince wanted to release it as a single but Warner Bros refused to grant him permission, perhaps fearing a reprise of 'The Most Beautiful Girl''s storming success. Undeterred, Prince pressed up promo copies for R&B radio stations, performed the song live on several television shows, shot a video for it, and placed adverts in *Billboard* magazine. But the single never materialized.

The rest of *1-800-NEWFUNK* mixes previously released material, such as George Clinton's 'Hollywood,' with new

work, including '17' by Madhouse, 'Minneapolis' by the NPG offshoot MPLS, and Mayte's remarkably successful version of 'If Eye Love U 2Night,' a Prince-penned song

> ■ *'The Most Beautiful Girl In The World' was a much-needed artistic and commercial success, suggesting that the singer could be just as vital as O{+> as he had been as Prince.*

previously recorded by Mica Paris. Despite its poor commercial performance, the 11-track album remains a worthy addition to the Prince canon, its mixture of upbeat funk and ballads yielding a number of fine examples of Prince's 90s update of the Minneapolis Sound. It might not have sold very well, but to Prince it served as further proof that he could carry on alone, without Warner Bros' backing.

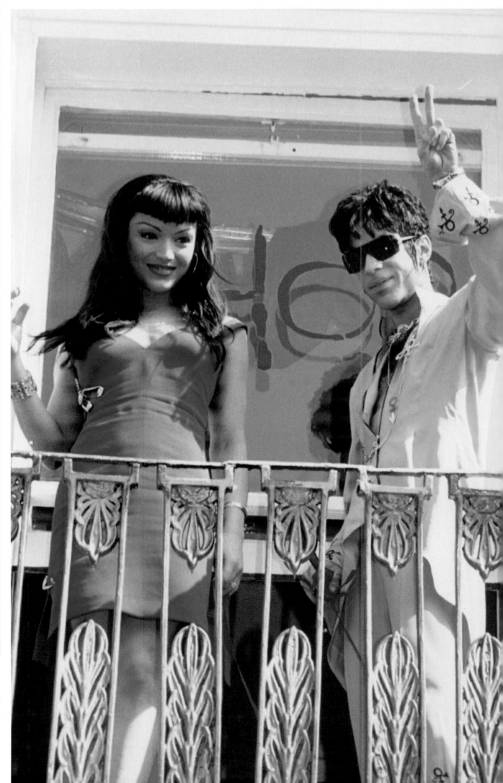

Prince and "the most beautiful girl in the world," Mayte Garcia, celebrate the opening of his NPG store in London, England.

HAVING HAD TO SIT THROUGH 1993 WITHOUT A MAJOR RELEASE, PRINCE MADE CLEAR HIS INTENTION TO MAKE UP FOR LOST TIME WHEN HE PRESENTED WARNER BROS WITH TWO NEW ALBUMS DURING THE FIRST HALF OF 1994. FIRST CAME *COME*, WHICH CONSISTED MOSTLY OF OLD MATERIAL RECORDED BEFORE HIS NAME CHANGE, AND THEN *THE GOLD EXPERIENCE*, MADE UP LARGELY OF NEW SONGS.

Come/The Black Album

(MARCH–NOVEMBER 1994)

Prince's plan was for *Come* to be credited to 'Prince,' with *The Gold Experience* to be credited to O{+> – and for both to be released on his 36th birthday (one year to the day after his name change). His exact reasoning is unclear, but it seems that he wanted to pit his two 'brands' against each other and see which one the public responded to best.

This kind of deliberate sabotage went against all good business sense and Warner Bros refused point blank. One new Prince album would be more than enough – particularly at a time when record-store shelves were already swamped with his recent output. The label found little to get excited about when Prince first delivered *Come* in March and requested he rework it – and add 'The Most Beautiful Girl In The World' to the tracklisting.

Prince returned in May with a new, much darker-sounding pressing of the album that still didn't feature his recent smash-hit and now omitted upbeat tracks such as 'Endorphinmachine' and 'Interactive,' which he had since decided were O{+> songs, not Prince songs. At the same time he also delivered *The Gold Experience*, which did include 'The Most Beautiful Girl' (and 'Endorphinmachine') but was credited to O{+>.

Of the two, Warner Bros eventually opted to release *Come*, largely because it was the one credited to the still-bankable Prince moniker. But this ultimately meant that on August 16 the label put out a dated album by a man who had no interest in promoting it, and whose audience had probably already grown tired of the soap opera surrounding his name-change and public battles with his label. *Come*'s jacket shows Prince staring out gravely in front of a cathedral, with his birth and 'death' dates, 1958–93, emblazoned across the front. (As if to hammer home the point there are photographs inside of a live-and-well Prince dated 1958 and a 'dead' Prince dated 1993.)

Sick of the name-calling and name-changing, *Rolling Stone* headed its review 'Oh, whoever,' before imploring its readers to "appreciate these moves as part of what has become the most spectacular slow-motion career derailment in the history of popular music." The *Detroit Free Press* voiced its disappointment by calling *Come* a "toss-off that doesn't merit the excitement usually accorded Prince albums."

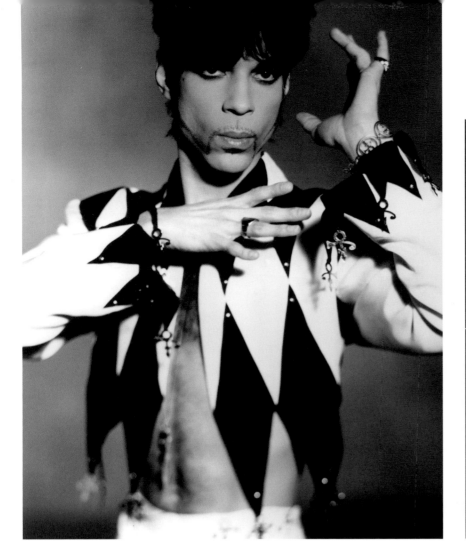

The album does have its moments. The *St Paul Pioneer Press* drew attention to its inclusion of a few songs that sound like "an old friend exposing something of himself, risking something real." Perhaps the strongest of these is 'Papa,' a brutal, spoken-word retread of the child-abuse story hinted at on *Love Symbol*'s 'Sacrifice Of Victor.' Over a sparse musical backdrop, Prince declares: "Don't abuse children, or else they turn out like me." The song eventually rises to a more upbeat, cathartic conclusion, with Prince singing of how "there's always a rainbow at the end of every rain." 'Solo,' meanwhile, is a largely a-cappella meditation on loneliness on which Prince's voice seems to echo out from the biggest, emptiest mansion in Minneapolis.

It's moments like these that mark *Come* out as one the singer's most interesting (and downright weird) albums, particularly when compared to the Prince-by-numbers themes that dominate the rest of the songs. The opening title track is an 11-minute paean to oral sex, 'Race' yet another so-so socially conscious collision of hip-hop and funk, 'Space' a largely unsuccessful attempt at trip-hop, and 'Loose!' and 'Pheromone' aimless retreads of early-90s dance music (the latter a blatant re-write of *Love Symbol*'s 'Continental').

While *Come* sold only 345,000 copies on its release in the USA, some fans now think of it as something of a 90s classic. But while it might sound good by comparison to the likes of *Chaos And Disorder* and *Newpower Soul*, it certainly doesn't come close to his best work of the 80s.

Comparing old and new Prince became a legitimate exercise in November when Prince opted finally – and somewhat puzzlingly – to allow Warner Bros to release *The Black Album*. Although it didn't get him any closer to fulfilling his contractual obligations to the label, Prince did pick up a reported one-million-dollar fee for *The Black Album* as part of a three-album deal (from which he later withdrew) that also included *The Gold Experience* and an unnamed movie soundtrack.

Warner Bros might have been glad to finally release *The Black Album*, But it didn't fare well with fans or critics. Seven years late, it was now, as the *Detroit Free Press* put it, "little more than an interesting period piece." *Time* magazine seemed to hit the mark when noting that, while listeners in 1987 "probably wouldn't have known what to make of [the album's] bitter outlook, today it [sounds] almost conventional."

Most of the fans who might have bought *The Black Album* had it been released in 1987 had moved on by 1994, or would have been content with their bootlegs of the original. The hardcore supporters that remained

> The Detroit Free Press voiced its disappointment by calling Come a "toss-off that doesn't merit the excitement usually accorded Prince albums."

weren't enough to send the record hurtling to the top of the charts. As another year rumbled to a close, Prince was left feeling even more despondent about his situation. His newest work, about which he felt most enthusiastic, remained in limbo; the older material that did make it out onto the shelves had failed to set the world alight. All he wanted to do now was make more records, but even that would prove difficult.

Money Don't Matter 2Night

AFTER *PURPLE RAIN* MADE HIM AN OVERNIGHT MILLIONAIRE, PRINCE WAS SUDDENLY THRUST INTO A WORLD WHERE MONEY WAS NO LONGER A CONCERN. ACCORDING TO BOB CAVALLO, HIS MANAGER THROUGHOUT THE 80S, PRINCE PAID FOR PAISLEY PARK IN CASH AND, BY THE TIME HE WAS 27, HAD $27 MILLION IN THE BANK.

One might justifiably assume that this would have made him financially secure for life. But just a few years later Prince faced severe financial difficulties following the loss-making Lovesexy tour and a string of albums that, while critically successful, had failed to reap the financial returns their reviews warranted.

In attempting to scrap the Japanese leg of the Lovesexy tour in favor of getting on with the *Batman* project, Prince was also beginning to demonstrate a tendency toward making less-than-sound business decisions. Had manager Steve Fargnoli not been able to convince him otherwise, Prince could have been sued for as much as $20 million for pulling out of the concerts.

Prince seemed unwilling to listen to sound financial advice, wanting instead to do what he wanted, when he

"I never was rich, so I have very little regard for money now. I only have respect for it inasmuch as it can feed somebody." PRINCE

wanted. "We had a big graph," Bob Cavallo later recalled. "I put it on an easel showing the decline in revenue and increase in spending. He just walked [up] and turned it over."

Fortunately, *Batman* was Prince's biggest commercial success since *Purple Rain*, and was followed in 1991 by another hit, *Diamonds And Pearls*, that helped put him back in the black following the failure of the previous year's *Graffiti Bridge* movie. Within a few years, however, Prince's finances would begin to fall apart again. By January 1995 the situation had become so bad that the *St Paul Pioneer Press* was reporting, "Paisley Park Enterprises, the company that oversees most of Prince's business interests, is not paying its bills on time or at all."

Prince's extravagant spending appeared to have finally caught up with him. Since opening Paisley Park he had kept the studios fully manned 24 hours a day on the off chance that he might want to record. In Los Angeles, meanwhile, he spent around $500,000 per year on having a studio manned and ready at the Record Plant just in case he decided to drop in on a whim.

Studio costs were just the start of it. Paisley Park's in-house catering team and ten-strong tailoring department, employed to make bespoke clothes for Prince, his band, and his girlfriends, were all employed full-time, as were his band and road crew – even if they weren't recording or touring. By the mid 90s, Prince was also filming expensive promotional videos on the Paisley Park soundstage for songs that would never get released, even though the space was supposed to be hired out for movie productions such as *Grumpy Old Men*. (In the end Warner Bros executives had to get involved in order to clear the soundstage long enough for the movie to be shot.)

Prince might have claimed to have signed a $100 million contract with Warner Bros in 1992, but the reality was that his albums were not selling enough for him to be earning anywhere near that. Even so, he had no problem with wasting two million dollars on his Glam Slam Minneapolis nightclub, or another two million dollars on recording and promoting the hopeless Carmen Electra album. He made numerous other decisions without giving any consideration to cost or practicality, such as opening further Glam Slam clubs in Miami and Los Angeles, setting up a series of NPG music stores, building extravagant stage and movie sets, and even buying multiple copies of the same bespoke canes from a local company during a brief period in which the cane became his fashion accessory of choice.

Prince's decisions weren't just costly to the singer himself. Having previously worked on the 'Gett Off' promo video (which went five times over its $200,000 budget in less than a week), director Rob Borm found himself working on '7.' "Before we even shot film," he later recalled, "we had probably spent $90,000." Then, with a set almost complete at Paisley Park, Prince decided he had had a better idea and moved the entire project to Los Angeles.

This was all very well except that, by 1993, Born was due $450,000 for his work. When he tried to get it, Paisley Park could only afford to pay him 70 cents on each dollar

Exodus (March 1995)

In 1994, having already turned down The New Power Generation's Goldnigga a year earlier, Warner Bros passed on the follow-up, Exodus. Prince had started work on the album in May, shortly after being sent back to the studio to make Come more commercially appealing.

Fully ignoring his contractual obligations to the label, he wrote and recorded all of the material on the album and released it on his own NPG Records on March 27 1995. (He also appears prominently throughout as both musician and singer, but used the pseudonym Tora Tora in the linernotes and covered his head with a scarf when making promotional appearances with the band in order to mask his identity.)

If *Goldnigga* was Prince voicing his dissatisfaction with Warner Bros, *Exodus* is a long, meandering expression of his complete and utter distain. For once it's the full-band performances that stand out; Prince's solo pieces, by contrast, are conspicuously colder and less engaging. The album's most forward-thinking concept comes during the spoken word intro, in which it is announced that NPG Records is looking for new talent – with the proviso that any prospective musicians be "free" because, "when it comes to downloading your work into your fans' computers, you can't have any contractual obligations."

What follows is, for the most part, a densely produced mess. While it might have been paper-thin, *Goldnigga* did at least gave a plotline. *Exodus* is just a series of jam-based funk ramblings and dull ballads held together by a series of loose, uninteresting segues, most of them featuring bassist Sonny T, who takes the place of Tony M in pushing the stereotypical black angle.

Everything that happens within these 12 dramatic segments – including various seductions and childhood reminiscences, and the drinking of some spiked soup – turns out to have been a dream, although few listeners are likely to have cared either way by the time they got to the last of the album's 21 tracks.

Exodus does contain a couple of moments worth hearing. 'Get Wild' is a dense, funky number that stands as a triumph of Prince's busy, mid-90s production style, while his attempt at an Italian accent during the 'mashed potatoes' segue provides a genuinely (if unintentionally) funny moment. The rest is eminently forgettable. The album is dedicated to 'His Royal Badness' in memory of 'Prince,' but it probably would have been more appropriate to dedicate it to his dearly departed sense of quality control.

owed. By the time he did get paid Born had already fallen into debt himself, and ended up giving all $315,000 to his creditors before declaring bankruptcy.

Born might even have been one of the lucky ones. Plenty of others found themselves up against a brick wall when it came to collecting debts owed by Paisley Park. Cane-makers Suzy and Gary Zahradka were forced to threaten legal action before receiving a belated check in return for their $4,500 invoices, while Record Plant studios ended up withholding a master tape Prince had accidentally left on the premises in order to ensure that a $150,000 bill got paid. Others simply met with a blank wall of confusion when they tried to get in touch with Paisley Park.

Part of the problem stemmed from Prince's revolving-door employment policy, and his decision to put people with little or no experience in charge of various key divisions of Paisley Park Enterprises. When the management team of Arnold Stiefel and Randy Phillips reached the end of their initial 12-month contract with Prince in late 1990 the singer opted not to renew it and instead named former bodyguard Gilbert Davison as the company's new president, promoting his PR Jill Willis to the position of vice president.

In October 1994, with Paisley Park's finances spiraling

> "I'm not scared of poverty. I grew up being poor ... these times are positive because they force you to decide if you're interested in living on this planet or not." PRINCE

out of control, Davison resigned. Prince brought in his half-brother and former head of security Duane Nelson as Davison's replacement, with Julie Knapp-Winge and Therese Stoulil flanking him. Nelson was then left in

to have improved since he left Warner Bros and struck out on his own. Releasing albums himself to a dedicated fanbase has allowed him to sell fewer copies but make more from each one. Prince took a much larger cut of the profits from *Emancipation* than he would have done under his Warner Bros contract. When it came to the follow-up, the multi-disc *Crystal Ball* set, he even waited until he had received enough pre-orders to make the project commercially viable before pressing it up, thus ensuring that he would break even at the very least. In the years since Prince has cut several deals with major labels, but only when it has suited him, signing one-off distribution deals with Arista for *Rave Un2 The Joy Fantastic*, Columbia for both *Musicology* and *Planet Earth*, and Universal for *3121*. Even then he has continued to pay all production costs, while leaving the promotional work to the label.

As the record industry changes and big-name stars look to sign so-called '360 degree' deals with live promoters – taking the focus away from album releases, which in turn become a mere adjunct to the tour – Prince appears once again to have been ahead of the game. He has certainly made a lot of money in recent years from lengthy live residencies such as the 3121 Jazz Cuisine at the Rio All-Suite Hotel in Las Vegas during 2006–07, and the 21 Nights In London run at the O$_2$ Arena in 2007, having perhaps realized that staying in one place for an extended period removes the expensive transport costs usually associated with touring. He has also taken to playing one-off events, including private parties, for vast sums. In December 2007 he reportedly earned two million dollars for a set at the 40th birthday of Turnberry real-estate heir Jeffrey Soffer, while he stood to make more than double that for an appearance at the 2008 Coachella festival.

Some might call him a sell out, but Prince seems to need to do these things in order to maintain his spending, both on himself and his music. The success of the 21 Nights In London shows allowed him to give away copies of his latest album, *Planet Earth*, to all attendees (having already negotiated an innovative distribution deal with the *Mail On Sunday* newspaper), and to shoot an entire *21 Nights In London* photo book released in September 2008.

Similarly the director Kevin Smith, who was involved in yet another unreleased Prince project in 2001, recalls speaking to a senior Paisley Park employee who told him, "I've produced 50 music videos. You've never seen them, 'cause they're for songs you've never heard. He puts them in The Vault. Fifty fully produced music videos with costumes and sets. Everything. That's just the way Prince is."

Fortunately for Prince he remains an incredible live performer, no matter how many times he plays the hits "for the last time." If he were relying on sales of new albums alone at this stage in his career he might well have ended up in the same sort of financial mess that rumor suggests Michael Jackson is in. Instead, he remains in the position he spent the mid 90s fighting to be in: one that allows him to do what he wants, when he wants.

charge of what have since been called arbitrary firings at the company. Rather than cut back on his spending, Prince was keen to cut back on his staff. All wardrobe director Heidi Presnail was told was that she was "being fired on a cutback, and they were eliminating my position."

Within two years Nelson, Stoulil, and Knapp-Winge were also gone, which meant that there had been more changes in the company during the past five years than there had been throughout the 80s. Even Levi Seacer Jr, the bassist who took over as head of Paisley Park Records after Alan Leeds resigned in 1992, had upped and left in November 1994 –

"I wouldn't mind if I just went broke, you know." *PRINCE*

along with his girlfriend, publicist Karen Lee – while Prince was safely out of the country at the European MTV Awards.

By 1996 what remained was a corporation without a head, and with nobody for Prince himself to answer to. Less and less information has come out of Paisley Park in the years since, making it difficult to determine the continuing state of Prince's financial situation. It does however appear

The Undertaker/The Sacrifice Of Victor

A few weeks after announcing his intention to concentrate solely on "alternative media projects," Prince holed himself up on the Paisley Park soundstage for most of in June and July 1993 to film *The Undertaker*. The original plan was to make a feature-length movie starring Nona Gaye and the television actress Vanessa Marcil, but that ended up being scrapped in favor of a wholly musical project.

Most of what became *The Undertaker* was drawn from a 30-minute live set recorded by Prince and NPG bassist Sonny T and drummer Michael Bland in mid June. Some of the footage featuring Vanessa Marcil was later inserted in between the seven songs, reducing the 'feature-length movie' concept to a slick, three-man jam interspersed with barely related dramatic moments – a half-baked mess attractive only to die-hard Prince fans hungry for long, blues-based jams. (None of the scenes shot with Nona Gaye were used.)

The movie begins in black-and-white with Marcil's character entering Paisley Park needing to use the phone. She is told where to find one, but ordered not to go past "the sign," because there's a rehearsal going on. After the man she calls, Victor, refuses to believe that she's "changed," the girl becomes distraught and takes an overdose of pills before wandering into the rehearsal

room. From here the viewer is treated to stripped-down versions of 'The Ride,' 'Poorgoo,' 'Honky Tonk Women,' 'Bambi' (from *Prince*), a snippet of 'Zannalee,' 'The Undertaker,' and 'Dolphin,' a studio version of which would subsequently appear on *The Gold Experience.*

As the band plays, Marcil's character dances, becomes ill, and then seems to die while Prince is singing the title track (another warning about the dangers of gang warfare and drug addiction). During 'Dolphin,' however, the girl comes to, throws her pills away, and leaves Paisley Park. A line from the title song – "Don't let the Devil make U dance with the undertaker" – flashes up on the screen as the credits roll, but the film's overall message is lost in a mess of muddled editing and overuse of primitive visual effects such as negative coloring and image warping.

All in all, it's hard to ascertain the point of the project beyond Prince's need to keep recording music. *The Undertaker* was given a limited VHS release through the NPG music store at the end of the year, and then distributed more widely by Warner Music Vision in March 1995, but seems mostly to have been an exercise in wasting money at a time when Prince really should have been more frugal. (He also reportedly pressed up CDs of the soundstage recording and planned to give them away free with *Musician* magazine in early 1994, but was blocked by Warner Bros.)

Prince had slightly more success with the March 1995 release of *The Sacrifice Of Victor*, a 45-minute edit of a live performance shot at Bagley's Warehouse in London during the early hours of September 8 1993. He had ended his Act II tour a few hours earlier at Wembley Arena

Experience. Mavis Staples popped up at one point to sing 'The Undertaker' and 'House In Order' (from her Paisley Park Records LP *The Voice*), while The Steeles and the NPG (fronted by Tony M) also played brief sets.

The Sacrifice Of Victor is certainly more enjoyable than *The Undertaker*, but is still not one for the casual fan, with 'Peach' the only well-known song on the setlist. It is probably most interesting as an indicator of Prince's mindset during the latter part of 1993. The opening footage is taken from the September 7 Wembley Arena show, and shows him taking to the stage in a black-and-white suit that could easily be mistaken for a skeleton costume and announcing: "London, my name is not Prince, and my name damn sure ain't Victor" (in response, it seems, to suggestions that 'The Sacrifice Of Victor,'

> *The Sacrifice Of Victor is certainly more enjoyable than The Undertaker, but is still not one for the casual fan, with 'Peach' the only well-known song on the setlist.*

and hired the Warehouse for an all-night end-of-tour party. Taking the stage at 3am, he performed a full set with The New Power Generation that included a number of tracks from *The Undertaker* and previews of material from *Come* and *The Gold*

which references child abuse, is autobiographical). After this announcement he is wrapped up in a black shroud and carried off stage as if in a funeral procession, having seemingly done everything he could to make it clear that 'Prince' is dead.

ALREADY UNHAPPY WITH THE WAY WARNER BROS WAS HANDLING HIS WORK, PRINCE BECAME INCENSED WHEN THE COMPANY REFUSED TO RELEASE *THE GOLD EXPERIENCE* AT THE SAME TIME AS *COME*. HE RESPONDED BY STEPPING UP HIS PUBLIC BATTLE WITH THE LABEL, APPEARING ON STAGE WITH 'SLAVE' WRITTEN ACROSS HIS FACE AND TELLING ANYONE WILLING TO LISTEN THAT HIS EMPLOYERS WERE HOLDING BACK HIS 'BEST ALBUM YET.'

The Gold Experience

(MAY 1994–JANUARY 1996)

He spent much of the rest of 1994 ignoring *Come*, which he completely refused to promote. When he did make a public appearance – either at Paisley Park or at his Glam Slam clubs – he would use it to showcase the unreleased *Gold Experience* material, or would give copies of its songs to DJs to play over the PA system. Tentative moves to release the album were made in September and October, but nothing came of them. Prince withdrew from the first set of talks, while the second was scuppered by a shift in personnel at Warner Bros.

As 1995 began the battle showed no sign of slowing down. On February 20 Prince was named Best International Male at the Brit Awards. "Prince? Best?" he began in a speech that left many thinking he had totally lost the plot. "*Gold Experience* better. In concert, perfectly free. On record, slave. Get Wild. Come! Peace, thank you."

Things became a little clearer a month later when he launched the Ultimate Live Experience tour, on which he intended to play mostly new material, going back no further than 'I Love U In Me' and '7.' The 20-date tour stopped at various European cities during March 1995, but was not the success Prince had envisioned. "This tour is crucial for him," UK promoter Chris Poole pointed out at the time. "He has a small cash-flow problem. He's not broke, but he's been spending his money on his music."

Unfortunately for Prince, where he had previously played a record-breaking 18-night stint at London's Wembley Arena, he was now struggling to sell tickets for four shows at the same venue. It got worse elsewhere: the Sheffield Arena was reportedly less than half full on the two evenings he played there. With touring being the main way for a musician to make money, this was not a good sign. (In a desperate attempt to raise more funds, fliers were handed out at each concert advertising that night's official aftershow event in the hope that fans would be willing to pay for another live experience immediately after the first.)

Prince made no secret of the fact that he was planning to play a lot of new, previously unheard material from *The Gold Experience*. He even implored fans to bring their tape recorders – somewhat ironically, given his subsequent aggressive stance toward those who trade in live

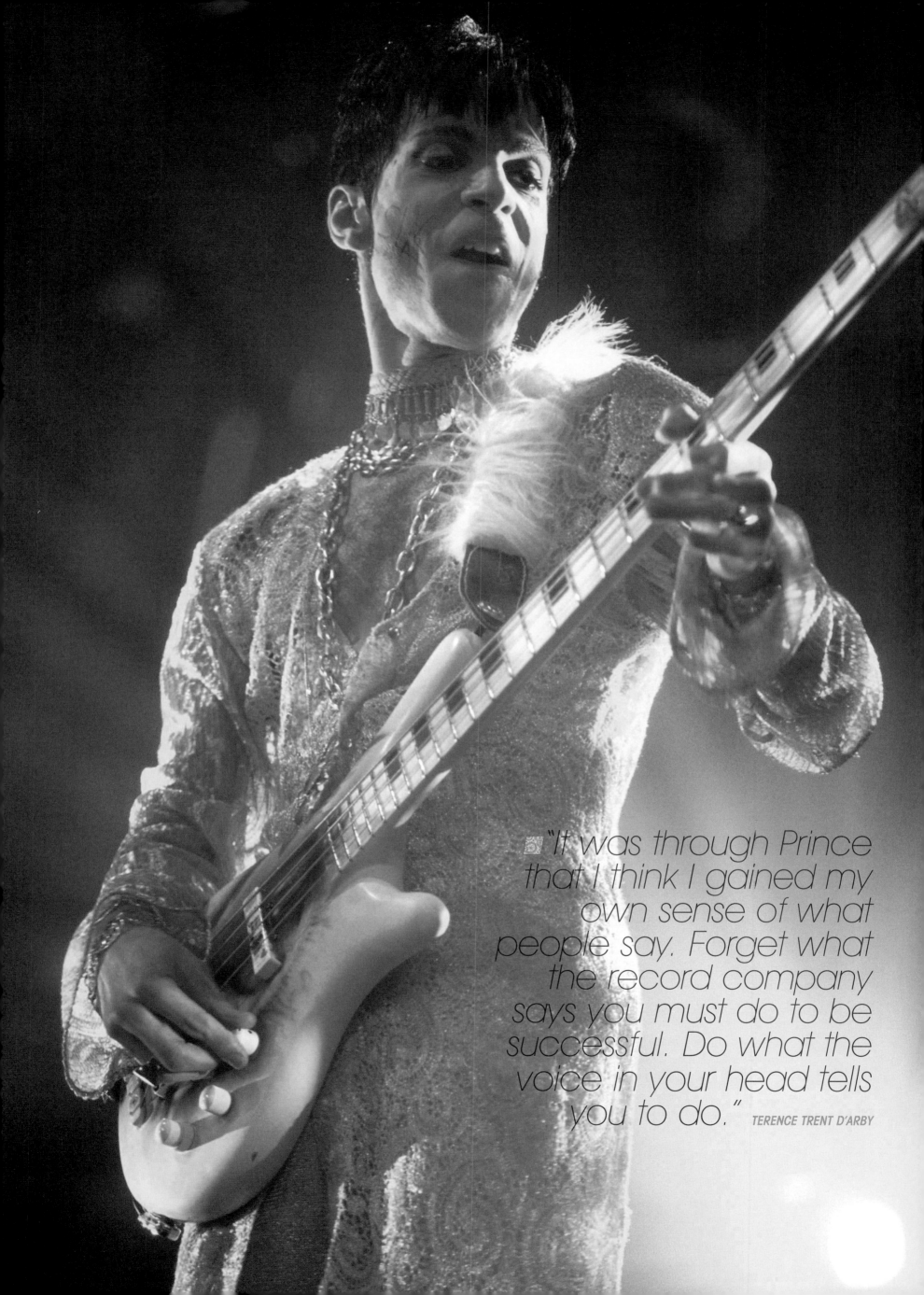

"It was through Prince that I think I gained my own sense of what people say. Forget what the record company says you must do to be successful. Do what the voice in your head tells you to do." TERENCE TRENT D'ARBY

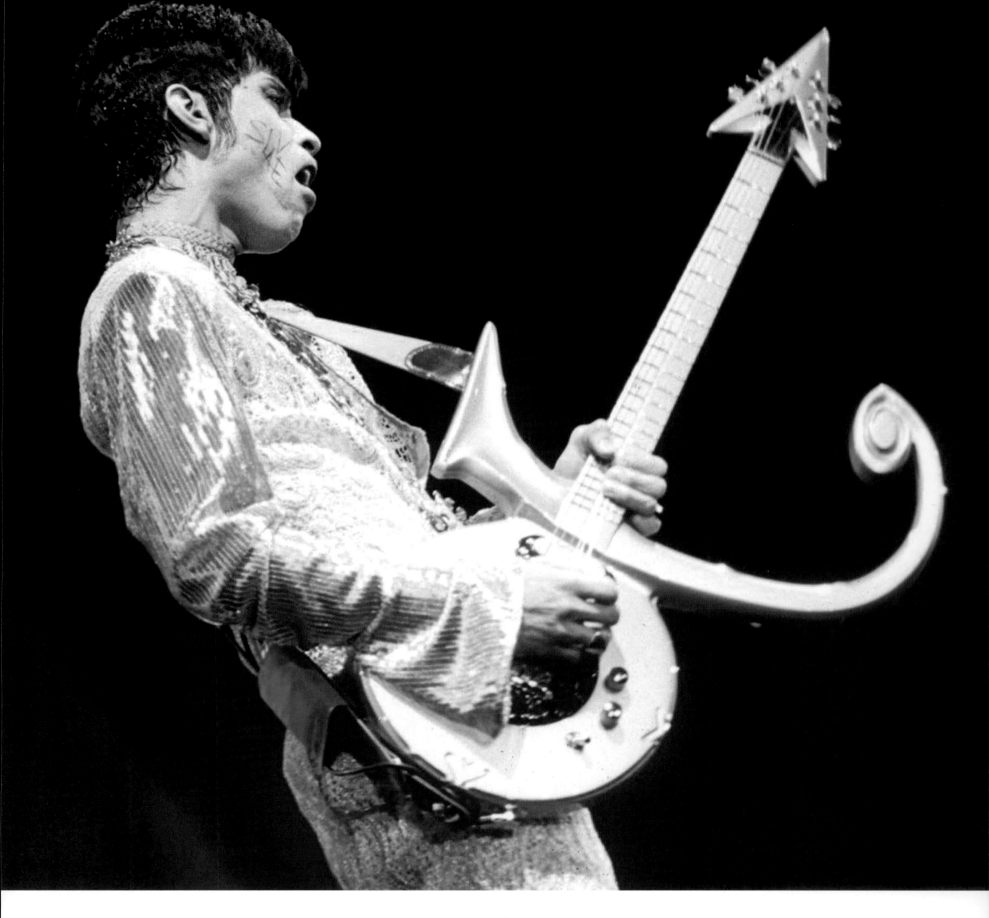

recordings – telling them that this would be their only chance to hear the music. Such a scenario was no doubt off-putting to those casual fans who had come to see Prince on his record-breaking Nude tour in 1990, and who have continued to turn out to hear him run through the hits "for the last time" in the years since.

The poor turnout affected the show itself, as Prince found himself having to cut back the production costs for fear of ending up seriously out of pocket. When the Ultimate Live Experience opened at Wembley Arena, Prince emerged from the Endorphinmachine – an extravagant structure flanked by representations of male and female genitalia, which took its name from one of the *Gold Experience* songs – and traveled to the front of the stage on a conveyor belt. Because of the expense of transporting the hugely cumbersome set Prince ended up leaving most of it, save the womb-like center, in London.

Even then the show was beset by technical problems that made the tour his most shambolic in a long time. After hiring and firing several sound engineers along the way, Prince had taken, by the end of the 20-date tour, to mixing the sound himself from within the womb. If this was the only chance his fans would get to hear the *Gold Experience* songs, he wasn't exactly presenting them in their best light.

The tour continued sporadically back in America, with several shows at Paisley Park after it was opened up to the public on August 1. Then, after much wrangling with

Warner Bros, *The Gold Experience* was finally released on September 26 1995. Despite the fact that much of it was already two years old, the album was well worth the wait, and sounded fresher than anything Prince had recorded in years. Finally, for the first time since *Sign "O" The Times*, he seemed able to put together an album full of commercial hooks and a sense of adventure that wasn't bogged down by weighty concepts.

Aside from references to Prince being "muerto" and further suggestions of a growing interest in internet technology and interactive media, *The Gold Experience* is, more than anything else, a collection of mostly great songs. It covers little new thematic ground, but that barely matters when the songs are as good as 'P Control,' 'Endorphinmachine,' and of course 'The Most Beautiful Girl In The World.' Even when he tries out Shuggie Otis-like sunshine funk on 'Shy,' or lets fly with his anger toward *Minneapolis Star-Tribune* columnist Cheryl Johnson (who took to calling him Symbolina after his name change) on 'Billy Jack Bitch,' the effect is much more powerful – and in the latter case, much funnier – than *Come*'s lumpen funk and dreary diatribes against Warner Bros. All in all, Prince seemed to have rediscovered his muse, notably on 'Dolphin,' one of his most lyrical and inventive power ballads, and the anthemic closer 'Gold,' a kind of 'Purple Rain' for the 90s.

Commercially, however, *The Gold Experience* was a disappointment. After two decades in the music business Prince seemed to have reached a point whereby hardcore fans would continue to buy whatever he released, but younger listeners were more interested in a new generation of stars. The album only just managed to sell 500,000 copies in America – partly, perhaps, because Prince had done most of his promotional work in support

of it long before it was actually available to buy, and partly because everything he did seemed to be overshadowed by his battle with Warner Bros – but did at least allow O{+> to beat Prince in the charts. (*The Gold Experience* reached Number Six, compared to *Come*'s Number 15.)

"A lot of the guys [at Warner Bros] who caused me problems have gone now, but I'm still waiting to see if things change. I still believe that The Gold Experience will never be released. They wouldn't even let me release a ballet I had written." PRINCE

To those critics who had rolled their eyes at the Prince/O{+> shenanigans, *The Gold Experience* was evidence that all was not lost. According to the *St Paul Pioneer Press*, it "fully redeems O{+> as the ruler of his wildly imaginative, funky, sexy kingdom," while *Vibe* called it a "Prince experience par excellence" and "his best effort since the 90s almost happened without him."

While it's true that *The Gold Experience* is Prince's best album of the 90s by some distance, it's also something of a backhanded compliment to focus on it purely in those terms. The album proved, after a string of disappointments, that Prince still had some spark left. The question was: how much? After touring Japan in January 1996 with what was essentially a continuation of the Ultimate Live Experience, Prince sacked The New Power Generation, many of whom had been playing with him since 1991. Having officially announced his intention of terminating his contract with Warner Bros in December 1995 it seemed that, just as had been the case when he let go of The Revolution almost a decade earlier, Prince now wanted to take back his music for himself in 1996.

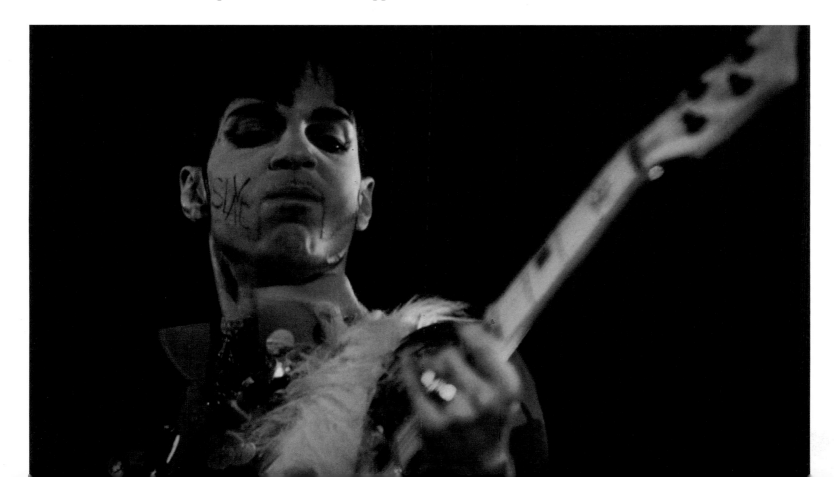

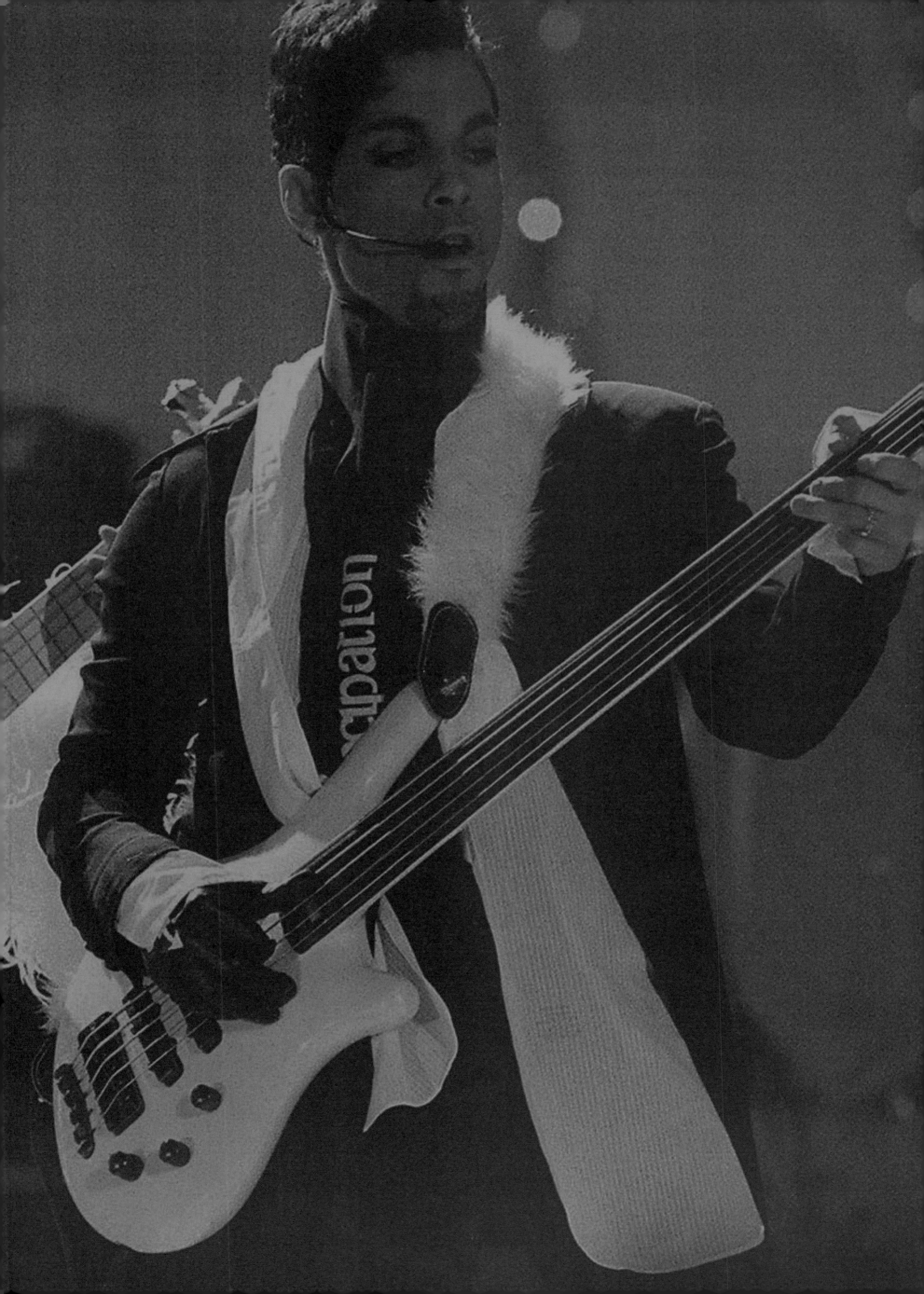

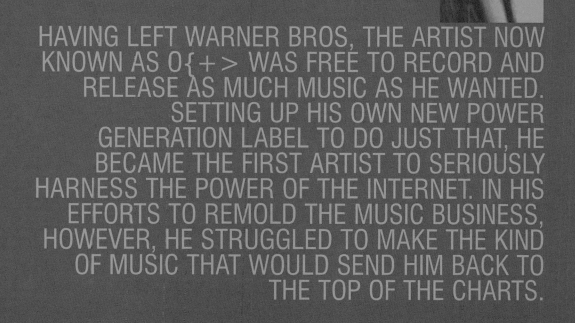

4

HAVING LEFT WARNER BROS, THE ARTIST NOW
KNOWN AS O{+> WAS FREE TO RECORD AND
RELEASE AS MUCH MUSIC AS HE WANTED.
SETTING UP HIS OWN NEW POWER
GENERATION LABEL TO DO JUST THAT, HE
BECAME THE FIRST ARTIST TO SERIOUSLY
HARNESS THE POWER OF THE INTERNET. IN HIS
EFFORTS TO REMOLD THE MUSIC BUSINESS,
HOWEVER, HE STRUGGLED TO MAKE THE KIND
OF MUSIC THAT WOULD SEND HIM BACK TO
THE TOP OF THE CHARTS.

EMANCIPATION
1996–2003

months after his son's death. At a time when many would have argued that he should have stayed at home with his wife, he was out on the road instead, seemingly throwing himself into his work as a way of dealing with what had happened.

To make matters worse, two former Paisley Park employees then decided to make Prince and Mayte's personal heartbreak public by selling their story to the press – and in doing so turned an unavoidable tragedy into a homicide case. Erlene and Arlene Mojica were twins from Puerto Rico who had been employed as Mayte's nanny and bodyguard respectively. They were fired in December 1996, reportedly because of suggestions that they were planning to speak to the press about life behind the closed doors of the Prince estate. (Prince later claimed that they had signed confidentiality agreements, but the Mojicas have said that their signatures were forged.)

Shortly thereafter, and apparently in retaliation to their having been sacked, the sisters contacted a local Minneapolis journalist, Tom Gasparoli, and gave their side of the story. Among their claims was the groundless insinuation that Prince had not given the baby enough of a chance to live before taking him off life support. Having heard the sisters' testimony, Gasparoli told them to go public with their claims. "I don't know if it's a crime," he told the Minneapolis radio station KSTP, "but it sure didn't sound right to me."

On March 9 1997 Britain's *News Of The World* ran a story entitled 'Bizarre Truth Behind Death Of Star's Baby.' The article was based on a number of the Mojicas' claims, including that Prince refused to allow Mayte to eat any meat during her pregnancy (and that the sisters had to sneak her out to a nearby TGI Friday's so that she could); that he wouldn't let her have an Ultrasound scan during her first trimester; and that he prevented doctors from giving her magnesium in order to avoid a miscarriage when she first started having contractions.

Thanks to Gasparoli, who shared the Mojicas' claims with any media outlet that would listen, the noise became so loud that local homicide detectives in Minneapolis were forced to get involved. Thankfully, it didn't take long for them to decide that it was "a natural death. We don't plan to investigate. There's no case here." The verdict was made official in June and the Mojicas were taken to court. They haven't spoken publicly about the affair since, but their 'revelations' clearly put further strain on Prince and Mayte's relationship.

"Some couples are brought together after the loss of a child," Mayte later noted. "Others are driven apart. In our case the latter happened." Their split was complicated and drawn out, but appears not to have been bitter. With Prince on tour for so much of 1996–97, it's entirely possible that he and Mayte simply grew apart at a time when they should have been working on making their relationship stronger.

The situation was further complicated by reports that Mayte had become involved with the Spanish dancer Joaquín Cortés, shortly after Prince bought her a mansion in Marbella. (The lyrics to *Rave Un2 The Joy Fantastic*'s 'I Love U But I Don't Trust U Anymore' appear to support

these theories.) Meanwhile, Prince himself is alleged to have been dating his future second wife, Manuela Testolini, as early as 1998.

A further strain was placed on the marriage when Prince became a Jehovah's Witness. He had been introduced to the faith, while at a rather low ebb, by Larry Graham, the former Sly & The Family Stone bassist, at the after-show party following the Nashville date of the Jam Of The Year tour during the early hours of August 22 1997.

Prince's new religious beliefs seemed to replace Mayte as the guiding force in his life. In 1999 he told *Paper* magazine that marriage contracts originated from Pontius Pilate's consensus to crucify Jesus, before explaining to the *New York Times* that he and Mayte had renounced their marriage vows after "read[ing] them over" and deciding that "there were a lot of things in there we didn't like."

A little while later he told the *Minneapolis Star-Tribune* that he and Mayte had "decided to do this whole thing together" for the benefit of their "spiritual wellbeing." He subsequently sent the newspaper a follow-up letter spelling out his distaste for "CONtracts" and reasserting various views that he felt had not been given adequate space in the original article. "These days Mayte and O{+> refer to each other as 'mate' or 'counterpart,' not husband and wife," he wrote, before explaining that the couple planned to renew their marriage with new vows that better suited them. (This never happened.)

Several years after splitting up with Prince, Mayte made a number of illuminating comments about him in an interview with the online magazine *Fiya*. "Now I know other men," she said, "I can see how in tune [Prince] is with women. It's the way he notices every detail about you … and when he looks at you he makes you feel like you're the center of the universe. That's very beguiling." Lamenting the fact that their marriage was allowed simply to fade away, she conceded, "I hate the fact I'm divorced. I'm now very wary of ever getting married again, because I believe marriage should be for life." Noting that Prince himself had since remarried, she added, "He's getting a divorce now."

AFTER FREEING HIMSELF FROM HIS WARNER BROS CONTRACT, MOST OBSERVERS EXPECTED PRINCE TO START RELEASING AS MUCH MUSIC AS HE POSSIBLY COULD. HAVING SPENT THE MAJORITY OF 1997 OUT ON THE ROAD, HOWEVER, HE DIDN'T GET AROUND TO RELEASING A FOLLOW-UP TO *EMANCIPATION* UNTIL JANUARY 1998 – AND EVEN THEN, IT WAS A COLLECTION OF OLD MATERIAL.

Crystal Ball (MAY 1997–JANUARY 1998)

Prince's recent albums might not have pushed the musical envelope in the same way as had his 80s output, but he was still plugging away at reinventing the music business. With *Crystal Ball*, he would become the first artist to sell an entire album online. In May 1997, he had started taking pre-orders for the multi-disc set via his new website, www.Love4OneAnother.com, and his 1-800-NEW-FUNK hotline. *Crystal Ball* was set to include three discs of archival material and a fourth disc of new songs, *The Truth*.

Prince was footing the bill for the production of the set himself, so decided not to start manufacturing it until he received a certain number of pre-orders (somewhere between 50,000 and 100,000). Whatever the figure, it didn't take long to reach it. With the promise of unreleased material cherry-picked from The Vault, demand among hardcore fans was high.

Crystal Ball was originally due to be sent out in June, but that proved to be a somewhat optimistic goal. Lacking the kind of manufacturing and distribution setup available to proper record labels, Prince's organization was overwhelmed from the start and couldn't keep up with demand. The first copies of the set were not sent out until January 29 1998, and even then there were problems with the mail order system, resulting in some fans receiving more than one copy while others didn't get theirs for months. As if to add insult to injury, *Crystal Ball* was then made available through conventional channels in March – and with a full-color booklet that wasn't included with pre-ordered copies. (Prince encouraged his fans to download the artwork from his website instead, as he would continue to do with the release of *Planet Earth* in 2007.)

The disastrous distribution served only to fuel fans' loss of faith in Prince as the 90s progressed, but that wasn't the only disappointment. *Crystal Ball* was supposed to come in a spherical, clear-plastic case, but when it finally saw the light of day it arrived in a flat, circular dish. The musical content, meanwhile, seemed hardly to represent the promised explosion of choice recordings from The Vault. Most of the unreleased songs from *Dream Factory* are

present, but had been overdubbed since the original 1986 sessions. The oldest track on the collection, 1983's 'Cloreen Baconskin,' might have offered the tantalizing prospect of a vintage collaboration with Morris Day, but is actually just an aimless 15-minute jam. And for every enjoyable mid-90s rarity, such as 'She Gave Her Angels' or the *Gold Experience* outtake 'Interactive,' there are dire remixes of *Come* and *Love Symbol* material. "As usual the music is funky and fun," wrote the *Minneapolis Star-Tribune*, "but most of it is for fanatics only."

The best part of the set was *The Truth*, an album of new material, most of it solo, acoustic, and embellished with only the lightest of overdubs. The performances are more intimate than anything Prince had recorded in years, while the songs pick up where *Emancipation* left off, continuing to trace the singer's life as a mature artist. The

blues-based 'Don't Play Me' alone makes the whole set worth owning for the way it demonstrates Prince's ability to assert himself without resorting to the bluster of *Chaos And Disorder*.

The *New Musical Express* described *The Truth* as a "minor revelation [that] sounds like nothing Prince, Squiggle, or The Artist has ever recorded." It's a shame then that pre-ordered copies of *Crystal Ball* followed it with a fifth disc tacked on in an attempt to appease those fans who felt they had wasted time and money on it. Prince wrote *Kamasutra* for his wedding to Mayte, and credits it here to The NPG Orchestra. The overall effect however is something that would better suit a new-age mail-order TV channel than a marriage ceremony, and suggests that Prince had little idea about the workings of classical music.

When Prince Met Larry (And Chaka)

As a member of Sly & The Family Stone during the late 60s and early 70s, Larry Graham pioneered the 'slap bass' technique, and is widely considered to be one of the best bassists of the rock era. He met Prince at an after-show party at the Music City Mix Factory in Nashville, Tennessee, in August 1997, and the two men quickly became inseparable. It wasn't long before Graham had become Prince's foremost spiritual guide, or before Prince had offered to produce an album for his new mentor in much the same way as he had in the past for romantic muses such as Susannah Melvoin and Mayte.

Prince started work on the album shortly thereafter, while also recording his own *Newpower Soul*. *GCS2000* would be Graham's first album since 1985 – and the first to be released under the name Graham Central Station since 1979 – and was scheduled for release in early 1999. By then Prince would also have recorded and released *Come 2 My House*, an album by Chaka Khan, famed for her role in the late 70s disco band Rufus and her 1984 cover of Prince's 'I Feel For You.'

The making of these two albums echoed the position Prince found himself in at the start of the decade, when he had tried to resuscitate the careers of Mavis Staples and George Clinton. Instead of letting Graham and Khan shape their own musical identities, Prince tried to remold them in his image, giving *GSC2000* and *Come 2 My House* the same sound as his own *Newpower Soul*. He had also thrown his weight behind two artists well past their prime – just as had been the case with Staples and Clinton.

While there might have been some interest in seeing Graham or Khan live, younger audiences were unlikely to want to listen to new records given an artificial contemporary sheen by either artist.

Prince took Graham and Khan out with him for the press tour in support of *Newpower Soul*, but did little to promote either act's new album beyond having them sit beside him while he praised their work. He seemed more interested in pushing the NPG label and its ethos. "I have no contract with Larry," he told *Good Morning America*. "We have a joke, you know, he says to me, 'Contract? Let's see, what would we put on it?' The prefix on contract is 'con.' I'm not trying to con him. I trust him and he trusts me."

The situation was much the same, it seemed, with Khan. "Chaka is another artist who was temporarily choked by restrictions, contracts, and bad business deals," Prince told *Guitar World* around the same time. "She's free now ... One of the pleasures of my life is being able to work with some of my musical heroes, and in doing so pay back some dues and have a great time."

It wasn't long before Prince realized that he didn't have the resources to run a label in the way he had previously, when Warner Bros bankrolled his Paisley Park imprint. His comments in the media began to take the form of pleas to bigger fish in the music industry to pick up Khan and Graham's albums for distribution.

"I don't want to see [Khan] get lost," he told Tavis Smiley on *BET Tonight*. "I challenge the radio stations, I challenge the record stores to take care of her." After praising Best Buy, Blockbuster, and HMV for being "really cool with us" for stocking the record, he noted how so many

contemporary artists – "the Lauryn Hills and the Erykah Badus" – have "much love for her." Larry Graham, he continued, "is Michael Jordan on the bass. Open and shut book. Now how do you not stock that if you love music?"

What the poor uptake of *Come 2 My House* and *GSC2000* proved, however, was that record retailers also loved money, and tended to avoid stocking records that were unlikely to generate a profit. At a time when Prince's own albums weren't selling too well, his side projects were even less successful. It's no coincidence, then, that Khan and Graham's comeback LPs were the last non-Prince albums to be released on NPG Records – suggesting that Prince has since realized that to become a major player he needed major-label backing, but that he had frittered away just such an opportunity in the early 90s with a series of half-baked projects that were never going to sell.

Former Sly & The Family Stone bassist Larry Graham on stage in 1998.

PRINCE'S SECOND NEW ALBUM OF 1998 WAS THE FIRST SINCE 1995'S *EXODUS* TO BE CREDITED TO THE NEW POWER GENERATION. HIS REASON FOR RETURNING TO THE NAME IS UNCLEAR, SINCE HE NO LONGER HAD TO HIDE BEHIND IT TO AVOID THE WRATH OF WARNER BROS.

Newpower Soul

(APRIL–DECEMBER 1998)

Perhaps he had finally come around to the idea that flooding the market with too many Prince/O{+> albums might be unwise; perhaps he realized that the album wasn't very good, and didn't want to highlight it as a bona fide solo record. If the latter is true, it doesn't really fit with the fact that *Newpower Soul* is the NPG album on which Prince features most prominently – he even put himself on the sleeve. If he thought he was revealing a great secret in doing so, however, he was mistaken.

Released on June 30, *Newpower Soul* performed more strongly than *Chaos And Disorder*, suggesting that Prince fans were more willing to indulge his funk missteps than his rock follies, despite the fact that it's one of the worst and least interesting albums of his career. Prince spends most of it plundering George Clinton, until he gets to 'Push It Up,' which cannibalizes his own 'Jam Of The Year.' The UK single 'Come On' is the best of a bad bunch of aimless funk songs; only 'Mad Sex' and the hidden track (number 49) 'Wasted Kisses' – a particularly dark tale sung from the perspective of a man who has just killed his lover – offer anything different. The rest of the album is made up of the sort of lukewarm funk everybody knew Prince was capable of making, but hardly anybody wanted to hear.

Prince put a fair amount of effort into promoting *Newpower Soul* live and on television, but most of the interviews he gave focused not on the music but on his assertion that he had made the right decision to go out on his own. "I think I'm better suited to market my own music," he told Tavis Smiley on *BET Tonight*. "I am in a position now with New Power Generation Records that I can take the music and repackage it … I was never allowed this before. You're talking about a lucrative sum of money, and I've made a lot of money since I left Time-Warner."

More interesting than *Newpower Soul* itself was the series of short tours Prince undertook in support of the album in the USA and Europe, giving fans another chance to see stripped-down performances of the hits, this time without second guitarist Kat Dyson but with the addition of backing singer Marva King. The shows were made all the more interesting by regular guest appearances from Larry Graham and Chaka Khan, funk veterans who both had NPG Records albums of their own to promote. In a decade full of low points, however, *Newpower Soul* stands as Prince's lowest.

Prince & The Muppets

The second season of *Muppets Tonight*, a spin-off from the long-running *Muppet Show* series, opened with a bang on September 13 1997 when it featured Prince (still calling himself O{+>) as a guest star. The culmination of a series of Prince-as-everyman television appearances, which had begun a year earlier with an incredibly open interview on *Oprah*, it was taped during a break from the Jam Of The Year tour, with the singer still ostensibly promoting *Emancipation*, almost a year after its release.

He also seemed keen still to score points against Warner Bros, a year after his departure from the label. At one point a ventriloquist's doll asks the singer if he would consider working with dummies, to which Prince replies: "I already have, but in my business they're called executives."

For the most part he was there to have fun, however, and appeared to be a lot more relaxed with The Muppets than he tended to be when fulfilling press and media obligations with human beings. Cue gentle mockery of his new name (a security guard tells Prince he is "the bear currently known as unamused"); a group of Muppets dressed as Prince from different eras, singing 'Delirious'; the singer himself dressed as a country bumpkin, with an alligator disguised as a pet dog; and a re-recorded version of 'Starfish & Coffee' filmed as a black-and-white flashback to the school days of the Muppets' take on a young Prince.

The show closes with 'She Gave Her Angels,' one of the many Prince songs of the time written for and inspired by Mayte. All in all, *Muppets Tonight* was one of the most bizarre television appearances Prince has ever made. It's also one of the few times in his career that he has seemed to let his guard down.

1999: The New Master

(DECEMBER 1998–FEBRUARY 1999)

With the new millennium fast approaching, it came as no surprise that '1999' began to play on the minds of Prince, his fans, and even casual listeners who had heard the singer's breakthrough hit at some point since its release in 1983. The Warner Bros executives would have been only too aware of the commercial potential of so timely a song, but when they decided to reissue it as a single in December 1998, Prince was enraged.

As far as Prince was concerned, the dissolution of his contract with Warner Bros meant that only he should be able to make money off new releases bearing his name. But since Warner Bros owned the '1999' master tapes, the label could release the song whenever it wanted (and would do so again the following December). In retaliation Prince decided to re-record and overdub the original '1999' for a new release on his own NPG label, the *1999: The New Master* EP.

> ## "Once Warner Bros refused to sell me my masters, I was faced with a problem." *PRINCE*

"Once Warner Bros refused to sell me my masters, I was faced with a problem," he told *USA Today* shortly after the EP's release. "But 'pro' is the prefix of 'problem,' so I decided to do something about it."

What he seemed to have decided to do, however, was destroy the legacy of the original, replacing a lean blast of future-funk with an overproduced mess that made misguided concessions to dance and hip-hop. Ironically, the new additions – DJ scratches, sampled Rosie Gaines vocals, a rap

by Doug E Fresh, and a Latin breakdown that probably would have worked much better live than on record – made the 'new master' sound more dated than the original.

The remaining six tracks on the EP comprise a series of tired variations on the same theme, including an 'Inevitable Mix' that replaces Lisa Coleman and Dez Dickerson's original vocals with the less fitting voices of Larry Graham and Rosie Gaines. The EP's most interesting moment is a poem read by actress Rosario Dawson over the instrumental intro of 'Little Red Corvette,' an anti-Christmas rant drawing on the Jehovah scriptures that says more about Prince's mindset at the time than a torrid remake designed to strike back at his former employers.

Perhaps the most notable aspect of the release was the fact that singer broke his 'Prince' boycott and credited it, somewhat cynically, to Prince & The Revolution. But not even that was enough to encourage his fans to buy it. *The New Master* EP only reached Number 150 on the *Billboard* pop albums chart, and Number 58 on the R&B albums chart. By contrast, Warner Bros's 1998 and 1999 reissues of the original single made it to Number 40 and Number 56 on the Hot 100 respectively.

For a while Prince threatened to tackle the rest of his back catalog in the same way, telling *Paper* magazine that, since Warner Bros wouldn't give him back the original masters, "I'm going to re-record them. All of them." This, he claimed, would result in "two catalogs with pretty much the same music – except mine will be better – and you can either give your money to WB, the big company, or to NPG. You choose." On the evidence of *1999: The New Master*, it's just as well he didn't bother. There would have been plenty of disappointment on both sides.

The Vault... Old Friends 4 Sale

(AUGUST 1999)

Since the 1996 release of *Chaos And Disorder*, Warner Bros had been sitting on the one last Prince album it was owed as part of the deal to terminate the singer's contract. Rather cannily, the label waited until Prince announced his return to another major label before putting out *The Vault … Old Friends 4 Sale* in an effort to steal some of the thunder from *Rave Un2 The Joy Fantastic*, which was scheduled for release through Arista in November 1999. That Warner Bros opted to credit *The Vault* to Prince – rather than O{+> – only heightened the snub.

Like *Chaos And Disorder*, *The Vault* came with a number of reminders that it was not necessarily something that Prince wanted released, from the "originally intended 4 private use only" disclaimer to the lack of detailed information in the liner notes (particularly by comparison to NPG Records' *Crystal Ball*). The prospect of more unreleased material from The Vault was enough to send the album to Number 85 in the USA and Number 47 in the UK, but most of those fans that bought it were left disappointed. As far as the *New Musical Express* was concerned, *The Vault* had been "cobbled together to cash in on a dwindling hardcore rump of completist fans."

Perhaps the biggest fault to be found with *The Vault* is the fact that it contains material that had previously been available on bootlegs and that might now have been of superior sound quality but was far less impressive from a musical standpoint. 'Old Friends 4 Sale,' for example, was written in the immediate aftermath of Chick Huntsberry's story about the singer appearing in the *National Enquirer*, and could potentially have resulted in one of Prince's most brutally honest recordings. The *Vault* version was recorded in the

early 90s, however, and any meaning to be found in the lyrics is crushed under the weight of schmaltzy over-production.

The Vault might be marginally more enjoyable to listen to than *Chaos And Disorder*, but many of the songs included on it are either unfinished or simply aimless. Three tracks come from the aborted soundtrack to *I'll Do Anything*, of which 'There Is Lonely' is an interesting ballad without a conclusion and 'My Little Pill' is an odd spoken-word piece that doesn't make much sense outside of its original context. Much of the rest of the material is jazz-orientated, but it's often so vague and bland that it passes by unnoticed.

> *The album's musical value is summed up by 'Extraordinary,' which is anything but.*

The album's musical value is summed up by 'Extraordinary,' which is anything but. It sounds instead as if Prince entered the title into a songwriting machine, pressed the 'falsetto ballad' button, and put the results onto disc without even listening to them.

One or two tracks do make for pleasant listening, among them 'Old Friends 4 Sale' and '5 Women+.' But if *The Vault … Old Friends 4 Sale* was designed to offer tantalizing evidence of the vast collection of unreleased excellence that Prince has everyone believe exists, it failed miserably. Many fans would have been thinking the same as *The Guardian* newspaper when it asked, in its review of the album, "What became of the talent formerly known as Prince?"

AFTER PROVING THAT HE COULD SUCCEED ON HIS OWN TERMS WITH *EMANCIPATION* IN 1996, PRINCE BEGAN TO LOOK INTO ALTERNATIVE METHODS OF DISTRIBUTION, INCLUDING WORKING IN CONJUNCTION WITH INDEPENDENT LABELS AND SELF-RELEASING AN ENTIRE PACKAGE ONLINE (SOMETHING NOBODY ELSE HAD EVER DONE).

Rave Un2 The Joy Fantastic

(APRIL–DECEMBER 1998)

But with *Newpower Soul* failing to set the charts alight, and the same fate befalling NPG Records releases by Chaka Khan and Larry Graham, he must have started wonder whether he would ever have any major commercial clout again. The year that gave the title to one of his major breakthrough hits was fast approaching, and the song itself looked likely to overshadow almost everything he had done during the 90s.

"If the sky has blood in it," Prince to told *BET Tonight* host Tavis Smiley, in response to a question about the ominous approach of the year 1999, "blue and red make purple." He gave a slightly less cryptic response during a similar discussion with *Details* magazine. "I have nothing against the music industry," he said, "I just wanted to be free of it to explore all options for releasing my music. And I'll tell you this – I'll work with the music industry again, probably to release my next album."

Prince had been fairly quiet during the early months of the year, releasing nothing except his torrid 'new master' of '1999' in an act of defiance against his old record company. His only other act of note had been to lash out

with lawsuits against fan magazines and websites that he claimed were cashing in on his copyrights. Then in April 1999 he began making tentative contact with various major labels with the help of L. Londell McMillan, the lawyer who had negotiated the deal to extract the singer from his Warner Bros contract.

Most of the meetings went badly. Prince found himself making the same complaints as before: that the labels wanted him to record identikit 'Prince' music, and stood to make much more out of it than he would himself. He seemed to have stepped right back into his mid-90s mindset in an interview with *Paper*, in which he compared the modern music industry to the movie *The Matrix*. "All the levels keep dissolving until you can't see what's behind anything," he said. "I'm not against the record industry. Their system is perfect. It benefits the people who it was designed to benefit: the owners."

Fortunately for Prince, one of the men he met with was Clive Davis at Arista. Davis was and is a legend in the music business, having signed Janis Joplin, Billy Joel, and Bruce Springsteen while at Columbia during 1967–72

before founding his own label, Arista, and putting together one of the most varied rosters in the business. By 1999 the label had been purchased by the Bertelsmann Music Group; Davis himself was gearing up for the release of Carlos Santana's *Supernatural*, a star-studded collaborative album that would eventually sell more than 25 million copies. Davis was the man with the midas touch, and was ready to put his powers to work on lifting another fallen star out of the doldrums and back onto primetime radio.

A deal was struck in May shortly after Davis listened to what Prince had recorded so far. In return for agreeing to work with a major label for the first time three years,

Prince was given an $11 million advance and a one-album deal that allowed him to keep his master tapes. All he had to do now was complete the album, which Arista would then use its own resources to promote and distribute, leaving Prince free to go his own way if he wasn't happy with the results.

"It's like going back to school and knowing that you don't have to stay," Prince told *USA Today*. There was nonetheless some surprise in the media that the man who had declared himself a slave to the industry three years earlier could even consider returning to a major label. Prince justified his decision by praising Davis, making it

The Joy In Repetition

With the 90s "almost happen[ing] without him," as one reviewer put it, Prince's artistic and commercial success fell into a sharp decline. But the rate at which he changed his mind and scrapped one project in favor of another remained the same. Given the quality of the material that *did* make it out into the world, it's unlikely that any of these unreleased works would have bothered the charts. But the lack of information about projects such as *The Dawn* (1997), *Madrid 2 Chicago* (2001), *High* (2001), and *Last December* (2002) serves only to increase speculation about them.

Little is known about any of these albums except for their titles and the fact that they were all 'announced' at some point or other. (One or two tracks earmarked for each may perhaps have ended up being released officially elsewhere.) There were also plans for several box sets: a seven-disc set of Prince samples for DJs with a suggested retail price of $700; a second volume of *Crystal Ball*, with the tracklisting set to be chosen by the fans; and another seven-disc set, *The Chocolate Invasion*, comprising all of the material that had been made available through the NPG Music Club until 2003. There were even rumors of a *3121* movie to accompany the album of the same name.

The most tantalizing of all the unreleased albums of the period was *Roundhouse Garden*, which Prince announced in 1998 as being a Revolution reunion album based on recordings from the mid 80s. Whether it would have entailed a full-scale reunion is unclear, but he did meet with his former bandmates at some point to discuss working together again. Problems arose when he allegedly demanded that Wendy Melvoin and Lisa Coleman renounce their homosexuality

before he could work with them, leading Bobby Z to withdraw from the project. (Prince later blamed Melvoin and Coleman for the fact that the album never saw the light of day, suggesting that people ought to ask *them* why it was never released.)

If *Roundhouse Garden* was the dream collaboration that never was, the weirdest unreleased project Prince began around the turn of the millennium was a planned *Rainbow Children* movie directed by Kevin Smith. While shooting his fifth movie, *Jay & Silent Bob Strike Back*, Smith got in touch with Prince to ask whether he could use 'The Most Beautiful Girl In The World' on the soundtrack. Prince declined, but offered Smith The Time's 'Jungle Love' instead, while also proposing an idea of his own.

It transpired that Prince was an avid fan of Smith's fourth movie, *Dogma*, a satire of Catholicism that led to death threats being sent to the director. As Smith later recalled in *An Evening With Kevin Smith*, Prince seemed to have got the wrong end of the stick. "Sitting there, listening to him talk about it," Smith said, "it's starting not to sound like the movie I made."

Prince nonetheless felt that Smith was the man to direct his next movie project, and invited him to Paisley Park to film the second annual fan event in June 2001. Part of Smith's job was to film a series of Q&A sessions, as well as fan responses to playbacks of *The Rainbow Children*. According to Smith, Prince wanted to make something that was "kind of like a concert film," but which included "bold things" like putting the words 'Jesus Christ is the son of God' on a screen and letting the crowd "deal with it."

Despite finding it impossible to connect with the project, Smith spent a week at Paisley Park and shot hours of footage. Along the way he picked up a lot of curious

information about the laws of 'Prince World,' including that, according to a producer by the name of Stephanie, the singer would often make outlandish requests, such as asking for a camel to be brought to him at 3am.

Perhaps unsurprisingly, the *Rainbow Children* movie never materialized. Smith was later asked to return to Paisley Park to edit the footage, which had already been through the hands of a number of other film technicians, after Prince decided to try to turn it into a recruitment video for Jehovah's Witnesses. Smith felt that he had "already [done] my recruitment film for Catholicism," so passed on the project. "If you're ever approached by a bunch of Jehovah's Witnesses and they say we'd like you to watch this video," he joked at the taping of *An Evening With Kevin Smith 2: Evening Harder*, "that's my latest film."

Dogma director Kevin Smith, who was hired to film fan reactions to *The Rainbow Children* at Paisley Park.

clear that he felt a bond with the man, not the company.

"When I was at Warner Bros I always heard from a third party," Prince claimed, perhaps forgetting the personal support he'd received in the early days. "Record companies want to own [our] creations, but no one owns the creations but the creator ... Clive agrees you should own your masters. He also told me, 'I have free will, too.'"

Davis for his part went around telling journalists what a genius Prince was, and making it clear that this was a comeback of the highest order. (The singer himself challenged journalists who used the 'c' word, asking, "Comeback from what?") Undeterred by Warner Bros's release of *The Vault ... Old Friends 4 Sale*, Prince pushed his new album, *Rave Un2 The Joy Fantastic*, as hard as any since *Emancipation*.

With *Rave* featuring guest appearances by the legendary saxophonist and former James Brown sideman Maceo Parker, Public Enemy's Chuck D, Ani DiFranco, and Gwen Stefani, comparisons to Santana's *Supernatural* were obvious, and all eyes were on Davis's power to mastermind another smash-hit. Prince of course tried to play down the comparison.

"I knew nothing about [Davis]," he told the *New York Times*, somewhat dubiously, "but he knows me. We agreed that this album is full of hits. It was just a question of whether or not we could agree on how it should be put

> "This is a poet, a renaissance man, an iconoclast. This is someone who is bringing the state of music further along. I don't want to get involved in whether this is hype or not – this man is at the top of his form." CLIVE DAVIS (PRESIDENT OF ARISTA)

out." As with *Emancipation*, Prince seemed rather too eager to prove his continuing relevance. "Tell me that's not a hit," he almost begged Anthony DeCurtis of the *New York Times* after playing him the album's first single, 'The Greatest Romance Ever Sold.'

Interest in the album rose when it was announced that, for the first time ever, a guest producer would be brought in on *Rave*, only for the excitement to die down when the man in question was revealed to be 'Prince' (the album itself is credited to O{+>). Despite 'O{+>''s assertion that 'Prince' had always been his best editor, many observers began to suspect that they would be getting another lackluster album in the *Newpower Soul* vein.

The disappointing identity of the 'guest' producer wasn't the only link back to Prince's heyday. The title came from a project he had shelved in 1988 because the title track, now resurrected, "sounded so much like 'Kiss'

that I wanted to put it in The Vault and let it marinade for a while." He also returned to using the Linn LM-1 drum machine for the first time in years. But none of this would be enough to make *Rave* a hit. Prince had been on the promotional trail for almost a month when 'The Greatest Romance Ever Sold' was released on October 5, but the single still failed to make a major impression. Part of the problem was that, after the success of 'The Most Beautiful Girl In The World,' he believed ballads were his best route into the charts. While Santana's Latin rock had lain dormant for long enough that it felt almost like a 'new' sound, 'The Greatest Romance' was just another Prince ballad.

When *Rave* itself was released on November 9, the most reviewers could agree on was that it was the sound of Prince at his most unashamedly commercial, which is true: it's undoubtedly his most chart-orientated album since *Diamonds And Pearls*. But while *Diamonds* did its best to capture the zeitgeist of early-90s R&B, *Rave* seemed to lag far behind the sound of contemporary producers such as The Neptunes and Timbaland.

According to the *New Musical Express*, *Rave* suggested that Prince had been "killed at the turn of the decade, and his record company have kept the incident a secret, releasing off-cuts from his previous sessions as new albums." *Entertainment Weekly* was kinder, noting that "when he's on, almost anything – even that nasty messiah complex – seems 4giveable," but still describing his cover of Sheryl Crow's 'Every Day Is A Winding Road' as a "borderline travesty."

Rave has its moments – notably 'Eye Love U But Eye Don't Trust U Anymore' – but for the most part it sounds like a tired, cynical attempt to get back into the charts, with the likes of 'Baby Knows' coming off like a tenth-generation retread of 'U Got The Look.' Of the guest collaborators, meanwhile, only Gwen Stefani was truly contemporary enough to attract a younger audience.

Taken as a whole, the album suffers from the same complaint as Prince's debut, *For You*: in trying to prove his ability to make hit records, he made everything much too clinical. There's none of the fun, spontaneity, or trust in happy accidents that so benefited the likes of *Sign "O" The Times*. "Once again I don't follow trends, they just follow me," he sings on the hip-hop-edged 'Undisputed,' but the album's musical content does nothing to back up the claim.

Ironically, with Prince keen for once to focus his efforts on pushing a major release in the USA, Arista's German-based parent company forced him to start in Europe, making television appearances and giving a handful of live performances in major cities such as Madrid, London, Paris, and Cologne. Given that the album only reached Number 145 in the UK, for example, it seemed like a wasted effort – particularly when it had hit Number 18 on *Billboard*. Some might have been happy enough with that

– it was, after all, Prince's best US chart placing since the release of *Emancipation* – but the man himself felt that Arista had botched the promotional campaign, and that Clive Davis had failed to deliver on his promise of hits.

Prince made a final stab at promoting the album in December, appearing on TV and even filming a pay-per-view New Year's Eve celebration, *Rave Un2 The Year 2000*, at Paisley Park. But as the millennium drew closer, he felt once again that he had been let down by a major label, and started posting messages on his website suggesting that Arista lacked commitment (while also pulling the plug on his own promotional efforts).

Prince also demanded that Arista release a second single from the album, but Davis refused to spend more money on an artist who had lost all interest in working the record himself. A stalemate ensued, resulting in Davis

pulling the plug on *Rave* and leaving it to slide back down the charts.

Mirroring the release of *1999: The New Master* a year earlier, Prince released a remixed version of the album entitled *Rave In2 The Joy Fantastic* to members of his NPG Music Club in April 2000. He left some tracks the same, remixed some of the others, and replaced 'Every Day Is A Winding Road' with 'Beautiful Strange,' a murky soundscape reminiscent of some of the weirder moments on *Come*.

All in all, the new *Rave* was another case of preaching to the converted, and as such was unlikely to find its way onto casual fans' stereos, even if it is marginally more interesting than its predecessor. As the new millennium dawned, Prince seemed like nothing more than an independent artist with a firm yet modestly sized fan-base.

Rainbow Child

PRINCE'S EARLY GROUNDING IN RELIGION CAME FROM THE BIBLE CLASSES HE ATTENDED AS A CHILD AT MINNEAPOLIS'S SEVENTH DAY ADVENTIST CHURCH. LIKE MOST ADOLESCENTS, HE GREW INTERESTED IN SEX, LEADING TO ALL MANNER OF RUMORS ABOUT WHAT HE GOT UP TO IN HIS BASEMENT HOME BENEATH BANDMATE ANDRÉ ANDERSON'S HOUSE. MUCH OF HIS SUBSEQUENT RECORDING CAREER CAN BE SEEN AS AN ATTEMPT TO RECONCILE HIS SPIRITUALITY WITH HIS SEXUALITY.

In the early days, on songs such as 'Let's Pretend We're Married,' Prince appeared to have no qualms about setting "I'm in love with God, he's the only way" against his desire to "fuck the taste out of your mouth." But by the mid 80s he seemed to have realized that, in his new role as a musical superstar, he ought to be a little more measured in his opinions, and took to addressing on stage his divided loyalties to a God who wants him to be a good, and an audience who "love it when I'm bad."

"I believe in God," he told *MTV* in 1985. "There is only one God. And I believe in an afterworld." Acknowledging the fact that he has been accused of "a lot of things contrary to this," he added, "I'm sincere in my beliefs. I pray every night and I don't ask for much. I just say 'thank you' all the time."

By 1988 Prince's beliefs had strengthened to the point

where he seemed to be erasing part of his past self entirely. The overall message of *Lovesexy* was muddled, but at its heart was a wish to fuse his sexual desires with a deeper faith in God. It might have been lost on many, but as far as Prince was concerned he was gradually getting closer to God – hence his symbolic killing-off of one of his old personae on stage each night on the accompanying tour.

Prince's spiritual struggles continued right through the 90s. "The only time you can get tranquil is when you are at one," he told the *New Musical Express* in 1995. "The only time that happens is when you are with God. He tells me to carry on doing what I'm doing, which is my music." With the music in question still gravitating toward the carnal, it's no wonder he was conflicted.

When Prince changed his name to O{+> in 1993, he claimed he had been told to do so by his 'spirit.' In subsequent interviews it did genuinely seem as though a huge burden had been lifted, and that he had become a better man in the process. But as the 90s progressed he seemed continually to be struck by one tragedy after another. At his lowest ebb following the death of his infant son in October 1996, he once again went looking for spiritual guidance. His search would lead him to reconnect with God in a much deeper way than ever before.

Toward the end of 1997's Jam Of The Year tour – arranged in support of *Emancipation*, an album written in 1996 in celebration of marriage and impending fatherhood – Prince met Larry Graham, who had become a Jehovah's Witness in 1975 after the hectic fallout from Sly & The Family Stone in the early 70s, and quickly began to open up to Prince about the faith, which takes a literal approach to *The New World Transcription Of The Holy Scriptures*, a revised edition of The Bible published in 1950.

Prince took to the religion almost immediately, and before long Graham had replaced Mayte as the singer's spiritual and emotional confidante and moved his family to Chanhassen, Minnesota. "Larry's a special individual", Prince told *Guitar World* in 1998. "Not only has he shown me so much spiritually about The Truth, he's given me a lot of bass licks I can steal."

He went on to explain how his newfound faith had changed his perspective. "['The One'] went from a love

Larry Graham, Prince's spiritual mentor during his conversion to the Jehovah's Witness faith. Prince shrouds himself for an appearance at the 2005 People's Choice Awards.

song to a song about respect for the Creator," he said, adding that the meaning of the lyrics changed significantly for him after he read the *New World* Bible. "It has to be the *New World* translation because that's the original one," he added. "Later translations have been tampered with in order to protect the guilty."

Prince took to the Jehovah's Witness faith almost immediately, and before long Graham had replaced Mayte as the singer's spiritual and emotional confidante and moved his family to Chanhassen, Minnesota.

Prince's religious conversion provoked a mixed response from fans when the singer started changing the lyrics to some songs and refusing to play others on account of their lyrical content. *Controversy*'s 'Sexuality' became 'Spirituality,' with a new cry of "Spirituality is all we ever need"; 'The Cross' became 'The Christ,' reflecting the Jehovah's Witnesses' rejection of Christian symbolism.

Many fans were upset by this. The man who once made it his business to break down as many barriers as possible was now advocating a conservative worldview and following a straight doctrine that ordered the world in a precise hierarchy: God, Man, Woman, Child, Animal. The more Prince became engrossed in his new faith, it seemed, the more withdrawn he became from real life, and even less accessible. "I don't believe in idol worship," he told *Entertainment Weekly* in 2004. "When I get asked for my autograph, I say no and tell them why, because I'm giving them something to think about."

Prince had spent much of his life changing on an almost yearly basis, but seemed to settle into a more settled routine after converting to the Jehovah's Witness faith. As late as 2006 he was praising The Bible in *Giant* magazine as "the guidebook to help men and women with their sins," noting that, if he needed advice about anything, there was nobody better to consult than Solomon, "the guy who had a thousand women!"

After polarizing opinion in 2001 with the overt religious content of *The Rainbow Children*, Prince reportedly began a more direct method of recruitment two years later – at least according to Cheryl Johnson, the *Minneapolis Star-Tribune* columnist with whom the singer had become embroiled in a public feud during the 90s. In 2003 Johnson reported that Prince and Graham had turned up in a "big black truck," knocked on a door, and started preaching the good word to a woman by the name (in the article at least) of Rochelle. Not only was this a Jewish household, but the two men had picked the evening of Yom Kippur to try to convert a Jewish woman to the Jehovah's Witnesses.

Prince has appeared to mellow somewhat in the years

since. He has never publicly renounced his faith, but did include enough innuendos and gentle sexual references on *Musicology* and *3121* to suggest that he was once again seeking to reconcile his carnal urges with his spiritual ones. Mavis Staples made a telling remark about the singer in a 2007 issue of *Humo* magazine. "I really wonder if his faith still means that much to him," she said. "Recently, in Vegas, he seemed very much like the old Prince."

The latest twist came in 2008, when rumors began to spread that Prince had become disillusioned with the Jehovah's Witness faith and started looking into Scientology. The singer's 21 Nights In London residency allegedly outraged Witnesses who felt that some of his song choices were too racy, and his dances far too seductive. (While he did play instrumental snippets of a few old songs such as 'Erotic City' and 'Nasty Girl,' he stopped short of singing anything that might be deemed 'outrageous.')

Prince reportedly attended a Scientology seminar in Minneapolis on February 14 2008. But whether he feels like undergoing another conversation in his pursuit of spiritual perfection as he approaches his sixth decade remains to be seen.

AFTER FAILING TO RE-ESTABLISH HIMSELF AS A MAJOR ARTIST AGAIN WITH *RAVE UN2 THE JOY FANTASTIC*, PRINCE SPENT MOST OF 2000 OUT OF VIEW, SEEMINGLY STUNG BY THE DISAPPOINTMENT. HIS ONLY PUBLIC APPEARANCES BEFORE NOVEMBER WERE AT PAISLEY PARK, TAKING THE FORM OF A SERIES OF EARLY-HOURS PARTIES AND THE FIRST ANNUAL PRINCE: A CELEBRATION FAN EVENT, WHICH RAN FROM JUNE 7–13.

The Rainbow Children

(SEPTEMBER 2000–NOVEMBER 2002)

Then, on November 7, he embarked on the first leg of his Hit N Run tour of the USA, giving fans yet another chance to see him perform the hits with another revamped NPG. The line-up this time included a second keyboard player, Kip Blackshire, brought in to bolster Morris Hayes's sound; Jerome Najee Rasheed on saxophone; Geneva, Prince's first official dancer since Mayte; and John Blackwell, perhaps the most powerful Prince drummer since Michael Bland. A second leg followed in April 2001 prior to a six-date mini-tour in June dubbed A Celebration.

To the wider world Prince appeared to have lost his way, with nothing left to offer but the same old greatest-hits sets. Anyone paying closer attention however would have noticed the release of a new single, 'The Work Pt. 1,' via Napster, the controversial, pioneering file-sharing site, in April 2001. But while the method of distribution was certainly innovative, the song itself was little more than a James Brown-style pastiche reminiscent of *Rave Un2 The Joy Fantastic*'s 'Prettyman.'

Two months later, Prince opened Paisley Park up for a second weeklong fan event, which this time took its name from the title of his forthcoming new album, *The Rainbow Children*. Prince had been quietly working on the record since the fall of 2000, and gave it its first airing at listening sessions during the event. Fan opinion was polarized, just

> *The Rainbow Children marked the return of Prince the artist, as opposed to Prince the hit-maker.*

as the critical response would be when the album went on sale in November (having been available to NPG Music Club subscribers as a download since mid October).

One of the most striking aspects of *The Rainbow Children* is the fact that, after letting his publishing deal with Warner/Chappell expire, Prince decided to return to

using his original name for the first time since *Come*. Anyone expecting this to herald a return to pop-orientated material would have been disappointed, however, as *The Rainbow Children* instead marked the return of Prince the artist, as opposed to Prince the hit-maker. But while the move away from turgid funk delighted some fans, others just couldn't get past the subject matter.

Having been introduced to the Jehovah's Witness faith by Larry Graham in 1998, Prince used *The Rainbow Children* to make his feelings about the religion public. In the past, on albums such as *Lovesexy*, he had attempted to reconcile his sexual desires with his religious beliefs. On *The Rainbow Children* his focus is entirely spiritual. A fully fledged concept album, it tells the story of how The Rainbow Children and their leader, The Wise One, have been penned in by a Digital Garden built by a group of evildoers known as The Banished Ones, and now have to go knocking door-to-door to find people willing to do The Work and help deconstruct the Garden.

So far, so thinly veiled, but some fans were at least glad that Prince seemed to be returning to more mature themes than the sex'n'dancing of old. More troubling however was that he seemed now to subscribe to a theocratic order than put women below men, and also seemed to have instilled in him some distinctly questionable views on race. "Holocaust aside, many lived and died," he sings on 'Muse 2 The Pharaoh,' before seemingly suggesting that it is better to be "B dead" than to be sold into slavery. He makes a similarly unwise claim on 'Family Name,' reminding listeners that, when all is said and done, the Jews were at least allowed to retain their original surnames, unlike those slaves whose names were taken by their white masters.

Coming from a man who once made it his business to break down racial and sexual barriers, all of this was nothing short of a travesty – not lease because there is much to enjoy elsewhere on the album. Many found it to be Prince's most daring and experimental release since the

80s – at least once they got past the distracting, slowed-down voice he used to narrate it (a deliberate contrast, perhaps, to his high-pitched evil twin, Camille). The album's organic, live-sounding production is certainly preferable to the over-egged R&B sound of much of his 90s output. Not all of its jazz-funk excursions are successful, but there is more flair to the arrangements than anything since *Lovesexy* – or even *Sign "O" The Times*.

The likes of 'Last December' and the title track make a good stab at stretching out and taking the listener on their own microcosmic journeys, and sound positively revelatory by comparison to Prince's other recent output. Some do however fall into Madhouse-lite territory, while the standout dance-track '1+1+1=3' bears more than a passing resemblance to the 1984 B-side 'Erotic City.' This time, instead of promising a night of unbridled passion, Prince explains to his future wife that him, plus her, plus God, equals three, and that there "ain't no room 4 disagree".

The critical response to the album was about as polarized as could be expected. On the one hand, *USA Today* called it "one of Prince's most challenging and fascinating works to date, whatever your take on the

Diamonds And Pearls. Named after a stripped-down album sent out to members of the NPG Music Club in May 2002, the One Nite Alone … tour took in 64 dates in the USA, Canada, Europe, and Japan, plus a one-off show recorded for a DVD released the following year.

Whereas recent tours in support of albums such as *Emancipation* and *Newpower Soul* had often seen Prince play to the strengths of his back catalog, One Nite Alone … put the focus on his band, marginally revamped since the Hit N Run shows. The rhythm section of Rhonda Smith and John Blackwell remained, while keyboard virtuoso Renato Neto replaced both Kip Blackshire and Morris Hayes.

Prince also hired a full brass section for the first time in a while, with Maceo Parker taking over most of the saxophone duties alongside Candy Dulfer, who joined mid-way through the American leg, with new trombonist Greg Boyer coming on board from the start. When the hits eventually arrived they were given radical new arrangements designed to show off the band's versatility. Prince threw a few more obscure songs into the set, such as *The Vault*'s 'Extraordinary,' *Parade*'s 'Venus De Milo,' and the instrumental 'Xenophobia.' He also played a fair number of songs from *The Rainbow Children* tracks, using the likes of 'Family Name' to proselytize the audience.

During the shows he would challenge fans in the front rows as to whether it was better to give or to receive. If they opted to 'give,' he would ask them to swap seats with someone at the back of the hall. "For those of you expecting to get your 'Purple Rain' on, you're in the wrong house," he told the assembled throngs. "We're not interested in what you know, but what you are willing to learn."

> ### "I wanna put up the words 'Jesus Christ is the son of God' on the screen and let them deal with it … I want to talk about religion and lead that into race and lead it into the music biz and radio, and basically at the end of the week I wanna change the world."
>
> *FILMMAKER KEVIN SMITH RECALLS PRINCE'S PLANS FOR HIS SECOND ANNUAL A CELEBRATION EVENT*

enigmatic valentines to God." The *Boston Globe* seemed in broad agreement, noting that, while not a "classic," *The Rainbow Children* "may be the most consistently satisfying Prince album since 1987's *Sign 'O' The Times*." *Rolling Stone* however took a rather different tone, bemoaning "a long trudge across the desert … with freak-in-the-pulpit leading the way, waving his synthesizer of holy justice."

For all its flaws, *The Rainbow Children* was at least a valiant attempt at creating something interesting. That Prince himself thought highly of the album is clear from the effort he put into promoting it, touring it determinedly like nothing since *Love Symbol* or even

These heavy-handed, didactic moments aside, the One Nite Alone … tour was one of Prince's most successful live engagements in recent memory. He ended the tour in November as content as he had been in some time. *The Rainbow Children* might have been the first major Prince album since his debut to fail to reach the *Billboard* Top 100, but he seemed happy to enter 2003 as a niche musician more interested in creating pure art than chasing chart placings. Through the NPG Music Club, he could now show his most devoted fans that he didn't have to try to make hits anymore, but instead serve up new music that charted his artistic maturation.

Prince, with percussionist Sheila E. back in the fold, performs on *The Tonight Show With Jay Leno* in December 2002.

IN SOME WAYS, *ONE NITE ALONE …* IS THE SOLO-PIANO COUNTERPART TO *THE TRUTH*, THE ACOUSTIC GUITAR-BASED ALBUM INCLUDED WITH PRE-ORDERED COPIES OF *CRYSTAL BALL*. PRINCE ISN'T STRICTLY ALONE ON THE ALBUM, AS DRUMMER JOHN BLACKWELL FEATURES ON A HANDFUL OF TRACKS, WHILE OTHERS ARE OVERDUBBED BY SYNTHESIZED SOUND-EFFECTS, BUT IT IS CERTAINLY ONE OF THE MOST INTIMATE-SOUNDING ALBUMS HE HAS MADE.

One Nite Alone …

One Nite Alone … Live!

(MAY–DECEMBER 2002)

Released to NPG Music Club members in May 2002, *One Nite Alone …* was recorded at the tail end of the *Rainbow Children* sessions. The result is a 35-minute oddity that feels intimate but never quite lets you decide whether or not you're listening to the 'real' Prince. Although it's a joy to hear him singing and playing so intimately, and without layers of overproduction, the overall effect is somewhat contradictory. One minute he's extolling the virtues of a loving relationship on a cover of Joni Mitchell's 'A Case Of U,' the next he's raging bitterly against a former lover on 'Have A Heart' and 'Pearls B4 The Swine.'

One song that breaks the happy-sad tension is 'Avalanche,' a return to the dubious themes of *The Rainbow Children*'s 'Family Name.' After branding Abraham Lincoln a racist who was "never in favor of setting R people free," he makes the groundless claim that the legendary A&R man John Hammond ripped off all of the acts he signed to Columbia Records.

One Nite Alone … was still a welcome treasure for the many devoted fans who relished the prospect of hearing Prince at his most fragile-sounding. However, the live album that shares its name – Prince's first – is not quite what one might have expected. Given that Prince had played numerous legendary shows over the years, and recorded most, if not all of them, it would have made sense for him to do something in the same vein as Bob Dylan's *Bootleg Series*. Instead he decided to release a three-disc document of his recent One Nite Alone … world tour.

That's not to say that releasing *One Nite Alone … Live!* was a mistake. The first two discs feature a smattering of old hits and rarities mixed with *Rainbow Children* songs recorded across eight nights that do an excellent job of capturing one of the best Prince tours in years. The third disc, taken from a pair of after-show performances, is less successful. Its mix of funk jams, extended rearrangements of old songs, and obscure covers might have sounded electrifying from within the confines of a small venue, but the magic doesn't quite translate onto CD.

One Nite Alone … Live! remains the only official live release in the Prince catalog to date. It will probably never take the place of the bootlegs cherished by hardcore fans, but it's a fine place to start.

She Loves Me 4 Me

Prince seemed to live out most of his relationship with Mayte Garcia in the public eye, from the highest peaks to the most tragic lows. His union with second wife Manuela Testolini, however, was much more low key.

Testolini is 18 years younger than Prince, and was a fan of the singer long before she met him. She is known to have posted occasionally on the online fan-forum at alt.music.prince, which somehow seemed to lead to her being hired to work for his charitable organization, Love4OneAnother. But such unorthodox assimilation is typical of a man whose world is so insular. Instead of taking the time to seek out a woman in a more conventional manner, Prince gave Testolini a role in his company, making it easier for him to stay close to her, and for her to see what his life was like.

Rumor has it that Prince started dating Testolini, who became his personal assistant in 1999, while still married to Mayte. The fact that she was chosen to appear in his 1998 promo video for 'The One' suggests a certain closeness. Her ascension within the Prince organization coincided with the singer's continued immersion in the Jehovah's Witness faith. It has been suggested that Testolini's religious beliefs were so close to Prince's own that she became almost as important to him, from a spiritual perspective, as Larry Graham.

Testolini became a more visible presence in Prince's life after he finalized his divorce from Mayte in May 2000. The new couple were seen together at basketball games, and at the annual Paisley Park celebrations, and were married on New Year's Eve 2001 in a Jehovah's Witness ceremony in Hawaii. Testolini remained by Prince's side throughout his conversion and during the promotion of *The Rainbow Children*, and is said to have had a strong positive influence on him, aiding his emergence from a period of artistic and commercial decline.

With Testolini by his side, Prince started opening Paisley Park up to fans again, and even took to attending Q&A sessions during the annual celebrations. He then followed a period of artistic experimentation with a return to commercial success, beginning with *Musicology*, his most popular album since 1996's *Emancipation*, with which it shares a theme of celebrating monogamy.

The end of the relationship proved to be as inconspicuous as the start. While it is known that Testolini filed for divorce on May 24 2006, her reasons have never been made public, though it's entirely possible

It has been suggested that Testolini's religious beliefs were so close to Prince's own that she became almost as important to him, from a spiritual perspective, as Larry Graham.

that married life with Prince was not quite as idyllic as a fan might have imagined.

Since then, although Prince has not entirely renounced religion, his monogamous worldview seems to have started to slip. He was briefly linked with the t-shirt designer Chelsea Rodgers in 2007, but, as he approaches 50, seems to have hit a dead-end when it comes to find a lasting relationship. He was seen at various public events around the time of his 21 Nights In London residency, but never with a woman on his arm, other than his hired dancers, The Twinz.

Prince and his second wife, Manuela, watch an LA Lakers basketball game on Christmas day 2004.

AFTER MAKING WHAT HE CLEARLY FELT WAS A MAJOR
ARTISTIC BREAKTHROUGH WITH *THE RAINBOW CHILDREN*,
PRINCE THREW HIMSELF INTO RECORDING A SERIES OF
EXPERIMENTAL INSTRUMENTAL ALBUMS.

Xpectation/C-Note/ N.E.W.S.

(JANUARY–JULY 2003)

The move echoed his decision to follow *Parade* by making the first Madhouse record in 1987, but while the Madhouse recordings had a sense of fun about them, the three low-key albums he released in 2003 smacked of pretension. Two of them were even subtitled *New Directions In Music From Prince*.

The first of these albums was made available to NPG Music Club members for download on New Year's Day. It was called *Xpectation*, but any high hopes were quickly dashed upon listening to it. With songs called things like 'Xosphere' and 'Xemplify,' and each one given a patronizing subtitle ('Xotica''s being 'Curiously unusual or excitingly strange'), some wondered whether a more appropriate title might have been *Xcrement*.

Recorded with current bandmembers John Blackwell (drums), Rhonda Smith (bass), and Candy Dulfer (sax), alongside pop-classical violinist Vanessa Mae, the album's ten songs are mostly in the pseudo-jazz vein of Madhouse. The title track in particular could have been lifted straight from *8*. There are a few interesting avant-garde touches,

but for the most part Prince's jazz explorations show no real progression from his first attempts 16 years earlier. The overall sound is slick and sophisticated, thanks to the quality of the band as a whole (and Mae in particular, who contributes some of the album's most interesting moments), but most of the songs still pass by unnoticed, while perhaps the greatest disappointment is that the impressive, ten-minute long 'Xenophobia,' played live during the One Nite Alone … tour, was left off the final tracklisting.

Two days after releasing *Xpectation*, Prince made *C-Note* available for download. Like it's predecessor, the album is a largely instrumental affair with thematically linked song titles: this time around each song is named for the city it was recorded in during soundchecks, with the first letter of each spelling out *C-Note*. 'Copenhagen,' 'Nagoya,' and 'Osaka' are all instrumental, while the only word sung on 'Tokyo' is the name of the city.

The album closes with a ballad, 'Empty Room,' that was once earmarked for *The Gold Experience*. The rest of the material is very much in the *Xpection* mold, but the fact

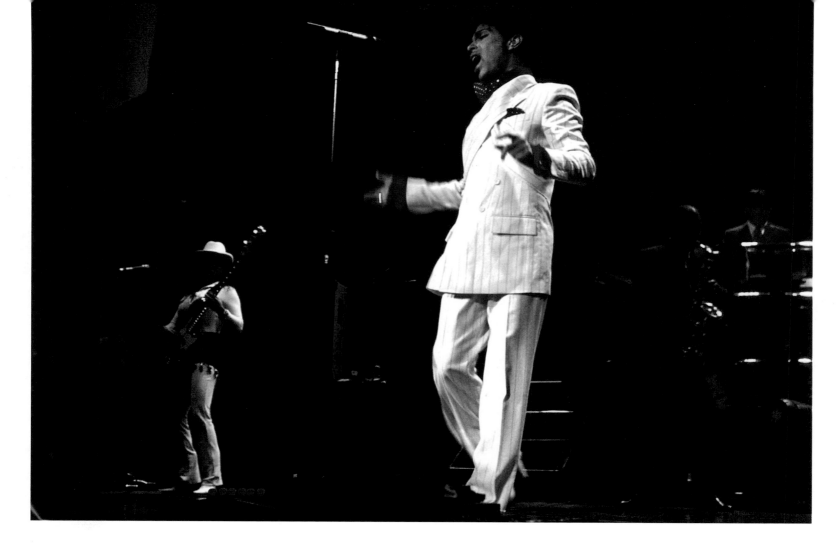

that it was recorded live with a seven-piece band gives it a more varied, organic sound.

Both *Xpectation* and *C-Note* can be viewed as test runs for *N.E.W.S.*, the only one of Prince's three LPs from 2003 to be given a conventional release. He perhaps needn't have bothered: this latest set of *New Directions In Music* became his lowest-selling album ever. The cruel irony is that *N.E.W.S.* is probably the most interesting set of instrumentals he has ever recorded. There is still a general air of pretension – the four tracks are titled 'North,' 'East,' 'South,' and West,' and each run to exactly 14 minutes – but the overall effect is much more dynamic and eclectic than previous instrumental efforts, with a sound that blends the most experimental side of Madhouse with the organic feel of *The Rainbow Children*.

N.E.W.S. was recorded in a single day, with Eric Leeds returning on sax alongside keyboardist Renato Neto, drummer John Blackwell, and bassist Rhonda Smith. The album's key strengths stem from the fact that Prince seemed finally to have realized that he didn't have to try to cram his understanding of jazz into five-minute pieces. The four lengthy tracks have a definite ebb and flow to them, taking in everything from Eastern intonations to harsh, abrasive guitar. All in all, *N.E.W.S.* remains Prince's finest jazz-infused album.

Prince didn't tour in support of any of these albums, but instead decided to revisit some of his more crowd-pleasing material on what was dubbed the World Tour 2003/2004, but which actually only entailed one date in Hong Kong, five in Australia, and two in Hawaii during October and December 2003.

Nonetheless, these eight concerts – Prince's first live shows in almost a year – were important in that they gave him a chance to reconnect with his back catalog for the first time since the Hit N Run shows of 2000–01. Cynics might argue that he needed little encouragement to revisit the hits "for the last time" once again, but the singer had genuinely seemed to distance himself from his best-known work on his 2002 tour. Now, away from the media glare he would have faced had he chosen to play in Europe or America, he took the opportunity to have fun with his back catalog, reinventing old songs with new arrangements, while also introducing some of the songs from his forthcoming *Musicology* LP.

Coming at the end of a year in which the only new Prince releases had been three instrumental albums aimed purely at the hardcore, the mini-tour seemed to give Prince the opportunity to reassess his status as a popstar.

> ◆ *Both Xpectation and C-Note can be viewed as test runs for N.E.W.S., the only one of Prince's three LPs from 2003 to be given a conventional release.*

Musicology would see him make another grasp for the mainstream for the first time since 1999, while the 2003 live shows seemed to have a similarly invigorating effect. During a break from the tour in November, Prince set about planning a full-scale US tour. It would end up running to 95 dates and be his biggest trek across the country since the one in support of *Purple Rain*. The year just ending might have been one of the quietest of his career, but Prince was poised to launch his biggest comeback yet in 2004.

Prince performs in Melbourne, Australia, in October 2003 as part of a mini-tour that saw him reconnect with his pop hits for the first time in several years.

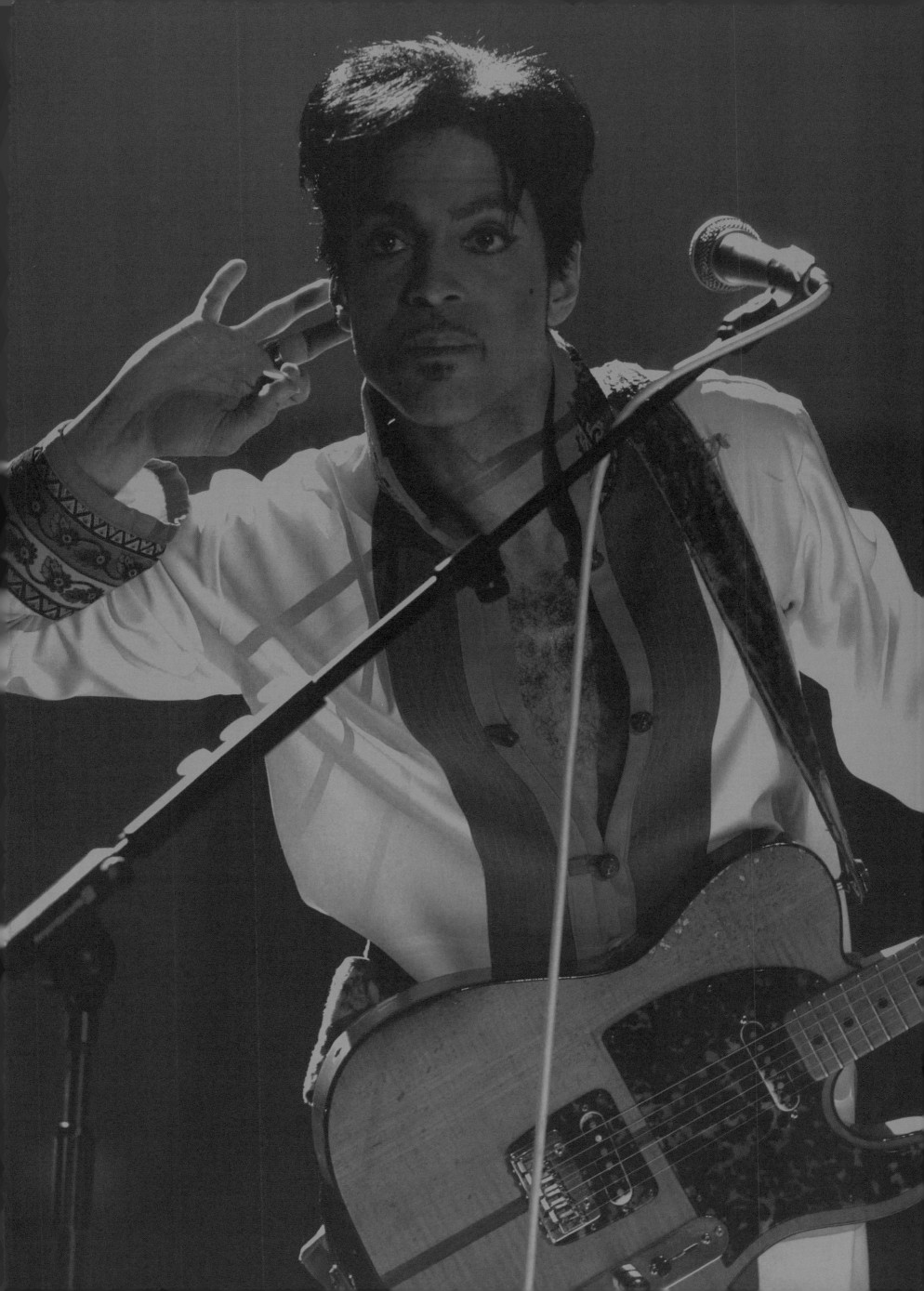

AT THE TURN OF THE MILLENNIUM, PRINCE'S
POPULARITY SEEMED TO HAVE HIT AN ALL-
TIME LOW. BUT WITH *PURPLE RAIN*
CELEBRATING ITS 20TH BIRTHDAY IN 2004,
AND THE SINGER HAVING RECENTLY RETURNED
TO HIS BIRTH NAME, HE MADE A CONCERTED
EFFORT TO RETURN TO THE MAINSTREAM.
THIS TIME IT WORKED, AND THE MAN ONCE
RIDICULED FOR HIS INCREASINGLY
IDIOSYNCRATIC BEHAVIOR WAS ONCE AGAIN
HAILED AS A MUSICAL GENIUS.

REBIRTH
2004–2008

PRINCE SEEMED TO HAVE ENDED 2003 ON A HIGH WITH
THE COMPLETION OF A SUCCESSFUL MINI-TOUR OF
HONG KONG, AUSTRALIA, AND HAWAII, BUT
THREATENED TO ALIENATE EVEN HIS MOST LOYAL FANS
AFTER AN INCIDENT AT MINNEAPOLIS INTERNATIONAL
AIRPORT IN DECEMBER.

Musicology (FEBRUARY–SEPTEMBER 2004)

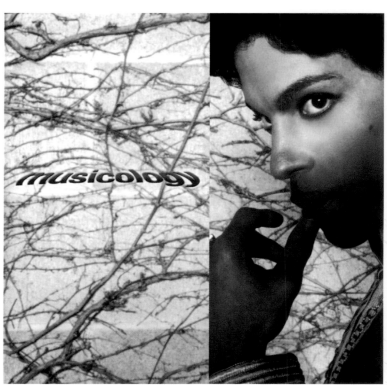

According to a report by *Minneapolis Star-Tribune* columnist and long-time Prince-watcher Cheryl Johnson, the trouble started when a fan tried to take a picture of the singer shortly after he landed; Prince's bodyguard then swiped the fan's camera and made off with it in a luggage cart.

A follow-up report on January 15 quoted a number of fans' disgust at their idol's actions. The *Tribune* continued to follow the story until April 7 when the fan involved in the incident, one Anthony Fitzgerald, sued Prince and his bodyguard for "assault and battery, loss of the camera, and intentional infliction of emotional distress." (Reports suggested that it had taken until then for the lawsuit to be put into motion because Prince's people had initially refused to accept it.)

Fortunately for Prince, only his most ardent fans were watching, and most of them quickly forgave him once his busiest and most successful year in recent memory began to take shape. At the end of January he started playing one-off shows in anticipation of the release of a new album, beginning a promotional blitz that reached its

pinnacle on February 8 with a duet at the Grammy Awards with Beyoncé. The pair performed a medley of hits from his *Purple Rain* (including 'Baby, I'm A Star' and 'Let's Go Crazy') alongside Beyoncé's 'Crazy In Love.'

For those outside the Prince hardcore, the Grammy performance was a timely reminder of the heights the singer could reach. Dressed in purple and gold, he seemed to have leapt out of the doldrums and onto the front pages almost overnight – just in time to mark *Purple Rain*'s 20th anniversary year.

Not everyone was impressed. Alan Leeds told the *St Paul Pioneer Press* that he found the level of performance "Vegas-y," while Prince himself noted: "I get asked every year to play at the Grammys. This year I did it because I have an album out that I want to promote and a concert tour that I want to promote." But it did enough to draw a large chunk of the world's media to the February 24 press release at which Prince officially unveiled the forthcoming *Musicology* album and tour.

The tour itself promised to be another 'all the hits for the last time' affair, but few of the assembled journalists

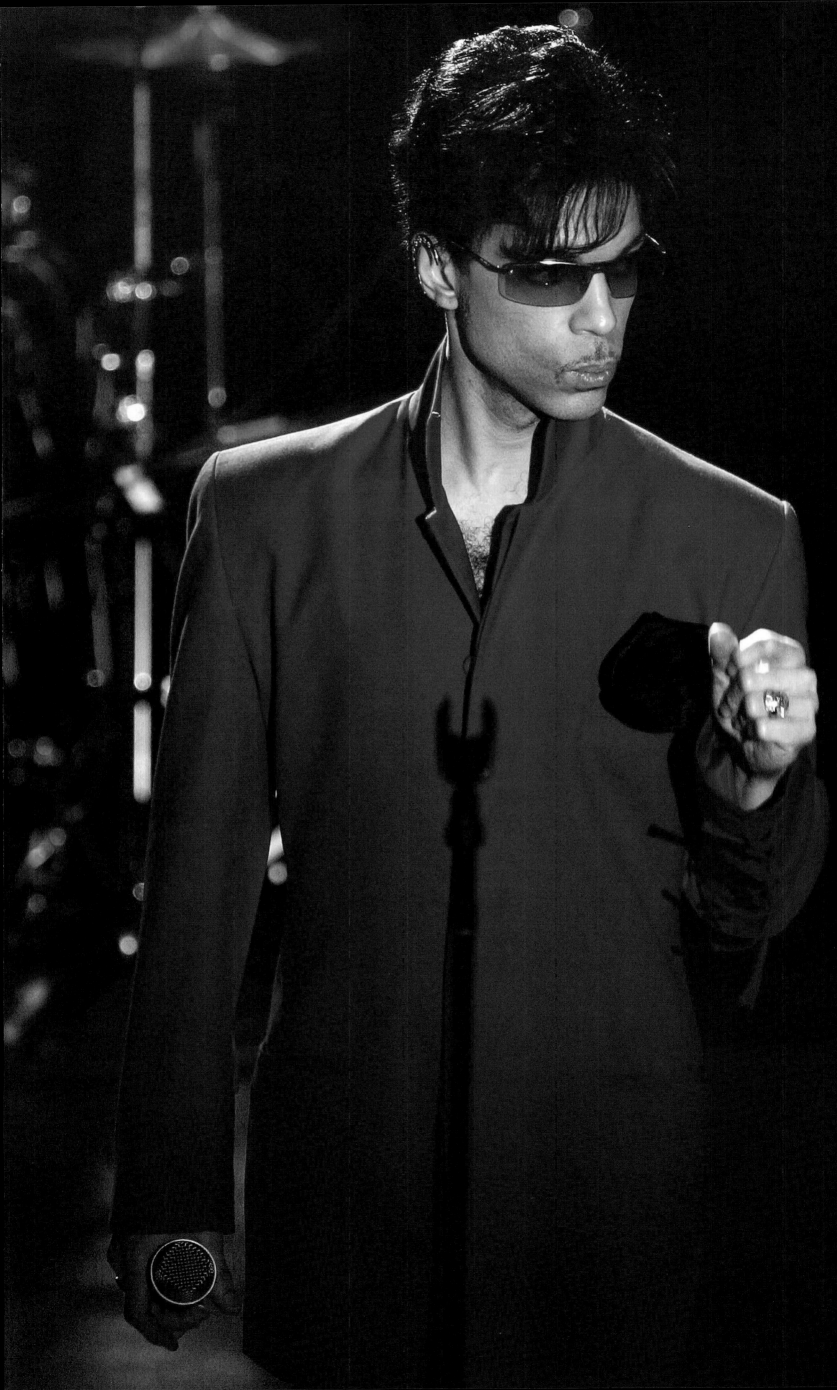

seemed to mind. It seemed to most of them that Prince had disappeared completely during the time he spent making records steeped in his Jehovah's Witness faith and releasing instrumental albums over the internet. After giving the wider world a breather, the returning Prince would be gratefully received – as would the news that he would be giving priority seating on the tour to NPG Music Club members – but the singer once again found himself having to challenge the idea that he was making a comeback. "I never went anywhere!" he told *Gallery Of Sound* later in the year. "I've been touring for a while. I took a break to make the *Musicology* project. It hasn't really stopped."

February 24's other big news was that, five years after the disappointment of *Rave Un2 The Joy Fantastic*, Prince was ready to have another go at working with a major label. At the time he had not yet decided which one; given the choice, he said, he would have asked "all of them to release it at once," but was willing to settle for the company "most hyped about pushing the product."

Perhaps the most interesting aspect of all of this was that Prince still planned to make *Musicology* available as a download first, and give copies away free to concertgoers.

"The CD," he noted, "is more or less a companion to the concert." Somewhat amazingly, he was able to convince Columbia Records to agree to promote and distribute the album through conventional channels even while he continued to pursue his own non-traditional methods.

"Sony [Columbia's parent company] has graciously agreed 2 augment the *Musicology* project with worldwide promotion and distribution," he wrote in an email to *Wired* magazine. "They r cool because they do not restrict NPG's ability 2 sell the product as well. It's a win-win situation."

The scheme might have looked like a catastrophe in

the making, but it worked. On April 20, three weeks after Prince had started giving copies away on the accompanying tour, *Musicology* appeared on record-store shelves as a combined Columbia/NPG release. According to Sony President Don Ienner, "With the first copy shipped, we started making money."

By then Prince had filled up further column inches after being inducted into the Rock And Roll Hall Of Fame

> **"Maybe we could put a [CD] sampler on every seat. Or give them the whole thing and build it into the ticket price."** PRINCE, SPEAKING IN 1996

and leading an all-star rendition of 'While My Guitar Gently Weeps' alongside Tom Petty and Jeff Lynne in tribute to the recently departed George Harrison. (Prince played the famous Eric Clapton guitar solo.) He had become a hot property once again. "There are many kings," Alicia Keys gushed in her introductory speech at the induction ceremony, "but there is only one Prince."

The singer himself then took to the stage to note: "When I first started out in this music industry, I was most concerned with freedom: freedom to produce, freedom to play all the instruments on my records, freedom to say anything I wanted to. After much negotiation, Warner Bros granted me my freedom, and I thank them for that." The event put Prince firmly back on the map. "After a decade spent tending only to his faithful," wrote *Time* magazine, "Prince has had a revelation: He's supposed to be a rock'n'roll star."

The American Musicology tour opened to ecstatic praise, with the initial run of 26 dates gradually expanding to include 96 shows in 69 cities – his longest run since the days of *Purple Rain*. Performing in the round, as he had done on the Lovesexy tour, Prince took to an X-shaped stage in the center of the arena and played a hits-based show with a smattering of *Musicology* songs. The highlight for many was the acoustic section, during which he treated rapt audiences to solo versions of 'Raspberry Beret,' 'Little Red Corvette,' and other early classics.

Prince tried to push *Musicology* as the tour's equal, telling interviewers that "school is back in session." Most of the reviews were suitably positive, with *Billboard* noting that the album "focuses on a fun and playful Prince, whose turns of phrase and instrumental dexterity call to mind why we embraced him in the first place," and *Rolling Stone* finding it "as appealing, focused, and straight-up satisfying an album as Prince has made since who knows when." The *New York Times* was one of the few publications to suggest that the album fell short of its early promise, describing it as "a casual exhibition of Princeliness" that could do with some of the "fighting spirit" of *The Rainbow Children*.

The general consensus, however, was that *Musicology* is

a good, solid record, but the *New Musical Express* got closest to the truth with its conclusion that the album offers "a kind of flawed redemption, neither inspired enough to be a true classic nor insipid enough to make it unworthy of your attention." Free from the turgid overproduction that marred much of *Emancipation* and *Rave Un2 The Joy Fantastic*, Prince seemed finally to have worked out how to make a contemporary-sounding record without losing his own style. Some of the songs might be lacking a little in terms of structure, but they work in the context of a concise, easily digestible album. Whereas some of his recent albums had been spoilt by bitterness, excess, or a determination to drive a funk riff home to the

point of banality, *Musicology* is the sound of Prince having fun. He even finds time to poke fun at Michael Jackson with the lines: "My voice is getting higher / And eye ain't never had my nose done."

With the rest of the album's musical and lyrical content pretty tame by comparison, the most controversial aspect of *Musicology* turned out to be the promo video for its third single, 'Cinnamon Girl.' A response to the newly suspicious mindset brought about by the terrorist attacks of September 11 2001, it cast a 14-year-old actress from New Zealand, Keisha Castle-Hughes, as an Arab-American schoolgirl who fantasizes about blowing herself up in airport after being subjected to racial

harassment. Prince seemed to be making the point that arbitrary suspicion can lead good people down dark paths, but the video was deemed too sensitive and banned by a number of television networks in Britain and America.

Despite Prince's desire for 'musicology' to became a byword for "letting the music come first," the music on his new album seemed to be completely overshadowed by his business practices. Even the Musicology tour, which

> "I am violently against this ... The charts are supposed to represent what consumers are spending money on. With the Prince album there is no choice." **UNNAMED DISTRIBUTOR**

ended in September, was reduced to a series of statistics by the end of the year when *Pollstar* magazine put it at the top of its list of the year's biggest concert draws. Prince, the magazine claimed, had earned more than $87 million from the 96 performances – $7 million more than Celine Dion had picked up during 2004 for her residency in Las Vegas. (Reports elsewhere suggested that one-and-a-half million people attended the Musicology tour.)

Perhaps the most amazing aspect of *Musicology* was the fact that it led to another music industry shakeup, albeit unintentionally. After a period of much confusion, Neilsen SoundScan, the organization responsible for counting record sales and compiling charts, decided that it would include copies of *Musicology* given away at concerts from the date of the album's official release (April 20) onward. Industry executives lined up to express their outrage, noting that, while *Musicology* was being presented as a 'free' CD, the cost of producing it had been

incorporated into the price of the concert ticket.

"Nobody can say no to that new CD if they want to see the show," one anonymous executive complained to the *Los Angeles Times*. Another panicked over a hypothetical situation whereby "a dinosaur act that no longer sells records but does great live business can do a stadium tour over the summer and dominate the *Billboard* 200."

Neilsen SoundScan CEO Rob Sisco sought to justify the decision, telling *Billboard* that "the manufacturer was paid by the promoter, who is reselling the merchandise to the customer. Given that there is a sale, with the album ending up in the hands of the consumer ... we feel we should count the sales."

As far as Prince was concerned, exploiting the loophole was a masterstroke, as *Musicology* achieved double-platinum status in the USA and reached Number Three on the *Billboard* chart. (It also peaked at Number Three in the UK without any sort of promotional gimmick.) *Billboard*'s chart editor Geoff Mayfield estimated that 25 per cent of the album's recorded sales came from ticket sales, leading most commentators to agree that *Musicology* would have achieved the same success even if Prince had not given it away. But that didn't stop *Billboard* from altering their policy so that all future ticket-and-album bundles had to give concertgoers the chance to opt out of buying the album alongside the ticket.

After completing the tour and maximizing its commercial potential, Prince was content to lay low for the rest of 2004 and enjoy the accolades that came flooding in. *Purple Rain* was given a deluxe 20th anniversary reissue on DVD in August to further rave reviews, while the end of the year brought with it a glut of awards from magazines: Funkmaster Of The Year from *GQ*, Best Use Of Technology from *Billboard*, and Artist Of The Year from his local newspaper, the *Minneapolis Star-Tribune*.

In a year where it had finally been deemed safe to like Prince again, none of this was surprising. More refreshing was the personality shift that seemed to occur within the star, as hinted at on *Musicology*'s more mature material (notably 'If Eye Was The Man In Ur Life' and 'Reflections'). "What we're trying to do is put the family first," Prince told interviewers who commented on the fact that he had put his 'rude' material behind him. "When you come to a certain age, you have certain responsibilities to deal with."

Inevitably, given the recent anniversary of his greatest critical and commercial success, Prince found himself looking back over his career to date. "When I was making sexy tunes," he told *Newsweek*, "that wasn't all I was doing. Back then, the sexiest thing on TV was *Dynasty*, and if you watch it now it's like *The Brady Bunch*." Laughing off the furor over his use of the word 'masturbate' in 'Darling Nikki,' he nonetheless encouraged contemporary acts not to try to emulate the controversies of his earlier career. "There's no more envelope to push," he said. "I pushed it off the table. It's on the floor."

Prince pays tribute to George Harrison after being inducted into the US Rock And Roll Hall Of Fame on March 15 2004.

AFTER ALL THE EXCITEMENT OF THE PREVIOUS YEAR, 2005 LOOKED LIKE BEING PRINCE'S QUIETEST 12 MONTHS SINCE HE SIGNED TO WARNER BROS IN 1977, AS HE HAD SPENT MOST OF IT JAMMING AND PERFORMING PRIVATE CONCERTS AT HIS RENTED LOS ANGELES HOME.

3121 (DECEMBER 2006–APRIL 2007)

Aside from releasing 'S.S.T.'/'Brand New Orleans' in response to the Hurricane Katrina tragedy, and giving all proceeds to associated charities, he had not issued any new music or given notice of anything forthcoming albums or tours.

To even the keenest observers it seemed that 2005 would end with Prince still trying to figure out how to follow the astounding success of *Musicology*. Then on December 9 a report in *Billboard* claimed that Prince had signed a deal with Universal for the release of his new album, *3121*. Four days later – on December 13, the day picked deliberately to mirror the album's title – the singer held a press conference to make the news official.

"I don't consider Universal a slave ship," he told reporters in response to the usual questions about why he had decided to work with a major label again. "I did my own agreement without the help of a lawyer and sat down and got exactly what I wanted to accomplish … I got a chance to structure an agreement the way I saw fit instead of the other way around."

He also took the opportunity to give those present the first taste of *3121* in the form of its lead single, 'Te Amo Corazón.' There was nothing particularly remarkable about the song, a gentle ballad with a slight Latin feel, but according to Prince it was not representative of the album as a whole. The wider world would have to wait a while to hear the rest, however, as he would spend the first quarter of 2006 acting as a sideman for his latest protégé, Támar, and making a series of high-profile television appearances. The most notable of these was a show-stopping performance at the BRIT Awards in February, for which he was reunited with Wendy Melvoin, Lisa Coleman, and Sheila E. for the first time since the mid 80s.

There was no way that Prince could top the *Musicology* marketing campaign, and no point in giving away 'free' albums with concert tickets now that *Billboard* had changed its chart-eligibility rules. Instead he launched a *Willy Wonka*-style search for the handful of 'Purple Tickets' that had been slipped into random copies of *3121*. The lucky few who found a ticket were invited to attend An Evening With Prince on May 6 2006. A different set of chart regulations meant that Britain was exempt from the

Prince launches his 3121 campaign in London, England, at the February 2006 BRIT Awards.

"There's definitely a throwback vibe to 3121, a mostly one-man-band effort that favors the musical minimalism and reliance on synthesizers of early-80s Prince." *MINNEAPOLIS STAR-TRIBUNE*

promotion, but a small band of fans from the USA, Mexico, and the Netherlands were flown to Los Angeles, given $250 spending money, and treated to an intimate performance in Prince's rented '3121' house.

The house itself had become something of a thorn in Prince's side. According to the *Minneapolis Star-Tribune*'s favorite Prince-watcher, Cheryl Johnson, the singer had moved to Los Angeles in 2005 after demolishing his purple home in Chanhassen, Minnesota. His first LA residence actually had the street address 3121, but in September of the same year he moved to a rented property at 1235 Sierra Alta Way, for which he paid $70,000 per month, and which he subsequently renamed '3121.'

The setup seemed perfect until it was reported in March 2006 that Prince was being sued by his landlord, the C Booz Multifamily I LLC, for redecorating the property without consent. His dream home had become a legal nightmare. Papers filed with Los Angeles Superior Court on January 13 2006 reveal that the landlord took exception to the fact that Prince had painted purple stripes and the 'Prince' and '3121' logos on the exterior; removed carpets and baseboards and cut a large hole in a bedroom wall; installed "plumbing and piping in downstairs bedroom for water transfer for beauty salon chairs"; and used "unlicensed carpenters and contractors."

News of the lawsuit was still trickling out when Prince performed at Sunset Boulevard's Tower Records at the stroke of midnight on March 21 to launch the album. The title was officially explained as a reference to the singer's current home, but there were a number of suggested Biblical links, not least Psalm 31:21: "Blessed be the LORD, for he hath showed me his marvelous kindness in a strong city." (The fact that *3121* was subtitled *The Music* also led to speculation that there had once been a movie project attached to it.)

With no 'comeback' story this time around, *3121* was given a slightly more muted welcome than its predecessor. Most of the reviews were positive: *Billboard* praised "one of those rare artists who can remain relevant without compromising his eccentric style"; *The Times* enjoyed the sound of "an artist learning to make peace with his past without turning into his own tribute act." *Entertainment Weekly* was a little more measured, noting that some of the tracks are not quite worthy of "Prince's prodigious gifts," suggesting that he "hasn't figured out how to reach back into his 80s bag of tricks and create something that feels contemporary" in the way that "disciples" such as OutKast and The Neptunes have.

Nonetheless, *Billboard*'s prediction that the record "could well return him to the top of the charts" rang true. Amazingly, *3121* was the first Prince album to debut at Number One in the USA, and his first chart-topper at all since 1989's *Batman*. Interestingly, while *Musicology* had sold 191,000 copies in its first week but only reached Number Three, *3121* sold slightly less – 183,000 – but still claimed the top spot. (Further accolades would follow later in the year when he won a Lifetime Achievement award at the Webbys, made a surprise appearance on the season finale of *American Idol*, and contributed the Golden Globe-

winning 'Song Of The Heart' to the *Happy Feet* soundtrack.)

Like its predecessor, *3121* is competent without showing off many new tricks, aside perhaps from the modern electro-funk of second single 'Black Sweat.' There's nothing wrong with the guitar rock of 'Fury,' the jazz-infused 'Satisfied,' or the upbeat, funky 'Get On The Boat,' but there's nothing particularly challenging about them either. It might be slightly more eclectic than *Musicology*, but *3121* is largely self-referential, right down to the way 'The Dance' references the screaming conclusion to 'The Beautiful Ones,' or even the fact that it was another album with a four-digit title. This, the *Minneapolis Star-Tribune* noted, "only leaves you wanting."

Prince himself was happy to have returned to the top of the charts with an album he acknowledged was "a trip back," and set about putting the next stage of *3121* into promotion. Having made a guest appearance with Morris Day & The Time at the Rio Hotel's Club Rio in Las Vegas on May 12, he set about planning his own Vegas engagement, and by October had moved into the hotel's top suite.

The news that Prince would be staging an indefinite run of Friday and Saturday shows at the newly renamed Club 3121 caused consternation. The man who once broke down so many barriers now seemed to be settling into one of rock'n'roll's biggest cliches, the fat Elvis decline, in an attempt to emulate the success Céline Dion had achieved in recent years with her own Vegas residency.

"It's pretty much the Prince world brought to Vegas!" one of the singer's backing dancers, Maya McClean, said in

Gett Off: Prince & Támar

Prince might have rediscovered his own muse during the early 21st century, but he didn't seem to have very much to offer anyone else. The last time he looked beyond his own work was when he attempted to bring Chaka Khan and Larry Graham back into the spotlight in 1998. Eight years would pass before he chose to take another artist under his wing. But although the album he produced for Támar was probably his mostly satisfying R&B disc in a decade, it ended up going almost the same way as Rosie Gaines's long-delayed Paisley Park album, and hardly anyone ever got to hear it.

Prince brought Támar Davis with him when he signed to Universal in December 2005, and originally planned to release her *Milk & Honey* LP on March 21 2006, the same day as his *3121*. But after being postponed for "various reasons," as stated in an official statement made by Támar a month later, it never saw the light of day, except for a hastily withdrawn Japanese release. (Leaked copies subsequently sold for up to $800 on eBay.)

Prince must have believed in Támar at one point. Asked by *Billboard* about what he had been listening to recently during the *3121* promotional run, Prince named Támar, describing her as "a brilliant writer and a kind soul," and noting that her album would now be coming out in May. "Prince has a willingness to promote *3121* because of Támar," explained Universal marketing executive Ted Cockle, adding that she is "basically his musical muse at the moment. She is with him at all times."

Prince's warmth of feeling for Támar was such that he gave her top billing on the short promotional tour in support of both of their forthcoming albums during January and February, and on the duet 'Beautiful, Loved And Blessed,' which featured on both *3121* and *Milk & Honey*, and on the B-side to Prince's 'Black Sweat.' "Who the bleep is Támar," the *Minneapolis Star-Tribune* asked, "and why is she getting top billing over Prince for Saturday's quickie concert at the Orpheum?"

Given that Támar seemed to have appeared out of nowhere, the newspaper was perhaps right to question the decision. But as the tour wound on, with dates and venues announced only a few days before each performance, Prince and his band continued to back Támar for what were mostly hour-long nightclub shows during the early hours of the morning.

Most of the reviews still focused on Prince, whom the *Washington Post* described as a "superb wingman," but he seemed content to play guitar and keyboards while Támar belted out a selection of her own songs and well-known soul covers. That's not to suggest that the headline act was poorly received. "If audience reaction counts for something," the *Chicago Sun Times* concluded, "then Támar impressed."

But what looked like the start of a promising career ended up coming to nothing. No sooner had Támar appeared than she disappeared, and despite all the effort Prince put into promoting it, *Milk & Honey* never actually made it into record stores. After being postponed from March to April to May to August, the album was finally, quietly shelved. No official reason was ever given, but it was once suggested that the media's 'lying' over the release date had something to do with it.

Milk & Honey's disappearance has left fans wondering about what might have been for both Prince and Támar. Had it been released, it could well have been a breakthrough release for the younger singer, and one that served as further evidence of the creative resurgence of her mentor. The album's 12 tracks are a masterclass in contemporary R&B, with a fresher, more modern sound than anything else Prince had attempted to do with the genre in recent times. Several of the funkier tracks, such as 'Milk & Honey,' 'Closer To My Heart,' and 'Holla And Shout,' would almost certainly have made themselves at home on commercial radio.

Of all the missteps and disappointments of Prince's later career, *Milk & Honey*'s failure to launch serves as one of the great lost opportunities. The *Minneapolis Star-Tribune* saw the initial emergence of Támar as proof that Prince knew when to share the spotlight, but subsequent events seemed to suggest the opposite. It's unlikely that Prince would end up riding anyone else's coattails, but when it came down to it, it seemed he didn't want to risk Támar getting in the way of his continued commercial resurgence.

Prince and Támar perform at New York's Bryant Park on June 16 2006 for Good Morning America.

his defense. "The fans can come and really experience what it's like to be in Prince's home." To that end Prince even brought his own personal chef, Lena Morgan, to run the adjoining 3121 Jazz Cuisine restaurant, where he performed early-hours after-show jams for VIP ticket holders. (The $312 ticket also included dinner and a complimentary bottle of champagne.)

In fact Prince's shows were something of a break from the tacky Vegas tradition. Instead of presenting a glitzy, Barbra Streisand-style revue, he was playing modest, stripped-down sets in a relatively intimate 900-seater club. The shows included a mix of classics ('Kiss'; a truncated 'Let's Go Crazy'), *3121* material, loose funk jams, and jazz/soul standards. He even let his band stretch out on an instrumental version of 'Down By The Riverside,' just as he had done with his 1987 group for renditions of Charlie Parker's 'Now's The Time.' The shows proved so successful that they ran until April 28 2007, with 'normal' tickets costing $125 each. Local news reports suggested that Prince was spending his days off pursuing his love of photography, and was planning to put a *3121* magazine into print to show off the results of his new hobby.

For the man who had previously undertaken massive international engagements, perfected the Hit N Run style mini-tour, and hosted numerous concerts in Paisley Park home, the 3121 residency gave Prince another option when it came to live performance. He still seemed to have an almost pathological compulsion to play music, but had long since grown tired of long jaunts, as evidenced by two

decades of cancellations, curtailments, and complete refusals to tour certain albums.

Playing in Vegas proved to Prince that could make just as much money by staying in one place as he could by taking an entire stage show and entourage across the country. Although he played a few more Club 3121-style

> 🔲 "*I think in a lot of ways I still sound like I did before, so with this new album, it helps make the connection.*" PRINCE

shows in the middle of 2007, including four dates at the Roosevelt Hotel in Los Angeles in June, he had for all intents and purposes finished promoting *3121* after his final night at the Rio on April 28. Despite launching a 3121 perfume in July with three performances in Minneapolis, Prince had already moved onto his next scheme, appearing in London in May to announce the Earth Tour.

Lisa Coleman, Sheila E., and Wendy Melvoin joined Prince on stage together for the first time in 20 years at the 2006 BRIT Awards.

The Super Bowl XLI Halftime Show

OVER THE YEARS, PRINCE SEEMS TO HAVE PERFECTED THE ART OF USING ONE HIGH-PROFILE TELEVISION APPEARANCE TO HERALD THE RELEASE OF A NEW ALBUM. HAVING PERFORMED AT THE GRAMMYS IN 2004 AND THE BRIT AWARDS IN 2006, IT MADE SENSE THAT HE WOULD ONE DAY FILL THE HALFTIME SPOT AT THE BIGGEST US SPORTING EVENT OF THE YEAR.

Much had been made of recent halftime performances by The Rolling Stones, whose set was something of an anti-climax, and Janet Jackson, whose 'wardrobe malfunction' in 2004 led to widespread condemnation and an investigation by the FCC. (Even Prince felt compelled to chime in on the controversy, telling *Entertainment Weekly* things had gone "too far" before asking, "What's the point?")

Three years after the Jackson incident, and after more than six months of negotiations, Prince was given the chance to show how these things should be done. On February 4 2007 he took his 'love symbol'-shaped stage to the Dolphin Arena in Miami, Florida, to play a 12-minute set of *Purple Rain*-era tracks alongside covers of 'Proud Mary' and 'All Along The Watchtower,' complete with a full marching band. A few tetchy criticisms aside – some observers felt that Prince had deliberately thrown a phallic pose with his guitar while his silhouette was projected onto a large sheet

– the show was a resounding success. Despite having to perform in torrential rain after a storm threatened to ruin the whole event, Prince was deemed to have delivered the most successful halftime show in years.

According to former manager Alan Leeds, Prince's Super Bowl show was "a landmark appearance that will be remembered for years to come." Perhaps the most notable aspect of it, Leeds noted, was that Prince "hasn't had a genuine hit record in many, many years [but] is still viewed in the fickle world of pop music as a major force."

With more than 140 million Americans watching – and plenty more viewers tuning in around the world – Prince's Super Bowl XLI appearance was probably the biggest promotional opportunity of his career. Not only did it mean that all eyes were on him in advance of a new album release, it also raised the bar for future halftime shows. The comparatively lackluster Tom Petty had no chance of competing in 2008.

Despite a few petty criticisms suggesting that he had thrown a deliberately phallic pose with his guitar, Prince's performance during the Super Bowl XLI Halftime Show was a resounding success.

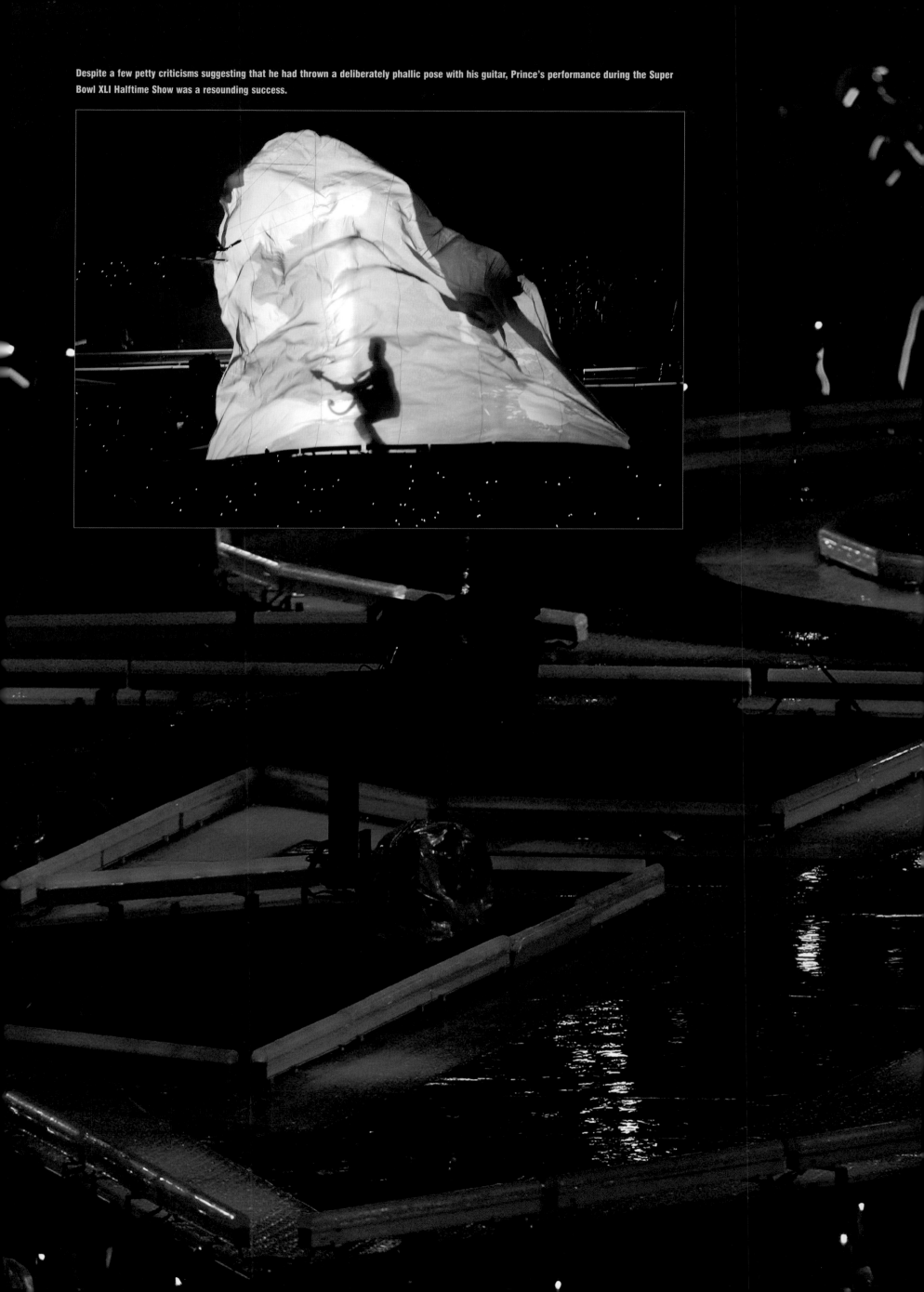

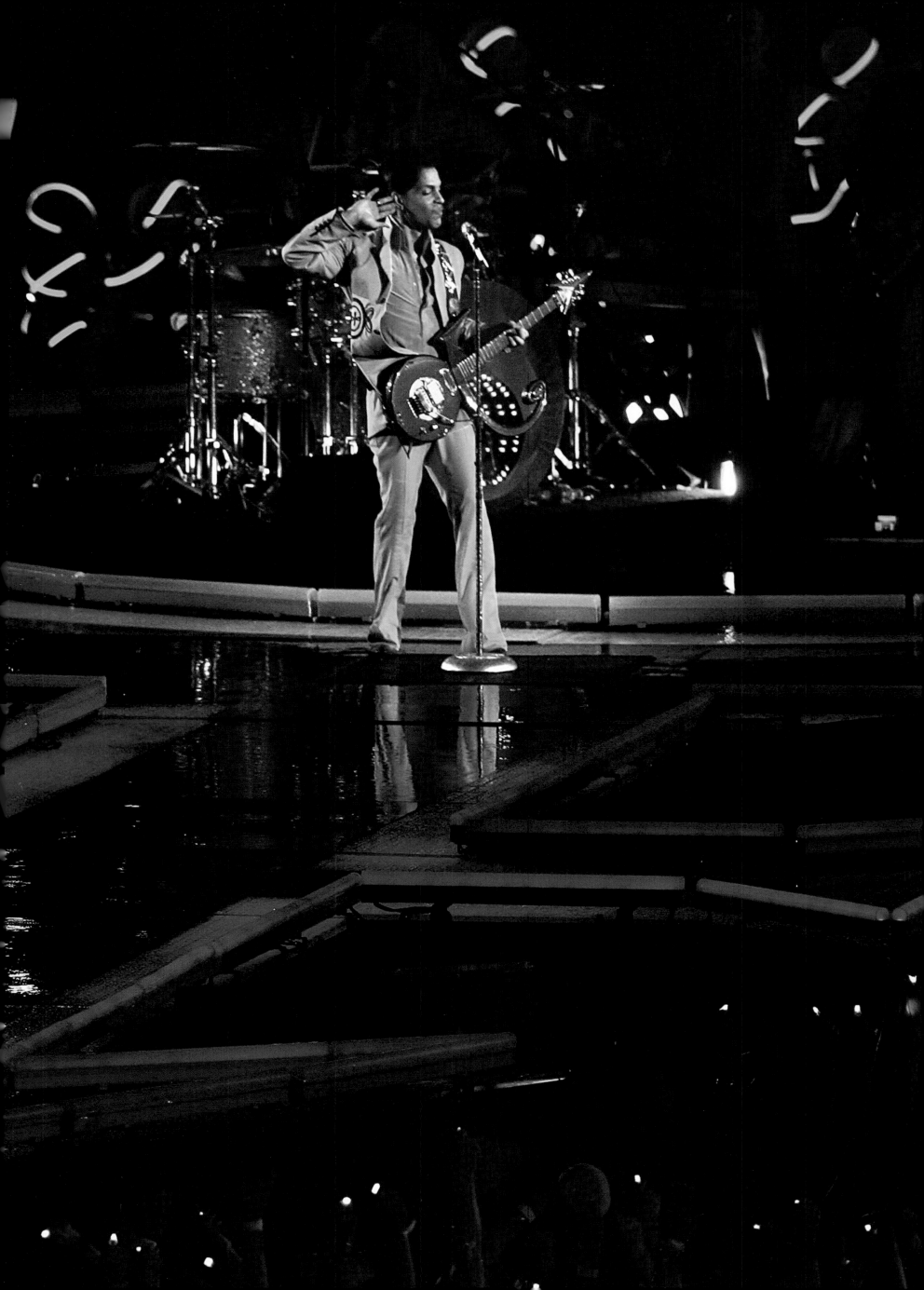

Prince & The Internet Revolution

DURING THE MID 90S, WHILE BATTLING WITH WARNER BROS, PRINCE LOOKED TO BE DEAD SET ON DESTROYING HIS PUBLIC IMAGE. BUT HE WAS ALSO IN THE PROCESS OF PIONEERING A WHOLE NEW WAY FOR MUSICIANS TO GET THEIR MUSIC OUT INTO THE WORLD.

It took quite a few years for the dust to settle and everyone else to catch up, but Prince was one of the very few people on the planet then trying to harness the potential of the internet. "Once the internet is a reality the music business is finished," he told the *New Musical Express* in 1995. "There won't be any need for record companies. If I can send you my music direct, what's the point of having a music business?"

All of this might have been news to the world at large, but not to Prince. "As early as 1989 he was envisioning a cyber world," Alan Leeds told www.housequake.com in 2007. "I know because he told me so, teasing me – and everyone else on his payroll – for not completely co-signing his vision."

It wasn't until 1997 that Prince found himself in a position where he could advertise his new album, *Crystal Ball*, over the internet, checking online orders to gauge how many fans were interested in the record before he started manufacturing it. As he explained to *Guitar World* a year later, he was just "testing the water to see if people would buy music over the internet … since the album was a success, it leads me to believe that the whole interactive thing offers great possibilities."

Prince's testing of the waters was also a landmark event for the music business as a whole. *Crystal Ball* was the first full album to be released online by any artist on the planet. And he did it all without anyone else's help. By then he had already opened and closed at least one website, www.thedawn.com, and would continue to set up others throughout the late 90s, including www.love4oneanother.com, which offered individual tracks for download on occasion; the mail-order site www.1800newfunk.com; and www.npgonlineltd.com.

While groups such as Metallica worked themselves into a frenzy over Napster, the illegal file-sharing program, Prince took a more measured view. "File-sharing seems 2 occur when people want more QUALITY over quantity," he wrote in an email interview with *Wired* magazine in 2004. "One good tune on a 20-song CD is a rip. The corporations that created this situation will get the fate they deserve 4 better or 4 worse … An MP3 is merely a tool. There is nothing 2 fear."

Rather than trying to fight the spread of music on the internet, Prince sought to give his fans high-quality music on his own terms. But it took him a while to get there. In the late 90s, just as the man himself was beginning to cultivate his presence on the internet, some of his more forward-thinking fans started setting up their own Prince websites. In February 1999 Prince started filing lawsuits against fan-run magazines and websites, claiming they were making money from bootlegging his music, creating unfair competition with his own activities, and, most ridiculously, breaching copyright laws by using the symbol he had changed his name to.

Most of the sites buckled under the pressure, but a few managed to stick around. The most notable of these was the print fanzine *Uptown*, which defended its right to continue in court with the help of lawyer and future Prince biographer Alex Hahn. The two parties eventually agreed an out of court settlement that allowed *Uptown* to stay in business provided it refrained from discussing bootlegged albums (individual songs were fine), stopped using the 'love symbol' glyph, and added a disclaimer stating that it was not an official Prince product.

Even so, most onlookers were bemused. The most forward-thinking man in music was now suing his own fans. "From a public relations standpoint," Alan Leeds told www.prince.org, "the situation was badly bungled." Further criticism came in from David Bowie, who had launched his own BowieNet portal a few years earlier and was making similar strides in harnessing the power of the internet. "To understand your presence on the net you have to be a part of it and work within it," he told *Shift* magazine. "I thought it looked so reactionary, for instance, of someone like Prince to clamp down on everything in terms of the lawsuits. You can't stop the sea from coming forwards."

For Prince, it seems, it was important not just to have a presence on the internet but to be in charge of it. In 2001, having recently issued his latest single, 'The Work Pt 1,' through Napster – one month after the site was legally ordered to prevent the sharing of copyrighted music – he made another breakthrough, launching www.npgmusicclub.com on Valentine's Day.

As Alan Leeds later put it, the internet was "the ideal invention … for a somewhat reclusive artist, who enjoys

Prince receives his Lifetime Achievement Award at the 2006 Webbys.

contact with fans under the guise of anonymity." For a one-off subscription fee of $25, members of the NPG Music Club (NPGMC) were offered exclusive merchandise, priority concert tickets, and previously unreleased music from The Vault, delivered in the form of digital downloads and members-only CDs. (The membership fee was originally set at $100, but lowered when Prince's release schedule slowed.)

In an interview with Yahoo! Internet Live, Prince described the NPGMC as "the experience for those who know better," claiming it as an antidote to the "packaged pop stars" then dominating mainstream radio. "Sometimes," he said, "I want to ask those people, 'Do you even know a D Minor chord?'"

Whether 'those who knew better' were attracted to the club is unclear, but it was certainly a success with fans. In March 2004 Prince built on his internet empire with the launch of the Musicology download store, which was named after his latest album. He made his recent internet-only albums available to download for a fee, and put *Musicology* itself on the site a month before it went on sale in stores.

To Prince this was just one more way of getting his music direct to fans as quickly as possible. "We didn't create r club to make other labels nervous," he explained in a email to *Business 2 Magazine*. "We make a lot of music and needed a worldwide distribution service that works as fast as we do … U can get music from r club in the time it takes 2 open an emale. 4 once, eye have a distribution service that actually works FASTER than eye do."

Prince's pioneering efforts were given the recognition they deserved on June 12 2006 at the 10th annual Webby Awards, where the singer was given a Lifetime Achievement Award. "Prince is a visionary who recognized early on that the web would completely change how we experience

music," Webby founder Tiffay Shlain noted in her official statement. "For more than a decade he has tapped the power of the web to forge a deeper connection with his fans and push the boundaries of technology and art."

Within just a few weeks, however, the NPG Music Club had been shut down. On July 4 a statement was sent out to members claiming that, in the wake of the Webby victory, "there is a feeling that the NPGMC [has] gone as far as it can go. In a world without limitations and infinite possibilities, has the time come 2 once again make a leap of faith and begin anew?" Prince seemed to be taking it upon himself to answer these questions, and put the club on hiatus until further notice.

Fans were dismayed. Not only had they lost their direct route to Prince, but also the music they had downloaded from the site, thanks to the encoding software used on it. Prince might have claimed to be taking time off to come up with ways to push the internet further, but it seemed that his boundary-breaking run had come to an end. It was then revealed that a trademark infringement lawsuit had been filed by the Nature Publishing Group against Prince's use of 'NPG' on the day that the website shut down.

On December 19 Prince launched another internet venture, the 'online magazine' www.3121.com. It didn't have the benefits of the NPGMC, but it was a start, as Prince began offering news reports, photos, and a weekly Jam Of The Week in streaming audio through it the

"The Warner Bros battle left its scars, but it also made him a lot more savvy in terms of protecting his rights," WEB SHERIFF'S JOHN GIACOBBI

following year. It didn't hang around for long, however, as another round of lawsuits led to Prince removing himself from the internet entirely.

In January 2004 the singer had forced www.guide2prince.org to close because of the fact that it allowed discussion of his bootlegs (the implication being that it facilitated the sale of them as well). In October of the same year he also went into battle with the owners of www.housequake.com, who subsequently came to an agreement with Prince's lawyers that allowed the site to continue as long as its bootleg trading forum was closed and no 'illegal' photos from the Musicology tour were posted.

In December 2006, www.princefams.com was told to stop using images of the singer altogether. That particular matter was dealt with fairly quickly, but things took a turn for the worse the following summer when fans began posting photos and video clips from Prince's 21 Nights In London residency. The end result was the start of a full-scale war on the internet that threatened to rival Prince's battle with Warner Bros a decade earlier.

Teaming up with Web Sheriff, an organization set up to help defend artists' intellectual property rights, Prince set

his sights squarely on some of the internet's most prominent sites. He challenged various BitTorrent portals to remove links to downloads of live recordings, YouTube to remove all videos containing his images and music (including an innocuous clip of a baby boy dancing to music that just happened to be by Prince), eBay to remove all auctions of counterfeit Prince material, and all other websites to remove his images, likenesses, and music.

"The Warner Bros battle left its scars, but it also made him a lot more savvy in terms of protecting his rights," Web Sheriff's John Giacobbi explained in an interview with *The Register*. "That dispute was about records and CDs, and now that we're into the digital age, he's fighting for his online rights."

Unfortunately Prince wasn't just targeting the likes of eBay and YouTube. In a replay of his actions of February 1999, he sent cease and desist letters to websites including www.prince.org, www.princefams.com, and www.housequake.com, ordering them to remove all copyrighted images, including album sleeves and even fan tattoos of his 'love symbol.'

This time the fan sites grouped together, forming the Prince Fans United (PFU) coalition on November 5 and taking a stand against what they saw as an attempt not to "enforce valid copyright" (as Prince had claimed) but to "stifle all critical commentary." Negotiations between the two parties continued well into 2008, but a draft agreement drawn up between them remains unsigned at the time of writing. All images and music that Prince owns the copyright to have been removed from the sites, but anything that can presented under the terms of 'fair usage'– including album sleeves – has remained.

The proliferation of Prince media on the web, originally cultivated by the singer himself, seems to have come back to haunt him. With all the mudslinging and litigation flying back and forth, it's no wonder that he wanted out. On December 23 2007 he took www.3121.com and all of its multimedia content offline, followed by the rest of his web portfolio. By the end of the year his official web presence was nothing but a blank screen.

One good thing did come of the clash between Prince and the fan coalition. On November 8, three days after the formation of PFU, Prince sent out 'PFUnk,' a seven-minute funk extravaganza allegedly recorded in one night. "I hate to let you know that it's on," he sings, seemingly in reference to the current tensions between fan and musician, before reminding his fans that "digital music disappears in a day … I love all y'all / Don't you ever mess with me no more."

The song was greeted as one of his best recordings in years, apparently confirming some fans' assertions that Prince's best music is driven by aggression. Some claimed it to be better than his three recent albums – *Musicology*, *3121*, and *Planet Earth* – put together. It was so good, in fact, that Prince released it as a digital-only single via iTunes later in the month.

123 "Everybody at Paisley Park was on a short leash" Jeff Gold in *Liquid Assets: Prince's Millions*

124 "He spent more energy in promoting his views" Alan Leeds to www.prince.org (2005)

125 "Prince wanted to have his cake and eat it too" Jeff Gold in *Liquid Assets: Prince's Millions*

126 "I wouldn't be in the music industry" Prince to *Los Angeles Times* (1996)

126 "I know what time it is" Prince to MSN Music Central (1996)

126 "I never meant to be compared to any slave" Prince on *OPRAH* (1996)

126 "I've washed my face" Prince to *Los Angeles Times* (1996)

126 "They gave me a lot of golden albums" Prince to *El Pais* (1997)

132 "We had a big graph" Bob Cavallo in *Liquid Assets: Prince's Millions*

"He's the closest thing to a genius that I've come into contact with."
WENDY MELVOIN

132 "Before we even shot film … we had probably spent $90,000" Rob Born in *Liquid Assets: Prince's Millions*

132 "I was never rich, so I have very little regard for money now" Prince to *Rolling Stone*

133 "I'm not scared of poverty" Prince to *El Pais* (1996)

134 "I wouldn't mind if I just went broke" Prince to the Electrifying Mojo (1985)

134 "I was being fired on a cutback" Heidi Presnail to the *St Paul Pioneer Press* (1995)

134 "You've never seen them, 'cause they're for songs you've never heard" as reported in *An Evening With Kevin Smith*

136 "He has a small cash-flow problem" Chris Poole in Liz Jones

139 "I'm still waiting to see if things change" Prince to British tabloids (1994)

CHAPTER 4

143 "Fulfilling the terms of his new contract included delivering this new album" Bob Merlis to *Los Angeles Times* (1996)

143 "That's what we were going for" Prince to *Los Angeles Times* (1996)

146 "I've never been this much in love" Prince to *OPRAH* (1996)

148 "My music wants to do what it wants to do" Prince to *Forbes* (1996)

149 "They ought to find the president and congratulate him" Prince to *Bass Player* (1999)

152 "I worked for a year and I must admit I'm amazed by the results" Prince to *Hello* (1996)

153 "It's the first time I've recorded a complete album in a state of freedom" Prince to *Oprah*

154 "It was all quite innocent, but quite intense" Mayte to www.fiyamag.com (2005)

155 "All the ingredients were there to unite us" Prince to *Hello!* (1996)

155 "I haven't had a nightmare since I decided to get married" Prince to *El Pais* (1996)

155 "My soul has been in love with Mayte for thousands of years" Prince to *Interview* (1997)

"[Watching Prince work] is a bit like watching astronauts walking on the moon – something beyond imagination." ALAN LEEDS

155 "I wasn't allowed to call him, ever" Mayte to fiyamag.com (2005)

157 "Some couples are brought together after the loss of a child" Mayte to www.fiyamag.com (2005)

157 "We believed he was going to come back" Mayte to www.fiyamag.com (2005)

157 "We don't plan to investigate. There's no case here" *City Pages* (1997)

166 "This is a poet, a renaissance man, an iconoclast" Clive Davis to *New York Times* (1999)

166 "When I was at Warner Bros I always heard from a third party" Prince to *Minneapolis Star-Tribune* (1999)

CHAPTER 5

180 "I get asked every year to play at the Grammys" Prince to *The Canadian Press* (2004)

182 "Maybe we should put a sampler on every seat" Prince to *Forbes* (1996)

182 "I'm going to ask all of them to release it at once" Prince at press conference (2004)

182 "The CD is more or less a companion to the concert" Prince to the *San Francisco Examiner* (2004)

182 "With the first copy shipped, we started making money" Don Ienner to *Rolling Stone* (2004)

184 "The charts are supposed to represent what consumers are spending money on" an unnamed record executive to *Billboard* (2004)

184 "What we're trying to do is put the family first" Prince to MTV.com (2004)

"He's the most complete pop artist of our time." PEPÉ WILLIE

189 "He's really down to earth" Maya McClean to www.clubplanet.com (2007)

192 "There's definitely a throwback vibe to *3121*" *Minneapolis Star-Tribune* (2006)

195 "It's pretty much the Prince world brought to Vegas!" Maya McClean to www.clubplanet.com (2007)

195 "She is with him at all times" Ted Cockle to *Music Week* (2006)

196 "I think in a lot of ways I still sound like I did before" Prince to www.housequake.com (2005)

197 "Hasn't had a genuine hit record in many, many years" Alan Leeds to www.housequake.com (2007)

Index

Words In Italics indicate album titles unless specified as something else. 'Words In Quotes' indicate song titles. Page references in **bold** refer to illustrations.